# 歲月 月 照 堂

臺 北 市 立 美 術 館

# TIME:
# The Images of
# Chang Chao-Tang,
# 1959-2013

# 「歲月／照堂：1959—2013影像展」　館長序
## TIME: The Images of Chang Chao-Tang, 1959-2013
### DIRECTOR'S FOREWORD

　　「隨時走路，即時在場」，張照堂自高中時期拿起相機開始拍照，至今仍未停歇，在超過50年來的影像創作生涯中，作品涵蓋攝影、電視片、紀錄片與劇情片等。他的作品不僅反應時代脈動也是深遠的歷史見證，曾多次獲得重要的文藝獎項，包括：金鐘獎（1980）、國家文藝獎（1999）、行政院文化獎（2011）等。他也從事攝影與影片的策展與教學，同時策劃、主編、撰寫臺灣攝影家的叢書與攝影主題的專書，在影像美學的傳承、累積、推廣與提攜後進上，不遺餘力，有著深遠的貢獻與影響。

　　在對人存在價值與時空位置的深刻觀照下，他的影像呈現出平凡中有超脫、既親切又疏離、荒謬中有詼諧的特質，體現出攝影家敏銳的觀察；深刻的理解與同情，和高度關懷與同理心。1962年，張照堂站在家中頂樓的陽台上，影子被夕陽遮蓋映照在牆上，頭正好切掉，於是他將相機背在身上，用自拍器按快門拍下無頭經典作，影像簡單、乾淨而有力量。沒有頭，代表一種失落與迷失的時代感，僅留下殘軀，增加一種想像力，也流露出現代主義中孤寂與疏離的氛圍，這種徘徊在現實與非

"Always on the go and first one on the spot" — Chang Chao-Tang has been taking photos ever since high school. During his fifty-year artistic career, he has created works spanning photography, television films, documentaries and feature films. Reflecting the state of the times, his works are also a testimony to history, and have been awarded various important artistic awards, such as the Golden Bell Award (1980), the National Award for Arts (1999) and the National Cultural Award (2011). In addition to curating photo exhibitions and teaching film production, he has planned, edited and wrote series of books about Taiwanese photographers and monographs on photographic subjects. Tireless in passing down, accumulating and promoting the photographic aesthetic tradition, as well as nurturing talents, he has made great contributions and has had a profound influence.

In terms of the existential values of man and the contemplation of people's temporal and spatial situation, his images are both ordinary and sublime, warm and detached, absurd and humorous, exemplifying the photographer's keen observations, deep understanding and sympathy, as well as profound compassion and empathy. In 1962, when Chang was standing on his balcony on the loft of his home, the sunset cast his shadow on the wall, with his head cut off. With the

現實邊緣的影像特質，也是他拍照50餘年一貫的獨特風格。

這次展覽是張照堂首次完整回顧展，展出自1959年創作至今的400餘件攝影作品（包括印樣與未經發表的肖像系列、數位相機及手機拍攝的組構影像系列）；8部紀錄片與電視影片；同時以「展中展」重現張照堂在1960年代參與「現代詩畫展」及「不定型展」等深具實驗性質的藝術展演現場與裝置作品、一些攝影原作、繪描、塗鴉、札記、拼貼等；以及主編臺灣攝影家的文稿、書籍等文件與影展海報等。展覽依創作時序及作品內容共規劃六項主題，包括：「少年心影（1959-1961）」、「存在告白（1962-1965）」、「裝置／塗鴉／原作（1966-1986）」、「社會記憶／內心風景（1970-2005）」、「數位發聲（2005-2013）」與「歲月容顏（1962-2013）」等，深度與廣度兼俱，完整呈現出張照堂的影像美學與成就，與在臺灣攝影與影像發展脈絡上承先啟後的重要地位。

臺北市立美術館今年跨進屬於它的第三十個年頭。在這一年，本館陸陸續續推出多檔擲地有聲的藝術展覽。「歲月／照堂：1959-2013影像展」的舉辦，不僅是攝影界的大事，也是本館今年策畫重量級藝術家的回顧展。展覽得以順利舉辦，本人對於攝影家、撰稿人及布萊特數碼科技有限公司、新中美貿易股份有限公司、原點國際藝術有限公司、後視野傳播事業有限公司、達蓋爾暗房工作室的鼎力協助及慨然出借攝影器材展出，在此致上最誠摯的敬意與感謝。

黃海鳴
臺北市立美術館　館長

camera slung over his body, he used the self-timer to take a classic headless self-portrait. The image is simple, clean-cut and powerful. Headlessness represents a sense of alienation and loss. The headless body is evocative and conveys the modernist sense of isolation and detachment. This visual quality hovering between the realistic and unrealistic has been his distinctive photographic style for over fifty years.

This exhibition, the first complete Chang Chao-Tang retrospective, features some 400 photographs dated between 1959 and now (including contact prints and portrait series that have never been shown, and composite images taken by the digital camera and cell phone camera); eight documentaries and TV films; and an "exhibition within an exhibition" recreating the settings and installations of highly experimental shows that Chang took part in in the 1960s, such as the "Modern Poetry Painting Exhibition" and the "Informel Exhibition"; some original photographs, drawings, scribblings, notes and collages, as well as manuscripts of his monographs of Taiwan photographers, books and posters of his exhibitions. Six themes have been set out according to the chronology and content of works, including "Images of Youth (1959-1961)", "Existential Voices (1962-1965)", "Installations, Scribblings and Original Works (1966-1986)", "Social Memory / Inner Landscapes (1970-2005)", "Digital Quest (2005-2013)" and "Faces in Time (1962-2013)". With both breadth and depth, they provide a comprehensive picture of the aesthetics and achievements of Chang Chao-Tang's images, and his important role as a link between past and future in the development of Taiwanese photography and images.

This year marks the 30th anniversary of the Taipei Fine Arts Museum. The museum will be presenting a series of heavyweight exhibitions. "Time: The Images of Chang Chao-Tang, 1959-2013" is not only a significant event in the photography circle, but also a major artist retrospective of the museum this year. The exhibition is made possible through the whole-hearted support of the photographer and the writers, as well as the assistance of Bright Digital Printing CO. LTD., Steelman Trading, Origin International Arts, Revision Communications and the Daguerre Darkroom Studio, which have generously loaned us photographic equipment. I wish to pay them my respects and thank them heartily.

Huang Hai-Ming
Director, Taipei Fine Arts Museum

專文
ESSAYS

# 關於歲月
## Regarding Time

■ 張照堂
Chang Chao-Tang

怎麼又是「歲月」？

朋友好奇地問我，我不知如何回答，只知道這兩個字長久以來一直嗡嗡作響在腦袋裡，趕也趕不走，一提到要取名字，「歲月」就出籠了。

時光倒回2005年，當時南藝學生在網路上幫我搭了一個部落格，我陸續在上面貼照片寫短文，八年來，累積了600多篇，大都已「歲月」為名。歲月路過、歲月對陣、歲月留言、歲月吟唱、歲月靜坐、歲月落髮、歲月怒火、歲月緘默、歲月塗鴉、歲月疼痛、歲月痙攣、歲月逆轉、歲月說不、歲月傾倒、歲月遺失、歲月陪伴、歲月存在、歲月虛無、歲月飛行、歲月飄蕩、歲月黃成、歲月陳達、歲月等待、歲月核災……這些年來，我似乎得了歲月不支症候群症，或許這是年邁60之後，一種呢呢喃喃的歲月宣告罷。

年輕的時候還喜歡用「看見」、「追尋」、「再見」、「告別」等標題字，最早是「攝影告別展」(1974)，那時請束上還寫

Are you really going on about "Time" again?

A friend asked me curiously, and I didn't know how to respond. All I know is that this word has droned on in my brain for a long time. I try to drive it out, but it won't go. As soon as the question of a title arises, "Time" slips out of the hatch.

Back in 2005, a student at Tainan National University of the Arts helped me set up a blog, and I started posting a long string of photos and essays. For eight years, I've built up 600 entries, and most of them are named "Time." Time Passes By, The Battle of Time, The Message of Time, The Song of Time, Meditation on Time, Time's Hair Loss, Time's Rage, Time's Silence, The Graffiti of Time, The Pain of Time, The Spasms of Time, Time Goes Backwards, Time Says No, Time Upside Down, Time Lost, My Companion Time, Time and Existence, Time and Nothingness, Time Flies, Time Floats, Time and Huang Cheng, Time and Chen Da, Time Waits, The Nuclear Disaster of Time... For years now, I seem to have come down with Time Collapse Syndrome. Perhaps this is just the kind of mumbled declaration about Time one makes after passing the age of 60.

When I was young I was quite fond of using titles with words like

著：「甚麼事情都有第一次，也有最後一次。」接著是《影像的追尋》攝影家連載 (1988)，然後是「看見與告別」攝影展 (1991)，當時我在序中寫著：「你看見，按下快門或記在腦海中，離開，告別。直覺。看見。經驗。告別。看見直覺。告別經驗。接下來該往哪裡走？」接著就是《看見淡水河》(1993)、《看見原鄉人》(1998)……近十年來，好多人又得了看見傳染症，都在看見，「看見喜悅」、「看見未來」、「看見自己」、「看見魔鬼」、「看見梵谷」、「看見臺灣」、「看見世界」……真的看見了嗎？最後發現一本神學靈修的書提到：「沒有看見」。很好，沒有看見，就回到「歲月」裡去罷。

在我的攝影歲月中，有好幾個過渡期，從初、高中時代的「少年心影」到大學時期的「存在告白」，從工作職場間的「社會風景」、「內心風景」、到年邁之後的「幻實風景」。從現實到非現實，從具象到抽象，從傳統到數位，從黑白到彩色，似乎歲月就像一條河，蜿蜒流轉，我們在河流中過渡，一渡一光景。

青少年時代拿著相機，懵懂又羞怯，總喜歡找不懂拒絕的孩

童拍照，或是從大人身旁側拍或背拍。從居住的小鎮逛到近郊的鄉野，斷續也拍了一些自己感興趣的庶民生活與勞動。在沒有明確意識下關注的人物與風景，如今看來，單純卻也透露幾分鄉愁與詩意。不清楚那時候自己在想甚麼，但我知道，那純真年代一去不返，一個過渡就到達下一個彼岸。

大學時代讀的是土木工程，拿到課本才發覺那些鋼筋混凝土、流體力學的程式很難下嚥，只好躲到圖書館與彈子房尋找出路。六〇年代臺灣的現代主義剛萌芽，文學、音樂、繪畫、戲劇、新詩……各路人馬在臺北都會蠶食孕育，存在主義、殘酷劇場等現代思潮也適時飄進臺灣。在政治、社會的保守與高壓下，現代藝術成為年輕人逃避與抒發的管道。當時自己只是一個不服規範又不甘寂寞的學生，熱心參與一些藝文活動，藉著尚能掌控的相機，自以為是的拍了一些照片。這些近乎以妝飾、擺置的劇場式影像，帶給文化圈許多訝異與爭論。當時我沒反駁甚麼，現在回想，「無頭」或許就是一種空虛、迷茫與憤怒的肢體宣告，「模糊」的意象引喻未知與無法捉模。自殘、自虐或死亡跡象或是一種救贖與解放罷。六〇年代的心情確是如

"Seeing", "Searching", "Goodbye" and "Farewell". My earliest one was the photo exhibition "The Farewell" (1974). At the time I wrote on the invitation cared: "Everything has a first time, and a last time." Next came the group photo publication *In Search of Past* (1988). Then there was the photo exhibition "Seeing" (1991), in the foreword for which I wrote: "You see. Click the shutter or remember it in your mind. Leaving, departure. Intuition. Seeing. Experience. Farewell. Seeing intuition. Bidding farewell to experience. Where should you go next?" Next, there was *Seeing the Tamsui River* (1993) and *Seeing the Hakka* (1998)... In the last decade, many people have been infected with the Seeing Bug. Now everyone is seeing. "Seeing Joy", "Seeing the Future", "Seeing Myself", "Seeing Monsters", "Seeing Van Gogh", "Seeing Taiwan", "Seeing the World"... Did they really see all that? Finally, I discovered a religious devotional book on the subject of "The Unseen". Very well — unseen. Let's just go back to Time.

Throughout the days I've spent photographing, I've had many periods of transition. From the "mindscapes of youth" in my middle school and high-school years to the "existential confessions" of my college days, from the "landscapes of society" and "landscapes of the heart" in my working years to my latterday "magical realist landscapes." From real to unreal,

from concrete to abstract, from analog to digital, from black-and-white to color, it seems that Time, just like a river, meanders and flows. We keep crossing its current, and with every crossing comes a different view.

As a teen I picked up a camera, bewildered and bashful. I always liked to take pictures of children who didn't know how to refuse, or to take a picture of them while standing next to, or in back of, an adult. From the little town where I lived, I would wander into the surrounding countryside, now and again photographing scenes that interested me of ordinary folks living and working. When I look at them now, the people and scenes I captured with no clear awareness reveal a simplemindedness yet also a certain feeling for the land and a sense of poetry. I'm not sure what I was thinking of at the time, but I do know that those years of innocence departed, never to return. I crossed the river and reached the other side.

During my college days I studied civil engineering. Only after I got hold of the textbooks did I realize just how hard it was to swallow those formulas for steel reinforced concrete and hydrodynamics, and all I could do was hide in the library or pachinko parlor in search of an escape route. In the 1960s Taiwanese modernism was just beginning to bud.

此，彷如自己是夜半中孤獨、虛妄的狼，不時想推開窗子向外嚎叫。

當然從軍役退伍進入職場後，已沒有那種顧影自傷與虛妄的環境與緣由了。進入電視臺拍新聞與專題報導，廣泛接觸社會各階層之後，鏡頭只能臣服於生命腳下，忠實反映周遭人物的喜怒哀樂，寫實是你唯一的途徑。縱使你仍然是一隻狼，仍然孤獨，但沒有理由虛妄，不再胡亂嚎叫，只能隱隱累積能量，努力使自己不被馴服罷了。

其實40歲之前自己是沒有什麼歲月感的，只知道每天要應付、追求的忙得團團轉，只有現在衝刺，沒有時間回望過去與未來。年事稍長，鏡框裡慢慢累積各種眼神與皺紋，寒熱與風霜，它們緩慢聚集、凝結在心底，歲月感遂逐一浮現。

現實中有太多的無奈與無助，不甘與惶然，一開始你用鏡頭貼近它，紀錄它，想從其中體驗一種生命的本質與變貌，藉以關注你周遭的生命與風景，以填補自己的空白。但畢竟攝影與

文學或繪畫不同，「攝影」這件行為，侵犯、干擾的成份無所不在，有違自然與人倫秩序，不足為傲。年輕時候帶著相機橫衝直撞，變成年長之後的不安承載，深怕之前所為，給對方帶來一些失禮、傷痕或不堪。相機的存在對一個攝影者來說，是一種必要之惡，它的獲取，也會帶來虧欠，這個負荷如何拿捏，端賴掌機人的思索與抉擇了。

或許是這樣的思考，自己慢慢從「面對」中抽離，從人群裡抽離。設法隱匿，或是背離，與現實保持若干距離，一種若即若離、似遠還近的觀望，成為我後來喜愛的拍攝思維與形式。隨時隨地帶著小型相機或手機出門，盡量選擇單純或留白的物件與空間，不再直陳，減少對話，試著以直覺、開放的角度，留駐歲月的剎那。不論鏡頭聚焦或失焦，貼近地面或伸往高處，隨機搖晃或凝定等待……所有這些作為，都是為了尋找另一種邊緣狀態的風景歲月罷。

因為不那麼現實，有人就說是超現實。現實與超現實並不對立，而是一種互補。正如生命、宇宙的形成，自然與超自然現象

Literature, music, painting, theater, new poetry… in Taipei, people were nibbling away at all these fields and slowly cultivating them. Modernist ideas like existentialism and theater of cruelty were wafting into Taiwan all the time. Amidst the conservatism and intense repressiveness of politics and society, modern art became the channel through which young people could escape and vent their feelings. Back then I was just a student who chafed against the rules and craved company, so I threw myself into some arts activities with enthusiasm. Picking up a camera, which I think I could operate fairly well, I took some pictures, full of a sense of self-importance. These rather theatrical images, almost decorative or posed, incited a lot of surprise and controversy in cultural circles. At the time I didn't say much in response. Now that I look back on it, "headlessness" may have merely meant a kind of bodily declaration of emptiness, confusion and anger. "Vague" images intimate the unknown and the ungraspable – portents of self-hurt, masochism and death, or a form of redemption and liberation. Back in the 1960s I really did feel like that, as if I were a solitary, illusory wolf at midnight, sometimes longing to open up the window and howl at the outside world.

Of course, after I finished my compulsory military service and entered the workforce, I no longer had the environment or the cause for narcissistic self-agony and illusion. I joined a television station, filming news reports and special features, and coming into broad contact with people from all levels of society. After that, your camera can only surrender at the feet of life, faithfully reflecting the joys, angers and sorrows of the people around you. Realism is the only road you can take. Even if you are still a wolf, and still solitary, you have no reason to be illusory. You can no longer howl with abandon. You can only steadily build up energy, and struggle to keep yourself from being tamed.

Actually, before I turned 40, I had no sense of the passing of time. I only knew that every day I had to run around in circles, coping and striving. I could only sprint in the present and had no time to ponder the past or the future. As the years stretched out, all sorts of expressions in my eyes and wrinkles on my face slowly accumulated in the mirror. Torrid summers and wintry chills – they slowly coalesced and condensed at the bottom of my heart. The sense of time gradually surfaced.

Reality too often makes a person feel powerless and helpless, dissatisfied and anxious. At first you use the camera to get near it, to document it. You hope to experience the essence and transfigurations of life from it. You hope, by focusing on the life and the scenes around you, to fill in

是共生共容的，並不互相排斥。現實與超現實的世界其實也沒有矛盾與衝突，就像白天與夜晚，清醒與夢幻，清晰與模糊，光明與黑暗，它們並不對立，而是互補，就是因為互補，方才建構我們豐饒、缺失、欣悅又惘然的生命與歲月。

　　每個人都在尋找自己的歲月，我的一部分歲月被拍攝成物像，呈現在這裡。另一部分歲月在夢裡頭，有些我清楚記得，還興奮地拿著相機一路跟隨，知道拍到夢寐以求的畫面，後來不知怎麼就醒了，扼腕不已。非現實的歲月似乎無法成像，相機在那個狀態失能了。我們能複製嗎？歲月無法複製，歲月無法暫停，它一逝不返。好在我們用相機複製了某一段歲月，不管現實、非現實或超現實，它總是我們的歲月，雖然過去，但可能牽引現在，或許意味將來。

your own blank spaces. But ultimately, photography is different from literature or painting. Within the behavior of photography, the elements of encroachment and harrassment are ever-present. You violate the natural and ethical order, and should not feel proud. When I was young I rushed around, poking and prodding, camera in hand. But since I've grown old, I find it hard to bear. I'm deeply averse to do as before, behaving impolitely to others, causing them pain or suffering. For a photographer, the existence of the camera is a necessary evil. Its gains also bring about losses. How this burden is borne ultimately depends on the thoughts and decisions of the person holding the camera.

Perhaps due to such a way of thinking, I slowly distanced myself from the act of "addressing", and removed myself from groups of people. Eventually, a method of lurking, or turning away, of maintaining a certain distance from reality, an aloof viewpoint, far away yet close at hand, became my favorite mode of thought and form of photography. I always carry a little camera or cellphone whenever I step out the door. As much as possible I choose simple objects and spaces with plenty of blank areas in them. I no longer express directly. I've reduced dialogue. Using intuition and an open perspective, I attempt to catch an instant of time. Whether the camera is in focus or out, whether it sticks to the ground or stretches toward the sky, randomly jittery or steadily waiting... all of these approaches are merely means to find a visage of time in a different state that exists along the margins.

Because it isn't all that realistic, some people call it surreal. The real and the surreal are not in opposition, but are mutually complementary. Just like the formation of life and the cosmos, or natural and supernatural phenomena, they are coexistent and mutually encompassing, not mutually exclusive. Actually, the real and surreal worlds are neither contradictory nor conflicting. Like day and night, awakening and dreaming, clarity and vagueness, brightness and dark, they do not stand in opposition, but complement each other. And because they are complementary, they make up our lives – abundant with defects, joys and disappointments — and they make up time.

Everyone is searching for their own time. Part of my time has been photographed and transformed into objective images, presented here. Another part of time lies within my dreams. Some of it I remembered clearly and, excitedly snatching up my camera, went out to pursue. I know I photographed the pictures I was seeking in my dreams, but later, somehow I woke up, and was greatly disillusioned. Unreal time seems

to be impossible to render tangible. In that state, the camera becomes inoperative. Can we reproduce it? Time cannot be reproduced. Time cannot stop. When it is gone, it does not return. When we have used the camera to reproduce a certain segment of time, whether it is real, unreal or surreal, it is always our time. Even though it has passed, it may draw in the present, or intimate the future.

# 大音希聲，大象無形
## 論張照堂的攝影藝術與生命風景

■ 郭力昕
Kuo Li-Hsin

# No Sound for
# the Greatest Music,
# No Shape for
# the Greatest Appearance

Chang Chao-Tang's Photographic Art and Aspects of His Life

文化藝評工作者
Critic

國立政治大學
廣播電視學系
副教授
Associate Professor
Department of
Radio and Television
National
Chengchi University

　　在攝影做為一種觀景窗與快門藝術的年代裡，張照堂也許是那段臺灣攝影史裡，藝術境界最高的一位攝影家。翻開張照堂的攝影履歷，洋洋灑灑不一而足：他從1958年就開始拍照，至今未歇寶刀不老，已超過半個世紀；他50多年來有至少30多次以上的攝影個展、聯展和策展紀錄，是「國家文藝獎」與「行政院文化獎」得主，同時從事電視片、紀錄片與劇情片的創作、策展與教學；他也策劃、主編、撰寫多種臺灣攝影家的叢書，與攝影主題的專書。

　　這些事功，也許說明了他對創作和推動攝影文化的熱情勤奮，但並不是我評斷張照堂的主要依據。對我而言，張照堂是一位真正的藝術家。這不僅由於他的多重才華與藝術境界，更在於他的藝術，和他做為一個人、他的生活、他的生命態度，是高度一致的。而且，他總是在一種既踏實於現實生活之中、靈魂又同時行走在世俗之外的共存狀態裡，使他做為一位藝術家，永遠有趣而不可預測。他是一位真正的藝術家，因為他甚至不在乎「藝術家」等這些頭銜或概念，而且嘲笑它。他寧可更在乎有趣的生活，與炙熱的生命。

In the era of photography as an art of the viewfinder and shutter, Chang Chao-Tang may be the photographer who has reached the highest plane of artistic attainment in the photographic history of Taiwan. There are numerous achievements in Chang's photographic record. He started to take photos in 1958 and has continued for more than half of a century, receiving the National Award for Arts and the National Cultural Award. He has planned, held and participated in more than 30 solo or joint photo exhibitions and received countless awards. He has produced TV programs, documentaries and feature films, as well as taught TV and film production. In addition, he has planned, edited and wrote series of books about Taiwanese photographers and monographs on photographic subjects.

All these achievements may illustrate Chang's passion for and endeavours in photography and promoting the photographic culture, but they are not the main criteria by which I appraise this artist. To me, Chang is a true artist, not only because of his multiple talents and artistic achievements, but more importantly by reason of the consistency of his art with his life and his attitude as a person. He is always in a marvelous state of simultaneously standing firmly in reality, while his soul resides in the spiritual realm. That is what makes him

重新閱讀由他主編的《臺灣攝影家群象》叢書[1]中《張照堂》這一冊裡，他所寫的短文〈非影像筆記〉，仍韻味無窮，其中一段札記，似乎生動地映照了張照堂的某種生命狀態：

加班到凌晨四點半，一個人站在十三樓等電梯，恍惚中抽著煙。指示燈上得很慢，長廊黑漆漆的，我好像聽到一種奇異的撞擊聲。電梯終於上來了，門一開，一隻犀牛從裡面擠了出來⋯⋯

（1975.12.15.）

這是他小兒子出生的那一年，張照堂為了生活負擔不得不努力工作。但世俗的工作，從未奪走他自由遊蕩的藝術靈魂和狂想能力。他用幻想力與幽默感，拒絕被俗世的生活迴圈所吸納、同化，也給予我們抵抗庸俗的想像和鼓舞力量。正是基於張照堂攝影創作背後的這種現實情境，使我們在觀看和分析他的攝影藝術時，必須將他所處的時代氛圍、生命情境、與他的人格特質等各種語境，一併閱讀，或許能比較準確的理解和評斷張照堂的攝影藝術，和它的意義。

## 時代背景

張照堂成長於一個極度壓抑、苦悶的年代，並且在這樣的時代氛圍裡，走過了他創作的精華歲月。臺灣的這個時代背景，政治空氣是高壓、肅殺的，攝影文化是空白或貧乏的；張照堂的攝影藝術，就在這樣的政治與文化悶局裡，迸出了一串獨醒的、清越的高音。

他出生於1943年，二次大戰未歇，日本仍殖民臺灣；他上小學時，蔣介石政權從中國大陸撤退到臺灣，政治上繼續高壓統治著臺灣人民。1950年韓戰爆發，臺灣成為美軍的後勤補給基地；美國為了防堵共產陣營在東亞擴張的冷戰佈局，將臺灣編入美國的軍事協防地區，並開始提供經濟援助。這個佈局，讓蔣介石和國民黨政權得以偏安殘喘於臺灣，並且可以開始對島內展開政治戒嚴，以正當化其獨裁統治。

1950年代到1985年代中期，是臺灣社會受到高度政治控制與思想箝制的三十多年，而張照堂的攝影創作高峰，正好落在

interesting and unpredictable as an artist. He is a real artist because he doesn't even care about this title or concept and laughs at it. I think the only thing he cares about is an interesting way of life and a passionate life.

In the volume devoted to Chang Chao-Tang from the series *Aspects & Visions: Taiwan Photographers* [1] for which he is editor-in-chief, there is an essay "Non-Image Notes" written by himself that lingers in my mind. I discovered a short note in it that seems to reflect the state of his life aptly and vividly:

**"Working overtime till 4:30 a.m., waiting for the elevator alone on the 13th floor, smoking in a trance. The pilot lamp moved up slowly, the corridor was in total darkness, and I thought I heard a strange bump. The elevator finally came up. When the door opened, a rhino burst out⋯" (Dec 15, 1975)**

It was the year when Chang's youngest son was born and he had to work hard to support his family. But all these daily duties never robbed him of his wandering artistic soul and his powers of imagination. He used this imagination and sense of humor to avoid being sucked in by the banal cycle of life — something which inspires and encourages us to resist vulgarity. In view of the realistic circumstances behind Chang's photography work, we should take the spirit of the times, his life situation and his personality traits into consideration in viewing and analyzing his work, in order to more accurately grasp and judge his art and its significance.

## Background

Chang Chao-Tang grew up in an oppressive era and spent his most prolific days in this atmosphere. During this period, the political climate was stifling in Taiwan, while there was not much of a photographic culture to speak of. Chang's photographic art emerged as a sober voice out of this political impasse and cultural vacuum.

Chang was born in 1943, when Japan still colonized Taiwan. When he entered elementary school, Chiang Kai-Shek retreated from mainland China to Taiwan, and continued to rule the Taiwanese with an iron fist. When the Korean War began in 1950, Taiwan became the supply base of the U.S. military. In order to prevent the expansion of the communist front in East Asia during the Cold War, the U.S. incorporated Taiwan

這個時代裡。蔣政權的右翼反共思想，與蔣介石深受日本士官訓練影響的軍國主義、窮兵黷武、與軍事化教育，讓臺灣人民在這個漫長的年代裡，從身體到精神都備受壓抑。除了反共話語之外的一切政治言論或進步思想，皆為禁忌；所有涉及社會現實之反映或再現的藝術表達形式，皆無空間。

在這樣緊張、低迷的社會空氣裡，當時主流的攝影實踐，只有兩種：一是做為官方喉舌的、歌功頌德粉飾太平的新聞照片，一是唯一容許在民間操作的「沙龍攝影」。前者沒有一般人能隨意進入的工作空間，更不必談反映真實社會的新聞自由空間。後者則由順從並配合國府藝文政策的中國早期攝影家郎靜山主導，將沙龍畫意的休閒業餘攝影，推廣為民間攝影文化唯一被認可的方向；若稍微將鏡頭對準比較寫實的農村景觀，或類似之真實生活題材，就會遭到壓制。沙龍攝影的題材和攝影概念千篇一律，但是因為這樣的題材有著不碰現實、去政治性的效果，受到了官方的歡迎和鼓勵。

國民黨政府的這項媒體與藝文政策，有其特定的歷史背景。

蔣介石的國民黨政權，在大陸與中共內戰的慘敗經驗裡，認為戰敗原因是自己的宣傳和思想工作不如共產黨。因此，當蔣政權落荒臺灣後，即立刻嚴格管制媒體的經營，抓緊一切可能產生思想與批判意識的藝術形式與教育機制，進行嚴厲的控制。在藝術方面，舉凡文學、戲劇、通俗音樂、電影、漫畫、攝影等等，一切合適反映現實社會、進行政治批評的創作形式，都納入滴水不漏的檢查機制裡。至於在創作題材上，若不對政治獨裁者歌功頌德、宣揚反共意識與愛國情操、或懷念神州故土，臺灣當時的創作者，起碼也要將藝術導入不食現實煙火的、抽象的、或各類形式主義的路徑，不允許看到現實社會裡農民勞工的貧困生活，或底層社會的真實景象。

在這種政治氣候與攝影文化的語境下，回顧張照堂的早期作品，及其創作全盛期的大部分作品，即可清楚的理解，做為具有卓越視覺藝術才華、和反叛時代之政治壓迫氣氛的張照堂，為何在他的影像裡，展示著這樣強烈的超現實感、荒謬劇場、或疏離觀點的美學。從1960年代起，受到西方現代主義思潮和藝術手法影響的臺灣文學界，及各類藝術創作圈，確實爭相

into its defense zone and began providing it with economic aid. This arrangement made it possible for Chiang Kai-Shek and his KMT regime to survive in Taiwan and to introduce martial law, in order to legitimize their dictatorship.

The years from the 1950s to 1985 were the time when Taiwan society was tightly controlled in politics and ideology. It was also the era when Chang Chao-Tang reached a height in his photographer's career. Due to Chiang Kai-Shek's right-wing anti-communist stance and his militarism influenced by Japanese military training, Taiwanese were oppressed both mentally and physically over this period. All political views and progressive ideas were all taboo apart from anti-communist propaganda. There was no room for any form of art reflecting social realities.

In this tense and oppressed atmosphere, only two kinds of mainstream photographic practices existed. One was news photos serving as the mouthpiece and propaganda for the government. The other was salon photography, the only practice allowed in the private sector. The profession of news photography was not open to ordinary practitioners, nor was there any freedom of the press to report on the social realities.

The latter practice was led by the early Chinese photographer Lang Jing-Shan who complied with the art policy of the government. Amateur salon photography was promoted as the only kind of nongovernmental photographic culture allowed. But once the lens was aimed at realistic village scenes or other real life subjects, such works would be suppressed. The subjects and concepts of salon photography were stereotyped. But since these subjects did not touch on reality and were apolitical, they were welcomed and encouraged by the government.

This media and arts policy of the Nationalist government had its special historical background. After Chiang Kai-Shek and his KMT regime lost the civil war with the Chinese Communist Party in mainland China, they blamed their defeat on inferior propaganda and ideological work. Thus, after fleeing to Taiwan, the Chiang regime imposed strict control over the operation of the media and censored all forms of art and education that could stimulate thinking and criticism. All art forms ideal for reflecting the real society and leveling political criticism such as literature, drama, popular music, film, comics and photography were subjected to the thorough mechanism of censorship. As for the subjects of art, even if Taiwanese artists refused to praise the political dictator, propagate anti-communist ideology or express patriotic sentiment or

模仿西方的現代主義美學語彙，成為某種流行和風雅。儘管如此，我認為在攝影這種能立刻反應政治現實、因此被嚴格看管的藝術形式裡，以及對張照堂這樣具叛逆性格的藝術家，超現實、荒謬、疏離、冷酷的影像語言，首先是一種試圖掙脫苦悶的抵抗與救贖之道。

張照堂在1960年代初期具代表性的、冷冽疏離的、超現實風格的攝影作品，一出手就是非常沈重的、具有壓迫性之巨大視覺張力的藝術。也就是說，他的攝影在創作之初，立刻抵達一個相當成熟的藝術高度。這樣的攝影家，讓人想起西方攝影史上的Andre Kertesz，Robert Frank，Henri Cartier-Bresson，和W. Eugene Smith等天才型人物。他們皆於創作之初，在影像掌握上，即已臻攝影快門藝術的成熟和高度。

張照堂出生於臺北縣的板橋，早期的一些經典影像，場景座落在他的家鄉，別有意味。做為張照堂故鄉的板橋，以及在板橋鎮的江仔翠（當時是一片荒郊野外的鄉下地方）、浮洲里（當時聚集著一些外省人的眷村）、或觀音山，在1960年代那個純

樸、封閉的農業社會，其實是有著屬於臺灣特定時空之代表性意義的。因此，那些「無頭」年輕男子的身軀，那些失焦模糊的兒童的臉，那如鬼魅般浮出鏡頭之前、立於稻田之中、裸身之上、顯影於布幔後、或閉鎖於塑膠袋內的怪異頭臉，出現在板橋的浮洲里、江仔翠、村道上、廢墟前，背景甚至是清晰的稻田與觀音山時，那些代表著家鄉的地景，與當時社會的抑悶氛圍，使這些無頭、糊臉、陰影與鬼魅，有了更讓人沈思的壓迫意義與窒息感。這些鬼魅，一方面是映照並宣洩著青年張照堂之抑悶不安的藝術精靈，同時也可以是臺灣社會在那個時代裡，身體和慾望沒有出口、靈魂和思想無路可逃的黑色共同印記。

## 關於「現代主義攝影」

張照堂攝影創作的一個高峰期，大約展現在1970-1985年間。若以他的重要個展來看，1983年的「恩寵與寬容」，大約以這個標題，代表了此時期的某種主要創作精神；而1986年的「逆旅」，則總結了這個時期的攝影成果。這段期間的作品，有一部份保持了他一慣冷冽、詭譎、突梯的視覺風格或訊息。但

the yearning for mainland China, they were at least expected to detach their works from real life, such as by adopting abstract or formalist approaches. The impoverished life of peasants and workers in reality and the truths at the bottom of society were not permitted.

Given this political climate and photographic cultural context, when we review Chang Chao-Tang's early works and most of the works from his heyday, it is not hard to understand why his images, products of his outstanding artistic talent and rebellious stance, show such a strong influence of the aesthetics of surrealism, absurd theatre and alienation. Since the 60s, Taiwanese literary and art groups influenced by western modernist trends and art techniques tried to imitate the modernist aesthetic vocabulary and made it fashionable. Even so, for an art form such as photography which can promptly reflect the political reality and was thus strictly monitored, and for an artist with such a rebellious personality like Chang, the surrealist, absurd, alienated and cold visual language was first of all a means of salvation and resistance in an attempt to get away from the gloom.

Chang Chao-Tang's representative, alienated and surrealist photography works emerged as a critical, oppressive art with great visual tension

in the early 60s. This means that his photography reached a certain degree of artistic maturity right at the beginning. This reminds us of geniuses such as Andre Kertesz, Robert Frank, Henri Cartier-Bresson and W. Eugene Smith, who all achieved maturity and excellence in the art of photography at the start of their careers.

Chang Chao-Tang was born in Panchiao, Taipei County. Some early classic images take on special meaning since they were taken in his hometown. Panchiao, Chang's hometown, together with Chiangzitrei (wild countryside at the time) and Fuzhou village (a military dependents' village) in Panchiao town, and Guanyinshan, had its special meaning in that time and space in the 60s when Taiwan was a simple and closed agricultural society. Those "headless" bodies of young men, those blurred children's faces and those weird faces that emerge like ghosts, standing on the paddy fields, on top of naked bodies, emerging from behind curtains or sealed inside a plastic bag, appear on village roads or ruins of Fuzhou village or Chiangzitrei, with paddy fields and Guanyinshan in the background. These landscapes representing homeland and the gloomy atmosphere of society at that time give these headless men, blurred faces, shadows and ghosts a greater sense of oppression. These ghosts mirror and give vent to the gloomy artistic

是更大一部份的代表作,則如「恩寵與寬容」這個展覽名稱所示,是一種非常厚重、溫暖、素樸的人文精神的流露和確認。這裡面有著溫潤人心的老人與童顏,有田間騎牛的兒童、街頭的算命先生、笑容專注玩撲克牌的戲班子成員、和面容哀戚的燒冥紙婦人等等。

這個時期張照堂的作品,在內容與風格上,和他在1970年代之前的早期作品,有著相當的差異。從個人的層面來看,進入壯年的張照堂,多少揮別了1960年代那個苦澀、憂鬱、憤怒的藝術青年狀態,走進社會與工作的現場,接受機會與挑戰,也大量地展現自己各方面的才華,並因而可以比較具體地觸摸、描摹臺灣社會的肌理與脈搏,不再僅僅停留於只是抽象地反映個人或社會的精神苦悶。

從當時的時代背景來看,1970年代的臺灣,雖然政治與思想控制依舊嚴厲,但是來自民間的政治反對聲音,和重新認識現實社會與本土文化的渴望,已經透過一些勇於突破現狀者的召喚,和媒體上的發聲,開始啟蒙著社會、鬆動著政治土壤。對於

本土文化、現實生活題材、和寫實主義攝影等的開啟與討論,應該相當程度的影響了張照堂,使他將鏡頭轉向人文精神與現實生活的場景。不過我要強調,儘管這個時期的張照堂,與青年張照堂的攝影相較,在題材或方向上顯得開闊與多元,但他一向的視覺風格和冷凝特質,則始終一致。

然而,在1986年之後,至2005年為止的最近二十年創作裡,張照堂在影像內容上,一方面可以看到他對生命有著更多的寬容與自在,另一方面又繼續著曖昧、鬼魅、抽象、虛實不定、與奇異趣味的張式風格。後者的這些趣味,讓人很快的想起活躍於1960-70年代的美國攝影家Garry Winogrand那些精彩銳利的街頭風景,與美國社會面貌;我們也可以在張照堂的影像裡,看到他在臺灣的寫實場景裡,呼應著Robert Frank和Lee Friedlander等大家的某些趣味。

從張照堂早期那些最強烈突出的超現實或荒謬劇場式的影像,到後期的這些對真實／虛擬／幻境的操演,使不少人認為張照堂的攝影藝術,是一種「現代攝影」或「現代主義攝影」,他也

spirit of young Chang Chao-Tang, and are also a dark symbol of Taiwan society in that era when there was no exit for the physical body and desire, and no escape for the soul and thinking.

## About Modernist Photography

One of the peaks of Chang's photography was around the years from 1970 and 1985. The title of the exhibition "Grace and Tolerance" in 1983 may be representative of his predominant creative spirit in this period, while "Inverse Journey" in 1986 summed up the achievements of his photography in the period. Some of the works from this period carry his usual cold, eccentric visual style or message, while other works, as the exhibition's title "Grace and Tolerance" suggests, reveal and affirm a profound, warm and simple human spirit. They show heart-warming old men and young faces, children riding on buffalos in the fields, fortunetellers on the street, actors playing poker with a smiling and attentive look, and grief-stricken women burning offerings.

Chang's works during this period were very different from his early works in the 70s in content and style. On a personal level, the older Chang had bidden farewell to his bitter, gloomy and angry artistic

youth of the 60s and entered society and the workplace to take up opportunities and challenges, and showcase his talents in all aspects. As a result, he was more able to feel the pulse of Taiwan society and document it, rather than just abstractly representing his personal or social sense of oppression.

With regard to the background of that period, although political and thought control was still strict in Taiwan in the 70s, there were already some opposition voices among the people. The desire to reengage with reality and local culture had begun to enlighten society and loosen the political soil through calls from some who tried to break the status quo and certain views expressed in the media. The discussions over local culture, real life themes and realist photography also influenced Chang in his decision to turn his camera to humanistic and real life events. However, I must stress that while Chang's subject matters and the development of his photography in this period are more diverse than his early photography, his visual style and cool character have remained unchanged.

Nevertheless, in Chang Chao-Tang's photographic works in nearly two decades from 1986 to 2005, we can see that while becoming more broad-minded and at peace with life in his subject matter, he continued

被認為是臺灣「現代主義攝影」最具代表性的人物。從張照堂的某個突出且一貫的攝影風格或語彙來看，似乎這樣「望影生義」的說法也自成道理；但是，這個詞彙和概念，或許還需要爭辯。

「現代性」做為西方歷史文明進展的定義性詞彙，或者「現代主義」做為西方社會一種文學藝術的美學理論或風格主張，衍生自西方的工業文明與科技理性。它是對西方現代性做為具有普世價值之「彌賽亞」的推廣。當臺灣1960年代起的藝文界，移植、模仿著西方現代主義文藝理論、哲學思維和美學形式時，臺灣卻大抵還不在「西方現代性」意義或規格下的社會與文化狀態裡。那時的臺灣，都市化與工業化尚未發生，人民的生活習性保留在農業社會的狀態（其實在某個意義上，這樣的習性在臺灣許多地方、或許多人身上，至今沒有多少根本的改變，包括不少在都市裡工作與居住的人）。工具理性、資本主義、公共領域、和推動改革的政治／社會制度等這些表徵西方現代性的一些主要內涵，在臺灣的1960年代，都還沒有出現。

也就是說，臺灣在1960-70年代的所謂「現代主義」文藝風格，並不是在回應著一個高度工業化、現代化了的社會，所產生的諸種理性、異化、疏離、壓迫、剝削，以及從而形成的藝術思維或話語實踐，而是去脈絡地將西方社會形成的一套藝術語彙，不著邊際地空降到臺灣的傳統社會語境裡。如果說，這是一種純粹「為賦新詞強說愁」的西方藝文技術移植和模仿，也不完全公允；當時臺灣社會的「愁」肯定是有的，但是這個「愁」，並非西方工業文明與資本主義社會裡所產生的那些社會／文化現象，而是臺灣當時的傳統社會，在資訊封閉、政治高壓、道德單一、與身體抑悶之下，所累積的煩悶感和束縛感。西方的「現代主義」文藝美學和語法，恰好可以「拿來」當做一個好用的、又在形式表達上「安全」（因為檢查藝術內容的官方看不懂）的、宣洩時代苦悶情緒的方法。

從這個社會與文化脈絡，回頭檢視張照堂的攝影，或許可以比較清楚的定位他的攝影藝術，跟西方概念下的現代主義攝影，大約並無太多文化意義上的連結。他攝影藝術的獨特性，不在於有多少神似西方現代主義語彙的影像，而是由於他回

with his ambiguous, unearthly, abstract and surprising personal style. This kind of taste reminds us of the sharp street scenery and depictions of American society in the work of American photographer Garry Winogrand active in the1960s and 70s. We can also see that his taste echoes that of Robert Frank and Lee Friedlander in his realistic Taiwanese scenes.

From Chang's early works of the strikingly surreal and absurd images, to the later exercises in realism/virtuality/fantasy, these achievements urged many to call Chang's photographic art "modern photography" or "modernist photography", and they honored Chang as the representative of Taiwanese "modernist photography". It seems to make sense in view of his outstanding and consistent style and vocabulary. However, this term and concept needs more discussion.

"Modern" is a term that defines the progress of western historical civilization, while "modernism" is a style or aesthetic theory of literature and art in western society. Both were the product of western industrial civilization and technological rationalism, and represent the propagation of western modernity as a universal value. However, Taiwan was probably not in the social and cultural state of western modernity when

the art communities were transplanting and imitating these modernist theories of art, philosophical thought and aesthetic forms from the 1960s. Urbanization and industrialization did not take place in Taiwan at that time and the way of life of Taiwanese was still in the mode of an agricultural society (in a certain sense, this way of life has not changed fundamentally for many people in many places in Taiwan, including people living and working in the cities.). Concepts such as instrumental reason, capitalism, public sphere and political/social systems that promote progress which are some of the main components of western modernism had no role yet in Taiwan in the 1960s.

This means that any modernist art style during the 1960s and 70s in Taiwan was not an artistic thinking or practice responding to the rationality or the alienation, oppression and exploitation of a highly industrialized and modernized society, but some de-contextualized art vocabulary formed in western modern society transplanted into the traditional social context of Taiwan. It is however not fair to say that this was just a hypocritical transplantation and imitation of western art skills. There was certainly "anxiety" in Taiwan. However, it was not related to the social/cultural phenomena produced in western industrial civilization and capitalist society, but had something to do with the

應、對抗當時所處的政治壓抑，與身體禁錮之臺灣戒嚴社會的方式，與西方的某些視覺語彙和心理情緒若合符節，且維妙維肖地相互輝映。也就是說，張照堂從西方之攝影、劇場、文學、電影裡的現代主義美學形式，和當時的存在主義哲學思潮裡，吸收、學習的那些形式美學和思考，應用到與「西方現代性」沒有多少關係的當時的臺灣社會裡，居然也能夠「牛頭對得上馬嘴」，成為宣洩、抵抗當時臺灣政治社會抑悶情境的一種奇異而有效的語言。

但是，若以西方之「現代主義攝影」的文化語境和創作概念，來看待或套用在張照堂的攝影上的話，我以為會是一種偏離了臺灣特定脈絡的閱讀或詮釋。另一方面，張照堂攝影藝術裡，同時存在的溫暖人文質地、與剃刀般冷凝鋒利的雙重性，也使得這位藝術家的獨特與豐富，不再需要「現代主義攝影家」這類以西方美學概念為尊的冠冕。或者，這樣的描述既不準確，亦不能完整的說明張照堂做為攝影家的多樣內涵。

## 再評價張照堂

張照堂的攝影創作持續了半個世紀，未曾真正中斷；從他的近作來看，他對快門藝術之攝影語彙的掌握依然精準，功力不減當年，趣味也未曾轉趨稀薄。然而，他的攝影藝術，至今停留在快門藝術的攝影概念裡，且這樣的藝術成績，在他早期的作品裡，已經粲然樹立。那麼，在這個數位化拼貼、改造、後製影像極為方便，使攝影可以自由地和多媒材、裝置、觀念、行動藝術等各類前衛實驗手法結合的年代裡，我們應該如何看待張照堂快門攝影藝術的價值，以及張照堂這位藝術家的意義？

先從他的快門藝術說起。攝影藝術的古典意義，即在於它是掌握快門瞬間的藝術，以及，創作者透過對瞬間的捕捉，據以描繪或詮釋世界。張照堂在這個平面影像形式裡，已到了一種多數人難以企及、遑論超越的純熟而深刻的境地。過於純熟的技藝，有時會讓藝術作品，減低或甚至喪失了原本動人的力量；而這似乎尚不成為張照堂攝影藝術的問題，乃是他總能用新鮮而犀利的視角，看見平凡場景中的異質趣味，而且以攝影

anguish and suffocation accumulated in Taiwanese traditional society as a result of information blockage, political pressure, homogeneous moral values and physical oppression. The western modernist aesthetic and grammar were just a convenient and safe form to vent the suppressed feelings (since they were beyond the comprehension of official censorship).

Maybe we can locate Chang's photographic art more precisely by reviewing his pictures in this social and cultural context and find out that his art doesn't have much to do with modernist photography in the western sense in terms of cultural implications. The uniqueness of his photography lies not in its resemblance to the western modernist vocabulary, but in the way his response and resistance to the Taiwanese society with its political oppression and physical imprisonment echo and mirror certain western visual vocabulary and psychological moods. That is to say, it was a coincidence that the modernist aesthetic forms that Chang learned from western photography, theater, literature and film, and the formal aesthetics and thinking he absorbed from the Existentialist philosophy were an effective language for countering the oppression in Taiwan society which had nothing to do with western modernity.

However, if one uses the cultural and creative context of western modernist photography to evaluate Chang's photography, I think it would be a reading or an interpretation that deviates from Taiwan's specific context. On the other hand, the duality of both warmth and sharpness in Chang's art makes him unique, without the need for such title as "modernist photographer" with its emphasis on western aesthetic. Moreover, this kind of description cannot precisely or fully illustrate the different sides of the photographer Chang Chao-Tang.

## Re-evaluating Chang Chao-Tang

Chang Chao-Tang has worked in photography for half a century. Judging from his recent works, his grasp of the photography vocabulary is still precise like in the old days, and the interest of his work has never faded. Nevertheless, the art of his photography is still rooted in the concept of shutter art, and this artistic achievement, as mentioned earlier, is already evidenced in his early works. Now, in an age when digital collage, alteration and post-production is so convenient that photography can freely combine with multimedia, installation art, conceptual art, action art and all kinds of avant-garde practices, how should we assess the value of Chang's shutter art, and the significance of this artist?

的快門和構圖，將它們轉化成藝術語言。

他的作品全部取材自現實場景，但幾乎沒有一幅作品，是直接描述事件本身、提供見證功能、或訴諸表面情緒的。所有的情緒、訊息或觀點，都經過進一層的隱喻、轉化、沈澱、或聯想，使他的攝影裡的苦痛、荒謬甚或殘酷，從沒有哭天搶地的喧囂，而是一種深邃、無言、甚至欲哭無淚的悲哀和喟嘆；即使在他很少出現的歡樂或笑靨的畫面裡，我們也不敢掉以輕心的觀看，而更多的是以凜然的心情，閱讀這些溫暖著我們的生命。

然而，張照堂的攝影藝術，或者說，他做為攝影藝術家的價值，不僅僅表現在快門功力與影像境界上，更在於他的藝術結晶，和他這個人、他的生命狀態，是極其一致的。也許很多人認為，談論藝術價值，不需要把藝術家的個人因素考量進來，只要從作品論斷即可，尤其對並非涉及新聞或紀錄攝影這類具有較多道德性考量的攝影類型時。但我仍希望提議，若能夠瞭解張照堂其人的特質，應該會更懂得欣賞他的攝影藝術，何以如此獨特，歷久不衰。

在吳忠維訪問、撰寫的《看・不見・張照堂》[2]（臺北：時報，2000）裡，張照堂誠實的描述自己並不積極；和國外一些成就突出的大攝影家相比，自己的創作顯得不夠努力或缺乏紀律。然而，他接受自己的這種創作狀態，覺得既然如此性情，即不欲刻意改變或勉強自己。也曾有評者認為，張照堂雖才氣縱橫，但是對攝影創作這件事，卻一直處在一種「業餘狀態」。坦白說，我早些年也多少有類似的看法。然而，多增添了一點歲月，和對生命的體悟，我相當地修正了自己的觀點。

有才情的藝術家大分兩類。一種是對創作高度紀律化、企圖心強、步步為營、精於計算、甚至生產行銷皆絲毫不差的人；他們成功的累積戰果，打造自己藝術的「重要性」，以確保能取得名列主流藝術殿堂的入場券。另一種人則認真創作，並忠於自己的生活；對如何可以更快的、更有效的推銷自己，沒有什麼太積極的興趣，甚至對那樣的「企圖心」不屑一顧。我當然不能說，具有積極性與企圖心、認真創作的藝術家，不值得鼓勵，但我個人毋寧是更欣賞後者的。

We can start from his shutter art. The classical meaning of photographic art is the art of instantaneity by controlling the shutter, and the way the photographer represents or interprets the world by capturing the moment. In this form of two-dimensional art, Chang has already reached a maturity and profundity that few can emulate or exceed. Refinement of technique sometimes lessens the power of the art works to move people. But this does not seem to pose a problem for Chang, since he can always detect the unusual interest in an ordinary scene from a fresh and sharp angle and use the shutter and composition to transform it into an artistic language.

All his works are taken from an actual scene, but none of them describes the event itself, bears witness or expresses a superficial emotion. All the emotions, messages or views are processed through metaphor, transformation, precipitation or association, making the pain, absurdity and cruelty less melodramatic or excruciating, and turning it into deep, speechless and even tearless sorrow. Even for those rare images of joy and smiles, we can't take them lightly, but have to read these lives that warm our hearts with a sense of awe.

However, Chang's art or his value as a photographic artist is not just manifested in his technique or the brilliance of his images, but also in the consistency of his works with his personality and life. Many people might say that we should not take into account the artist's personal factors in judging the value of art, and should only judge by the works. This is particularly true for a photographic form with fewer ethical considerations than news or documentary photography. Nevertheless, I would still suggest if one understands Chang's personality, one would know how to better appreciate his work and understand why his art is so unique and enduring.

In Wu Chung-Wei's *Seeing/Without/Chang Chao-Tang*,[2] Chang admits that he does not hold exhibitions actively, nor does he have any special plan or ambition. Unlike some outstanding photographers in other countries, he does not work hard enough on his creations and lacks discipline. However, he accepts his own creative habits, and is not inclined to change or force himself owing to his temperament. Some critics think that while Chang has talent, he has always been a sort of an amateur in photography. In fact, that was what I thought before. But after gaining some experience of life as I got older, I have revised my previous view to a certain degree.

There are two kinds of talented artists. One kind is highly disciplined

張照堂認真工作，熱情生活，對各類藝術的吸收與涉獵極廣，尤其音樂、電影、文學和劇場。他勤於從最新的藝術創作和思潮中不斷汲取養分，對教育學生也不吝惜自己的時間和經驗。他不急於展示自己，一方面看到他的從容自在與自信，另一方面，也說明了這位藝術家是一直向前看的。

他的「不積極」、「業餘」、隨遇而安，並且願意將許多精力和時間，留給教育學生、吸取新的藝術養分、和熱烈的生活。這些於我而言，皆說明了張照堂基本上不是一個自戀的人。他熱情而專心地注視著世界，並不老是看著鏡子中的自己。這樣的特質，可以使他的藝術裡包含更多的真誠與純粹，更少的矯情造作。當生命狀態與藝術作品可以如此誠懇一致，則「業餘」與「無企圖心」所生產出來的攝影藝術，毋寧是更動人的。

中年之後，得以重新閱讀、思索、再評估半個世紀以來的張照堂的攝影，我因而可以比較懂得張照堂的藝術精神，和他生命的意義與重量。他的藝術，以及更重要的，他這個人的存在與生命態度，已經成為一種風範和標竿。我相信，張照堂心裡

的那頭犀牛，還是一樣不馴服的、生命力勃發的，要從壓迫狹仄的電梯裡，衝擠出來。

註釋：

[1] 《臺灣攝影家群象》（臺北：躍昇文化，1989）叢書由張照堂主編，共13冊，包括：鄧南光、張才、李鳴鵰、林權助、鄭桑溪等五位臺灣早期攝影家，張照堂、王信、梁正居等三位1960-1980年代之資深攝影家，以及侯聰慧、劉振祥、高重黎、吳忠維、周慶輝等五位1980年代後崛起之中生代攝影家。

[2] 《看‧不見‧張照堂》（臺北：時報文化，2000）是由攝影家吳忠維所訪問、撰寫的關於張照堂之攝影創作理念的書。此乃張照堂做為第三屆「國藝基金會文藝獎」美術類得主、由該基金會委託作者撰寫的一份得獎人傳記性質的出版。

in making art and has strong ambition, meticulous in management, calculation, production and promotion. These artists accumulate their achievements to ensure the "importance" of their art, so that they can enter the temple of mainstream art. The other kind works hard on his creations but is truer to his own life, having no interest in selling himself faster and more efficiently, or even scorning such "ambition". I cannot say that the first kind of artists is not worth encouraging, but I admire the latter kind more.

Chang works hard and lives with passion, studying various kinds of art, especially music, film and theater. He derives nutrients constantly from the latest artistic creations and ideological trends, and generously gives his time and shares his experience when teaching his students. We can see his confidence from the lack of urge to showcase himself. It also suggests that this artist is always looking forward and does not dwell on his own achievements.

He is "passive", "amateur" and adaptable, willing to devote time and energy to teaching students and enriching his life. To me, it shows that Chang is not a narcissist. He pays attention to this world, instead of always looking at himself in the mirror. This quality fills his art with

purity and genuineness instead of hypocrisy. When his life is so sincere and consistent with his art, the photographic art he creates as an "unambitious amateur" is no doubt more moving and enduring.

As I reconsider and re-evaluate Chang's work of half a century after entering middle age, I can understand his artistic spirit and also the weight and meaning of his life much more deeply. His art, and more important, the attitudes he holds in his existence and life, have become a natural model. I believe that the rhino inside Chang's heart is still going to burst out from the narrow elevator with an untamed and powerful force.

NOTES:

[1] *Aspects & Visions: Taiwan Photographers* was edited by Chang Chao-Tang with 13 volumes on five of Taiwan's early photographers — Teng Nan-Kuang, Chang Tsai, Lee Ming-Tiao, Lin Quan-Zhu and Cheng Sang-Hsi, three senior photographers — Chang Chao-Tang, Wang Xin, and Liang Cheng-Ju from around 1960-1980, and five mid-generation photographers — Hou Cong-Hui, Liu Zhen-Xiang, Kao Chong-Li, Wu Chung-Wei and Zhou Qing-Hui — who emerged after the 80s.

[2] *Seeing/Without/Chang Chao-Tang* is a book about Chang Chao-Tang's photographic concepts with interviews conducted and written by photographer Wu Chung-Wei. It was published by the National Culture and Arts Foundation (NCAF) after Chang won the 3rd National Award for Arts in the fine arts category.

# 「操」弄現實成為
# 可「疑(問)」的現實
## 論張照堂攝影

# From Manipulating Reality
# to Questioning Reality

Loose Thoughts on the Photography
of Chang Chao-Tang

■ 顧錚
Gu Zheng

攝影家／評論家
Photographer & Critic

復旦大學
新聞學院教授
Professor
School of Journalism
Fudan University

復旦大學
視覺文化研究中心
副主任
Deputy Director
Research Center for Visual Culture
Fudan University

　　評說張照堂的攝影，對於評說者來說是一種挑戰，也是一種激勵。他的照片是開放的，沒有局限觀眾的視野，而是相反，刺激了觀眾言說的衝動，也打開了觀眾的視野。他的照片讓人覺得現實經過他的觀看還有一種（甚至是幾種）的面紗被他揭開了。他的觀看還讓人發現，攝影還具有這樣的轉變人們對於現實的觀感的可能。這種對現實施以「變形」的魔術，可能帶來了包括了拍攝與理解上的雙重可能。對於拍攝者來說，如何轉換現實中的事物，即從單純的記錄自覺地向著記錄的虛構的轉變，是一個挑戰。而對於觀看者來說，如何將已經被定格為一張影像中的現實再轉換成屬於一己的內在現實，也是一種挑戰。

　　對於張照堂來說，攝影，其實就是將現實中的具體的物與事，通過影像的轉換，使之無限接近於另外一種現實（也許是一種攝影家個人的心理現實）的實踐。這是一種努力使兩種現實合體的實踐。這種以影像方式呈現的攝影家的個人心理現實，在許多情況下或許可以被冠名為超現實主義圖像。正如美國哲學家阿瑟‧丹托在《藝術是什麼》中說的：「超──現實是一種通靈的現實，躲避意識的心靈，而且超現實主義

To critique the photography of Chang Chao-Tang is a challenge for a critic, but it is also a source of stimulation. His photographs are open. They do not limit the vision of the viewer. Quite the contrary, they spur the viewer's urge to articulate, and open wide the viewer's vision. His photos make a person feel that reality, passing through his gaze, has been unveiled in a way (or even many ways). His gaze allows one to discover that photography really does possess the potential to transform people's perceptions of reality. This magical ability to transmogrify reality may bring about two different possibilities, in photography and in comprehension. For someone who takes pictures, how to transform the things of reality — to move from simple documentation toward the fabrication of documentation — is a challenge. And for the viewer, it also a challenge to transform what has already been frozen as an image of reality into something that belongs to an inner reality of one's own.

For Chang Chao-Tang, photography is actually the practice of making the concrete objects and events of reality unrestictedly approach a different mode of reality through the transformation of images. This is a practice of endeavoring to achieve the synthesis of two realities. In many circumstances, this method of expressing the personal psychological reality of the photographer in images may be labeled as

者覺得，真正的藝術正是以此心理學現實為基礎。」（Arthur C. Danto, *What Art Is*, New Haven &London:Yale University Press, 2013,P13）

如張照堂的那些照片所啟發我們的，在許多情況下，超現實主義影像有可能超越了人們可以把握的現實的表象，呈現了現實的別樣（beyond）的圖像。在這樣的超現實影像中，世界的秘密或有稍許的暴露。這既挑戰攝影家的眼力，也錘鍊攝影家的眼力。

我認為，超現實主義不是要通過把日常陌生化給人們以當頭棒喝，而是認為世界本來就是如此陌生怪誕。我們以為這現實平常且熟悉，是因為我們並沒有深入到現實的深處。我們對於這個世界的自以為是的熟悉、或者不假思索的熟悉，都不是這個世界的本相與真相，或者說只是表面的真相。如果我們有本領深陷現實的深處，那麼它們之陌生自是天經地義，而所謂的熟悉則從此在我們心中永無容身之地。超現實主義者眼中的世界，既屬於他們的精神與日常，也屬於應該被眾人所分享的精

神與日常。只是這些他們所捕捉到的令人對現實起疑的陌生的日常，是否要通過某種形式的分享與傳播是要取決於他們。人們會認為，只是當他們想要與眾人分享時世界才會變得這樣詭異。不過，事實並非如此。現實本來就是複雜的，不同的觀看手段與方式就會帶來不同的世界。觀看者的本領與世界觀，往往使得他所要與我們分享的世界是如此的不同，就像張照堂的這些告訴了我們現實之荒謬的照片。這樣的荒謬、荒唐的世界，能夠理解者當然欣喜若狂，而不能理解者則大惑不解。這歸根結底在於世界觀的不同，在於生命體驗的不同，在於個體的主體性所立足的基礎之不同。

張照堂的這些照片，絲毫沒有改變現實，但這些照片因為改變了現實在照片中的形象，因此同時也就改變了人們對於現實的觀感，介入到眾人的心靈現實中來。他是用異常來顛覆正常，因此既否定了正常，也證實了正常的普遍性。他以超現實影像來掘發現實的吊詭，因此既否定了現實，又肯定了現實的撲朔迷離與不可把握。張照堂的照片自始至終透露悲觀的基調。但是他的巨大的悲觀並不妨礙他以巨大的熱情來展現自

surrealist imagery. As the American philosopher Arthur Danto noted in *What Art Is*: "Sur-reality was a kind of psychology of reality, hidden from the conscious mind, and it was on this psychological reality that the Surrealists felt true art is based." (Arthur C. Danto, *What Art Is*, New Haven & London: Yale University Press, 2013, p. 13)

The reason we are stirred by photographs such as Chang Chao-Tang's is that in many situations surrealistic images may transcend the surface images of reality we can grasp, and express images that go beyond reality. In these surreal images, the secrets of the world may be revealed a little. This challenges a photographer's power of vision, and tempers it.

I believe that the purpose of surrealism is not to give people an awakening shock by making the ordinary seem unfamiliar, but rather to make us see that the world has always been unfamiliar and bizarre. We believe this reality to be commonplace and familiar, but that is because we have not delved down deep into the depths of reality. The familiar appearance we complacently, or perhaps unthinkingly, consider the world to have is not its fundamental form, nor its true form, but may be described as the true form of its surface. Once we are able to delve into the deep levels of reality, then strangeness becomes axiomatic,

and so-called familiarity can never again find shelter in our minds. The world in the eye of the surrealist belongs to both their psyche and the everyday, and is a part of their psyche and the everyday that ought to be shared with everyone. The only thing is, once they have captured these unfamiliar everydaynesses inciting uncertainty regarding reality, it's up to them to determine what form they should take to be shared or disseminated. People may assume that it is only when they wish to share with others that the world becomes so peculiar, but in fact such is not the case. Reality is inherently complicated. Different means and methods of viewing will bring about different worlds. The viewer's own aptitudes and worldview often make it so that the world they wish to share with us is different as well — just like the photos of Chang Chao-Tang that tell us of the world's absurdity. Those who are able to comprehend such an irrational, preposterous world will naturally delight in it, while those who cannot comprehend it will remain bewildered. This is rooted in a difference of worldviews, in a difference of life experiences, and in a difference of individual subjective identities.

The photographs of Chang Chao-Tang do not alter reality in the least. Yet because they alter the image of reality within the picture, these photos also alter people's perceptions of reality, and interject themselves within

己的悲觀視像——這是他用於對抗這個世界的重要形式。他用本質上的虛無對抗現實的引誘，以根本無稽的視覺擺平現實的平庸，向沉悶的夜空燃放關於日常生活的知見與「偏見」。我認為，真正意義上的視覺創造，一定是為「偏見」所引導，並且引導後來的「偏見」。一部藝術史，其實就是一部偏見的的歷史。正常的、普遍的，就無法形成偏見。而更弔詭的是往往是「偏」的所「見」則提示了更為普遍的、當然也是埋藏更深的真相。津津樂道於表層的「真相」的發現，顯然不是張照堂的攝影所要承擔的工作。

張照堂的攝影深深地牽扯到了他的臺灣同時代人對於「現代」、「現代主義」和「現代性」的理解這個問題上。是這個連現代主義一詞本身都要受到質疑的現代主義——超現實主義，通過富於預見的影像給予現代性以重要的啟示。這麼說並不是要把超現實主義置於現代主義之上或者把這兩者對立起來，而是要強調只有這麼認識超現實主義，才有可能對於現代主義攝影、對於張照堂的攝影獲得新的認識。從某種意義上說，如張照堂這樣的攝影，才是我們進入超現實主義迷津的指引，也

是我們更好地理解現代主義的途徑。

討論臺灣現代主義攝影，我想超現實主義應該是臺灣現代主義攝影從中汲取養分的源流之一。雖然在張照堂早年身處的時代，由於臺灣的政治局勢，對於現代主義未必有特別的放任，但畢竟現代主義還是有一定的活躍空間。因此，包括張照堂在內的臺灣藝文人士也會有機會注意到超現實主義的存在並且展開屬於自己的理解與對話的實踐。在可說是臺灣最早揭竿而起的現代主義攝影群體V-10成員當中，從調性上來說，或許張照堂的攝影是其中最為陰冷的。但這種陰冷，卻真切地傳達出當時臺灣社會整體心態的溫度。包括攝影在內的現代主義藝術，在政治高壓之下，有實其存在就是一種對抗本身。而張照堂的照片，卻又呈現出不同於現代主義美學趣味的更為獨特的面目。

伊戈內在評價超現實主義的歷史作用時說：「超現實主義（自認為是開創性的革命卻最終淪為資產階級的娛樂消遣）最大益處是更直接地告訴了我們在1914-1918年的大屠殺之

the psychic reality of the group. He uses the abnormal to subvert the normal. Thus, he refutes the normal and also attests to the universality of the normal. Through surreal images he unearths the paradoxical nature of reality. Thus, he refutes reality, but also affirms the puzzling, ungraspable nature of reality. Chang Chao-Tang's photos have always revealed a pessimistic tone. Yet his enormous pessimism has not hindered his great passion for manifesting his own pessimistic vision- this is the major form he has adopted to fight back against the world. He uses intrinsic nothingness to resist the seductions of reality. He uses an innately ludicrous vision to measure the mediocrity of reality, igniting the stifling night air with realizations and "skewed perceptions" of quotidian life. The history of art is actually the history of skewed perceptions. That which is normal, that which is ordinary, cannot form a skewed perception. And even more paradoxically, it is often the skewed vision that suggests the true form that is more universal and, of course, buried more deeply. Those who relish the "true form" that exists on the surface will discover that this is clearly not the work that Chang Chao-Tang's photography attempts to undertake.

Chang Chao-Tang's photography is deeply connected to the issue of how the Taiwanese of his era understood "modern," "modernism" and

"modernity." It was a modernism in which even the word modernism itself needed to be questioned. And surrealism, rich with portentous images, provided an important revelation of the meaning of modernity. To put it thusly is not to place surrealism within the confines of modernism, nor to place the two in opposing positions, but to emphasize that only by understanding surrealism in this light can one gain a fresh recognition of modernist photography and the work of Chang Chao-Tang. In a sense, photos such as Chang's are both guideposts allowing us to enter the labyrinth of surrealism, and a path to a better understanding of modernism. And Chang's photos presented a visage even more unique than the compelling aesthetic of modernism.

Surrealism, in my view, is one of the sources of nutrition that Taiwanese modernist photography has absorbed. Even though the era in which Chang lived as a young man, owing to Taiwan's political situation, did not give particularly free rein to modernism, ultimately it did afford a certain amount of room for modernist activity. Therefore, Taiwanese artists including Chang Chao-Tang did have the opportunity to notice the existence of surrealism and to put into practice their own understanding of it, allowing a dialogue to unfold. Among the members of V-10 — what might be described as the earliest group of Taiwanese to raise the

後，歐洲人那種悲慘的精神狀態。」（帕特里斯‧伊戈內Patrice Higonnet，喇衛國譯，《巴黎神話──從啟蒙運動到超現實主義》，商務印書館，2013，P.384）同樣的，張照堂的相當一部分拍攝於臺灣非常時期的照片，可以被視為政治高壓時期的臺灣人的「悲慘的精神狀態」的寫照。外部壓力與內部緊張兩相夾攻之下，社會整體所呈現出來的不安、無力、錯謬、驚愕以及憤怒，都通過他的極其冷峻、收斂卻極盡「變形」之能事的照片表現了出來。而即使到了今天這樣的後解嚴時代，人的根本意義上的絕望，攝影家對於人生的殘酷與荒謬的深刻理解，仍然是他的攝影所要聚焦並且展現的重中之重。

　　比如，在張照堂的作品裡，有三幅拍攝於不同時期的「無頭」照片。如果把這三幅照片聯繫起來看，也許會發現他於人與生命的根本看法。最早的兩幅都是拍攝於1962年。一幅是裸體背影，光滑的軀體與粗糙堅硬的山石構成了視覺的衝突，而另外一幅則是上半身的黑影，遠處的坡岸似乎成為了水平切割頭顱的利刃。這兩幅照片似乎可以說明，人做為慾望的魁儡，既是實在的，又是虛幻的，而相對於軀體，精神（頭腦）則

沒有存在的價值與意義，或者說即使存在也充滿了被割除的危險。如果說這兩幅照片體現了攝影家製造人的奇異形象的高超能力的話，那麼拍攝於1979年的《屏東 坊寮》，則更是給出了群體的無頭形象。這個影像來自於這群人在沙灘上進行某種身體活動時的某個瞬間。拍攝者張照堂將鏡頭插入到其過程中，中止時間於連續的過程中，剝離事件的具體意義而只是裸露實存的光景。這張令具體事件失去具體性、令事件的意義懸置的照片，更充分地體現他的有關人的觀念的一貫性，也提示了他的基本拍攝手法。這張照片或許也可以理解為對於無頭的大眾的批判。如果把這張照片與歐仁‧阿杰（Eugène Atget）拍攝的巴黎人在地鐵口仰頭觀看日全蝕的照片連繫在一起看，我們就會發現，他們採取的手法與體現的觀念是相同的。將具體事件非具體化，將具體性與意義懸置，通過切斷與具體性的聯繫而生產一種無意義的意義。從單體的無頭形象到群體的無頭形象，置身戒嚴時期的張照堂近二十年間縈繞心頭的有關人的根本看法、有關時代的根本批判終於大功告成。肉身其在乎，精神無寄。這，可能是他想要與我們分享的觀點之一。

banner of modernist photography — Chang Chao-Tang's photography may be the coldest, in terms of tonality. Yet his coldness vividly conveyed the temperature of Taiwanese society's mindset as a whole. Given the intense oppression of the government, the very existence of modernist art, including photography, was a form of resistance in itself.

In critiquing the historical impact of surrealism, the French historian Patrice Higonnet commented: "The greatest benefit of surrealism (considering itself to be a groundbreaking revolution yet ultimately reduced to a form of bourgeois entertainment and consumption) was that it informed us of Europeans' psychological state of tragedy following the great slaughter of 1914-1918." (Patrice Higonnet, *Paris: Capital of the World*, Commercial Press: 2013, p. 384) Likewise, a corresponding aspect of Chang Chao-Tang's work is that he captured exceedingly time-specific photos of Taiwan, which may be seen as a portrait of the "psychological state of tragedy" of Taiwanese people during a time of intense political oppression. The unease, powerlessness, falsehood, consternation and rage projected by society as a whole under the double assault of external pressure and internal nervousness all found expression through his photographs, calm and disciplined yet greatly "transformed." And in today's post-martial law era, the basic meaning of people's hopelessness,

and the photographer's profound understanding of the bitterness and absurdity of life, are still the very core of his photography's focus and expression.

For example, among Chang's works can be found three "headless" photos taken in different periods. If one were to view these three images side by side, one might discover his basic view of people and life. The two earliest photos were taken in 1962. One shows a person's naked back, the slick torso forming a visual conflict with the rugged, hard mountain rocks. The other photo is a dark silhouette of the upper half of a body, a distant mountain ridge seemingly slicing off the skull horizontally like a sharp blade. These two pictures seem to explain the dejection of human desire–substantive yet illusory. Yet the opposite of the body is the spirit (brain), the value or meaning of which does not exist, or if it does exist, it is filled with the danger of being cut off. If these two pictures manifest the photographer's superlative ability to produce bizarre images of people, then *Fangliao, Pintung,* photographed in 1980, provides a collective image of headlessness. This image comes from a certain split second when a group of people were doing some kind of group exercise on a beach. Chang Chao-Tang interjected his camera lens into this ongoing process, suspending time, and stripping away the concrete meaning of

真正意義上的超現實主義，其目的是改變人生，同時也改變世界。雖然它作為藝術主張已經在一定程度上宣告了自身的失敗。但它的藝術主張仍然具有啟示性。它要打開心靈視像的願望與努力值得尊重。它是通過與視覺的對決來改變眾人對於世界與人生的觀感。張照堂即使並不心存改變世界的雄心，但以獨特的觀看來改變眾人對於世界的觀感應該是他的志向。他的這種視覺實踐，在一定程度上就參與了改變世界的實踐。真正意義上的超現實主義，是正視身處的現實、勇於面對現實並且通過視覺顛覆的方式來提出一種對於現實的視覺不服從。無論是政治高壓之下的苦悶還是解嚴之後的「無物之陣」般的去壓失重狀態，都需要藝術家從自身的處境與立場出發，告示自己有關人生與現實的視覺宣言。

張照堂的攝影實踐不是觀念先行的手法套用，以求得與現代主義的外觀相似，而是從個人的生理、直覺與日常出發，作出對於現實世界的批判與嘲弄，通過對於日常的顛覆性呈現而獲得對於現實的超越。他的攝影從攝影本體、攝影語言等方面來著手，在表達其世界觀的同時也提示自己的攝影觀。張照堂的超

現實主義，是巧妙「操」弄他眼前的現實元素，以一種視覺誑語的形式展開對於現實的批判，這也可以諧音為「操現實主義」。現代主義從本質上說屬於對於現實的態度。而超現實主義，即使按照其中文字面意義看，也包含一種對於現實的態度。它當然不能簡單地理解為是對於現實的超越。因為超越有時也可視為從現實的逃避。張照堂的攝影是對於現實的一種別樣的現實性的深度開掘，使得現實成為超越現實的參考物。

現代主義攝影的基本手法之一是強調對於現實的逼真再現。這在歷史上屬於對於沙龍攝影美學「操弄」現實的挑戰。現代主義攝影更新了眾人的視覺經驗，但人們往往將這種更新了的視覺經驗等同於對現實的質疑。其實不然，提出世界內在幽暗的一面，往往需要更為毅然的與現實做一步決裂、決鬥的勇氣與決心。而超現實主義從一開始就提出了對於現實本質的質疑，並且通過像攝影這樣的手段進一步「操」弄現實成為可「疑（問）」的現實，提請我們起而直視並且以各種方式否定現實與自身，在達成對於自身的超越的同時，超越現實對於人的觀念與行為的束縛。

the event, leaving only the extant scene exposed. Making the concrete event lose its concreteness and placing the meaning of the event in a state of suspension, this photo fully embodies his consistent viewpoint of people, and points out his basic method of photography. Perhaps it also communicates criticism of the headless masses. If we were to place this photo next to Eugène Atget's picture of a group of Parisians gazing up in unison at a solar eclipse, we would find a similarity in both their method and concept of expression. Deconcretizing concrete events, suspending concreteness and meaning, he cut off the connection with concreteness, and in so doing produced a form of meaningless meaning. From the image of a headless individual to the image of a headless crowd, Chang Chao-Tang, living in the era of martial law, finally articulated the fundamental view of people and the fundamental critique of time that had haunted his heart for nearly twenty years. Infatuated with the flesh, the spirit is severed. Perhaps this is one of the viewpoints he wished to share with us.

In terms of its true meaning, surrealism's objective is to change life, and also to change the world. To a certain extent it has already proclaimed the failure of its own artistic mission, yet such an artistic mission remains revelatory. Its determination to open the eyes of the soul deserve

respect. Through a confrontation with the visual, it has changed people's perceptions of the world and of life. And while Chang Chao-Tang may never have harbored the ambition to change the world, his aspiration was surely to change people's perceptions of the world through a unique way of looking at things. This visual praxis, to some degree, took part in a practical effort to change the world. The true meaning of surrealism is to look squarely at one's reality, to bravely face reality and through visually subversive methods, to produce a visual insubordination to reality. Whether it be the suffocating sense of political suppression of the martial law era, or the sense of weightlessness when society shook off its pressures after martial law was lifted, both require artists to embark from their own predicament and standpoint and proclaim their own visual declaration regarding life and reality.

Chang Chao-Tang's method of doing photography is not to proceed from a concept in order to achieve an external appearance in conformity with modernism, but rather to begin by considering individual physiology, intuition and everyday experience, to criticize and poke fun at the real world, and to transcend reality through his subversive presentation of the everyday. His photography sets out to examine the act of photography itself and the language of photography, while expressing his

張照堂熱衷於上街。猶記2011年他來上海時，剛放下行李，就獨自一人走上街頭去拍照的情景。從根本上說，張照堂是一個街頭攝影家。大體上，攝影家可以按照他們的工作方式分成兩類。一類是在人類活動的各種公開場所觀察人類舉止，捕捉有關人類活動的一舉一動，實現自己對於現實的記錄、觀察與評價。對於他們，街頭是重要的工作場所之一。這是即興觀察型的攝影。另外一類攝影家是他或搭建或棲身於一個密閉的屋子裡，然後請人嚴格按照自己意圖表演並拍攝之。這屬於向壁虛構型的攝影。從張照堂的工作方式來說，他顯然屬於前一類攝影家。街頭，是他的攝影棚與道具箱，也是他的會客廳。他的那些精彩的抓拍照片，大多來自臺灣街頭或公共空間。無論是人還是物，經過他的巧妙的空間組合（視覺構成），都會顯示出一種別樣的現實感。

　　就如同巴黎的超現實主義者在巴黎街頭所邂逅的人物之詭異、鏡頭所撿拾的物件之豐富、以之所呈現的意象之複雜，張照堂照片中的現實人生也同樣光怪離奇。他的攝影詞彙表所羅列的，就是人類生生死死的各種形態。本質上的悲觀是張照堂的攝影的底色，這些悲觀情緒從相紙滲透、浮現並且泛出絕望的銀光。

　　而現代城市的街頭，也永遠在等待著那些期待與某種「意外收穫」相遇的攝影家。張照堂在街頭發現的，其實不僅僅只是人類的物質遺棄的碎片，更是人類的精神檢樣的抽樣。粗心的人類有時以為自己已經巧妙地掩蓋了自己的隱秘世界，其實未必。通過張照堂的銳利的眼睛，我們發現人類仍然是一個拙於掩藏自己的慾望與思想的部族。當然，張照堂發現的以及他記錄的，既揭示了人類的秘密，同時也在一定程度上暴露了他自己的內心秘密。不過這不打緊，因為他就是樂於作為人類一分子在排查、提檢人類的精神活動並且將其視覺化。他是少數能夠以某種方式說出他個人對於現實的某種預感的攝影家。而且，我們又確實需要這種具有某種先知性質的照片。

views of both photography and the world. Chang Chao-Tang's surrealism is an ingenious manipulation of the elements of reality as he sees them, engaging in criticism of reality through the form of visual deception. It is a form of reality manipulation. By its very nature, modernism bespeaks an attitude toward reality. And even the meaning of the word roots composing the word surrealism suggest that it encompasses an attitude toward reality. Of course, it cannot be simplistically understood as a transcendence of reality. Transcendence can sometimes be seen as an escape from reality. But Chang Chao-Tang's photography is something else entirely, a realistic unearthing of reality, an article of reference causing reality to transcend reality.

One of the basic methods of realistic photography is to emphasize a true-to-life representation of reality. Historically, it challenged the "manipulation of reality" that took place in the aesthetic of salon photography. Modernist photography renovate the public's visual experiences, but people frequently equate this renovation of visual experience as a questioning of reality. In fact, such is not the case. To call attention to the hidden inner face of the world, we often need a more resolute courage and determination to break with reality, to duel with reality. And surrealism has always questioned the basic nature of reality,

and through such methods as photography, it goes further to manipulate reality so that it becomes a questioning of reality that enjoins us to face reality and ourselves straight on, and also to refute reality and ourselves in a variety of ways, so that we not only achieve a transcendence of ourselves, but also transcend the shackles that reality places on human perception and behavior.

Chang Chao-Tang is passionate about getting out on the street. As I recall in 2011 when he visited Shanghai, no sooner had he set down his suitcase than he went out by himself onto the street to take pictures of the scenes. Fundamentally, Chang Chao-Tang is a street photographer. In general, photographers can be divided into two categories based on their work method. The first kind goes into different public venues where people are active, observes the behavior of people and captures their every movement, producing the photographer's own documentation, observation and evaluation of reality. For them, the street is an important place of work. This is spontaneous, observational photography. The other kind of photographer builds or dwells in a closed-off house, then takes pictures of people whom they have asked to perform according to strict arrangements. This is fabricated photography. Judging from Chang's work method, he clearly belongs to the former group. The street

is his studio and his prop box, and his reception hall too. Most of those miraculously captured photos of his come from the streets or public places of Taiwan. Through his masterful combination of spaces (his visual compositions), both people and objects reveal a distinctive sense of reality.

Just as the surrealists of Paris chanced upon the strangeness of people on the streets of Paris, harvesting an abundance of objects with their cameras and producing a complexity of images, the real life in Chang's photos is equally bizarre and surprising. His photographic vocabulary spans the array of human life and death. Fundamental pessimism is the base tone of Chang's photography. These pessimistic emotions permeate and surface from the film paper, overflowing with the silver light of despair.

And the streets of the modern city are eternally waiting for the kind of photography who anticipates an encounter with an "accidental harvest." Chang Chao-Tang has discovered that on the streets can be found not only the fragments of matter that humanity has abandoned, but samples of the human spirit. Careless people sometimes assume they have cleverly covered up their own secret worlds, when in fact they haven't.

Through the sharp eyes of Chang Chao-Tang, we've discovered that human beings are still a tribe digging in their own buried desires and thoughts. Of course, what he has discovered and recorded has not only revealed the secrets of humanity, but also to a certain extent exposed his own inner secrets. But this does not matter, because he takes joy in being a part of humanity, evaluating and examining the spiritual activity of humanity, and making it visual. He is one of the few photographers who can in some way communicate his own sense of premonition regarding reality. We need these kinds of prophetic photographs.

# 遮隱・面具・缺席
## 張照堂攝影中的視覺系統

■ 林志明
Lin Chih-Ming

# Concealment, Masks, Absence

The Visual System in
Chang Chao-Tang's Photography

國立臺北教育大學
藝術與造形設計學系
教授兼系主任

Professor, Director
Department of Arts and Design
National Taipei University of Education

> ……我感覺不到一點盲域：在這景框裡發生的所有事物，一旦離開這景框，就絕對地死去。當我們定義攝影為一靜止的影像時，這不只意謂它所呈現的人物不會動；這意謂他們不會出走：他們是像蝴蝶一樣被麻醉及編入檔案。

—— 羅蘭・巴特，《明室》，頁90（法文版）

　　張照堂的攝影作品中有一些長存的視覺系統，使得人們在觀看它們時，很容易加以辨識。且先不稱這些系統為「風格」元素，因為它們可能和傳統的構圖、符號、意境、符旨等元素不完全相合。由下面的分析來看，它們也都屬於「觀看」這個和攝影特別相關的層面，於是，把它們稱為視覺系統，應有其適切性。除了本文標題提及的遮隱、面具、缺席這三個很獨特又長存的元素之外，另外也有靜物轉生及影像之影像這兩個沒那麼獨特或長在，但和前三者有其相關的元素，也會在本文後段加入作為補充。以下就以一些實例為線索，觀察這些一再出現的系統性特徵。

> … I sense no blind field: everything which happens within the frame dies absolutely once this frame is passed beyond. When we define the Photograph as a motionless image, this does not mean only that the figures it represents do not move; it means that they do not emerge, do not leave: they are anesthetized and fastened down, like butterflies.

- Roland Barthes, *Camera Lucida*, p. 57.

In the photography of Chang Chao-Tang one may discover several longstanding visual systems, and they are indeed easily recognizable to the observer. These systems should not be considered elements of "style," because they may not accord with such conventional elements as composition, symbols, conceptions and significations. As we will see in the following analysis, they are all related to the question of "gazing," a stratum with a special connection to photography. Thus, referring to them as a visual system is quite apt. In addition to the quite unique and longstanding elements noted in the title – concealment, masks, and absence – there are two additional elements – the vitalization of inanimate objects, and images of images – which are not particularly unique or longstanding, but are related to the previous three elements, and thus will be explored supplementally in the latter sections of this

遮隱

在張照堂的攝影中，經常出現的一個特徵是遮隱，而且是由最早期發表的作品便是如此。

《板橋 1959》（頁88），這張攝於林家花園外圍巷弄的街頭攝影，主題人物是一位大人牽著一個小孩行走，路兩邊的建築物，左邊是傳統建築，右邊是依附有竹枝和電線桿的磚造民宅。畫面元素因為對比和對稱而顯得「可讀性」很高。大人位於傳統的一方，那是帶有燕尾的傳統建築，如果不是廟宇便是有地位人家的宅第。這個半矮的牆面雖然樸素卻帶有傳統的典雅，對比起來，右邊一排民宅顯得輪廓雜亂，而代表現代性可和傳統建築側面相對的電線桿，也因為電線排列方式而出現凌亂，而非現代的秩序及效率。這一排家屋由畫面中心線來看，量體稍不如左邊的傳統建築，但也因此，它們留出一片天空，正好襯托學步中（?）的小孩。

看到這裡，影像的「意涵」似是很清楚的：成年人位於傳統的

一方，他帶著具有現代性符號的兒童學步，整體影像具有「傳承」的意思。或許，更進一步還有友善溫婉的古典和踽踽學步前途未卜的現代。可是，這張照片中出現了第三位人物，處在前述二位人物連結的手及身體輪廓線，所形成的一個三角形空洞中，那是另一位雙手置於腰旁的小孩。他的眼神似有點生氣，或至少給人質疑、不耐的感覺。這第二位小孩在此的出現，給了這張照片在傳承、溫婉、友善之外全然不同的情緒。然而，他為何有此表情呢？這一點卻因為作為主題人物的小孩完全是背對著我們，臉孔受到遮掩，顯得難以判定。這個以「背影」進行遮隱的視覺系統，建構了這個影像和一般「鄉土寫實」或是「溫情懷舊」相當不同的情調。那毋寧是種不確定、曖昧的感覺開始默默地探出了頭。

「背向觀者的主題人物」，多看一些這個年代的照片，可以發現這是個張照堂喜歡使用的元素。在《板橋 1960》（頁89）這張照片中（板橋是他的出生地），磚造的屋子會讓人覺得這可能是前一張照片接近的街區，而陽光斜射而來的方位，以及它在磚牆面上留下的光影，給了影像一種舊時代的斑剝感，而且

paper. Below I present a few concrete examples as evidence by which to observe these repeatedly appearing systematic special characteristics.

# Concealment

Frequently in the photographs of Chang Chao-Tang there appears the element of concealment, a trait particularly evident in his earliest published works.

The photo *Panchiao, Taiwan 1959* (p.88), taken at the head of an alley outside the Lin Family Garden, centers on an adult and a child walking hand-in-hand. A traditional building is on the left side of the lane, while on the right is a brick house with bamboo poles leaning up against it and electrical wires running overhead. Because of their contrast and symmetry, the pictorial elements possess a high degree of "readability." The man is positioned on the side of tradition, near a traditional building with flying "swallowtail" eaves — either a temple or the home of a family with high social standing. The wall on this side may be plain, but it conveys a sense of traditional elegance. Conversely, the row of houses on the right side has a cluttered contour, and the telephone poles — symbols of modernity standing in contrast to the side of the traditional building — sport wires

strung up in a tangled arrangement, and thus appear jumbled, lacking a modern sense of order and efficiency. Viewed down the photograph's central line of sight, this row of houses receives slightly less volume than the traditional building on the right, but consequently, a piece of sky is left open above it, perfectly contrasting the child that is (possibly) just learning to walk.

When we see this, the implications of this image seem clear: The adult is positioned on the side of tradition, taking a child, who symbolizes modernity, out for a walk. The entire image conveys the meaning of "passing on a legacy." Perhaps, going even further, it may set the classical — amiable and gentle — alongside the modern as it learns to walk into an unknown future. However, a third person appears in the picture, situated in the triangular hole formed by the joined hands of the two main figures and the contours of their bodies: a child with his arms hanging at his sides. His eyes look a little angry, or at least give off a feeling of doubt and lack of acceptance. The appearance of the second child here projects an emotion completely different from familial warmth and tenderness. But why does he wear this expression? This point is impossible to determine, as the child playing the role of the main figure in the picture has his back to us, and his face is completely concealed. This visual system of concealment

五十多年後看來，尤其如此。一如前面的影像構成方式，符號性事物出現於畫面側翼，那是張「銘謝賜票」的公告招貼，雖然今天看來脈絡不明，但基本意思是清楚的。和它相對的則是三個人物，也是一個大人兩個小孩，其中大人應是團體中的主要個體，不僅因為他是三人構圖三角形的頂點，也因為他是兩位小孩目光焦點所在。這個人物背對著我們，看不見他表情和手勢；究竟發生了什麼使兩位小孩那麼感興趣的事情，只能由小店陳列的食品罐去推敲。

今天看來，這畫面瀰漫著一種逝去時代的風味，或者引用新媒體藝術家袁廣鳴的說法，像是幅「逝去的風景」：不只是斜照下的夕陽、磚屋、屋中販售的食物，裝這些東西的容器，也是那時人的穿著，腳下的木屐、轉腳處鋪的石塊、商店的開窗和支持這開口的棍子。然而有兩個事物卻不只是時代性的；它們是遮隱系統的另一個表現，而且已由前述的光影點題：那深不見底的商店開口，以及極左側兩屋之間被窺見的一條街巷。總有一種感覺，會有什麼人由這黝黑的商店裡冒了出來，或是過一刻由街角突然走出來，畫面頓時有了永恒的懸疑。

1962年張照堂在新竹五指山上拍攝了黃永松一系列的裸像[1]（頁127），這些男性裸像可以作各種方式的解讀。比如人和環境的對比：把人體，尤其是年輕清瘦男體，置放在看來並不友善的境中，而且其身體大都內屈佝僂，顯露出一種既受到環境壓迫，但又加以抗拒的姿態。

這群照片的另一個解讀方式也可和同時期其它的「無頭人」影像連結形成脈絡。張照堂的「無頭人」影像從來不是巴塔耶（Bataille）所創《去了頭》（Acéphale）刊物所標榜的去除理性的狂暴。在馬松（Masson）為此刊1936年創刊號繪製的封面形像裡，無頭之人兩腿之間以骷髏頭遮蔽，右手握著一個燃燒的心，左手則持著一把匕首。此無頭之人的造形姿態和達文西或西方傳統的維諸維人（Virtruvian Man）接近，雙臂雙腿打開，直立在畫面中央，原是人的理想形式。

張照堂的無頭之人並沒有這樣的暴力象徵，乃至恐怖美學，他的人物往往是像前一張影像一樣蜷縮成一團，呈現出一種孤單內向，獨自面對著天地山川的感覺（頁129）。

through presentation of a figure's back creates a tone quite different from that of the average image of "local realism" or "warm nostalgia." A sense of uncertainty and ambiguity begins to stealthily rear its head.

If we look at several other photos from this era, we discover that a main figure with their back to the viewer was an element that Chang favored. In *Panchiao, Taiwan 1960* (p.89) – Panchiao was his place of birth – the houses made of brick suggest that this was taken in the same neighborhood as the previous photo, and the position of the slanting sun and the light and shadows it casts on the brick wall give the image a crumbling feel as if from an older era, particularly when viewed more than fifty years after it was taken. With a method of composition similar to the previous one, symbolic things appear on the side wings of the picture – that is, a poster with the public announcement, "Thank you for your votes." Today the context is unknown, but the basic meaning is clear. Set alongside it are three people – also an adult and two children. The grown man seems to be the principle subject of the group, not only because he is the apex of the triangle formed by the three figures, but also because he is the object on which the two children are gazing. This figure has his back to us. We cannot see his facial expression or his hand gestures. What exactly has taken place to draw such rapt attention from the two children, we may only deduce from the jars of food on display.

Viewed today, this picture brims with the feeling of a bygone era, or, to paraphrase the new media artist Yuan Goang-Ming, it is like a landscape that has disappeared: not only the light of the setting sun, the brick house, the foodstuff for sale in the house and the containers holding these things, but also the people's clothes, the wooden sandals on their feet, the stones laid at the corner of the building, the store window and the stick propping the shutter up. Two things, however, are not specific to the era. They are another expression of the system of concealment, as well as the aforementioned motif of light and shadow – the impenetrably dark window and the alleyway peeping out from between two houses at the far left side. Overall, there is a feeling that someone will emerge from this pitch black store, or in a moment someone will suddenly walk out from around the corner. The picture instantly is possessed of an eternal suspension.

In 1962 on Mt. Wuzhi in Hsinchu County, Chang took a series of nude portraits of Huang Yung-sung [1] (p.127). These images of male nudity may be interpreted in many different ways. For example, it may be a comparison of humans and the environment: placing the body, especially a young, slender male form, in a seemingly inhospitable environment, with

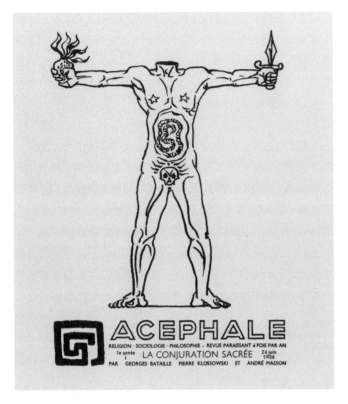

這種感覺有時化為一種黑色幽默,或是詭異的連結,比如張照堂1962年在居家陽臺自拍的影像,人頭的影子雖不見,身軀卻和一層像是對岸薄雲似的山際線相連。遠看彷彿是人身上嫁接著兩片薄薄的直昇機葉片(頁124)。

雖然有許多延伸和脈絡連結的可能(甚至一種受戒嚴氣氛壓迫的泛政治解讀也是可能的),張照堂的「無頭之人」攝影,仍然參與他視覺系統的第一個特徵,也就是由主題的遮隱產生的曖昧性:只是這裡除了背影,更進一步把人物的頭部隱藏,也簡化了背景和其中原有的符號性元素。人和環境間的關係,在此系列中也不再是種融和的、自然的、彷彿就在其中不知不覺共同生長的關係;而是營照一種緊張的、對比的、將人之孤獨赤裸相對峙於天地之漠然自在。

## 面具

在這些1960年代的影像中,常有道路在畫面中央出現,並

most of his body bent inward, revealing a posture of being oppressed by the environment, but also resisting it.

Another way of interpreting this group of photographs is that they may be connected in a consistent thread with other images of "headless people" from the same era. Chang's images of headless people never represented the irrational, wild violence expressed by the logo of the magazine *Acéphale* published by Georges Bataille (*Acéphale* is the Greek word for "headless"). In this cover illustration drawn by André Masson for the publication's first edition, the area between the headless man's legs is concealed by a skull, while the left hand holds a flaming heart and the right grasps a dagger. The form and posture of this headless man is similar to those of the Virtruvian Man, a sketch by Leonardo da Vinci that has become canonical in the Western tradition as an expression of the ideal human form: both arms spread wide, standing erect in the center of the picture.

Chang's headless people did not imply such violent symbolism, nor an aesthetic of terror. His figures were usually coiled in a ball, as in the photo noted above, expressing a sense of solitude and introversion, facing the universe and the wilderness in isolation. (p.129)

This feeling sometimes serves as a form of black humor or suggests an uncanny association. For example, in a self-portrait Chang took on the balcony of his home in 1962, the head of his shadow is missing, but his torso aligns with a ridge of mountains that seems to float far away on a thin bank of clouds. Viewed from a distance, it appears as if two slender helicopter blades have been grafted onto the body. (p.124)

Although many elaborations or associations are possible (an omnipolitical interpretation of oppression from the atmosphere of martial law is even possible), Chang's "headless" photos still partake in the first element of his visual system, which is producing a sense of ambiguity through the concealment of the subject: it's only that here, in addition to turning the figure's back to the viewer, he goes a step further and hides the person's head, simplifying the background and the original symbolic elements. In this series, the relationship between man and the environment is no longer a communal, natural relationship, as if unconsciously growing together. Instead, it presents a sense of tension and contrast, pitting the solitary nakedness of man against the indifferent complacence of the world.

在接近地平線時蜿蜒向更遠無限之處。它舒緩了人和環境的對立：畢竟道路是人的痕跡或人在地表上的建構。這時期張照堂影像中這條向後延伸又有點蜿蜒的道路有時是條土路，今日或因難得一見而給人懷舊之情，但許多時候也可以看到它工業化的鋪面；就在這條路上，另一種遮隱的方式測試著它效力。它使用一個明顯人為的元素：面具。

最明顯的，但也許不是最簡單的面具是穿戴式的。

在《板橋 江仔翠 1964》的影像中（頁150），一個頭戴面具、雙手扶頰的少年幾乎要滑出畫面，前景人物和背景間有種相互脫離的分離感。這是因為人物被擺置在畫面前緣，造成類似剪影的效果。幸好，正是有一條蜿蜒小路，把人物和背景連結了起來。這背景應是那年代臺灣典型的景象，工廠廠房正在興起，然而代表農業社會的水田就在旁邊，兩者以「短兵相接」的方式的對應著。前景人物的面具² 則有點像是一邊黑一邊白的臉譜，甚至更神似意大利風流喜劇中的 Arlequin，是個（人格）分裂的意象。

這個黑白對比的意象掩蓋人物主要的表情，但遮掩同時也是一種揭露，這在此處的面具應用上就更明顯起來：它把個別人物轉化為一個典型。這張面具除了遮隱之外的彰顯作用，在下面這張背景寫有「天天樂撞球場」、「日日滿小飯店」合併招牌的影像中更為明顯：那招牌在黑白照片中也是左暗右白的兩個條塊貼合在一起，兩者字數一樣而且首兩字都用疊字，意味上卻可是對比的，因為撞球場是消遣娛樂的之處，飯店則引發民生必須的聯想。前景人物在此同樣和背景處於一種脫離的關係，他雖失焦但眼神左右不一，在此益發清楚。整體的閒置或廢棄空間意象，加強了這人物憂鬱、與環境格格不入的神情（頁158）。

然而，「面具」這個元素也可以有許多發展及變奏，比如它不一定要像是一般所常見的穿戴式面具。有些作品，人物臉上就像是直接被貼上一個直接否定它的遮片（頁151）。

或者面具的出現，也可使用像是臉譜的方式，直接塗妝在臉孔上，或是套上一個透明塑膠套（頁152）。這樣的作法使得人物五官仍然大量留存於可以辨識的狀態，只是部份地受到「遮隱」。

## Masks

In Chang's images from the 1960s, roadways often appear in the center of the pictures, and as they approach the horizon, they meander off toward an infinitely further point. Thus, he ameliorates the antagonism between humankind and environment: ultimately the road is a human mark or a human construction on the surface of the earth. During this period the roads in Chang's photos that stretched into the background, bending a little, were often dirt roads. Today they engender a sense of nostalgia, probably because such roads are hard to find. But many times one can also see industrialized pavement; on these roads a different kind of concealment tests its effectiveness. He uses an obviously manmade element: masks.

The most obvious mask, but perhaps not the simplest, is the kind one wears.

In *Panchiao, Taiwan, 1964* (p.150) a youth wearing a mask, with two hands pressing on the sides of his head, seems to almost slide out of the picture. A sense of mutual estrangement seems to exist between the figure in the foreground and the background scene. This is because the human figure has been placed at the bottom edge, producing an almost

contre-jour effect. Fortunately, a gently curving path connects the figure to the background. This background may be seen as a classic landscape of Taiwan during that era. A factory building is in the process of being built, yet a rice paddy, representative of agrarian society, lies directly at hand. The two respond to one another, as if "fighting at close quarters." The young man's mask ² is a little reminiscent of the face paint seen in Chinese opera, with one side white and the other black. It even echoes the spirit of the Harlequin, popular in Italian comedy, evoking an image of split personality.

This image of contrasting black and white covers up the person's general expression, but such concealment is also a form of revealing. This becomes even more evident in the way the mask is used: He transforms each individual into an archetype. The mask's function as not only obfuscation but also expression is especially clear in the following image, in the background of which is a sign with a twofold message: "Happy Every Day Billiard Hall" and "Full Every Day Diner." In this black-and-white photo, the sign is also composed of two vertical strips, one black and the other white. Each side of the sign contains the same number of Chinese characters, and the first character on both sides is repeated (meaning "every day"). A contrast is implicit, as a billiard hall is a place

強力加上去的「外物」，給予它一個原本沒有的性格，比如套上塑膠套的情況，使得人物突然變有點像是個被棄置的假人。

另一個「面具」的變奏，則是利用攝影的各種特性使得臉像變得模糊不清。這一點存於他為數不多的自拍像中，但在60年代末期便有所表現。1968年他的16mm實驗短片《剎那間容顏》，後來以靜照方式取出放大為單張巨幅作品於「現代攝影聯展」中展出。[3] 當移動速度與與影片速度不能配合，或者是運用了疊影效果，其結果也像臉孔是覆上了一張「面具」（頁160-163）。這面具雖然遮蔽了影像中的人物，至少使它變得更難以辨識，但它因為揭露了影像本身的技術條件，轉而將觀者的思考指向影像本身的人工性質。

由攝影史的角度來看，面具的運用並不罕見，比如石元泰博和戴安‧阿勃絲都曾以拍攝戴面具人物的方式留下詭異之作。不過，他們的面具來源單一，都是現成的萬聖節時刻所現，張照堂和他們比較起來，其對於面具的著迷和變化多端，更可以看出這個元素在他的視覺系統中所占的地位。

## 缺席

雖然張照堂在1970年代中期以後，開始致力於「社會寫實攝影」（至少他在年表中曾如此宣稱）[4]，但面具仍持續在其攝影影像中出現。《臺北 行天宮 1978》的主角人物便是位戴著米奇老鼠面具的小孩（頁308）。這張照片也保留了前景和背景的對比。小孩身旁疾行的人物，因為速度形成了模糊的身影，這一點也突顯了小孩因為戴上黑白面具而顯得靜止分明的形象（他身上條紋狀的衣服基本上也給人這樣的黑白對比、甚至帶有分裂性格的感覺）。面具小孩在此的出現，和環境間頗有一種不協調，甚至突兀的效果。這個效果，有一部份也來自背景人物：其中有些人正在持香拜拜。這行為在行天宮並不特別，但和米奇面具相對照，在地傳統及外來通俗文化間的對比卻是明顯的。

然而，就在這張影像的背景中，出現了張照堂作品視覺系統的另一種重要元素。它和前兩個元素有相關性，但也有所不同：如果遮隱和面具都使得某些事物成為不可見，因而在意義層次像是為薄薄的影像拉開一層「厚度」，它們同時也在產生這不

of entertainment, while a diner invites associations with the necessities of life. As in the previous photo, the human figure in the foreground maintains a severed relationship with the background, which in this case is particularly clear — he is out of focus, and his eyes are out of alignment. The entire image of the derelict and abandoned space reinforces the human figure's spirit of melancholy and incompatibility with his surroundings. (p.158)

Nevertheless, the mask as an element may have many different variations. For example, is does not necessarily have to be the customary kind of mask that is worn. In some of Chang's photos, a screen seems to be directly affixed to the face of the human figure, refuting it. (p.151)

Or the appearance of a mask can be used like face paint, directly applied to the face itself, or a transparent plastic bag placed over the head. (p.152) This method leaves the figure's facial features in a condition where they may be recognized, and they are only partially "concealed." When a "foreign object" is powerfully appended, this gives it a personality it originally did not possess. For example, when a plastic bag is slipped over a person, the person suddenly seems a little like a mannequin that has been discarded.

Another variation of the mask is to blur or obfuscate the face using different photographic techniques. This approach can be found in just a handful of Chang's self-portraits, but in the late 1960s he also used it in other forms of expression. In 1968 he made a 16mm experimental short film, *Face in Motion*, and later converted individual frames into independent blown-up, large-scale still photos which he presented as part of a modern photography group exhibition. [3] When the speed of an action and the speed of the film are out of synch, or when a double image effect is applied, the result is that the face itself appears to be superimposed as a mask. (p.160-163) Although this mask conceals the person in the image, or at least it makes them difficult to recognize, it also reveals the technical conditions of the image itself, thus directing the viewer's thoughts to the artificial nature of the image.

From the perspective of the history of photography, the use of masks is not rare. For example, Diane Arbus produced a number of strange works featuring people wearing masks. Nevertheless, their masks were all of a similar nature - the kind of readymade masks that appear around Halloween. Compared to them, Chang Chao-Tang was far more infatuated with masks and used a much greater variety, and this clearly shows the position of importance this element held in his visual system.

可見時展現了一些事物（人物的背影、面具本身）；現在，我們接下來要這個元素則像是一則禪宗公案，目標除了是「缺席」本身，也設法在說缺席時「解消」展現。其方法和公案接近，是「指向」某物，而不是展現某物；而且，在展現這指向時，除了所指之某物不可見，也呈現出指向者之不重要。它大都出現於群像，比如這張影像背後的人群，雖然有些人在拜拜，但他們拜拜的對象並不可見（而那在文化上也很難用米奇代入，雖然圖像邏輯上是可能的）。更進一步，也不是所有人皆在拜拜，更有其它人把目光看向「景框之外」，指向一些不同的方向，而其「所指」，在畫面上難以推測，只能說是一種「缺席」狀態。

《臺北 五號水門 1984》顯然是在處理這個方向的問題（頁297）。影像中的人物可分為兩個群，前、中景的四位男子，有兩位佇立，兩位正在行走，他們都朝著畫面左方觀看，但引起他們觀看的事件則隱身於框外。背景另有兩位人物，應是一男一女；他們卻是不受此事件影響，繼續往前行。最靠近畫面前方的男子，則帶著一條狗，牠也是不受影響，對於四人觀看的事件或對象沒有興趣，吐著舌頭面向鏡頭。有點不太能確定地是在直視

鏡頭（因這直視對狗的意義難以判定）或是在觀察拍攝者的姿態、動作（可以想像拍攝者的手舉起，機身或許遮蔽了頭部），甚至有可能開始作一種防衛或攻擊的準備。

畫面呈現觀看中的人群，但被觀看者因位於框外而顯示缺席；畫面深處繼續行走的男女以及相反地朝向前方攝影者的家犬，他們則不受此觀看事件影響，各自關注著自身感興趣的事情。除了被觀看者的缺席不見外，整個畫面雖然構圖佈局是平衡的，但核心意義卻也呈顯為一種缺乏狀態。所指既是看而不見，指向者亦因意義無法凝聚而呈自我解消的態勢。

當畫面中的人物專心致志地沉浸於一件事情時，其狀況就彷彿旁人都不存在，而畫面前的拍攝者或觀看者，對於畫面中人物也可被當作是不存在的。美國藝術史家及評論家米歇爾·弗里德稱這是一件重要的存有論虛構。這樣作法的效果之一，便是使得畫面景像純然變成一個被觀看的對象，彷彿有一道第四牆隔離在觀者和畫面人物之間。[5] 在歐洲表現吸納美學的畫作中，人物常是在作閱讀、繪畫、彈琴、遊戲、玩牌或睡眠等動作，他

## Absence

By the mid-1970s, Chang had begun pursuing "social realistic photography" (at least he declares so in his own chronology),[4] but masks still continued to appear in his photographic images. The main figure in *Hsingtian Temple, Taiwan 1978* is a child wearing a Mickey Mouse mask. (p.308) This photo also retains a contrast between foreground and background. The person rushing past the child appears as a blur because of the speed at which he is walking. This highlights the still, distinct character of the child's appearance due to his wearing a mask (the striped jacket he is wearing also produces a sense of contrasting black and white, or even a feeling of schizophrenia). The appearance of a masked child feels quite out of place with this setting, or even has an effect of abruptness. This effect comes partly from the people in the background, some of whom are in the midst of worshipping deities with joss sticks. This form of behavior is far from peculiar at Hsingtian Temple, but set in contrast with a Mickey Mouse mask, the disparity between tradition and pop culture is readily apparent.

Yet within the background of this image there appears another important element in Chang's visual system. It is related to the two previous elements, but also somewhat different: If concealment and masks both serve to make certain things invisible, and thus at the level of meaning they seem to draw back a veil of "thickness" from the thin image, the production of invisibility necessitates that something else must materialize (a person's back or the mask itself). Now, the element we consider next is similar to a Zen koan. The objective not only is "absence" itself but is also to devise a means to manifest "nullification" at the moment the word absence is spoken. The method is similar to a koan — to allude to a certain object without expressing it. Furthermore, they all appear in group photos. For example, even though some of the people gathered in the background of this image are worshipping, we cannot see the object of their worship (and culturally it is difficult to insert Mickey into this role, though the logic of the picture allows for this possibility). Moreover, not everyone in the crowd is offering incense. Others are staring "outside the frame," signifying a few different directions, and the "signified" is difficult to deduce from the picture itself. We can only describe it as a state of "absence."

*Floodgate No. 5, Taipei 1984* is clearly a treatment of this line of exploration (p.297). The people in the photo can be divided into two groups. In the foreground and center ground are four men, two standing still and two walking. They are all looking toward the left side of the picture, but whatever

們不只專心從事，旁若無人，彷彿「此境」不存在，而且更會被此動作帶到另一個「彼境」。這個彼境，比如作夢者的夢境，在旁觀者眼中無法顯現，但仍是可以依人物表情及經驗常理加以推斷的。這種沉浸或吸納的美學在張照堂的作品中也會出現，但它經常伴隨的是一種缺席狀態。比如《三峽 1984》這張作品（頁213），望向框外的人物雖然只有一位，並且被放置於遠景；背影人物又再出現但屬於中景和遠景的連結元素；更近的元素便是三三兩兩，沉浸於自我活動的小群體，他們或者在午睡（假寐？），或者在玩牌（但紙牌看不見因而無法確定），或是蹲踞在河堤旁聊天。這些人群各自沉浸於自己正在進行的事務很明顯，但其佈置也達到一種去中心化的效果。

## 靜物轉生

如果說遮隱、面具或缺席都是使得「現實」因為某種消隱而彷彿增加了一層厚度，產生了一種異樣的感覺，要在日常之中產生出非日常，使習焉而不察變得突然富含不可言說之神秘，另一個

方法是使無生命事物和有生命事物間的界線產生模糊。這時的心理感受二十世紀初時曾被稱命名為詭異，後來受到弗洛依德大加重視，並以其受壓抑者之回返理論重新改寫。

比如《萬華 河濱公園 1986》這幅影像，同樣是以望向框外不同方向的人物使畫面的意義去除中心並製造缺席，但此時畫面又多了一些使意義再度凝聚的靜物元素（雖然他們的「視線」也是看向框外）。在河邊出現了獅、虎、豹的塑像，其存在本身便是詭異的，為何有人要將其放置於水域之旁，而且為何牠們要被放在一起？而且三者風格又不相近？

如果萬華淡水河邊的獅、虎、豹因為其俗民藝術風格，給人的感覺比較是種不合時宜、錯置其位的違和感，而不是給人靜物轉生的詭異甚至恐怖感，張照堂2005年之後拍攝的系列影像在詭異感受的呈現上，就更為明顯許多。收集在《臺灣－核災之後⋯⋯》系列中的黑白影像：豎立在小學校園中的母子牽手塑像，看來不只像是經歷風霜而開始斑駁的塑像，他們也像龐貝或是神話中的人物，突然石化，僵立在其生前的動作之中。狗

event has attracted their attention is hidden outside the frame. Two other people in the background – probably a man and a woman – are not influenced by this event, and keep walking away. The man closest to the camera has a dog with him. Also uninterested in the incident or object that has attracted the gazes of the four men, it lolls its tongue at the camera. It is a little hard to be sure if it is looking directly at the camera (because such a direct gaze is hard to judge in a dog) or is observing the posture and movements of the photographer (one can imagine the photographer's hand to be held up and the camera to be covering his face), or even getting ready for some protective action or an attack.

The picture shows a group of men in the act of gazing, but the gazed-upon object is situated out of frame – it is exhibiting absence. The couple in the deep field of the image continuing to walk and the dog at the opposite end in the foreground looking toward the photographer are unaffected by the gazed-upon event, each of them concentrating on whatever interests them personally. Not only is the gazed-upon object absent, but even though the composition and arrangement of the entire picture is balanced, the core meaning manifests a state of deficiency. It signifies a state of seeing but being unseen, and the signified exhibits a condition of self-nullification, as its significance cannot take shape.

When the people in a picture are deeply absorbed in an event, it is as if the people around them don't exist, and from the perspective of the people in the picture, the photographer or viewer in front of the picture do not exist either. The American art historian and critic Michael Fried termed this a major ontological construct. One of the effects of this method is to make the picture become a purely gazed-upon object, as if there is a fourth wall between the viewer and the people in the picture. [5] In European paintings expressing the aesthetic of absorption, human figures are often presented reading, painting, playing a musical instrument, playing a game, playing cards or sleeping. Not only are they concentrating on an activity, but there are no people around them, as if "this world" did not exist and they have been transported to a different world by what they are doing. And this other world, like the dream world of a dreamer, cannot be manifested in the eyes of spectators, but can be logically deduced from the human figure's expressions and experiences. Such an aesthetic of immersion or "absorption" also appears in the works of Chang Chao-Tang, but he usually accompanies it with a state of absence. For example, in the photograph *Sansia, Taiwan 1984* (p.213) only one person is gazing out beyond the frame, and he is positioned in the distance. A person with his back to the camera also appears, but he serves as an element bridging the center ground with the background.

頭人身的塑像不知是人變狗或狗變人，總之是物種界線受到跨越，而這在今天因為各種病毒的知識，只會令人聞之色變。這尊塑像蹲踞於樹邊草叢之中，兩手伸於胸前，像是在乞討，也可能是在提供什麼。牠背後的不鏽鋼垃圾桶雖然多少映照出觀者或甚至攝影者拉長的身影，但也更以反襯的方式強調了人——狗塑像的表層比較接近生物的質感。（頁358）

以上的塑像一方面是黑白的影像，另一方面也沒有刻劃眼睛，其生命感多少已有被剝奪的傾向（符合「核災之後」生不如死的感覺），在《夢遊－遠行之前……》系列中，張照堂則以在他為罕見的彩色攝影為媒材：作品中的塑像臉孔泛著青苔，甚至感覺已和一旁的樹幹結為一體，但人物的瞳孔製作完好，甚至具有類似生命體的反光，其逼真程度又更上一層樓。（頁349）

張照堂早年常用的面具也在此回返，但這時整是描繪而成，包括瞳仁。它不再有遮隱任何事物的需要，反而是用一種說不出其意味的表情質疑著觀者。這種人和物之間、有生命者和無生命者之間界線泯滅而產生的反轉效應，當然也可以作用於人

本身，比如三個人戴遮眼罩治療器這張影像，雖然三位人物身前機具的盒子多少說明了它的用途，但看到他們各自不同的身體樣態和手部表情，又不禁令人感慨人受到機器吸納制約的日子已逐漸進入日常生活之中。（頁355）

## 影像的影像

先前我們看到，《剎那間容顏》短片中的靜照被取出來放大，當作系列性的照片展出。這種作法其實接近翻拍，是由影像取得影像。一般由影像取得影像的攝影，或是拍攝影像的攝影，往往會帶有後設影像的思考性，像是以攝影來談論攝影（比如Sherrie Levine或Richard Prince的創作）。不過，在張照堂以影像為主題的攝影中，反而比較少看到理論性的思考，多的是我們先前看到的符號運用或詭異感受。比如《三峽 1980》的作品（頁209），看來應是一裱框行櫥窗：右下角由裸女構成男人頭像下緣寫著「三峽畫框館」等字樣。這些圖像相當一般，但除了前述的奇形拼圖像外，其餘皆是攝影，類型也算整齊，

The element closer to the viewer is a small group of men in twos and threes, each involved in his own activity. Perhaps they are having a siesta (or nodding off?) or playing a card game (this is unclear, as no cards can be seen) or squatting by the side of the river chatting. Clearly, each person in this cluster is doing their own thing, but the way the photograph is arranged gives it a decentralized effect.

## The Vitalization of Inanimate Objects

If concealment, masks or absence perform a certain vanishing act that endows reality with an extra layer of solidity, producing a certain peculiar feeling, another method to produce a sense of the unusual within the everyday and to suddenly fill the taken-for-granted with ineffable mystery is to blur the lines between inanimate objects and living things. In the early 20th century, psychologists defined such an experience as "the uncanny," a state Sigmund Freud would later explore more fully, particularly in relation to his theory of the "return of the repressed."

For example, in *Wanhua, Taiwan 1986* human figures also look out beyond the frame in different directions, endowing the photo with a sense of decentralization and manufacturing a state of absence, but in

this case certain still life elements have been added to the picture, giving the idea a greater coherence (although their "line of sight" is also facing outward beyond the frame). The statues of a lion, a tiger and a leopard in a riverside park are uncanny in their own right. Why would someone want to place them next to a body of water? And why would they be placed together? And why are the three statues stylistically dissimilar?

If the lion, tiger and leopard along the banks of the Tamsui River in Wanhua, due to their folk art style, evoke a discordant sense of anachronism or misplacement, rather than an uncanny or even frightening sense of inanimate objects sprung to life, the series of photographs Chang released beginning in 2005 far more evidently expressed a sense of the uncanny. The black-and-white photos collected in the series *Taiwan – And then Nuclear Disaster...* A statue of a mother and child holding hands, standing on a grade school campus, appears to be not only a statue battered by weather and starting to crumble, but also suddenly ossified, locked in their final actions of life, like frozen forms from Pompeii or mythical figures. A dog-headed human statue is hard to define as a man-turned-dog or a dog-turned-man, but in either case it crosses the line between species. And today, given our awareness of various diseases, it can only have a shocking effect. This

甚至排列對稱：由兩位小孩（雙胞胎？）浴盆玩水的生活照為中心點，左邊是少女（明星）的沙龍照，右邊則是這奇形男子；在上方是一位老婦人的古典相館照，她左方則是一張放大的人像照。這些影像後方的空間有點雜亂，但玻璃映射著對面的街景，仔細看也看得到攝影者。雖然男女老少是種再通俗不過的取樣，但由於右下角的奇形人物介入，整體也往一種窺視的詭異感滑移，好像邀請人讀讀每個圖像中的視覺雙關語或疊合形象。

到了2004年，張照堂對於圖像的轉拍，有了更有趣的嘗試。他利用大型輸出被懸掛的時刻，拍攝了一些影像，並立刻使得這些影像的「物質性」得到彰顯，雖然那樣的輸出是為數位技術而成為可能。《臺南 2004》影像中（頁313），南藝高牆上懸掛的超大海報原是鄧南光所攝1940年的臺北太平町，然而因為施工的梯子、折痕和風向所營成的鼓脹感，原先鄧南光被稱為溫婉的寫實風格，立刻被改造為一更加具衝擊性的元素，而其為影像的本質，也完全地暴露了出來。地上因為佈放了另一張鄭桑溪《關渡 1960》的大特寫輸出，其人物臉孔的粗糙性，也因罕有的變形透視加強許多。

影像因為受到各式各樣的改變、斑駁化、物質化，因而更突顯其影像性質，不再像是一種透明媒體：直接地、無中介性地只呈現出它所看見的，而不會有任何影像自身作為媒材的作用；這個神話的解消，也出現於張照堂晚近的彩色作品。

在《夢遊－遠行之前……》系列中，有一張斑剝、失焦的少女海報，雖然人物的五官經過簡化還保有某種魅力，但在此一薄薄如紙的層次上，有著附加、模糊、斑駁、脫落等各種作用，而且，彷彿他攝影其他所有的視覺系統元素，如前述的隱藏、面具、缺席、靜物轉生，都匯聚到這張似虛似幻的臉龐上來。（頁348）

## 小結

張照堂攝影的視覺系統是否仍有其它元素呢？我想至少還有兩個相關層面可以分析，一是他有段時間經常使用廣角鏡頭，在很近的距離拍攝對象的臉孔。另一個特質則較多見於其早期實驗創作，可說是一種多元領域和攝影間的跨域交會作用，比如

statue, crouching in the grass next to a tree, has its arms stretched out in front of its chest, as if it is begging, or perhaps offering something. The stainless steel garbage bin behind it holds the elongated reflection of an observer, or even the photographer, but it also serves to accentuate, by way of contrast, the texture of the surface of the man/dog statue, which is closer to that of a living thing. (p.358)

Because the aforementioned statues are black-and-white images, and also have no eyes carved in them, they tend to feel slightly deprived of life (in keeping with the nihilistic post-apocalyptic theme). In the series *The Sleep Walking Before…*, Chang uncharacteristically uses color film as his medium: The statues' faces are covered by moss, even seem to meld with the nearby tree branches, but the pupils of the people's eyes are perfectly produced, even reflecting the light like living things, effecting a heightened level of lifelikeness. (p.349)

The masks that Chang employed in his early years also make a return appearance here. This time, however, they are completely painted on, including the pupils. They no longer serve the purpose of concealing anything, but in fact question the viewer with expressions of inexplicable implications. This kind of effect of reversal produced by erasing the line

between people and things, between the living and the inanimate, can naturally be applied to people themselves. For example, in a photo of three people wearing medical devices that conceal their eyes, the device's boxes in front of the three people provide some form of explanation as to how they should be used, but when one views the different bodily postures and hand gestures that each of them has, it is impossible not to feel that an age when people have been absorbed and controlled by machines has already gradually intruded upon everyday life. (p.355)

## Images of Images

Earlier we noted how Chang had selected still frames from his short film *Face in Motion*, blown them up and exhibited them as a series of photographs. This method is in fact similar to photographic reproduction — deriving an image from an image. Most photography in which images are derived from images, or which film other images, usually carries a meta-image intellectual orientation, as if using photography to discuss photography (e.g., the works of Sherrie Levine or Richard Prince). Nonetheless, in those photos by Chang whose subjects are images, one rarely sees theoretical consideration. Most involve the use of symbols or a sense of the uncanny that we have observed before. For example, *Sansia, Taiwan*

劇場、電影、繪畫、裝置。前者或許和前文談到的「面具」有關，但也屬於拍攝者和被拍攝者間關係的範疇；後者雖和當代攝影的許多發展有密切關係，但其精密探討，可能必須回到當時臺灣藝術發展的相關脈絡。這兩者其實都已越出單純的視覺系統概念，且留待未來更擴大的探討。

註釋：

[1] 張照堂，《1962・夏日》，中國時報，1996年4月7日，第43版。轉引自傅遠政，《場景之外 — 張照堂攝影作品研究》，國立臺北教育大學藝術學系碩士論文，林志明指導，2007年8月，第10頁註11。

[2] 張照後來回憶說，這面具是當時他以手上的印刷品剪下自製的，見張照堂口述，吳忠維整理撰寫，《揮手的姿勢 看・不見・張照堂》，臺北市：時報，2000，頁79。

[3] 傅遠政，《場景之外：張照堂攝影作品研究》，前引書，頁17。

[4] 此年表見於張照堂主編，臺灣攝影群象中的《張照堂》一書，出版資訊為臺北：躍昇，1989。不過，後來在和吳忠維的訪談書中，張照堂不認為自己是「報導攝影家」，見《揮手的姿勢 看・不見・張照堂》，前引書，頁102。

[5] Fried關於這方面的論著有許多，尤其是1980年所著的 *Absorption and Theatricality: Painting and Beholder in the Age of Diderot*, Berkeley: California UP. 和攝影特別相關的著作則可參考其2008年著作 *Why Photography Matters as Art as Never Before*. New Haven: Yale University Press. 這個問題的中文探討請參考林志明，《專注、世界與日常：Michael Fried論Jeff Wall》，《數位攝影的發明對數位藝術的衝擊》，臺北：中華攝影教育學會，2012，頁83-97。

*1980* (p.209) appears to be a picture of a picture frame shop window: In the lower right corner is a drawing of a man's head composed of nude women's bodies, near the bottom edge of which are written the words, "Sansia Picture Frame Gallery." These pictures are quite ordinary, but in addition to the aforementioned strange puzzle picture, the others are photographs. Their arrangement is orderly, even lined up symmetrically. In the center is a candid photograph of two children (twins?) playing in a wash basin. To their left is a salon photo of a teenage girl (a pop idol), and to their right is the odd puzzle drawing. Above them is an old-style photo-studio full-length portrait of an old lady, and to her left is a magnified three-quarter headshot of a man. The space behind the pictures is a little disorderly, but the glass reflects the opposing street scene — if one looks closely, one can make out the photographer. Although these samplings of males, females, old and young could not be more commonplace, with the insertion of the strange drawing in the lower right corner, the entire image slides in the direction of an uncanny sense of peeping-tommery, as if inviting one to read the visual double entendre of superimposed images in each picture.

In 2004, Chang Chao-Tang began an even more interesting experiment in image alteration. He made large-scale printouts of photos, hung them up and took a number of photos of them, thus immediately expressing the "materiality" of the images — even though such printouts were made possible through digital technology. In the photograph *Tainan, Taiwan 2004*, (P.313) a poster hung from a wall at Tainan National University of the Arts was originally a photograph taken by Deng Nan-Guang in the Óhira Machi district of Taipei in 1940 (during the Japanese colonial era), but because a construction site ladder is present and the poster is ripped and puffed up by the wind, Deng's gentle realist style is suddenly changed into an element of aggression, and its basic nature as an image is completely exposed. Laid out on the ground is a large-scale printout of *Guando Fisherman, 1960*, a close-up by Cheng Shang-Hsi. Due to an unusual distortion in shape, the roughness of its subject's face is given a stronger sense of perspective.

As images are altered, weathered and rendered material in a variety of ways, their nature as images is highlighted. No longer do they resemble a transparent medium: directly and without mediation, they only appear as they are seen and have no function as an image in itself serving as medium. This dissolution of myth also surfaces in Chang's latest color works.

In the series *The Sleep Walking Before···*, there is a tattered, out-of-focus poster of a teenage girl. Although her facial features still retain a certain simplified attractiveness, on this paper-thin layer they have a processed, vague, motley, disassembled effect. Furthermore, it is as if all the other elements of the visual system in Chang's photography — concealment, masks, absence, the transformation of the inanimate into the living – have come together on this illusory face. (p.348)

## Concluding Observations

Does the visual system in Chang Chao-Tang's photography contain other elements? I think there are at least two related levels that may be analyzed. The first is that for a period he used a wide-angle lens to photograph people's faces at close range. This may be related to the aforementioned element of masks, but also belongs within the scope of the relationship between photographer and photographed. Another special feature that appeared more frequently in his earlier experimental works may be described as a cross-boundary intersection between photography and a variety of disciplines, such as theater, film, painting and installation. While parallels may be drawn to many developments in contemporary photography as a whole, an intensive exploration of this topic may require a return to the context of Taiwanese art history. Both of these elements extend beyond the simple concept of a visual system, and await broader consideration in the future.

NOTES:

[1] Chang Chao-Tang, "1962 Summer," *China Times*, April 7, 1996, p. 43. Cited in: Fu Yuan-Cheng, *Beyond the Scene – Chang Chao-Tang's Photography Works*, National Taipei University of Education master's thesis, directing professor Chih-ming Lin, August 2007.

[2] Chang later recalled that he had made the mask himself by cutting out a printed picture. See Chang's oral history as cited in: Wu Chung-Wei, *The Pose of a Waving Hand: Seen and Unseen, Chang Chao-Tang* (Chinese-language), Taipei: China Times Publishing, 2000, p. 79.

[3] Op. cit., Fu Yuan-Cheng, *Beyond the Scene - Chang Chao-Tang's Photography Works*, p. 17.

[4] This chronology appeared in *Aspects & Visions: Taiwan Photographers: No. 3, Chang Chao-Tang*, edited by Chang Chao-Tang (Taipei: Yue Sheng, 1989). However, he later told Wu Chung-Wei in an interview that he did not consider himself to be a photojournalist. See: op. cit., Wu Chung-Wei, The Pose of a Waving Hand, p. 102.

[5] Fried has offered several comments on this issue, especially in his 1980 book *Absorption and Theatricality: Painting and Beholder in the Age of Diderot* (Berkeley: California UP). Also see his 2008 book with particular reference to photography, *Why Photography Matters as Art as Never Before* (New Haven: Yale University Press). For a Chinese-language discussion of this issue, see: Chih-ming Lin, "Concentration, World and the Everyday: Michael Fried on Jeff Wall," *The Impact of the Invention of Digital Photography on Digital Art* (Taipei: The Chinese Society of Photographic)

# 明室中有暗房
# 暗房裡有微光

■ 張世倫
Chang Shih-Lun

政治大學
新聞研究所碩士

M.A.
Department of Journalism
National Chengchi University

倫敦大學金匠學院
文化研究中心
博士候選人

Doctoral Candidate
Centre for Cultural Studies
Goldsmiths College University of London

# A Dark Room
# in Clear Chamber,
# a Faint Light
# in a Darkroom

那張攝於1975年，名為《張世倫49天》的嬰孩大頭照，我約略知道它是在什麼樣的時空情境下所產生（「嬰兒床上……窗邊有斜光……接寫鏡……北方的乾淨光線……」[1]）。然而某種程度上，對我而言，這些片段、零碎的物件、空間與氛圍，畢竟是後天生成的「偽記憶」。做為「被攝者」的我，腦海裡不可能真確地擁有自己降臨世間後第49日的生活印象。

所謂的生命，畢竟不是一座按照分類編碼就能找到原始出處與歸檔位置的資料庫；所謂的歲月，因此時常是後天的添加與附會，遠多於先天的初始與本源；所謂的影像，因此既可能是「此曾在」的視覺見證，卻也常變成感傷鄉愁的發散原點，隨著時間不斷輪轉，衍生出各種變異的分叉與歧義。

## 我出生了，但……

但於我而言，無論喜歡與否，那張照片總是頑強且無法抹滅地，彷彿鬼魂般纏繞著那個不斷長大的、並彷彿陀螺般不斷遠離「49日」的自己。我的意思是，那張照片本身靜默、純粹，且趨

That close-up of a baby's face taken in 1975 titled *Chang Shih-Lun, Day 49* — I have an approximate idea of what circumstances produced it ("On a baby's bed... slanting light from the window... extension tube... a clean light from the north..."[1] ). Yet to a certain degree, for me, those patchy, fragmentary objects, that space and atmosphere are ultimately counterfeit memories generated after the fact. As the one who was photographed, my mind could never truly retain my impressions of life on my 49th day in the world.

So-called life is not a database from which one can extract the original output and file location according to category or serial number. Consequently, so-called time is often supplemented and construed at a later date, becoming far more than the source at the outset. And so-called images, while as much as possible serving as visual verification of "that-has-been," nonetheless often become source points for the dispersal of piquant feelings, constantly revolving in time, engendering a host of shifting bifurcations and divergent meanings.

## I Was Born, But...

But for me, whether I like it or not, that photograph is tenacious and

近於某種視覺的零度原點，但它就像是有張不必開口就能表意的嘴，不斷地重複著一句說了一半的話：「我出生了，但……[2]」。

「我出生了」，照片裡的孩童證據確鑿地「誕生」了，一如影像也不容否認地「發生」了，拍攝者對於被攝者的慈愛之情，以及被攝者面對拍攝者（及其代表之「世界」）的好奇，都屏氣凝神地凍結在此一不可逆的黑白瞬間。只是，這張照片另有一種懸而未決、略帶神秘的延宕感，那個面向鏡頭的凝視，因此也像是一個意味深長的停頓，像是在說，然後呢？

對一般人來說，這張照片的重點或許在於證據式的，且難免帶著些人情趣味傾向的「我出生了」；但對於「被攝者」的「我」而言，「我出生了」後面那個未完成且代表語氣轉折的「但……」，在影像「發生」的那刻還沒有那麼強的餘韻，卻是身為「被攝者」的我，在往後不斷面對這張照片時，最主要的問題意識與情意結。

## 被攝者

一般來說，人們在解讀照片時，多是對攝影者的意圖與視野感到好奇，或對照片的時代意涵與社會脈絡抱持知性上的興趣，至於「被攝者」如何看待、理解，乃至面對影像裡的「自己」，則通常不大是影像論述或文藝清談的焦點[3]。羅蘭‧巴特（Roland Barthes）在《明室》（Camera Lucida: Reflections on Photography）裡，曾討論了自己做為「被攝者」的尷尬情境，例如在意識到相機鏡頭的存在時，便會不由自主地「擺起姿勢」，順應著社會規則，讓自己成為一幅等待被抓取的「影像」，然而這樣的「影像」無比僵硬沈重，總與真實多變的「自己」不相符合。

「被攝者」面臨的艱難情境，在於面對鏡頭的「自己」，竟同時是：我自以為的「我」、我希冀別人以為的「我」、攝影者眼中的「我」，以及攝影者藉以展現技藝的「我」。面對「我」的四重分裂，巴特認為「被攝者」通常只能弔詭地不斷模仿自己，並將自己逐漸轉化成一個異化於自身的物體。巴特因此宣稱，對於

ineradicable, coiling like a wraith around that self that has been growing up ever since, constantly spinning away from "Day 49" like a top. What I mean is the photo itself is serene and pure, and approaches a certain visual Degree Zero, but it is like a pair of lips that need not speak to express themselves, constantly repeating a half-spoken sentence: "I Was Born, But..."[2]

"I Was Born." The child in the picture irrefutably came into the world. As the image proves, this was an incontestable happening. The photographer's feelings of love for the subject, and the subject's curiosity toward the photographer (and the "world" that he represented) are frozen concentratedly in this irreversible black-and-white moment. The only thing is, this photo also has a certain sense of suspension, or barely mentioned, mysterious postponement. And for this reason, that gaze facing the camera seems to intimate a profound pause, as if asking: What next?

Perhaps for most people the main point of this photograph is to serve as evidence, and it also inevitably tends to touch the human heart strings, evoking a sense of affinity toward "I Was Born." But for the "me" that was the subject of the photo, constantly looking at it after it was taken, long after the reverberations from the moment of the image's "happening" have diminished, that unfinished "but" representing a transition in expressive tone that lies in the background behind "I Was Born" is the principal problem of which I am conscious, and my primary emotive bond to the image.

## The Photographed Thing

Generally speaking, when interpreting a photograph most people feel curious about the photographer's intentions and vision, or feel an intellectual interest in the temporal setting or societal context of the photo, yet how the subject sees and understands, or even addresses the "me" in the image is not commonly a focus of concern in photographic theory or conversations on the arts.[3] However, in his book La Chambre claire: Note sur la photographie (literally, "The Clear Chamber"; translated in English as Camera Lucida: Reflections on Photography), Roland Barthes discusses his own awkward predicament as "the photographed thing." For example, when conscious of the existence of the camera, he could not help but take a pose, following social convention, allowing himself to become an image waiting to be captured. Yet such an image is incomparably inflexible and cumbersome,

「被攝者」而言，在拍照過程中變成「影像／物體」的自己，就像經歷了一場微型的死亡。[4]

然而，一位父親在暗房裡倚著窗邊微光，拍攝自己剛滿週月不久的嬰孩，嬰孩本身則尚未能意識到相機的意義與功能，更遑論有所自覺地「擺起姿勢」，把自身變成「影像／物體」。那張照片，因此具備著某種奇特而缺乏防備的直接感，或者用巴特式的術語，某種接近於「零度」的存在狀態，至少就「被攝者」的角度來說，這張照片並沒有「我自以為的我」，更沒有「我希冀別人以為的我」。

或許人生在世的無可奈何之一，就在於難以避免地，要三不五時暴露自身於鏡頭下，模仿自己，變成影像（當然有些人樂此不疲、甘之如飴）。做為「被攝者」的我，如同其他人那般，總是意識到照相機的「在場」，從而顯得不夠自在。《張世倫49天》裡的直觀、坦然與純粹（他甚至不知道如何作「鬼臉」[5]），從而成為一種奇特的、關於「被攝者」情境的個人參照點，甚至由於他（或者應該用「它」──那張影像）的意象過於強烈，之

後任何關於我的肖像照（那些我有所意識，並難免在意地擺弄姿勢），某種意義上，彷彿只是在突顯與此原點間的巨大落差罷了。

## 面具

我也瞧過分明是哀傷情境下的個體，在面對拍攝一張離別照的相機鏡頭時，竟也能擠出一抹意味不明的的淡薄微笑，原本似乎勉強的臉部抽動，卻也完全抹滅了成相照片裡應該隱含的憂鬱。人們總以為照片必能揭露出「被攝者」的氣質與真相，倒是巴特坦承以對，宣稱好的肖像照就像一幅幅「面具」，賦予面容各式各樣的文化意義與普遍性[6]。

狀似直白的那張照片，後來（對我來說有點奇怪地）成為臺灣攝影史的名作之一，因此也不乏各式各樣的「面具」附身。例如在雲門舞集處理島嶼歷史與白色恐怖的舞作《家族合唱》（1997）裡，它曾以背景畫面方式出現在一個眾多舞者臉部蒙

and fully incompatible with the real self that is constantly in flux.

The conundrum facing the "photographed thing" is that the "me" facing the camera is simultaneously the "me" I take myself to be, the "me" I wish others to take me to be, the "me" in the eye of the photographer, and the "me" the photographer has expressed through his art. Confronted with this fracturing of the self into four quarters, Barthes averred that the "photographed thing" has little choice but to paradoxically imitate themselves over and over, and gradually transform into an object external from themselves. According to Barthes, in the process of photography the "photographed thing" becomes an "image/object," as if experiencing a micro death.[4]

Even so, a father in a darkroom making use of a faint light from the window photographs his own baby barely more than a month old. The baby himself has not yet become conscious of the meaning or function of a camera, let alone how to pose with self-awareness, or to turn himself into an "image/object." This photo consequently possesses a special sense of unguarded directness. Or to put it in Barthesian terminology, it possess a state of existence approaching "Degree Zero."

Perhaps one of life's greatest exasperations is that inevitably we are often exposed to the camera and must imitate ourselves and turn ourselves into images (of course, some people take endless delight in this and gladly put up with the inconveniences involved). As a "photographed thing" I was always aware of the presence of the camera, just like anyone else, and thus appeared insufficiently at ease. The direct, composed purity of *"Chang Shih-Lun, Day 49"* ("he made no faces when photographed")[5] thus became a unique personal reference point regarding the state of being photographed. And because his (or perhaps I should use "its" — the picture's) image was overly powerful, all the later portraits of me (in which I was aware of them and couldn't help consciously posing for them) at a certain level even seemed to merely underscore the enormous distance from this starting point.

## Masks

I have even clearly witnessed individuals in a sad situation, when facing a camera for a farewell photo, squeeze out an ambiguous, feeble smile. What at first seemed to be a forced twitch of the face was completely wiped away and became the melancholy that a photograph ought to suggest. People always assume a photograph must be able to reveal

面、雙手向身後交握打直,彷彿正駝背步向槍決地點的肅殺場景裡(所以,「它」變成「臺灣人」政治受難與寄託希望的象徵嗎?);還有一次,它以帆布形式輸出成400x600cm的誇張尺寸,高掛在忠孝東路、敦化南路的公共空間,引人醒目(這下,又成了「臺北人」的代表)[7]。

不消說,對於「被攝者」的我而言,這些場景與(巴特意義下的)「面具」,雖然都出自良善動機,它的諸多變異與化身,有時卻難免令我感到陌生、尷尬、甚或疏離。彷彿那張照片有了自己的生命與軌跡,它的流通與路徑自有法門,並且象徵了某種遠超出於我所能想像的「普遍性」,且不必然與真正的「我」有太多的交集與匯流。我也幻想過,乾脆模仿畫家馬格利特(Rene Magritte)著名的《這不是一根煙斗》(This is not a pipe),宣稱那幅名為《張世倫49天》的照片,根本就不是做為一個「人」的「我」——「這不是張世倫」,乾脆拿著一隻筆,在所有找得到的這張照片下,做出如此這般的陳述好了。但有一回,在東京都寫真美術館查詢資料,發現「它」被錯誤建檔成「張世綸」,也只能拿著護照到櫃臺,有些氣急敗壞、彷彿權益受損式地說:

「這張照片拍的是我,而你們建檔的漢字,把我的名字寫錯了,請更正。」

同樣是「面具」,我比較喜歡的,反而是一張攝於1978年,三歲的他戴著米老鼠面具,佇立在廟宇香客前的照片。影像裡的孩童,站立的姿態有些傾斜,手的擺放不甚自然,無法窺知面具後的表情,但假如用比較徵候式的方式閱讀,影像裡的他,彷彿在嘗試調和自身與外在世界間,究竟該維持什麼樣的人己關係與互動分際。身體的傾斜與不自然,搭配影像左端彷彿鬼魅的成人身影,破壞了畫面的平衡感,從而暗示了自我與外在的調和,從來就不是一個簡單穩定的過程,影像裡流露的一絲荒謬感,象徵著是人們耗盡一生,也未必能完全領悟的存在主義式命題。

## 奇怪的名片

有一回,我在維多利亞港旁的香港文化中心,看著四個半小時的《沙灘上的愛因斯坦》(Einstein on the Beach)公演,表

the disposition and true appearance of the subject. But Barthes frankly observes that portrait photographs are like so many masks, endowed with an array of cultural meanings and universalities. [6]

Later, that photo of unaffectedness became (for me, a little strangely) one of the most famous works in the history of Taiwanese photography, and because of this an assortment of masks have attached themselves to it. For example, in Cloud Gate Dance Theatre's 1997 production *Portrait of the Families*, dealing with Taiwanese history and the White Terror, it appeared as a backdrop in a bleak scene in which an assembly of dancers, faces covered, hands stretched straight behind their backs, hands clasped, marched hunchbacked as if to a firing squad. (So "it" has become a symbol of "the Taiwanese people," their political hardships and the projections of their hopes?) Also one time, it was printed out on a preposterously large sheet 400cm x 600cm and hung like a sail in public, on the corner of Zhongxiao East Road and Dunhua South Road, to get people's attention. (That time it became a representative of "Taipei people.") [7]

Needless to say, as the "photographed thing," these venues and "masks" (according to the Barthesian meaning of the word) with their numerous permutations and transmutations — although they all arise from good intentions — sometimes cannot help but make me feel disconnected, embarrassed or even alienated. It is as if that photograph has its own life and trajectory, as if its circulation and its history have their own destiny, symbolizing a certain universality far beyond what I can imagine, and it need not have too much intersection or convergence with the real "me." I have even fantasized of imitating Rene Magritte's famous painting *This Is Not a Pipe* and announcing that the famous photo called *Chang Shih-Lun, Day 49* is not "me" the person at all, by picking up a pen and on every copy of that photo I could get my hands on, writing the declaration: "This Is Not Chang Shih-Lun." But one time, when I was in Tokyo Metropolitan Museum of Photography looking up some information, I discovered that "it" was incorrectly titled. The wrong character for "Lun" appeared in my name. Immediately, I compulsively grabbed my passport and proceeded to the service desk, and somewhat flustered, as if my rights had been infringed, I said: "This is a picture of me, and you've used the wrong kanji. You've misspelled my name. Please correct it."

Also a mask — one that I prefer, in fact — is a photo taken in 1978, of him at the age of three wearing a Mickey Mouse mask standing in front of

演很長，分心晃神是難免的，突然想到《明室》裡，曾出現一張羅伯特‧威爾遜（Robert Wilson）與菲力普‧格拉斯（Philip Glass）翹著二郎腿合照的相片[8]。巴特說，他深深被這張照片吸引，卻難以用言語訴說清楚，究竟是哪一個影像細節，讓他如此神迷沈醉，他以此陳述照片「刺點」的不可言喻與私己性。

我想起在自己成長過程裡，曾遇過許多在認識我之前，便已看過並熟悉「那張照片」的人。他們通常會說，「啊，原來你就是那張照片裡的大頭小孩」，許多人並會告訴我，自己有多麼喜歡這張照片（通常都很熱烈真摯，我也就不好耍弄馬格利特的小把戲，宣稱那張照片不是「張世倫」了）。他們的理由，通常南轅北轍，例如欣賞其可愛、簡約、超現實、有慰藉感、沈靜、親切、詭異、怪奇、像外星人等。總而言之，他們的說法，大多非常個人化且含混模糊，外人（即便我是此一照片的「被攝者」）通常不大能夠理解體會，他們其實不必（也不能）說分明。倒是「那張照片」，不知不覺間竟變成了「奇怪的名片」，雖然我並無意願，老實說也有些排斥，但在形勢比人強的狀況下，硬是變成許多時候，認識人或被人介紹的開場話題。

然而我的眼睛，畢竟不如照片裡那麼清澈，中年面容，也不再像初生兒般純粹，「這種奇怪的名片，雖然有時候還是方便，但給人這麼強烈的先入為主印象，好像也不太好吧？」，有時難免會這樣想。畢竟照片，尤其那種充滿關注的凝視，例如親情或愛情，背後總是一種希冀與期望，就現在說：「他出生了，但……（之後又會如何呢？沒人知道。）」

《沙灘上的愛因斯坦》裡有一位孩童演員角色，他在劇裡時而是踏著滑板的少年，時而是年邁威權的法官大人，有一幕他被包裹在宛如透明棺材的升降機裡載沉載浮，頭上的時鐘不斷錯亂地來回快速轉動，而在另一個場景裡，他手持科幻般的發光亮球，獨自佇立在一座高臺上，未來的主人翁，究竟他是要把球拋出去，抑或是自己要跳下地面？但在各式各樣的猜測揣想，與低限音樂的規律迴動下，他到最後，終究只擺弄了一堆彷彿是「即將」、「已經」或「太遲」的身體姿勢，卻什麼也沒能做，但在這齣充滿隨機數字符號的作品裡，我發誓在某一幕裡，聽到了演員宛如傳遞密語般地，喊出了我的數字：「49」。

worshippers at a temple. The child in the image stands tilted at a bit of an angle, the positioning of his arms not particularly natural, his expression behind the mask indiscernible. Yet if one reads it with more of a semiological approach, the boy in the image seems to be attempting to harmonize himself with the exterior world, striving to determine the proper relationship, interaction and differentiation between himself and others. The tilt and unnatural posture of his body, in combination with the shadow of an adult on the left side of the photo that seems almost like a phantom, shatters the photo's sense of balance, and therefore intimates that the harmony between self and external world has never been an easy, stable process. The image reveals a subtle sense of the absurd, symbolizing the existential proposition that even people use up their lives, there is no way that one could fully comprehend it.

## A Peculiar Calling Card

One time at the Hong Kong Cultural Centre at the edge of Victoria Harbor, I watched the 4½-hour opera *Einstein on the Beach*. It was a long performance, and letting one's mind wander was hard to avoid. Suddenly I thought of a photo I'd seen in *Camera Lucida,* a double portrait of Robert Wilson and Philip Glass with their legs crossed.[8]

Barthes said he was deeply arrested by the picture, though he could not clearly enunciate precisely which detail left him enchanted. The photo delivers a punctum that is ineffable and "lands in a vague zone of myself."

I recall the many people I met while growing up who had seen and were familiar with "that photo" before they had ever met me. They would usually say to me, "Oh, so you're that big-headed boy in that photo." Many people would tell me how much they liked that photo. (Usually they were quite enthusiastic and sincere, therefore I would not play the naughty little Rene Magritte game and tell them that that picture was not Chang Shih-lun.) Their reasons for liking it were scattered all over the map – it was cute, minimalist, surreal, comforting, tranquil, tender, otherworldly, strange, or extraterrestrial. Generally speaking, their explanations have tended to be very individualized and vague. As an outsider (albeit being the subject of the photo), I usually cannot fully understand or appreciate their perceptions, and they actually do not need to (and cannot) articulate them clearly. In fact, "that photo" has imperceptibly become a peculiar calling card. I am reluctant and, honestly, feel a certain resistance, but due to circumstances more powerful than me, it has often become an opening topic whenever I meet people or someone introduces me.

## 普魯斯特的期望

相傳普魯斯特（Marcel Proust）對於鍾愛心儀的對象，總會極為熱烈地向他們索取肖像照，做為個人私藏留念。有一回，一位男孩拗不過其懇切請求，遂在照片後留下如此字句：「看著我的臉：我的名字是可能已經；我也叫做不再存在，太遲了，永別。」[9]

或許所有的肖像照，背後都有著類似的，來自影像「拍攝者」與照片「觀看者」的急切與指望，但對「被攝者」而言，那個只屬於一時一刻的、來自生活整體的剖面瞬間，竟被攝影術奇蹟似地轉化，並以扁平的二度空間形式長存於世。此一平面，無論如何揣想並賦予其某種固定不動的本質，恐怕都是徒勞無功。與其說它見證了什麼，不如說是那「可能已經」、「不再存在」與「太遲了」，方精準地標示出它擺盪在時間之流的過去、當下與未來，不斷遊走各端地擾動人心，並永遠拒絕被固定於一尊的詭奇狀態。

每張肖像照，因此都像是一個嘗試與我們告別，卻無法真正割捨的懸置狀態。照片就像是在一連串從不止息的月臺揮手，看慣了，揮久了，人們也就忘了，影像代表的，究竟是分離，還是重逢。

註釋：

1　吳忠維，《揮手的姿勢：看·不見·張照堂》，臺北：時報出版，頁93-94，2000。

2　借用小津安二郎1932年的電影片名。

3　除非作品本身明顯有著影像倫理問題，「被攝者」的觀點才會受到重視。例如美國攝影家Dorothea Lange在經濟大蕭條拍攝的名作Migrant Mother所引發的爭議。

4　見Roland Barthes. *Camera Lucida: Reflections on Photography*. Translated by Richard Howard. New York: Hill and Wang, 1980. pp.10-15.

5　寫下這句話時，心理響起的是Peter Handke的*Song of Childhood*

6　同註4，pp.34-38。

7　「看見臺北-城市百年」攝影展，2000。

8　此兩人為《沙灘上的愛因斯坦》的編導。

9　見Georgio Agamben. *Profanations*. Translated by Jeff Fort. New York: Zone Books, 2007. P.27.

Yet in the end my eyes are not as limpid as those in the picture. My middle-age face is no longer as pure as my newborn visage. "This peculiar calling card may occasionally be convenient, but it gives people such a powerful first impression — isn't there something not right about that?" Sometimes I can't help thinking this. After all, lying in the background of photographs, especially those filled with the attentive gaze of parental or romantic love, there is always a kind of hope or expectation, which says: "He was born, but... (what will happen afterward? No one knows.)"

In *Einstein on the Beach* there is a child character. Sometimes in the opera he is a youth riding a skateboard, at other times a judge at the height of power. In one scene he is placed in a helicopter resembling a transparent coffin that descends and ascends, a clock mounted on it constantly spinning back and forth erratically. In another scene his hand holds a science fiction-esque luminescent ball, standing alone on a lofty platform. The master of the future. Will he ultimately toss the ball out, or throw himself to the ground? Amidst all sorts of guesses and conjectures, to the metronomic cadence of the minimalist music, in the end he only strikes a series of poses, but never does anything. Yet in this opera filled with random numbers and symbols, I swear that in one of its scenes I heard an actor, as if transmitting a secret language, yell out my number: "49."

## Proust's Expectations

Legend has it that Marcel Proust would always passionately demand a photo portrait from everyone he adored, to cherish as a keepsake. One time, a boy, unable to reject his earnest entreaties, gave him a photo with the following sentence written on the back: "Look at my face: my name is Might Have Been; I am also called No More, Too Late, Farewell." [9]

Perhaps in the background of every photographic portrait lie such urgent expectations from both photographer and viewer. But for the "photographed thing," it only counts as a moment in time, a single cross-section of the entirety of life, miraculously transformed through the photographic technique, flattened into two dimensions and immortalized. Whatever conjectures we project onto this flat surface, no matter how we imbue it with a fixed and immovable nature, I'm afraid it will all be a futile effort. Rather than considering it evidence of something, it would be better to call it "Might Have Been," "No More" and "Too Late." This would precisely identify its strange state, tossed to

and fro in the current of time from the past to the present to the future, constantly roaming and stirring the human heart, forever refusing to be set in stone.

Thus every portrait photo seems to be an attempt to bid us farewell, yet they are unable to truly escape a state of suspension. Photographs seem to be ceaselessly waving from a train platform. We've grown accustomed to seeing them – they've been waving a long time — so we forget whether photos represent parting, or meeting again.

NOTES:

1  Wu Chung-Wei, *The Pose of a Waving Hand: Seen and Unseen, Chang Chao-Tang* (Chinese-language), Taipei: China Times Publishing, p. 93-94.

2  Here, I reference the title of the 1932 film by Yasujirō Ozu.

3  The subject's perspective rarely receives attention, unless the work itself obviously incites a question of image ethics. One example of this is the controversy sparked by the American photographer Dorothea Lange's Great Depression image *Migrant Mother*.

4  Roland Barthes, *Camera Lucida: Reflections on Photography*, tr. by Richard Howard. New York: Hill and Wang, 1980. p.10-15.

5  When I wrote this sentence, *Song of Childhood* by Peter Handke was in my mind.

6  Op. cit., Barthes, p. 34-38.

7  The 2000 photo exhibition "Visions of Taipei – A Century of the City"

8  Philip Glass composed *Einstein on the Beach*, and Robert Wilson directed it.

9  See Georgio Agamben, *Profanations*, tr. Jeff Fort. New York: Zone Books, 2007. p. 27.

# 雙重性的紀實之眼

## 初論張照堂一九七〇年代的紀錄片

■ 孫松榮
Sing Song-Yong

國立臺南藝術大學
動畫藝術與影像美學研究所
副教授

Associate Professor
Graduate Institute of Animation and Film Art
Tainan National University of the Arts

《藝術觀點ACT》主編
Editor-in-chief
Art Critique of Taiwan

# The Dualistic Documentary Eye

## A Preliminary Study of Chang Chao-Tang's Documentaries of the 1970s

近半個世紀以來，張照堂的影像創作跨越眾多領域，最令人廣為熟悉與備受推崇的無疑是攝影——這個令他在1999年獲頒國家文藝獎美術類的視覺類別。張氏另一個卓越超群，在我看來，無論就重要性還是先驅性都不比攝影來得絲毫遜色的藝術成就，乃是他在紀錄片所做的開創性實踐。然而弔詭的是，前者似乎遮蔽了後者的光芒，不管是從作品的可近性和接受性，還是被評論的廣度抑或被研究的深度，兩者簡直不成比例。對於這樣一位在一九六〇年代末即開始從事電視新聞採訪、紀錄片拍攝和新聞雜誌影片製作，至今雖已從臺南藝術大學音像紀錄與影像維護研究所（原「音像紀錄研究所」）榮退卻仍持續往返南北教導學生影像創作的資深藝術家而言，不可不謂是一件值得省思的事情。北美館此次全方位重新觀照與重訪張照堂，不僅是他的靜態影像也同時是動態影像的創作歷程，將會是一個開啟我們以嶄新視域來檢視其總體影像實踐和思想的契機。

奠基於此種脈絡下，本文嘗試針對張氏的紀錄片——尤其是於1970所拍攝的幾部傑出作品——就歷史、美學及理論面向進

For nearly half a century, Chang Chao-Tang's image art has spanned a variety of disciplines. The form that has won him the widest recognition and praise has doubtlessly been photography. Indeed, for this he won the 1999 National Award for the Arts in the category of visual arts. In my view, another artistic accomplishment in which Mr. Chang stands preeminent and in no way lags behind his photography, both in terms of significance and originality, is his groundbreaking work in documentary film. Yet paradoxically, the former seems to have obscured the glory of the latter. Whether it be in terms of accessibility or reception, breadth of criticism or depth of research, the two simply cannot be compared. For such a senior artist, who began to do television news interviews, documentary filmmaking and news magazine footage at the end of the 1960s and today has retired from the Tainan National University of the Arts Graduate Institute of Studies in Documentary & Film Archiving but still continues to travel between northern and southern Taiwan teaching image art, this must certainly be a matter worthy of reflection. As Taipei Fine Arts Museum reconsiders and revisits Chang Chao-Tang in all his dimensions, it is the history of not only his still photos, but also his moving pictures which can enable a brand new vision that will inspire us to examine his overall practical work in and thoughts regarding images.

行初步探究，以勾勒這些影片所具有的影像力量。值得一提的，《紀念・陳達》、《再見・洪通》及《王船祭典》，即是張照堂於1968年進入中國電視公司（後簡稱「中視」）擔任攝影記者所完成的其中三部特殊紀錄之作。《紀念・陳達》與《再見・洪通》分別於1977年和1978年拍攝完成，部分影像曾在中視的「六十分鐘」節目上播出；而《王船祭典》則於1979年攝於臺南縣蘇厝鄉，同年8月在「六十分鐘」上播出。[1] 以當時臺灣紀錄片的意識形態結構和產製系統而言，這幾部生產於由國民黨所經營的電視臺的紀錄片，最顯著的不同之處，在於拍攝者竟將鏡頭對準素人藝術家與民俗宗教活動（而非和黨政宣傳有關的情事），以之作為作品題旨。其次，這些紀錄片完全略去了任何具有說教、解釋、宣揚等意圖的畫外音，取而代之的是透過配樂與影像、音樂與人物、修辭手法與風土地景之間有關同步和非同步的配置來擬構某種異質音像的效果。這幾樣一目了然的特徵，當然一方面映現出時代背景的特殊且複雜的意涵，另一方面則是始終和張照堂的攝影手法與藝術觀念脫不了關係。這幾方面的結合與相互影響，非常關鍵，缺一不可。

## 從攝影到紀錄片

攝影和紀錄片這兩種影像創置，縱然無論就媒介屬性、表達內容還是創作型態而言均截然不同，卻在張照堂漫長而堅韌不懈的創作生命中，佔有舉足輕重的位置：在運動與靜止、聲響與時間、個人與集體之間相互作用，相輔相成。當1962年的張照堂還只是一位大一學生的時候，他在臺北縣的荒野與街頭所拍下的一系列凸顯失焦、搖晃及無頭者影像、並於三年之後發表在和啟蒙老師鄭桑溪合辦的「現代攝影雙人展」上的著名照片，靠著一種——郭力昕在〈大音希聲，大象無形：論張照堂的攝影藝術與生命風景〉這一篇透徹闡釋張氏現代主義攝影風格的文章中所論及的——交雜著「試圖掙脫苦悶的抵抗與救贖之道、沉思的壓迫性與窒息感」（郭力昕 2011：23-24）的特異影像造形，孤傲地在彼時的攝影界崛起，一鳴驚人。這一刻的張照堂，浸染於超現實主義、荒謬劇場、存在主義等西方現代派藝術及搖滾樂的洗禮中，在靜照中框構去形體的主體，凸顯形而未形、形而失形的身體圖像。1966，他以洛夫的詩作〈石室之死亡〉在「現代詩展」上發表了一件以照片疊印

Based on this background, this text attempts to engage in a preliminary exploration of the historical, aesthetic and theoretical dimensions of Chang's documentaries- especially several outstanding works filmed in the 1970s- in order to provide a general impression of the visual power of these films. Particularly noteworthy are *Homage to Chen Da, Homage to Hung Tung* and *The Boat-Burning Festival*, three documentaries completed by Chang after he had joined China Television Company (CTV) as a photojournalist in 1968. Chang filmed *Homage to Chen Da* and *Homage to Hung Tung* in 1977 and 1978, respectively. Portions of these films were aired on the CTV program "Sixty Minutes". He filmed *The Boat-Burning Festival* in Sucuo Township, Tainan County in 1979, and it was aired on "Sixty Minutes" in August of that year.[1] In light of the ideological structure and production system of Taiwanese documentaries of that era, what made these documentaries stand out- especially given that they were produced by a television network run by the Chinese Nationalist Party (KMT) — was the subject matter on which the filmmaker focused: outsider artists and rituals of folk religion (not matters related to partisan propaganda). Secondly, these documentaries completely steered clear of any didactic, explanatory or propagandistic off-screen narration, and in its place Chang fashioned a certain heterogeneous audio effect through synchronous and asynchronous juxtapositions of soundtrack and images, music and people, rhetorical methods and vernacular landscape. These instantly recognizable symbols on the one hand revealed the special, complicated implications of that era, yet they can also never be divorced from Chang's photographic method and artistic perspective. The combination and mutual influence of these several factors are very crucial, and each is an essential element of the whole.

## From Photos to Documentaries

Even though photography and documentary are completely different types of image art in terms of the nature of the medium, the content expressed and the form of creation, they both occupy decisive positions in Chang's long, intrepid artistic career:mutually efficacious and complementary in the balance between action and stasis, reverberation and time, the individual and the collective. Back in 1962 when Chang was just a freshman in college, he took a series of now famous photos in the wilds and streets of Taipei County — blurry, jittery, headless images — and three years later he released them in a joint exhibition with his mentor Cheng Shang-Hsi titled "Modern Photography." With a special form of image that Kuo Li-Hsin limpidly limns in his article on Chang's modernist photographic style, "The Greatest Music Is Silent, the Greatest

的自拍特寫上罩以玻璃櫃的同名作品：放大的雙眼神情嚴肅，炯炯有光──這實在離鮑德威爾（David Bordwell）展現反思主體的「平板鏡頭」概念不遠。1967年，應黃華成之邀構思了一部題為《日記》的八釐米短片，張氏發表於《劇場》雜誌舉辦的「第二回實驗電影發表會」：十分鐘的影片共有五、六個段落，其中一個段落描繪一位臉面塗抹白粉的男子，用放大鏡在一張小學畢業紀念照上找人，扔掉靜照接著翻牆跳走離開的過程。這幾部作品，連同張氏在中視值晚班的某一個1970年的晚上利用十六釐米攝影機，將速度設定為每秒兩格所拍攝並於後製加入希臘電子音樂家范吉利斯（Vangelis）的《脈衝》為配樂的情況下，完成了一幅凝望鏡頭、伸舌頭、扮鬼臉等姿態的自畫像《剎那間容顏》（1976年剪輯完成，當時並未公開發表），無可諱言的都是創作者有意識地透過鏡子和鏡頭的佈署對自我開展反身化、解形化及再形象化的實驗之作。這時期的張照堂，從攝影、複合藝術裝置到尤其是實驗短片，顯然除了彰顯出帶有西方現代主義表徵的反身性機器裝置的概念外，更不斷藉由一種強制性且置換性的修辭語彙（放大、重複曝光、加速、配樂、晃動、模糊、色彩疊映等）對自我──這

一個以人形為外在輪廓的主體──進行反覆的查驗、檢視、掃描：似乎想透過由外而內、由內而外、上下顛倒的層層影像試驗，提煉出一幅多重性自我的圖譜。

此趟自我追尋的影像之旅彌足珍貴，在我看來，它並非僅抽象地呈顯出如同許多評論家認為的是一種藝術家在邁向成熟期所必然展露出的憤怒和憂鬱的青年狀態，甚或張照堂自己都認定為不過是「迎向虛無」與「起病的診斷紀錄」（張照堂2012：54、56）。這些不免沾染些沉鬱卻始終不失反思甚至摻雜了戲謔和荒謬味道的影像，骨子裡並非沒有任何批判的意圖。當所攝主體（特別這涉及的是創作者本人）決定將其目光直視鏡頭或攝影機產生鏡像效應之際，這絕非偶然。面對一九六〇年代處在戒嚴令下的臺灣，作者的介入影像顯然試圖創置出一種宛如多面體的形象來質疑與看穿單面向的現實世界，從平板鏡頭、鏡像效果到多頭疊印的佈署無非就是在凸顯多重態、伺機而動的伏流形體。由此來重看前述張氏一九六〇年代的系列無頭者影像照片，不僅是透過多頭者（從想像的個體到被國家禁錮的實存公民）對無頭者（被剝奪身體與

Image Is Formless: On Chang Chao-Tang's Photographic Art and Life Landscapes", as mingling "an attempt to struggle free from the dismal way of resistance and redemption, and a rumination on the nature of oppression and a sense of asphyxiation" (Kuo Li-Hsin 2011:23-24) , he rose to prominence overnight in Taiwan's photography community. At that point in time, Chang Chao-Tang was immersed in Western influences — surrealism, Theater of the Absurd, existentialism, modernist art, and rock and roll. Framing disembodied subjects in still photos, he highlighted images of incorporeal, formless bodily forms. At a "Modern Poetry Exhibition" in 1966, he displayed a photo above the poem "Death of a Stone Cell" by Lo Fu, giving it the same title. It was a close-up self-portrait with a double-exposure of a glass cabinet: His outsized eyes had a solemn expression, bright and piercing — which was certainly not far removed from David Bordwell's concept of the planimetric shot that reveals reflection in the subject. In 1967 Chang conceptualized an 8mm short film titled *Diary* at the invitation of Huang Hua-cheng. Chang had it screened at the "2nd Experimental Film Festival" organized by *Theater* magazine: The ten-minute film had five or six segments. In one, a man, his face smeared with white powder, used a magnifying glass to look for people in a grade-school graduation picture, then threw the photo away, leaped over a wall and ran away. These several works — including *Face in*

*Motion*, a self-portrait Chang made when working the night shift at CTV one evening in the 1970s, filmed with a 16mm camera set at two frames per second, in which he stared at the camera, stuck out his tongue and made funny faces, and in post-production inserted the music track *Pulstar* by the Greek electronica artist Vangelis (he completed editing in 1976, but did not release it at the time) — were all undeniably experimental projects in which the artist consciously reflected, deconfigured and reconfigured himself through the arrangement of the mirror and the lens. Clearly during this era Chang Chao-Tang's photography and mixed media installations, and particularly his experimental short films, manifested a self-reflective concept of mechanical installation with a sense of Western modernist representation, but also constantly engaged in repetitive examination, investigation and scanning of the self — this subject with an external contour in human form — through a powerful, metathetical rhetorical vocabulary (magnification, multiple exposures, accelerated film speeds, musical soundtracks, swaying, blurring, color overlays, etc.): seemingly intent upon experimenting with multilayered images that internalized the external, externalized the internal, and inverted up and down, crafting a multi-replicative picture album of himself.

思想自由的人民）的棒喝：「是該好好覺醒的時候了！」；更重要的是，亦激化出對去頭者——也就是專制政權首腦進行斬首——的想像。張照堂這個對無頭者或去頭者的擬構堪稱意義非凡，寓意性十足，無意之間觸及卻也重新組裝了無頭身體——這個被巴塔耶（Georges Bataille）在法西斯政權正逐步鯨吞一九三〇年代的歐洲之際所致力思索的概念。換言之，若擴大地來闡釋這一個失去頭顱圖像的政治寓言，相較於巴氏處處彰顯陰暗面與殘酷性的超現實意念，張氏的無頭與去頭者並非只是要去除理性（法西斯政權的崛起，弔詭的即為此一表徵的體現）和對抗臣服於理性的奴化態度，更進一步招喚出潛藏在身體與思想的反動因子。

是故，這個表面上看來帶有些負面的、逃避式的甚或形式美學的無頭和去頭形體，是意味深長的。從形式切入模塑寫實材料，抑或，由可觸可感的身體行抽象造形，即是身為藝術家的張照堂與生俱來的一種擬構現實世界的感性力量。縱然連他自己也不只一次在許多訪談，及尤其在《臺灣攝影家群象：3張照堂》裡的作品年表說明中以1974年的「攝影告別展」作為

創作分水嶺，並清楚地載明：「與不能明確的自我告了一了斷」的宣示。然值得思考的，如果這一個「不能明確的自我」意味著一九六〇年代的失焦、蒼白、荒謬及殘缺等等前成熟期的藝術家特質，在我看來，它們無法也實在不能和作者訣別，甚至更沒有和一九七〇年代張照堂同時致力於以紀錄片（散狀地出現在電視新聞雜誌節目）和攝影（總結在1983年的「恩寵與寬容」）作為平行的影像創作一刀兩斷，而是持續附著在張氏兼具高度冷冽與詭譎風格、敏銳與感性特徵的影像實踐和思想裡。[2]

我的確切意思是：張氏創置攝影與紀錄片的感覺結構和語彙系統，恐怕由始至終並沒有徹底的改變過。如果他一再地聲稱自己在每一段創作時期都不斷地處於變換的狀態是為了不想重複同樣的創作模式和內容是有違此項判斷的話，我會進一步強調：改變不意味絕對不同，而指向每一個創作時期的轉化。就攝影而言，這顯然指的是一九七〇、八〇年代中期他融合冷冽、詭譎、突梯的視覺風格與厚重、溫暖、素樸的人文精神的現代主義攝影（郭力昕 2011：24）。而在紀錄片方面，我

This journey in images in search of himself was invaluable. In my view, he abstractly expressed not only that youthful state of anger and angst that an artist inevitably reveals when coming of age, as many critics have opined, but also, as Chang himself defined it, nothing other than "embracing emptiness" and "a diagnostic record of the onset of illness." (Chang Chao-Tang, 2012:54, 56) These images inevitably stained with a certain melancholia yet consistently contemplative, even infused with a jocular, absurd flavor, had at their heart no intention to be critical. When the photographed subjects (especially when they involved the artist himself) decided to look directly into the camera, producing the effect of staring into a mirror, this certainly was no coincidence. In the context of Taiwan of the 1960s, under the control of martial law, the intervention of the photographer was obviously an attempt to create a multifaceted image to cast doubt upon and see through the monodimensionality of the real world. His planimetric shots and mirror effects and his arrangement of many superimposed heads were nothing other than subterranean forms highlighting multiplicity, waiting for the opportune moment to emerge. Thus, re-examining Chang's series of headless images from the 1960s, we see they not only employed the multi-headed (both imaginary individuals and actual citizens detained by the state) as a clarion call to the headless (those deprived of their bodies and their freedom of thought): "It is time

to wake up good and proper!" More importantly, they also spurred the imaginations of the decapitated — that is, those whose brains had been neutered by the authoritarian regime. Chang's creation of headless or decapitated people was quite extraordinary and highly metaphorical, unconsciously touching upon and reassembling the concept of *Acéphale* (literally, "headlessness") that Georges Bataille energetically espoused in the 1930s, as fascism was beginning to overrun Europe. In other words, to explicate the political metaphor of these headless images at a more expanded level, compared to Bataille's ubiquitous manifestation of the surreal ideas of dark faces and cruelty, Chang's headless and decapitated people were not simply an attempt to remove reason (the rise of fascism was paradoxically a manifestation of this phenomenon) nor an attitude of resistance to the enslavement that conquers reason, but went further to arouse the elements of counteraction lying dormant in people's bodies and minds.

Therefore, this form of headlessness or decapitation, which on the surface appears to convey negativity, evasion or even a formal aesthetic, has profound implications. Using forms, Chang sculpted realistic material. Using flesh-and-blood bodies, he enacted abstract forms. That is, as an artist, he innately possessed an emotive force that allowed him

在本文一開始提及的《紀念‧陳達》、《再見‧洪通》及尤其是《王船祭典》最能體現出張氏此種並非從現代派抽身轉向被他自己稱為「社會寫實攝影」（張照堂 1989：年表）的創作路徑，而是一種同時結合風格實驗與本土文化題材的音像紀錄型態。自從張照堂進入中視及舉辦了「攝影告別展」之後，其影像內容丕變，相較於過往的攝影確實出現了更多取材自生活和寫實場景的影像事件，但唯一不曾變更的是他揉塑出某種渾然天成的造形影像：即使張氏的攝影之眼對準了現實世界中的人事物，但值得注意的，當觀閱者接觸其靜照的第一時刻，引人注目的往往是殊異框構的影像世界，簡永彬為張氏的《臺灣攝影家群象：3 張照堂》所作的〈「攝影裝置」：張照堂作品試讀〉花了不少篇幅來論述照片的視覺角度、三角線構圖及攝影架構等面向所引發的不安定感、疏遠及怪異，堪稱最佳代表（簡永彬 1989：「攝影裝置」）。

## 紀實的幻化生命

如此一來，如果張照堂一九七○年代之後的攝影並非是——被他認定為——社會寫實攝影的範式，[3] 而較傾向於郭力昕指稱的現代主義攝影（郭力昕 2011：20），那讓我倍感好奇的：這一個時期由他和電視團隊所拍攝的紀錄片又是體現了甚麼樣的影像精神和思維結構？從一九七○年代的「新聞集錦」、「芬芳寶島」、「六十分鐘」到一九八○年代初的「美不勝收」和「映像之旅」等新聞雜誌節目，張氏跑遍海內外，一方面採訪了各個領域的藝術工作者和藝術家（例如第一位華人記者王小亭、巨人張英武、林懷民、音樂家馬水龍、溫隆信、朱宗慶、民間歌手陳達、畫家莊喆、廖修平、李錫奇、江漢東、朱為白、素人畫家洪通、吳李玉哥、謝孝德父親、攝影家張國雄、凌明聲、郭英聲等）；另一方面，則是先後與黃春明、杜可風、雷驤、朱全斌、阮義忠及蔣勳等人合作，攝製了許多和鄉土、民俗、鄉鎮族群、文化、藝術等題材相關的專題報導（如《李光輝返鄉：往事如煙》、《大甲馬祖回娘家》、《祭典之美》、《礦之旅》等）（張照堂 2012：55-57）。回顧這些和本土文化與歷史議題密切相關的紀錄影片，其脈絡，在一定程度上顯然和一九七○年代臺灣處在內外政治局勢的高度動盪和嚴峻挑戰（「保釣運動」、中華民國退出

to represent the real world. Yet even he clearly stated on more than one occasion, in several interviews, especially in the chronology section of *Aspects & Visions – Taiwan Photographers: No. 3, Chang Chao-Tang*, that the 1974 photo exhibition "The Farewell" was a creative watershed, after which:"I parted ways with my inexplicable self". However, it is worth considering that if this "inexplicable self" implies the qualities of the artist in the 1960s before he reached maturity — unfocused, blanched, absurd, incomplete and so forth — then in my opinion, they are inseparable from the artist himself. Indeed, it is impossible to completely divide the documentaries upon which Chang labored throughout the 1970s (most of which appeared in television news magazine programs) and his photography (encapsulated in 1983 solo exhibition "Human Grace and Forgiveness") as two forms of image art undertaken in parallel. Rather, they were both accomplished according to Chang's penetrating, eccentric style and his trenchant, visceral approach to images.[2]

My specific meaning is that both the photos and documentaries of Chang Chao-Tang, in terms of emotional composition and vocabulary system, probably experienced no thorough alteration from beginning to end. If his repeated declarations of being in a constant state of transition in every creative phase, because he does not wish to repeat the same

artistic models and content, stand in contradiction of this judgment, I would go one step further to emphasize:change does not necessarily imply absolute difference, but signals an alteration of direction in each creative period. In regard to his photography, this clearly references his modernist photography of the 1970s through the mid-1980s, which blended a cold, bizarre, sly visual style with a deep, warm, simple human spirit. (Kuo Li-Hsin 2011:24) As for his documentaries, the three works I noted at the beginning of this article — *Homage to Chen Da, Homage to Hung Tung* and especially *The Boat-Burning Festival* — most ably manifest Chang's creative path away from modernism and toward what he himself described as "social realist photography" (Chang Chao-Tang 1989: Chronology of Works), a form of audiovisual documentary that simultaneously integrated stylistic experimentation with local cultural subject matter. After Chang went to work for CTV and held "The Farewell", the content of his images changed greatly. Compared to his photos of the past, he undeniably took a greater amount of material from everyday life and real-life settings and events, yet the one thing that did not change was his molding of a completely natural form of image: Even if Chang's photographic eye focused on people and events in the real world, it is worth noting that in the first instant in which the viewer comes into contact with his still photos, what usually catches the eye is a uniquely

聯合國、先後與日、美兩國斷交等重大事件），由各個不同的文藝雜誌、藝術領域和團體、大眾傳播媒體對有關西化與在地化、現代化與傳統所開展的一場激烈的文化主體反思運動和考古工程密切相關。這意味著：一九七〇年代重要的不僅是對國族的省思，更催生出一股來自民間各地反思現實和回歸土地的浪潮。張照堂自然無法逃脫於這一個張力、動力及影響力皆十足的時代巨網，《紀念·陳達》、《再見·洪通》及《王船祭典》這幾部完成於鄉土文學論戰及文化造型運動高峰的作品，即可顯露出創作者獨樹一幟的藝術性格和思想。

《紀念·陳達》，是張照堂與中視電視團隊重新踩上許常惠和史惟亮於1967年因「民歌採集運動」的緣故而在恆春發現陳達彈唱月琴的足跡，於1972年首次南下屏東拍攝當時已近六十七歲的老者。這部曾在「六十分鐘」部分播出的紀錄影片，張氏於2000年將分別在1972年和1977年拍攝陳達的畫面進行重新剪接並加上照片，以不同質性的影像構成向已故藝術家致敬。影片的開場即是驅車前往鄉下、在日光下穿越一片片自然景緻的畫面（山脈、樹林、農田、水牛），接著以伸縮鏡頭捕捉出現在

路上的一位揹著月琴、穿著白色圓領內衣與藍短褲的陳達。攝影機跟隨他，進入屋子內外，開始記錄端坐在藤椅上的音樂家彈奏一曲又一曲的恆春調。這幾首現場演唱帶有頌揚和勸世味道的歌謠，一邊禮讚國家政府建設、公僕表現和遠到而來的客人，一邊則娓娓道來一己對姻緣、傳宗接代、未來生活的描繪與想像。張照堂的鏡頭焦點緊鎖著陳達演奏時的神情和撥弦姿態，但不忘拍攝家中簡陋物件（牆上的符咒、雨傘、神檯等），尤其在他彈著《思想起》即興唱起「甚麼人在遊覽／你的心頭就會清／光復後才建設的總統八大景」之際，攝影機離開主角，長時間地捕捉位於陋室旁農村崎嶇不平的路上路過的幾隻乾瘦水牛、牧牛的婦人、孩子們。比較歌曲內容與現實景象，對比與落差實在強烈。陳達謳歌生命，慷慨激昂，但他一生歷經波折，29歲時患病右眼盲瞎，終生未娶，最終更死於非命。影片的下一個場景：1977年，陳達應邀北上演唱，張氏拍攝坐在關渡河岸邊裹著冬衣、戴著帽子彈唱的老音樂家。一首歌謠才剛完畢，緊跟著接上一張陳達托腮與牆上掛著陳廖全特寫照的黑白靜照，引導進入這時更顯老態的月琴歌手在臺北的「稻草人」餐廳裡面對李光輝彈唱的場景。當陳達當面歌頌李光輝的生命

framed visual world. In Photo Installation – "A Preliminary Reading of Chang Chao-Tang's Works", which Chien Yung-pin wrote for *Aspects & Visions – Taiwan Photographers: No. 3, Chang Chao-Tang*, he devoted considerable ink to discussing the way the visual angles, triangular composition and photographic framework of Chang's photographs evoke a sense of disquiet, alienation and bizarreness, going so far as to call them the finest examples of their kind. (Chien Yung-Pin 1989: "Photo Installation")

## Documentation of Life Transported

Thus, if Chang Chao-Tang's photography of the 1970s and thereafter did not fit the paradigm of social realist photography – as he considered it to – but more closely approximated what Kuo Li-Hsin termed modernist photography (Kuo Li-Hsin 2011:23-24),[3] that greatly baits my curiosity: What kind of visual spirit and thought structure did the documentaries he filmed with his television crew engender? From "News Anthology", "Fragrant Formosa" and "Sixty Minutes" in the 1970s to such news magazine programs of the early 1980s as "Beauty Supreme" and "A Journey in Images", Chang traveled far and wide, in Taiwan and abroad. He interviewed artisans and artists in a wide variety of fields

(e.g., the first Chinese journalist H.S. Wong; the giant Chang Ying-Chih, choreographer Lin Hwai-Min; the musicians Ma Shui-Long, David Wen and Ju Tzong-Ching; the folk singer Chen Da; the painters Chuang Che, Liao Shiou-Ping, Lee Shi-Chi, Chiang Han-Tong and Chu Wei-Bor; the outsider artists Hung Tung, Wu-Li, Yu-Ge and Hsieh Hsiao-De; and the photographers Chang Kuo-Hsiung, Ling Ming-Sheng and Kuo Ying-Sheng). In addition, collaborating with a succession of people including Huang Chunming, Christopher Doyle, Lei Hsiang, Bing Chu, Juan I-Jong and Chiang Hsun, he filmed many special reports on topics related to the nativist movement, folk customs, rural communities, culture and art (such as *The Past Is Like Smoke:Lee Guang-Hui Comes Home; The Mazu of Dajia; The Beauty of Ritual;* and *Journey in the Mines*) (Chang Chao-Tang 2012:55-57) Looking back on these documentaries closely related to local culture and history, their trajectory of development is to a certain degree clearly linked to the trajectory of history in the 1970s- the turmoil and serious challenges of Taiwan's political predicament, both internal and external (the Pan-Chinese "Defend Diaoyutai Movement", the ROC's expulsion from the United Nations, the loss of diplomatic relations first with Japan and then with the U.S.), the fervent debate over cultural identity involving Westernization vs. localization and modernization vs. tradition taking place in a variety of different arts

事蹟時，畫面字卡浮現著「二戰後最後一名倖存軍人 原住民 日本兵」，後者手裡拿著菸專心聆聽前者唱著彷彿跟他無關的故事。李氏的一生傳奇，阿美族人，原名史尼育唔Suniuo（又譯史尼雍）、日本名為「中村輝夫」，第二次世界大戰時擔任「高砂義勇隊」的隊員，於1943年被徵召至印尼從軍，日本戰敗後他獨自一人滯留印尼摩羅泰島上的蠻荒叢林中獨自生活了三十年左右，直到1974年底被發現後隔年即被送回臺灣。但他回鄉不到短短幾年的時間，就由於肺癌在1981年病逝於臺東縣東河鄉。張照堂在片中將陳達肖像照和紀實影像交叉並置的作法，讓在當時只是一部關於素人藝術家的訪問短片，由於加入了極具靜態和凝神之故的靜照，更添弔古之意。

如同《紀念‧陳達》，《再見‧洪通》為一部張照堂重新組構了一九七〇年代南下南鯤鯓（北門鄉鯤江村）拍攝引起海內外轟動的素人藝術家的影片。1970年，五十歲的洪通決定投入畫作（期間也曾拜曾培堯為師），兩年之後他懸掛於南鯤鯓代天府廟前牆上的畫作意外獲《漢聲雜誌》英文版報導而開始引起關注，接著主編何政廣在《雄獅美術》（第26期）、高信疆在《中

國時報》陸續大篇幅策畫洪氏專題更擴大了這股集民俗、神秘與詭譎於一體的素人繪畫的風潮。由此來檢視張氏於2000年完成剪輯1974、1976年及1978年的洪通的影片片段，紀錄片開頭以匈牙利音樂家史真佐（Tibor Szemzö）帶有高度詭異和不安旋律的曲目《島嶼快照》（1987）引介正於畫作和畫具顏料散滿四處的屋內作畫的畫家。下一個場景，穿著白色短袖襯衫的畫家互換持筆的左右手在畫紙上由上而下依序寫出幾個大字，口中念念有詞，接著大聲歌唱。為了捕捉這一個幾乎既像是被神靈附體又似開壇作法的創作狀態，攝影家不停地在畫家身後兩邊取景，深怕遺漏了神啟般的一刻。當女記者用臺語兩次追問洪通「你現在畫的圖和剛剛唱的歌的意思一樣嗎」的時候，畫家的回答出乎意料：「不，不一樣」。當記者請求洪氏解釋十個字形奇異的大字「天下國大山／明河森古文」時，藝術家只是說：「意思很深的……這無法解釋的，生命是無法解釋的」。他不只不正面回應，反而將問題拋給記者：「解釋出來，我有獎賞」。此刻史真佐的配樂再度響起，鏡頭重新瞄準作畫的洪通、牆上一幅幅畫著小人頭卻懷著不同身形（花、字、動物、無以名狀之形等）的素描、另一個房間裡倒掛的素描、由帽子衣

magazines, the art community, arts groups and mass media outlets, as well as archaeological excavation projects. This suggests that during the 1970s what was of importance was not only reflection upon the national identity, but also reflections on reality arising from the general populace and the movement to re-emphasis the native land of Taiwan. Chang was naturally unable to distance himself from this great net of tension, motivation and influence cast over the era. The films *Homage to Chen Da, Homage to Hung Tung* and *The Boat-Burning Festival* were completed at the height of the nativist literature controversy and the "cultural shaping movement", and reveal the filmmaker's unique artistic character and thought process.

With *Homage to Chen Da*, Chang Chao-Tang and his CTV film crew followed in the footsteps of Hsu Chang-hui and Shih Wei-Liang, who, as part of a project collecting folksongs, discovered Chen Da singing and playing the moon lute in the town of Hengchun in 1967. In 1972 he went south to Pingdong for the first time to film the old man who at that time was nearly 67. In 2000, Chang Chao-Tang re-edited the documentary footage he took of Chen Da on two separate occasions, in 1972 and 1977, which originally aired as part of the program "Sixty Minutes". He also added extra photographs, rearranging the images with a different

tone to express respect for the artist, who had by then passed away. The opening segment is a car driving south into the countryside under the sun, passing through one natural scene after another (mountains, forests, farms, water buffalo). Next, the camera zooms in on Chen Da as he appears on a road, with a moon lute strapped to his back, wearing a white T-shirt and blue shorts. The camera follows the musician as he enters his house, sits on a rattan chair and begins playing a series of tunes in the Hunchung style. These folksongs, performed live with a feeling of praise and encouragement, pay tribute to the infrastructure projects of the national government and the performance of public servants, welcome his guests from far away, portray marriage and raising children, and imagine life in the future. When Chen Da is performing, Chang Chao-Tang's camera locks in on his expressions and the way he plays the lute, but it also captures some of the simple objects in Chen's home (talismanic calligraphy on the wall, an umbrella, a shrine for the gods). In particular, when Chen Da sings *Thinking about Something*, improvising, "What kind of people are going on a tour?/You'll know for sure/The president's eight major construction projects..." the camera pans away from the main subject and lingers on a few skinny water buffalo, a woman cowherd and some children walking down the bumpy farmtown road next to his shack. Juxtaposing the song lyrics with the actual scene

服褲子構成的人形、及一張張彩色斑斕、造型奇特、不明符號的畫……。昔日洪通的作畫現場和不按牌理出牌的應答，化身為視聽檔案史，增添這部紀錄片的珍貴性。《再見‧洪通》也剪入了1976年（3月13號至25號）將洪通名聲推向頂點的「洪通首次個展」現場的新聞資料片片段：臺北美國新聞處林肯廳水泄不通，被觀眾簇擁包圍的藝術家現身。影片另段呈現洪通的時間，字卡顯現的日期是1978年：回到鯤江村的畫家此時風采不再，創作日漸減少，在五王爺廟做點小生意的妻子（劉來豫）則對身體不適、胃口不好的先生顯露擔憂眼神。顯然，從神奇、崛起到沒落是這部描繪洪通創作歷程的紀錄片的主要題旨，張照堂在影片後半段將洪通的活動影像與由他、李賢文、莊靈拍攝的靜照，並搭配柯恩（Leonard Cohen）的歌曲《停在電線上的鳥》（1969）組構起來的段落，如同歌詞所唱的「像午夜唱詩班裡的醉漢／我用盡自己的方式追求自由」，突顯出畫家以其獨特畫風崛起，猶如流星的風華，短暫燦爛、卻令人無限懷念。影片另個值得注意的地方，還在於張照堂藉由音樂逼顯出作畫時不可思議的瞬間，並以單一鏡頭疊加鋪排的型態，於景框內外，組成一個洪通超越了民俗藝術和民間藝術的界線、及匯融神奇造

型與泛靈論的另類影像世界。

《王船祭典》堪稱是張照堂一九七〇年代的紀錄片代表作，敘事構成和音像語彙凝鍊，環環相扣、密度極高。這部與杜可風合作攝製的影片，從頭到尾，採線性進程來記錄臺南縣安定鄉蘇厝村的「祭王爺」和「燒王船」的民俗活動，當中沒遺漏在祭典中同等重要的歌仔戲、布袋戲及宋江陣等活動。影片一開場，張氏以靜照攝影師現身，拍下主持祭典大禮的廟方主事人員集體合照的相片，作為這一部將以邁克‧歐菲爾德（Mike Oldfield）的音樂Ommadawn（1975）貫穿全程祭典的序幕。不像《紀念‧陳達》和《再見‧洪通》，《王船祭典》並沒有任何來自祭祀現場的聲響，一幕幕猶如直接從暗房顯影的畫面，從井然有序地安排各式神偶的手勢、阿嬤凝望的眼神到成群結隊的善男信女跟隨酬神隊伍浩浩湯湯地巡禮，幾乎像是張照堂精心彙編的攝影書。它的成就之一，一方面是遠離了在記錄前述兩位民間藝術家時不得不堅守的客觀報導，另一方面則將此紀實性的影像素材轉化為創作者能積極介入、重新創置宗教事件的作法。此種同時呈顯客觀與主觀、寫實與真實的影音構成，即是我在

creates a powerful analogy and contrast. Chen Da sang the praises of life with passion, yet his own life was filled with setbacks. At 29, he fell ill and lost sight in his right eye. He never married, and ultimately, he died a violent death. The film's next scene:1977. Chen Da has come to Taipei for a concert. Chang Chao-Tang films the old singer sitting on the banks of the Tamsui River at Guandu dressed in winter clothes, wearing a hat and strumming his moon lute. As soon as one song is finished, the camera quickly moves to black-and-white still photos hanging on a wall- of Chen Da and also a close-up of the elderly lady Chen Liao-Chuan resting her head in her hands — as a means of introducing Chen Da, by then quite elderly himself, in the restaurant Scarecrow, strumming the moon lute and singing for Lee Guang-hui. As Chen Da extols the events of Lee's life in song, these words appear on the screen: "The last surviving soldier of World War II, indigenous person, Japanese soldier." Lee holds a cigarette in his hand listening with concentration to Chen's singing, as if it is a story that has nothing to do with him. Lee lived a legendary life. A member of the Amis people named Suniuo- his Japanese name was Nakamura Teruo- he served in World War II as a member of the Takasago Volunteers. In 1943 he was sent to fight in Indonesia. After the Japanese lost the war, he remained living on his own in the wild jungles of Morotai Island for around 30 years. He was discovered at the end of

1974, and a year later was returned to Taiwan. But in 1981, after only a few years back in his homeland, he died of lung cancer in Donghe Rural Township, Taitung County. Chang's method of inserting a photo portrait of Chen Da as well as documentary images added an extra dimension of historicity to what at the time was merely a short film interviewing a folk artist, because the still photo possessed a strong sense of stasis and concentration.

Like *Homage to Chen Da*, *Homage to Hung Tung* is a film introducing an outsider artist who had made an impact both in Taiwan and overseas, which Chang made by reordering footage from the 1970s when he went south to Nankunshen (Kunjiang Village, Beimen Rural Township). In 1970, the 50-year-old Hung Tung decided to begin painting (he studied under Tseng Pei-Yao during this period). Two years later the painting he hung on the wall in front of Nankunshen Temple fortuitously became the subject of a report in *Echo Magazine of Things*. Afterwards, major exposés by Ho Cheng-Kuang in *Lion Art magazine* (issue 26), of which he was editor-in-chief, and Kao Hsin-Chiang in the *China Post* expanded the popularity of Hung's outsider art, which were at once folkloric, mysterious and strange. The documentary, which Chang finished editing in 2000, made of segments filmed in 1974, 1976 and 1978, begins with

上文論及張氏攝影的一種同時結合風格實驗與本土文化題材的音像紀錄美學。毫無疑問,《王船祭典》不只接續(甚或內化)了作者靜態影像的觀念系統,更是體現出此種雙重性的影像試驗和藝術思維如何在紀錄片中被如此密合且近乎完美結合的事實:所述事件提供實踐創作意念的存有場域,而創置手法作為重新構成影像主體的概念化範式。兩廂的融合,尤其是在開始燒王船信眾開始顯得異常蠢動抓狂,及張照堂於此時所突然插入的連續幾個描寫小孩朝紅氣球奔跑、幾位持香阿嬤的迷惘眼神、小孩在媽媽肩膀上安睡的慢動作鏡頭之際,邁向高潮。歐菲爾德音樂的人聲、鼓聲節律為整艘陷入火海的王船助興吶喊,船舷的紙紮船伕和祭儀紛紛落下,風勢助長了火苗,船桅飛舞,並在迅速墜落前被停格拯救……。由此開始,慢動作的宗教祭祀在漫天紙屑、火花、塵埃飛舞如夢似幻的狀況下化為兩個相互接合的事件進程:由抬神轎的信眾、祭司及乩童圍繞王船的狂熱,進入到信眾跪地祈禱、不可思議的出神忘我狀態。張照堂匠心獨運,多虧靜照攝影這不可被磨滅的遺澤,《王船祭典》一方面繼承了張氏一九七○年代踏查民間諸眾信仰的藝術信念,記錄一張臉、一抹眼神、一條皺紋,一個幾乎不可被言語

轉譯只能形象化地呈顯的民間圖庫……。另一方面,則是以線性進展來拍攝的祭祀大典,透過張照堂慧心巧思雜揉著介於東方與西方、傳統與現代、現實與實驗等面向的影像和音樂表徵,彰顯出一種以農業社會、民俗祭典為脈動的時間性。我所概略提及的兩種幻化時間(狂熱、出神),當然還可以加上影片一開始時以字卡寫著「農曆歲次己未年 三月十九」的傳統時間,無疑是顯現出臺灣社會在全面走向理性化、現代化和資訊化之際,另種高度差異化、另一類非現代感的時間形狀──《王船祭典》即是這樣一部以雙重性風格和思維打破現代與傳統、現實與抽象、同質與異質邊界,並賦予多重時空、庶民文化乃至地區性歷史記憶的臺灣紀錄片經典。

*Snapshot from the Island* (1987), a song with a bizarre and unsettling melody by the Hungarian musician Tibor Szemzö, introducing the painter as he is painting, in a room with painting tools and paint strewn all around. In the next scene the artist, wearing white short-sleeved shirt, switches brushes between his left and right hands, writing out several Chinese characters from top to bottom on a sheet of drawing paper. He mumbles the words with his lips, and then begins to sing out loud. In order to capture the artist's creative state, nearly possessed by a spirit or an act of divination, the photographer ceaselessly takes pictures on either side of the painter, fearful of leaving out a single inspired moment. After a woman reporter asks Hung Tung twice in Taiwanese, "Do the picture you're painting now and the song you just sang mean the same thing?" the painter answers unexpectedly: "No, they're not the same." When the reporter asks Hung to explain the ten strangely shaped Chinese characters (literally, "Country under heaven great mountain/Bright river forest ancient language", the artist merely replies: "The meaning is very deep... It can't be explained. Life can't be explained." He not only did not answer directly, but threw another question back at the reporter: "If I explain it, do I get a prize?" At this moment the background music by Szemzö rises again, and the camera shifts back to Hung Tung painting; a number of sketches on the wall of little figures

with the heads of people but bodies of different forms (flowers, Chinese characters, animals or unnameable shapes); a sketch hung upside down in the next room; a human form made of a hat, shirt and pants; and numerous paintings of colored speckles, strange shapes, ambiguous symbols... The audiovisual record of Hung Tung's painting studio as it was in former days, as well as his extemporaneous responses, heighten the value of this documentary. *Homage to Hung Tung* also includes news cast segments covering Hung's first solo exhibition in 1976 (March 13-25), which lifted Hung to his highest point of recognition. The USIS Lincoln Center in Taipei was packed cheek to jowl, and the artist was surrounded by admirers. In a different segment of the film when Hung Tung appears, screen text declares the year to be 1978: Back in Kunjiang Village, the artist no longer possesses his former presence, and his productivity is slowly diminishing. His wife (Liu Lai-Yu), who is doing a little business outside the "Temple of the Five King Masters", appears worried about her husband, who is in poor health and lacks an appetite. Clearly, this documentary's primary objective is to portray Hung Tung's artistic career, from his inspired beginning, to his rise and his fall. In the second half of the film, Chang Chao-Tang portrays Hung Tung in a montage of motion pictures and still photos by himself, Lee Shien-Wen and Chuang Ling, set to Leonard Cohen's 1969 song *Bird on the Wire*. Just as the song

引用書目：

李道明、許碩舜訪問，〈張照堂：做了一些事〉，《電影欣賞》，第65期，1993年9/10月，頁37-42。

張照堂主編，《臺灣攝影家群象：3 張照堂》，臺北：躍昇，1989。

〈從實驗到紀實：張照堂的七零年代自述〉，《藝術觀點ACT》，第51期，2011年7月，頁52-59。

簡永彬，〈「攝影裝置」：張照堂作品試讀〉，收錄於《臺灣攝影家群象：3 張照堂》，張照堂主編。臺北：躍昇，1989，無頁數。

郭力昕，〈大音希聲，大象無形：論張照堂的攝影藝術與生命風景〉，收錄於《光影‧鏡頭外：張照堂的行于足跡》。臺北：行政院文化建設委員會，2011年12月，頁19-30。（原載：〈大音希聲，大象無形：論張照堂與臺灣「現代主義攝影」〉，《美術館》，第16期，2010年4月，頁99-107。）

郭力昕，〈影像介入現實的政治話語能力：檢視戰後臺灣的紀實攝影與紀錄片〉，《文化研究》，第15期，2012年秋季，頁316-325。

Bordwell, David. "Transcultural Spaces: Toward a Poetics of Chinese Film," *Chinese-Language Film: Historiography, Poetics, Politics.* Sheldon H. Lu, Emilie Yueh-yu Yeh (eds). Honolulu: University of Hawaii Press, 2005. p. 141-162.

註釋：

[1] 這些詳細資訊，來自張照堂與筆者之間的電郵內容（2013/06/19）。

[2] 這也就是為何縱使對張氏作品如數家珍的郭力昕，在〈大音希聲，大象無形：論張照堂的攝影藝術與生命風景〉裡論及：「從個人的層面來看，進入壯年的張照堂，多少揮別了1960年代那個苦澀、憂鬱、憤怒的藝術青年狀態，走進社會與工作的現場，接受機會與挑戰，也大量地展現自己各方面的才華，並因而可以比較具體地觸摸、描摹臺灣社會的肌理與脈搏，不再僅僅停留於抽象地再現個人的或全社會的精神苦悶」，卻也不得不概括出「儘管這個時期（指一九七〇年代）的張照堂，與青年張照堂的攝影，在題材或方向上顯出開闊與多元，但他一向的視覺風格和冷凝特質，卻始終是一致的」這個結論（郭力昕2011: 24-25）。

[3] 對郭力昕而言，若以「寫實主義影像」的框架來檢視臺灣紀實攝影史，一九七〇年代中期以前的攝影家（如從鄧南光到陳石岸等）雖拍攝了些現實題材的影像，但仍難脫離沙龍畫意的基調。值得強調的是，郭氏所論及的一九七〇年代鄉土寫實攝影與專題攝影的創作者名單（如王信、梁正居、林柏樑、黃永松、阮義忠等），並未提及張照堂（郭力昕 2012：318）。

lyrics say, "Like a drunk in a midnight choir/I have tried in my way to be free", the film portrays how the painter rose with a unique artistic style and shown like a shooting star, displayed brilliance for a brief moment but left us with immense longing. A different aspect of this film worth noting is that Chang uses music to reveal amazing moments when the artist is painting, and by superimposing images from a single camera, inside and outside of the camera frame, forms an alternative world of images in which Hung Tung transcends the boundaries of folk art and popular art, blending in mystical forms and animism.

*The Boat-Burning Festival* has been called Chang's representative work of documentary filmmaking in the 1970s, with a narrative structure and audiovisual vocabulary that are streamlined, tightly linked and very compact. This film, which Chang made in cooperation with Christopher Doyle, adopts a linear process from beginning to end to document the folk culture events the "Rites of the King Master" and the "Burning of the King's Boat" that take place in Sucuo Village in Anding Rural Township, Tainan County. Throughout, Chang does not leave out any of the activities of equal importance in the rites, such as *gezai* opera, hand puppet performances and "Song Jiang" martial arts processions. As the film opens Chang appears as a still photographer, taking group pictures of the main temple members who were hosting the rites. Mike Oldfield's music *Ommadawn* (1975) is played as a prelude, and returns throughout all of the rites. Unlike *Homage to Chen Da* and *Homage to Hung Tung*, *The Boat-Burning Festival* does not include any natural sound from the scene of the rites themselves. Each scene seems to arise directly from the darkroom. From the graceful, orderly gestures of the various deity figures, to the rapt gazes of old ladies and the throngs of pilgrims following in the wake of the shrine bearers' magisterial procession, everything almost seems to come from one of Chang's meticulously scripted photo books. One of his achievements was to distance himself from the obligatory objective reporting, evident in his films on the two folk artists mentioned above, while transforming this documentary film into a means for the cinematographer himself to intervene actively and re-create religious events. This audiovisual structure that simultaneously manifests the objective and the subjective, realism and reality, is the aesthetic of audiovisual documentation I touched upon above that combines both stylistic experimentation and local cultural subject matter. Without a doubt, *The Boat-Burning Festival* not only extended (or internalized) the conceptual system the artist employed in his static images, but also demonstrated that this duality of image experimentation and artistic thought could be fit and nearly

perfectly combined in a documentary: the depicted events provided extant venues for the practical implementation of his creative ideas, and his creative techniques served as conceptualized paradigms for the reconstruction of the subjects of his images. The blending of the two reaches a climax when the worshippers begin to get noticeably agitated and frenetic as the king's boat begins to burn. At this moment Chang suddenly inserts a series of slow-moving images – children running after a red balloon, several old ladies holding joss sticks with bemused looks in their eyes, a child sleeping peacefully on his mother's shoulders. The human voices and drumbeats in Mike Oldfield's music rise to a fevered pitch as the entire boat collapses into a sea of fire. The paper models of boatmen on the boat fall, and the ritual comes to a close. Winds fuel the flames, and the masts take flight, but before they fall swiftly, they are stopped and saved... Starting from this point, the slow-moving religious ritual – bits of paper, sparks and ashes filling the air and dancing as if in a dream – segues to two mutually connected events:first, priests, shamans and pilgrims lifting the deities' palanquins circle the burning boat in a religious frenzy, and then worshippers kneel in prayer in an otherworldly trance. Chang Chao-Tang's inimitable originality is thanks to the indelible beneficence of his still photos. *The Boat-Burning Festival* is an extension of Chang's artistic calling during the 1970s to survey the faith of local Taiwanese, documenting each face, eye and wrinkle, and to produce an archive of the people that is nearly ineffable and untranslatable and can only be expressed in images. Moreover, by filming a major religious rite on a linear trajectory, Chang cleverly and skillfully meshes visual and musical elements to span such dimensions as Eastern and Western, tradition and modernity, realism and experimentalism, and to manifest a temporality centered on the milieu of agrarian society and folk ritual. Of course, to the two moments of transportation that I have briefly mentioned (frenzy and trance), one can add the traditional timeframe denoted on screen at the beginning of the film:"Third Month, 19th Day of the *Jiwei* Year" (the 56th year of the 60-year cycle of the lunar calendar). Doubtlessly, this conveys an extremely different temporal state with an alternative, non-modern sense existing within a Taiwanese society embracing rationalism, modernism and information. *The Boat-Burning Festival* is a classic of Taiwanese documentary film that dissolves the borderlines between modernity and tradition, reality and abstraction, homogeneity and heterogeneity through a dualistic style and mindset, and is endowed with multiple temporal-spatial contexts, folk culture and local historical memory.

CITED REFERENCES
..................................................................................................................

Interview with Lee Daw-Ming, Hsu Shuo-Shun. "Chang Chao-Tang: I've Done a Few Things,"
*Film Appreciation Journal*, No. 65, 9/10/1993, p. 37-42.

Chang Chao-Tang, ed., *Aspects & Visions - Taiwan Photographers: No. 3, Chang Chao-Tang*.
Taipei: Yue Sheng, 1989.

Chang Chao-Tang, "From Experimentation to Documentary - Chang Chao-Tang on His Work in the 1970s,"
*Art Critique of Taiwan*, No. 51, July 2011, p. 52-59.

Chien Yung-Pin, "Photo Installation – A Preliminary Reading of Chang Chao-Tang's Works,"
*Aspects & Visions – Taiwan Photographers: No. 3, Chang Chao-Tang*, Chang Chao-Tang, ed., Yue Sheng, 1989.

Kuo Li-Hsin, "The Greatest Music Is Silent, the Greatest Image Is Formless: On Chang Chao-Tang's
Photographic Art and Life Landscapes," reprinted in *Beyond Light and Lens – The Footprints of Chang Chao-
Tang*. Taipei: Council for Cultural Affairs, Dec. 2011, p. 19-30. (Originally published as: The Greatest Music
Is Silent, the Greatest Image Is Formless: On Chang Chao-Tang and Taiwanese 'Modernist Photography,' Art
Museum Magazine, No. 16, April 2010, p. 99-107.)

Kuo Li-Hsin, "The Politically Discursive Ability of the Intervention of Images in Reality: An Examination of
Post-War Taiwanese Documentary and Documentary Film," *Router: A Journal of Cultural Studies*, No. 15,
Autumn 2012, p. 316-325.

Bordwell, David. "Transcultural Spaces: Toward a Poetics of Chinese Film," *Chinese-Language Film:
Historiography, Poetics, Politics*. Sheldon H. Lu, Emilie Yueh-Yu Yeh (eds). Honolulu: University of Hawaii
Press, 2005. p. 141-162.

NOTES:
..................................................................................................................

[1]  These details come from email messages exchanged between Chang Chao-Tang and the author (06/19/2013).

[2]  This dovetails with the perspectives of Kuo Li-Hsin, a scholar intimately familiar with Chang's works, presented
in "The Greatest Music Is Silent, the Greatest Image Is Formless: On Chang Chao-Tang's Photographic Art and
Life Landscapes." Viewed at the level of the individual, Chang Chao-Tang, who was coming into his prime, more
or less bid farewell to that bitter, melancholy, angry state of artistic youthfulness with which he was possessed
in the 1960s. He joined society and entered the workplace, accepted opportunities and challenges, and greatly
demonstrated his talent in a wide range of endeavors. Thus, he was more able to concretely touch upon and portray
the texture and the pulse of Taiwanese society, no longer merely halted at abstractly reproducing his own sense of
spiritual suffocation or that of society as a whole." However, he inevitably reached this conclusion: "Even though the
Chang Chao-Tang of this period (the 1970s) was broader and more diverse in subject matter than the photography
of the young Chang Chao-Tang, his visual style and cold tone remained the same from beginning to end." (Kuo Li-
Hsin 2011: 24-25) (Bold indicates the author's emphasis.)

[3]  In Kuo Li-Hsin's view, if one were to interpret the history of Taiwanese documentary within the framework of
"realist photography," then the photographers working prior to the mid-1970s (such as Deng Nan-Guang and Chen
Shih-An) may have produced a number of images with realistic subject matter, but they still were unable to break
free from the stylistic tone of salon portraiture. Worth emphasizing is that Kuo Li-Hsin's list of photographers
engaged in nativist photography and thematic photography of the 1970s (such as Wang Hsin, Liang Cheng-
Chu, Lin Bo-Liang, Huang Yongsong, Juan I-Jong) did not include Chang Chao-Tang. (Kuo Li-Hsin 2012: 318)

# 疏離與詭異
## 關於張照堂影像與音樂的雜想

■ 何東洪
Ho Tung-Hung

# Detachment
# and Bizarreness

## Some Thoughts on Chang Chao-Tang's Films
## and Their Relationship with Music

音樂社會學工作者
Music Sociologist

輔仁大學心理學系
助理教授
Associate Professor
Department of Psychology
Fu Jen Catholic University

## 疏離作為一種形式：《紀念‧陳達》

若攝影是流動世間的瞬間捕獲，那我們可否將影像（片）視為各個瞬間捕獲的光與影在時間序列中的重置呢？若瞬間、剎那的「靜」，同時也是聲響上的「無」或「默」，那影像（片）所牽引出的「動」的軌跡，如何與聲音交織？

張照堂說，拍照與影片的對比，如同提煉與演繹：

影片是容易更貼近現實……在影片中一些情感變化及事物狀態隨時間推移的演繹，是在靜照中比較不容易達成的。……而靜照作為另一種現實的再現，卻是比較 抽離疏遠的。所以，影片比較容易做到動人的傳達，而靜照要呈現出現象與情境的剎那力道則是要更多精神、才識與機運。（吳忠維：2000：178）

即便如此，這次展出的張照堂的影片作品，除了《再見‧洪通》比較像我們所熟悉的紀錄片外，其餘的很難稱得上是紀錄片，更難說它們「貼近現實」。也就是說，這些影片必須與他在

## Detachment as a form: *Homage to Chen Da*

If photography captures moments of the moving world, can we see film as the rearrangement of the time sequence of the light and shadows captured at different moments? If the "stillness" of moments is analogous to "silence" in terms of sound, how does the "movement" in film relate to sound?

According to Chang Chao-Tang, the difference between photography and filmmaking is like that between refinement and interpretation:

"Films are closer to reality...the interpretation of emotional changes and the progression of things with time is easier in film than in still photography...As the representation of another reality, still photography is more detached and distant. Thus, it is easier to convey poignancy with film, whereas in order to express the forcefulness of the event and situation at a certain moment, still photography requires more work, talent and luck." (Wu Chung-Wei, 2000, p.178)

靜照中所使用的「形式」一併看待，這裡說的，不是形式與內容二分的形式，而是美學上承載內容的形式，它是思維，是考量與轉變媒介與素材條件，而透過內容所呈現的藝術觀；美學形式形塑了作者的風格。郭力昕認為張照堂的作品雖然有著不同時期的內容與風格，但貫穿其間的「曖昧、鬼魅、抽象、虛實不定、與奇異趣味」奠定了張照堂在臺灣現代主義攝影的地位。（郭力昕，2011，頁025）我把郭力昕指出張照堂在美學形式的特殊性暫時稱為疏離感，這種堅持的形式承載著內容，不管是攝影或是影像。

因此即使影片可以較貼近現實，經過張照堂的處理，「現實」卻不是這麼一回事。

關於聲音與影像的處理，《紀念・陳達》除了一開始的吹奏版《思想起》的配樂外，約34分鐘的聲軌以拍攝陳達月琴演奏剪輯而成，沒有陳達的訪談，也沒有一般紀錄片有的背景聲響。影片以1972年的恆春，對比著1977年臺北稻草人餐廳與關渡河岸；1972年恆春家徒四壁的矮厝，與坐在枯樹旁、土路上趕牛的鄰居老婦、玩耍的孩童，伴隨著江湖走唱的「一級貧戶」陳達，對比著1977年人在臺北，被冠上「民族樂手」、「說唱藝人」的陳達，兩種時空，兩樣身分。張照堂以陳達在《五孔小調》、《思想起》曲調的即興、變奏吟唱上，將影片帶到最後三分鐘的奇異場景：1977年稻草人音樂餐廳中的一幅肖像照（張照堂的姑婆陳廖全）與兩位移動的身影──北上駐唱的陳達，與1943年以日本皇軍身份參戰，獨自置身於印尼叢林，至1975年才「歸國」的阿美族高砂義勇軍李光輝。三位歲月老人的影像與聲響，在空間化的影像時間裡產生連結。

隨後觀看者的視角從關渡河岸，被帶回陳達赤足踽踽走在鄉村路上，幾張靜照後，影像終止在陳達背著月琴，人在新店溪堤防上的背面照。

三分鐘的奇異場景是理解張照堂美學形式「疏離感」的重要線索。經由張照堂的引介串連，陳達在以西洋搖滾樂為主的稻草人西餐廳中，即興唱出當時被招待北上遊玩的李光輝的故事。我們看到的是兩人肢體沒有互動，在張照堂的攝影捕捉下，

Nevertheless, among the films by Chang Chao-Tang screened on this occasion, only *Homage to Chen Da* is more like the documentaries we are familiar with, while other works can hardly be called documentaries, much less "close to reality". That is to say, these films must be seen together with the "form" he adopts in his still photography. This "form" refers not to form as opposed to content, but to the aesthetic form that carries content, the aesthetic thinking involved in the consideration and change of medium and materials to present the content. The aesthetic form shapes the style of the artist. As Kuo Li-Hsin wrote, while Chang Chao-Tang's work has a different content and style in different periods, the "ambiguous, unearthly, abstract and surprising personal style" that runs through it seals his place in Taiwan's modernist photography (Kuo Li-Hsin, 2011, p.25). I will call Chang's unique aesthetic form as described by Kuo Li-Hsin "detachment" for the time being. This persistent form carries the content whether in his photography or in his film works.

Even if film can come closer to reality, it is a somewhat different "reality" that Chang Chao-Tang presents.

In terms of the treatment of sound and images, apart from the instrumental version of *Thinking About Something* in the beginning of *Homage to Chen Da*, the soundtrack of around 34 minutes was edited from the recordings of Chen Da's performance on the yueqin, without any interview with Chen Da, or the usual background sound found in documentaries. The film contrasts Hengchun in 1972 with the Scarecrow Restaurant in Taipei and the Guandu river bank in 1977. A bare low house, old women sitting beside a withered tree and driving cattle on a mud road as well as children playing serve as a background to the destitute itinerant singer Chen Da in Hengchun in 1972, contrasting with Chen Da hailed as a "folk musician" and "storytelling singer" in Taipei in 1977. Set to Chen Da's improvised singing of the tunes *Yueqin Song* and *Thinking About Something* is the extraordinary scene in the last three minutes of the film: a photograph (depicting Chang Chao-Tang's great aunt Chen Liao-Quan) and two moving figures in the Scarecrow Music Restaurant in 1977 — Chen Da who travelled to North Taiwan to sing, and Li Guang-Hui, a member of the Takasago Volunteers of the Ami tribe, who "fought" on the side of the Japanese army from 1943 and lived alone in the Indonesian jungles until 1975, when he returned to his homeland. The images and sounds of three elderly people are connected in spatialized filmic time.

Afterwards, the viewer's gaze is brought back from the Guandu river

我們與牆上陳廖全的黑白肖像照，一同凝視並聆聽著陳達與李光輝的身影與聲響。

除了1960年代到70年代初期由許常惠與史惟亮民歌採集運動所留下的磁帶紀錄，以及1979年第一唱片發行的《陳達與恆春調說唱》黑膠專輯以外，1970年代蔚為風潮的「中國現代民歌──校園民歌」脈絡，其實無法處理陳達這種活著的傳統，最終僅留下鄭怡那首徒具聲響表面的頻率高底排列，卻不知如何擺放情緒與時代感，如今聽來讓人渾身起雞皮疙瘩的蒼白《月琴》。

1978年雲門舞集公演《薪傳》，大量採用陳達的《思想起》組曲，該劇往後長年巡演，讓陳達的聲音與故事未被人們完全遺忘。但除此之外，陳達對於成長於1980-1990年代年輕人而言是陌生的。這個當時被稱為民俗藝人的傳統，就這樣與流行音樂斷了關係，直到1980年代末出現陳明章與陳明瑜關於市井小民故事的民謠吟唱，與1990年代末林生祥與鍾永豐的轉化，這個傳統才被重新接上。

回到影片上，張照堂的美學形式與陳達生命的銜接有著一種時代性的疏離共感。

1960年代末，為西方現代主義思潮、攝影、文學、戲劇所吸引的張照堂，從1968年開始書寫、譯介西方嬉皮、搖滾樂、抗議歌曲等青年反叛文化。在廣告公司待了一年後，他進入中視新聞部。長達13年的電視臺工作讓他有機會全臺走透透，在體制內的邊緣位置，進行影像與聲音的實驗。除了攝影與紀錄片本行外，1973-75年間他在《音樂與音響》雜誌撰寫西洋搖滾樂評介。關於大學時期的攝影與影像實驗作品，他如此自述：「當時的創作心情，純粹是自己對生命以及文學、藝術、思潮的理解與反映。離開學校後，進入新的環境與生活職場，才在民間、社會場域中逐漸轉化自己的位置與關心。」

對當時的臺灣而言，現代主義在政治上是相對安全的。雖然它提供青年內省的空間，滋養了個人的美學敏銳度，但終究無法以集體性反叛與書寫，來對臺灣社會進行嚴厲的批判。楊澤主編的專書將1970年代稱為「理想繼續燃燒」，但這種時代標

bank to Chen Da walking barefoot on a country road. After a few stills, the film ends on a photo showing the rear view of Chen Da on the Xindian River embankment carrying his yueqin on his back.

The three-minute singular scene is an important clue to Chang's aesthetic form of "detachment". Through Chang Chao-Tang's introduction, Chen Da performed in the western-style Scarecrow Restaurant which mainly featured western rock and roll, extemporizing and singing the story of Li Guang-Hui who had been invited to Northern Taiwan for a trip. There were no physical interactions between the two. But through Chang Chao-Tang's camera, we and Chen Liao-Quan in the black-and-white photograph on the wall gaze at and listen to Chen Da and Li Guang-Hui.

Apart from the tapes left behind by the folk song collection movement led by Hsu Tsang-Houei and Shih Wei-Liang in the 1960s and early 1970s, and the vinyl record *Chen Da and the Hengchun Style of Storytelling Singing* released by First Record in 1979, a living tradition like Chen Da did not fit into the Chinese modern folk song and campus folk song context of the 1970s. In the end, only the bland song *Yueqin* sung by Jeng Yi that now gives you the shivers, without conveying sentiments

or a sense of the times, remains.

In 1978, Cloud Gate Dance Theatre performed *Legacy*, which made extensive use of the suite *Thinking About Something* by Chen Da. As the work continued to tour over the years, Chen Da's voice and story were not completely forgotten. But apart from that, young people growing up in the 1980s and 1990s were ignorant about Chen Da. Hence, the so-called folk artist tradition became separated from pop music. It was not until the folk songs of Chen Ming-Chang and Chen Ming-Yu telling the stories of ordinary people in the 1980s, and the creations of Lin Sheng-Xiang and Qian Yong-Feng in the late 1990s that this tradition was carried on again.

To return to the films, Chang Chao-Tang's aesthetic form and Chen Da's life have a common sense of detachment that belonged to the times.

In the late 1960s, Chang Chao-Tang became attracted to western modernist thinking, photography, literature and drama. In 1968, he started writing and translating to introduce the western youth rebel culture such as hippies, rock and roll and protest songs. After working in an advertising company for a year, he joined the news department of China Television Company. Thirteen years of television work allowed him to travel through

籤，或如舒國治在其中一篇文章標題所流露，最終大多僅能以「遊藝」在臺北都會各角落，來展現現代西方流行文化對這輩人的衝擊與洗禮。

即便鄉土文學論戰如火如荼開戰，張照堂至始至終都沒直接涉入。關於現實主義，在與吳忠維的對談中他這麼回答：「當時我也沒有和這些帶起風潮的人物有特別的往來，但是對於所謂的『都會之外』的人跟地方我是有一種親密的情感。」這種親密感對張照堂而言，是一種鄉土的召喚，雖無關於當時的文學運動。他喜歡陳映真的短篇小說和黃春明的早期作品，特別是七等生的小說，因為「他雖然是有關鄉土，但描寫的手法和意識型態還是滿疏離、滿現代的。」（吳忠維，2000：139）

1975-77年「中國現代民歌」開始被建構並形成一股風潮，一方面改造美國民歌傳統，另方面以意識型態篩選臺灣歌謠傳統，活生生並與當下互動的在地歌謠，被固定在歷史過往的傳說與歌謠所取代（例如余光中與楊弦合作的《鄉愁四韻》）。「中國現代民歌」的潛在命題，因此是去除了美國民歌發展上

的聲響（例如與黑人音樂或樂團編制的結合），只保留了民歌的意象與姿態（包括彈奏民謠吉它的姿態），並與退出聯合國及臺美斷交等政權的正當性危機接軌。傳承自「中國」意識的民族聲響與政治保守的文化純粹派，中國現代民歌最終也須靠攏商業力量，而在流行文化場域中轉到「校園民歌」的旗幟下。

行走各地的張照堂，移動著他的城鄉差異感知，思索著現代人對於人性的思索與搖滾樂的人文精神。

1972年對比1977年的陳達，一貫的恆春民謠的聲軌，在即興的主題變化與不變的調性之間，難以跟僅以一種時間刻度丈量著當下的流行音樂共存。當人們的社會經驗與時間意識僅能把活生生的傳統固著，歷史遂成為鄉愁，一種回不去的渴望，不管是關於中國的，或是臺灣的文化。

張照堂說當時陳達在稻草人駐唱時非常受到年輕人的喜愛，但在這樣的空間裡，陳達的音樂只有慰藉都市人的感傷，而缺乏溫暖。某天張照堂帶陳達出去走走，在公館後方新店溪堤防

Taiwan to carry out film and sound experiments at the periphery of the establishment. Apart from his photography and documentary vocation, he wrote about western rock music in the *Music & Audiophile* magazine from 1973 to 1975. On his photography and film experiments during his college days, he said, "My works from that period were solely about my understanding of life, literature, art and trends of thought and my response to them. It was only after I left college and entered a new environment and the work place that I gradually changed my position and turned to other concerns in the social context."

At that time, modernism was politically relatively safe. Even though it stimulated young people's thinking and nurtured their aesthetic taste, they were unable to launch a scathing attack on Taiwan society through collective rebelliousness. Even though "the ideals are still lofty", they could only share their knowledge of modern western pop culture through "amateur arts" in different corners of Taipei. Despite the raging debate over nativist literature, Chang Chao-Tang never took part in it.

On the subject of modernism, Chang made the following remarks in his interview with Wu Chung-Wei: "I was not particularly close with those figures who started the trends. However, I felt a closeness to the people and places 'outside the metropolis'". For Chang, this closeness was the calling of the native soil, which had nothing to do with the literary movement. He liked the short stories of Chen Ying-Zhen and the early works of Wang Chun-Ming, and the novels of Chi Teng-Sheng in particular, because "even though he wrote about the native soil, his descriptive techniques and thinking are rather alienated and modern." (Wu Chung-Wei, 2000, p.139)

From 1975 to 1977, modern Chinese folk songs evolved and became a craze, partly by adapting the American folk song tradition. The Taiwanese song tradition went through a process of ideological selection, so that local songs from a living tradition were displaced by songs that hark back to a historical past (such as *Nostalgia Four Verses*, a collaboration between Yu Kuang-Chung and Yang Hsien). Modern Chinese folk songs borrowed from the gestures (including playing the folk guitar), but not the sound of American folk songs (such as the combination with black music or orchestra arrangement). This phenomenon coincided with the legitimacy crisis that arose as a result of Taiwan's withdrawal from the United Nations and the severance of diplomatic relations with the US. While inheriting the tradition of folk sounds with a "Chinese" consciousness and the ideology of the politically conservative purists, modern Chinese folk

拍下了那張背影靜照。

我們何以體會這種「感傷，卻沒有溫暖」的聲音與影像的交織呢？作為觀看者與聆聽者，或許我們也必須拉開自身移動的記憶，才能體會那歷史與文化脈絡的當下，張照堂與陳達，甚至是李光輝在時間序列的時刻點所交織的疏離與共感的矛盾：

> 陳達開始用他的月琴與歌聲吟唱開來
> 述說著生命的艱困與流亡
> 李光輝應該聽出那種滄桑罷
> 那可是他們彼此的歲月之歌啊……(引自「哆拉老師的又一天」部落格)

透過靜照與影像（它們不也是一張張移動的靜照嗎？）的編排，在《紀念‧陳達》影片裡，被陳達的吟唱聲響所牽引出的，不是「鄉愁」般的時代意識，而是一種可以提供跨時代感知的媒介。透過疏離感，我們重新整理並敘說經驗，帶著質疑貼近現實。

## 詭異：《王船祭典》與《再見‧洪通》

疏離感在張照堂的美學形式上，依題材也可能轉變成一種讓觀者暫時性地無所適從所產生的詭異。詭異是對感知惰性的一種挑逗。日常生活裡我們總是在時間消逝後開始察覺時間。但透過美學形式，創作者可以擷取、重組與形構一個新的時間序列。

《王船祭典》讓觀看者知覺的不是現實的再現，而是現實的拆解。張照堂把拍了兩天的臺南縣安定鄉的民間信仰祭典通通消音，配上1975年英國古典搖滾樂手Mike Oldfield專輯 *Ommadawn* 一整面長達十九分鐘的 *Ommadawn Part I* 一曲。1981年MTV時代來臨之前，除了音樂的宣傳影像，或演唱會實況錄影，音樂畫面總是隨聆聽者的想像狀態而浮動的。這個作品詭異之處在於張照堂拉掉了祭典中北管式的鼓吹、祭典上的誦詞、人聲鼎沸等交織的多重聲響，而讓 *Ommadawn Part I* 的節奏與漸進重複旋律，導引著被重新編排的祭典影像。這大概是臺灣第一支也是最長的MV了。《王船祭典》大膽地重構／挑戰了影像的聲響結構，用聲響把我們習以為常的民間慶典「陌

songs eventually had to side with commercial interests, and ended up under the umbrella name "campus folk songs" in popular culture.

With his awareness of the urban/rural dichotomy, the widely travelled Chang Chao-Tang pondered on how modern man perceived human nature and the humanistic spirit of rock and roll.

Whether it was Chen Da in 1972 or 1977, the same soundtrack of Hengchun folk songs with the varying or constant key of the improvised theme can hardly co-exist with pop music. When the living tradition cannot be passed down, history becomes a kind of nostalgia, a longing for something in the past, whether it is Chinese or Taiwanese culture.

According to Chang Chao-Tang, when Chen Da sang at the Scarecrow restaurant, he was very popular with the young audiences. However, in a space like that, his music could only ease the city dwellers' sadness, but it lacked warmth. One day, Chang took Chen Da out for a walk, and took the still photograph of his rear view at the Xindian River embankment behind Gongguan.

How do we understand the interweaving of images and sounds that are "sad but without warmth"? As viewers and listeners, maybe we should put our own memories aside in order to understand the contradictory sense of detachment and empathy created by Chang Chao-Tang, Chen Da and even Li Guang-Hui in that historical and cultural context:

> "With his yueqin and singing, Chen Da started to tell of the hardships of life and of exile. Li Guang-Hui must have understood the vicissitudes of life implied. It was a song about their own lives."
> (quoted from Chang Chao-Tang's blog)

Through the arrangement of still photography and film images (aren't they moving still photos as well?), what emerges from the singing of Chen Da is not a sense of "nostalgia", but a medium that can bridge the feelings of different times. Through the sense of detachment, we reorganize and recount the experiences, and approach reality with questions.

## Bizarreness:
## *The Boat-Burning Festival* and *Homage to Hung Tung*

In Chang Chao-Tang's aesthetic form, detachment can also become

生化」，祭典儀式眾聲喧嘩所建構的狂喜，如今也被置換。

　　張照堂的大膽，在於他不拘泥於中（臺）／西、鄉土／現代等二元對立的思維。但危險之處在於當影像中主體的再現被挪移，成為另一種加工的客體時，即便賦予他們新的影像與聲響的張力拉扯，此種詭異仍有可能被拒斥，甚至被控訴為對「神聖的褻瀆」。因此當時中視播出《王船祭典》時，遭祭典活動主事者抗議，不得已，張照堂重剪了一支影音「正常」的紀錄片，第二天再播一次。

　　如果說《王船祭典》的詭異源自祭典現場的聲響被消除，那麼《再見‧洪通》兩段配樂所產生的反差與詭異，讓最為接近紀錄片的樣貌終究是不安份的。

　　洪通，在1970年代臺北藝文界以「尋找鄉土」之名，在高級文化場域與藝術市場中進行藝術知識與權力較勁下，以「素人畫家」的身分被帶進場。此一吸納收編的過程在張照堂的攝影與配樂詮釋下，洪通宛如一隻疲憊的小鳥，或是一隻不適合駐足於

地表人群促擁與價格喧囂中的「鳥人」，孤獨且哀傷。

　　一開始的簡短配樂，是宇宙天地發出低沈的共鳴聲響，召喚著鳥人的到來。牠肉身化為洪通，反覆吟唱著四句聯，畫著天機般的字符──「天下國大山，名河森古文」。影片反覆響起低沈的共鳴樂句，洪通的創作如靜照般與其居家生活交相呈現。直到配樂轉調，強烈節奏帶出活潑音色，領著影像進入洪通「原始、神秘、奔放的豐富色采」的畫作中。簡約主義音樂基礎上所排序的音符，以不同音色與聲響的共鳴、迴聲，對比著的1976年美國新聞處洪通個展上人潮雜踏的畫面。洪通就這樣如同被觀賞者逛夜市的隨意與獵奇心所捕獲，巡迴各地。經過張照堂巧妙的編輯，將觀賞者外表穿著與凝視的眼神所透露的全民式瘋狂嫁接洪通畫面的特寫，宛如讓音樂敘說著鳥人落入地表的哀嚎聲。畫面進入1978年洪通畫作價格大跌後，與臺北記者們的閒話家常，談論他為何停止作畫。那段洪通嫂的訪談很有趣，覷腆的鄉下老婦，面對臺北來操著國語的記者，經由張照堂的翻譯，面帶無奈微笑的回應，道出「落難」鳥人的起落，也道出了「鄉土」的無言。

bizarreness based on the subject matter, leaving the viewers temporarily confused. Bizarreness is a challenge to our sluggish senses. In everyday life, we are only conscious of time after it has passed. But through the aesthetic form, the artist can extract and rearrange time to create a new chronology.

*The Boat-Burning Festival* is not a representation of reality, but the deconstruction of reality. After erasing the sound from the film he shot about a folk festival in Sucuo, Tainan County over two days, he scored it with a nineteen-minute song *Ommadawn, Part One* from the album *Ommadawn* by the British rock singer Mike Oldfield in 1975. Before the advent of the MTV era in 1981, apart from music advertising images or video recordings of live concerts, the images of music videos always flowed with listeners' imagination. The bizarre thing about this film is that Chang Chao-Tang erased the multiple sounds of beiguan music and the recitations during the ceremony, as well as the sounds of the crowds, and scored the edited images of the ceremony with the rhythm and recurring melody of *Ommadawn, Part One*. *The Boat-Burning Festival* boldly reconstructs/challenges the sound structures of the images, defamiliarizing the familiar folk festival with sound, and substituting the joy evoked by the noise of the crowds.

Chang Chao-Tang's boldness lies in breaking with the Chinese (Taiwanese)/western, nativist/modern dichotomy. However, the danger is that when the subject represented in the film becomes a processed object, this bizarreness may be rejected as a "blasphemy", even if a new tension between images and sounds is created. When *The Boat-Burning Festival* was aired on CTV, it drew protest from the organizers of the festival. As a result, Chang had to cut a documentary with "normal" images and sounds, which was aired on the next day.

If the bizarreness of *The Boat-Burning Festival* comes from the erasure of the live sounds of the festival, the strangeness of *Homage to Hung Tung* results from the contrast between the two scores. This strangeness is unsettling for this most documentary-like film.

Hung Tung was introduced as a "naïve painter" by the Taipei artistic circle in the 1970s as part of their "search for nativism", in a power struggle with the high art realm and the art market. Chang Chao-Tang interprets this process of incorporation with his photography and score, in which the painter appeared like a tired bird, or a lonely and sad "bird man" who doesn't belong to the world of crowds and price tags.

停格一會兒靜照後，接下來的三分二十秒，大概是這次張照堂影像展出作品中最具有張力的寧靜時刻。Leonard Cohen的 *Bird On the Wire* 猶如神來之筆，將鳥人的「孤傲與失落」化為Cohen歌聲中的聲音顆粒。

Like a bird on the wire
Like a drunk in the midnight choir
I have tried in my way to be free.

歌曲於是結束。大概沒有人能像張照堂一樣，把Cohen歌曲的特質作那麼簡潔有力的陳述了：

嗓音是誠摯卻無助的，詞曲時而浪漫（無藥可救的），時而苦澀（自我掙扎的），但經常充滿追索及挫敗之後的哀傷與絕望。（張照堂，1993：53）

「素人畫家」洪通的起與落不正是如此嗎？

《再見‧洪通》使用的第一段配樂，是當代匈牙利作曲家Tibor Szemzo的現代音樂。簡約主義與多重聲響音層堆疊而成的，帶有神秘、沈靜的人文聲音地景。對比的是Cohen這段張照堂從1960年代到1970年代萃取自搖滾樂關於悲、哀、苦、無助，或是疏離的基本主調。

從1980年代左右開始，進入不惑之年的張照堂，轉而聽ECM、當代音樂，和很多青年搖滾樂迷邁入中年所選擇的音樂方向相似，只是他的路途是更為靜謐與低調。

## 回到基調

客體化與主體能動之間的拉扯，是現代人的重要課題。這種拉扯經常呈現在工作規範與思想之間的張力。面對張力，我們或者馴服於工作規範，或是在思想上企圖逾越。根據張照堂自述，《剎那間容顏》是一部「有點像癲癇患者起病的診斷紀錄。」張照堂當時在電視臺值夜班，無聊之際遂將攝影機速度放慢至1/12，自己作為被拍攝的客體，玩耍一番。後製技術上

The short soundtrack in the beginning is a low sound like the harmony of the sounds of the universe, calling for the bird man, who reveals himself as Hung Tung, repeatedly chanting two couplets, and tracing Chinese characters that seem to suggest a divine secret. The low harmonic sounds are heard repeatedly, while the film switches between stills of Hung Tung's work and scenes from his home life. Later, the music changes, with strong rhythm and lively tunes introducing Hung Tung's paintings with their "primitive, mysterious and bold rich colours". The notes of the minimalist music and their harmony and echoes accompany shots of the crowds at Hung Tung's solo exhibition at the US Information Service in 1976. Discovered by viewers like visitors roaming through the night market, Hung Tung's works now toured to different places. Through skillful editing, Chang Chao-Tang cut between the mass frenzy suggested by the appearance and gaze of the viewers and close-ups of Hung Tung, using music to mimic the cry of the bird man upon landing on earth. This is followed by a conversation with Taipei reporters about why he stopped painting after the prices of his paintings plunged in 1978. The interview with Hung Tung's wife was quite interesting. Smiling helplessly, the shy old countrywoman responded to questions asked by reporters from Taipei in Mandarin translated by Chang Chao-Tang, and talked about the rise and fall of the bird man, testifying to the silence of "nativism".

After some still frames, the three minutes and twenty seconds that follow may be the one segment that contains the utmost tension among the Chang Chao-Tang's films screened on this occasion. Like a magic touch, the lyrics of Leonard Cohen's *Bird on the Wire* express the "pride and sense of alienation" of the bird man.

"Like a bird on the wire
Like a drunk in the midnight choir
I have tried in my way to be free."

The song ends. Perhaps no one but Chang Chao-Tang can turn the qualities of Cohen's song into such a terse and powerful statement:

"The voice is sincere and yet helpless. The lyrics are (incurably) romantic at times, and bitter (with self-struggle) at times, but always full of the sadness and despair after a quest and failure."
(Chang Chao-Tang, 1993, p.53)

Isn't that a description of the fame and oblivion of the "naïve painter" Hung Tung?

請沖片師將影片染上三種顏色、將影片的時序作多重倒置與疊印而成。希臘電子實驗音樂家Vangelis的《脈衝星》一曲，以合成器音色的脈衝為節奏架構出漸強式重複樂句，各種樂器的層疊與展開，在固定間隔的瞬間「抽慉」下，變奏的旋律搭配張照堂臉部的各式各樣晃動的瞬間重組的再現。曲子終止前那三次機械式的報時，宛如把恆星演化末期，自身引力內縮作用而成為密度極高的中子星所產生的幾毫秒週期輻射波，轉喻為人的抽慉狀態。雖然張照堂表示這支影片幾乎是他告別70年代的實驗作品，不過從配樂的選擇與特殊化的靜照式影片搭配上，我們依舊可以捕捉到他作品裡，對於個體是社會「內縮」的一貫比擬。《剎那間容顏》片中張照堂的容顏，若變成是各式各樣人們的容顏呢？若他們之間容顏更迭以不同的節奏安排著會是如何？若這些人的容顏以身影在日常作息的瞬間之間的舒緩拉長，又將會是如何呢？

從這個角度看，作品《人在路上》中的「旅程」意念，不正是《歲月風景》三段張照堂作品的回顧式的另一面嗎？《人在路上》中的生老病死，這個在平凡不過的課題，以慢速播放火車的前進與乘客們安詳、疲憊、期待等等容顏的敘說交織著。而ECM音樂的舒緩所構成的聽覺空間感，讓地景想像空間內化為人們的各種旅程聲軌。但張照堂就是怪，當我們在聽覺與視覺開始契合，進入一種寧靜、沈思狀態時，他總要干擾。街頭行吟盲人女歌手（江湖走唱）的江湖調，將上述的寧靜畫面與聲軌賦予一種我們雖然可能聽不懂，卻隱約可以意會的平民大眾口語文化反差（再一次，臺／西、民俗／現代等等的反差）上的結合。但片終走在鐵軌擰著包袱的男人與背著孩童工作走在山路的農婦，將我們帶回江湖調的聲響裡，最終停格於盲歌手容顏上。

感受著上述作品中影像與聲響契合上的疏離與詭異，終究我們可以暫時安定地進入《歲月風景》作品。《歲月風景》如電影連續定格方式，蒙太奇地鋪陳著三段近四十年來張照堂從現代人身上捕獲的束縛與自由所對立著的總總人生容顏。比起放大後的個別靜照作品，如同觀賞電影，《歲月風景》在時間長流裡光與影刻畫的反差，鑲嵌著ECM音樂的沈靜與低調跳動，使得它更能讓我們對生命的總總產生關連性的沈思空間。

---

The first score used in *Homage to Hung Tung* is modern music by contemporary Hungarian composer Tibor Szemzo. With a minimalist style and made up of layers of multiple sounds, it has mysterious and quiet humanistic sound qualities. In contrast is Cohen's song which typifies the sad, bitter, helpless or alienated mood of rock music from the 1960s to the 1970s.

From the 1980s, the middle-aged Chang Chao-Tang turned to ECM and contemporary music, just like many rock fans upon reaching middle age. However, his choice is even quieter and more low-key.

## Back to the Main Key

The contradiction between objectification and subjectification is an important issue for modern man. This contradiction is often manifested in the tension between work discipline and thinking. Faced with this tension, we either submit to the work discipline or seek to break it in our thinking. According to Chang Chao-Tang, *Face in Motion* is a bit like "the diagnosis of an epileptic". While on night shift at the television station, he slowed down the camera speed to 1/12 to shoot his own face for fun. During postproduction, he asked the printing operator to colour the film with three colours, and print the film by reversing the time sequences and using superimposition. The song *Pulstar* by Greek experimental electronic musician Vangelis uses a synthesizer pulse sequence to create repetitive musical phrases with increasing intensity. Various instruments overlap and "twitch" at regular intervals. The variations of the melody accompany the reconstruction of the motions of Chang's face. At the end of the song, a mechanized voice speaks three times, announcing the time of day. Like the terminal phase of a star's life when, compacted by the centripetal pressures of its own gravity, it transforms into an extremely dense neutron star from which waves of radiation emanate in cycles of milliseconds, this passage metonymically suggests the human condition when seized by a stroke. According to Chang Chao-Tang, this film spells an end to his experimental works in the 1970s. However, through his choice of score and the still-like film images, we can still grasp the consistent use of the individual as a metaphor for the "compression" of society in his works. What if Chang Chao-Tang's face in *Face in Motion* is replaced by the faces of all sorts of people? What if their faces alternate with different rhythms?

Seen from this angle, isn't the idea of the "journey" in *On the Road* just another variation of the retrospective element of the three works by Chang Chao-Tang in *Moments in Time*? *On the Road* deals with the banal

另外，張照堂的作品中，背影總是最讓人好奇！有時我想以孩童時的那種心境，老是想跑到電影螢幕的另一面探個究竟，試著從三維空間的想像探究著二維空間裡張照堂所設下的引誘。只是，我的好奇可能也將不會有固定答案。

註釋：

⋯⋯⋯⋯⋯⋯⋯⋯⋯⋯⋯⋯⋯⋯⋯⋯⋯⋯⋯⋯⋯⋯⋯⋯⋯⋯⋯⋯⋯⋯⋯⋯⋯⋯⋯⋯⋯⋯⋯⋯⋯⋯⋯

「歲月／照堂 1959-2013影像展」播放影片名單：
《剎那間容顏》　　　1976
《王船祭典》　　　　1979
《祭典之美／族之旅》1980
《紀念・陳達》　　　2000
《再見・洪通》　　　2000
《歲月風景》　　　　2010
《人在路上》　　　　2003

參考書目

⋯⋯⋯⋯⋯⋯⋯⋯⋯⋯⋯⋯⋯⋯⋯⋯⋯⋯⋯⋯⋯⋯⋯⋯⋯⋯⋯⋯⋯⋯⋯⋯⋯⋯⋯⋯⋯⋯⋯⋯⋯⋯⋯

吳忠維，2000，《揮手的姿勢：看・不見・張照堂》，臺北：時報文化出版社。

張照堂，1993，〈流放的詩人歌手：連那・寇恩（Leonard Cohen）〉，《誠品閱讀人文特刊》No.8，頁52-55。

張照堂，2012，〈從實驗到紀實：照堂的七〇年代自述〉，《藝術觀點》，No.51，頁52-59。

subject of birth, aging, sickness and death. The travelling train and the faces of passengers by turns peaceful, tired and expectant are shown in slow motion. The leisurely EMC music creates a sense of space, so that the imagination of the landscape is internalized as the sound of the journey of the people. However, just as our sight and hearing enter a quiet, contemplative state, Chang Chao-Tang insists on interrupting it. The singing of the blind female street singer provides a folk culture contrast (such as the contrast between Taiwanese and western, between folk and modern) to the quiet images and soundtrack mentioned above. At the end of the film, the image of the man carrying a bundle walking on the railway tracks and the peasant woman carrying a child walking on a mountain path takes us back to the sound of the street singer, ending in a freeze frame of the blind singer's face.

With the sense of detachment and bizarreness evoked by the matching of images and sounds in the above-mentioned works in mind, we can enjoy and reflect on *Moments in Time*. Like the continuous freeze frames of films, *Moments in Time* uses montage to showcase the opposition of constraints and freedom in modern man that Chang captured over the course of some forty years in three segments. As in a film, the contrasts of light and shadows, accompanied by the quiet ECM music with its low

pulsations, lead us to reflect on various related aspects of life.

Finally, the figures viewed from behind in Chang Chao-Tang's works also arouse our great curiosity. Sometimes, I wish I could peek behind the film screen, and explore the baits offered by Chang in two-dimensional space with three-dimensional imagination. However, my curiosity will probably not be satisfied.

NOTES:

⋯⋯⋯⋯⋯⋯⋯⋯⋯⋯⋯⋯⋯⋯⋯⋯⋯⋯⋯⋯⋯⋯⋯⋯⋯⋯⋯⋯⋯⋯⋯⋯⋯⋯⋯⋯⋯⋯⋯⋯⋯⋯⋯

List of films screened in "TIME: The Images of Chang Chao-Tang, 1959-2013 "
　*Face in Motion*, 1976
　*The Boat-Burning Festival*, 1979
　*The Beauty of Ritual / A People's Journey*, 1980
　*Homage to Chen Da*, 2000
　*Homage to Hung Tung*, 2000
　*Moments in Time*, 2010
　*On the Road*, 2003

BIBLIOGRAPHY

⋯⋯⋯⋯⋯⋯⋯⋯⋯⋯⋯⋯⋯⋯⋯⋯⋯⋯⋯⋯⋯⋯⋯⋯⋯⋯⋯⋯⋯⋯⋯⋯⋯⋯⋯⋯⋯⋯⋯⋯⋯⋯⋯

Wu Chung-Wei , *Seeing/Without/Chang Chao-Tang*, Taipei, 2000.
Chang Chao-Tang, "The exiled poet-singer Leonard Cohen", *Eslite Book Review*, No.8, 1993, p. 52-55.
Chang Chao-Tang, "From Experiment to Documentary - Chang Chao-Tang's Statement on the 1970s",
*Art Critique of Taiwan*, No.51, 2012, p. 52-59.

# 閱讀張照堂所編著攝影集的些許思考

■ 沈昭良
Shen Chao-Liang

攝影工作者
Photographer

## Reflections On Photo Anthologies Edited by Chang Chao-Tang

　　在眾多的視覺載體與展演形式中，攝影集不僅可結合編輯與設計實務，遂行單一作者在特定議題上的完整意志與視覺展現，編輯／策展人更可藉此突顯其史觀脈絡與美學策略，加上可長期保存、不受展演時空限制、閱覽便捷、貼近原作的印刷質量及藉由紙張所延伸的精神連結等特性，幾乎已是全球專業攝影創作者、編輯者、策展人，在不同階段的策劃與創作路程中，必經的專業歷練。

　　隨著歐美出版業界，陸續推出針對拉丁美洲、瑞士、日本以及中國大陸等地區與國家的攝影集史彙編，未來，植基於各方攝影集史梳理，所牽動的教育、學術、評介、創作、出版、展演與收藏等等的效應，勢必帶動國內對於攝影藝術更為周延與全面的關注，同時有效協助與提升攝影，逐漸成為臺灣主流藝術展演中的獨立藝術形式。

　　相較於亞洲其他國家的攝影集，近年來西方藝術及出版業界，對於日本攝影家拍製的攝影集，特別是1960-1970年代間的高質量攝影出版品，所投射的關注目光，引發的展演及再版市

Photography anthologies, collections and monographs occupy a special place in an art world comprising a variety of visual art forms, exhibition formats and performance styles. Photography books combine the goals of both designers and editors while enabling individual artists to express ideas in a visual format. Books give editors and curators an opportunity to define historical and aesthetic contexts, and then preserve their vision in a format not subject to the time and space limitations of exhibitions. Furthermore, books can be held, browsed, and high-quality prints can be inspected more conveniently such that spiritual connections with the work can be deepened and extended. Familiar to many, photography books have been a part of every photographer's, editor's and curator's professional experience for some time.

Books published in Europe and North America have continued to promote the national photographic histories of Latin American countries, Switzerland, Japan and China. In the future, the effect various history-oriented photography books will have on domestic education, criticism, art, publishing, exhibition, performance and art collection fields is bound to focus more attention on photography, thus lifting it to the status of a mainstream art form in Taiwan.

場效應，延伸的史料研究及論述等等，一直是處在熱絡且持續加溫的進行式。而同樣位處亞洲，臺灣與日本相隔距離不過三個多小時航程，面對這般的熱烈景況，不免好奇其中的原由為何？

除了日本國內植基於專業的科技研發、完整的攝影教育、穩實的研究論述、蓬勃的出版事業等等面向的長期積累精進，尚包括當時具備高技術印刷職能的專業人士，所提供的印務支援，以及早期日本社會普遍欠缺如同歐美先進國家，擁有完善成熟的美術館或藝廊空間，得以提供專業攝影藝術家展演的場地與機會。

為此，這批已然對日本近代攝影史產生極為重要影響的攝影家們，轉由攝影集這類出版型式的媒介載體，形成另一種結合影像暨文字書寫、表述、議論及展演的空間與實體。而類似高質量攝影集的大量付梓，不僅為當時豐盈飽滿的創作能量帶來循環與出口，奠定日後攝影集製作的穩定基礎，締造日本攝影史發展過程中的重要里程碑，更成為撼動西方世界影像論述與研究的重要文件。

近年來隨著上述的發展趨勢，加上國內出版業界對於轉譯國外相關攝影書籍的熱潮，臺灣內部也逐漸形成對於國內攝影集史料蒐集與研究的關注，國內雖在總量上遠不及日本、韓國等亞洲鄰近具備完整攝影教育的國家，但也在相對軟硬體資源欠缺的先天條件下，透過公部門、民間出版社及獨立出版等路迤，發展出聚焦於具體或抽象獨立議題，個人創作或群展合輯，針對特定族群、地域與事件等不同類型的影像彙編。

而曾經歷攝影記者、劇情片攝影師、紀錄片導演、電視臺監製、影展籌劃、圖書主編、策展人、大學教授、攝影家等專業工作，同時於報章雜誌與網路平臺，持續進行生活及影像書寫的張照堂，即是極少數國內曾大量參與相關攝影集編製的主事者。所主編或參與編纂攝影集／書包括：《生活筆記》（1977／78／79／80），《影像的追尋：臺灣攝影家寫實風貌》（上、下）（1988），《臺灣攝影家群象》叢書（1）：鄧南光、鄭桑溪、張照堂、王信、侯聰慧、劉振祥等六冊（1989~），《看見與告別：臺灣攝影家九人意象》（1991），《看見淡水河》、《雲門・快門20》（1993），《臺灣攝影家群象》叢書（2）：張才、李鳴鵰、林權助、梁正居、

In recent years, the western art and publishing worlds have set their sights on Japanese photography monographs — especially the high-quality publications of the 1960s and 70s — more so than photography books from other Asian countries. This focus has influenced exhibitions and performances, resulted in subsequent printings and extended research into historical data, theory and other aspects of Japanese photography. As Taiwan and Japan are both situated in Asia and less than three hours apart by plane, one cannot help but be curious about this disproportionate enthusiasm for Japan.

In the 1960s and 70s, professional photography in Japan was supported by firmly established technology research, comprehensive photography education, a stable theoretical framework, flourishing publishing industry and high-tech printing capabilities. Nonetheless, photographers had little opportunity to exhibit work, as Japan at this point still lacked the mature infrastructure of art museums and galleries seen in the West.

Photographers important enough to have a lasting influence on Japanese photography turned to another means of integrating image, text, commentary and exhibition — namely books. A great number of high-quality photography anthologies were printed, the publication of which not only led to the circulation of this period's robust creativity, established a foundation for future publications, and was a significant milestone in the development of Japanese photography, but also later proved to be a groundbreaking subject of research that contributed to the theory of images in the West.

Following these developments, Taiwanese publishing houses translated an increasing number of foreign photography books for the local market, which prompted research into Taiwan's own history of photography. Although activity has not reached that of other Asian countries with well established photography education programs such as Japan and Korea, image compilation and publishing still continues to advance through public, corporate and independent means. The field lacks both technological resources and conceptual sophistication, but still a rich variety of subject matter — from documentary photography to abstraction, from monographs to books presenting the work of several photographers curated by editors, to volumes organized around certain peoples, places and events — has been presented over the years.

Chang Chao-Tang is an experienced photojournalists, film industry

高重黎、吳忠維、周慶輝等七冊(1996)，《看見原鄉人：臺灣客家光影紀事》、《女人‧臺北》(1997)，《老‧臺北‧人》、《認真的臺北人》(1998-99)，《家園重見：走過921影像報告》、《風中舞影》(2000-01)，《鄉愁‧記憶：鄧南光》(2002)，《狗眼人生：葉清芳創作回顧》(2006)，《張照堂》(韓文版)(2008)，《歲月‧風景 1959-2005》、《歲月印樣 1959-1961》(2010)，《快門‧開演／Ten Eyes on Stage》(2011)，《凝視‧對望：福爾摩莎之眼》、《臺灣臉書：用心生活》(2012)等等。包括個人的《STAGE》(2010)也在其建議修正下，得以將大量且類型的當代式影像，醞釀鋪陳，同時融入人文、在地與時間感。

張照堂對於攝影集編輯的喜好，主要跟他早年從事新聞工作，經常四處採訪旅行的過程中，習慣性在各地的美術館、書店尋找筆記書有關。1977年，開始以名為《生活筆記》的筆記書，展開他的編輯旅程。鮮紅的彩繪圖像封面，筆記書裡開宗明義寫著「學習每天用短短幾十個字，將生活上的追憶和感受寫出來，是這本筆記最終的目的。」，內容除廣泛採用繪圖、歷史人物、他人和自身所攝圖像，也在每一個跨頁的上方編輯了一些字句，包括：「無論你怎麼去餵狼，狼終向樹林望著。」，「一張像片，只有在它不再是一張像片，而成為一種精神時，才有資格被掛在牆上。」，「我想我已經懷孕了。嗯。」等等深省信念或生活囈語。1977-1980年間的三本筆記書，雖延續字句或短文的搭配，視覺內容則改以攝影作品為主，除了張照堂自身所攝，也收錄了包括梁正居、阮義忠、雷驤、黃永松及關曉榮等人當時的作品。

1988年以後，張照堂則開始正式參與並主導國內大量攝影史料的編纂，同時逐步發展出前述幾類概括性歸納的影像編輯工作。其中《影像的追尋：臺灣攝影家寫實風貌》(上、下)、《臺灣攝影家群象》叢書(1、2)和《鄉愁‧記憶：鄧南光》，乃針對個別攝影家所進行暨漫長且珍貴的訪談整理。《看見淡水河》、《看見原鄉人：臺灣客家光影紀事》、《女人‧臺北》、《老‧臺北‧人》、《認真的臺北人》、《家園重見：走過921影像報告》為針對特定族群、地域、與事件的影像彙編。《看見與告別：臺灣攝影家九人意象》、《狗眼人生：葉清芳創作回顧》、《凝視‧對望：福爾摩莎之眼》、《張照堂》(韓文版)、《歲月‧風景 1959-2005》、《歲月印樣 1959-1961》則屬個

camera operator, documentary film director, television producer, film festival organizer, editor, curator, college professor, photographer, and continues to write about his life and photography for newspapers, magazines and websites. As a rare individual who has served as senior editor for many photography books or participated in their production, Chang's projects include *Book of Days*, in four volumes (1977, 78, 79, and 80); *In Search of Past: Taiwan Realism Photography 40s – 60s*, volumes 1 and 2 (1988); *Aspect & Vision: Taiwan Photographers (1)*, in six volumes: *Deng Nan-Guang, Cheng Shang-Hsi, Chang Chao-Tang, Wang Hsin, Hou Tsung-Hui, Liu Chen-Shiang* (from 1989); *Seeing: Perspectives of Nine Taiwanese Photographers* (1991); *50 Years of Tamsui River Views; 20 Years of the Cloud Gate Dance Group* (1993); *Aspect & Vision: Taiwan Photographers* (2), in seven volumes: *Chang Tsai, Lee Ming-Tiao, Lin Chuan-Chu, Liang Chen-Chu, Kao Chung-Li, Wu Chung-Wei, Chou Ching-Hui* (all 1996); *Image of Hakka; Women in Taipei* (1997); *Taipei : Past; Working Hard in Taipei* (1998-99); *The Homeland: After the 921 Earthquake; Dancing in the Wind* (2000-01); *Nostalgia & Memory: Deng Nan-Guang* (2002); *Life in a Dog's Eye: Ye Chienfan* (2006); *Chang Chao-Tang* (Korean Edition, 2008); *Moments in Time 1959-2005; The Invisible Contact* 1959-1961 (2010); *Ten Eyes on Stage* (2011); *To Gaze and to Look Beyond: Eyes of Formosa* (catalog); and *Faces of Taiwan,*

*A Mindful Living: Regional Culture Photo Collection* (2012). He also advised me when I was writing *Stage* (2010), an experience which made possible the incorporation of diverse contemporary imagery, ideas from the humanities and distinct senses of time and place in the book.

Chang's love of serving as editor for photography books comes from his early days working in the news industry, where he traveled extensively for the purpose of conducting interviews, and at the same time went looking for notebooks at museums and bookstores. In 1977 he started a notebook later published under the title *Book of Days*, which was the first step in his journey as an editor. A scarlet painting graced its cover, and a statement making clear Chang's intentions, "The goal of keeping this notebook is to write a few lines every day that record my recollections and perceptions of life," was written inside. In addition to extensive use of drawings and pictures of historical figures or photographs taken by himself and others, Chang also editorialized across the upper margins of each page. Reflecting deep convictions or sometimes just rambling, marginalia included statements such as "Regardless of how you raise a wolf, it will always long for the forest" or "Only when a photograph is no longer a photograph , but becomes a spirit is it worthy of being hung on a wall" and "I think I'm pregnant, ugh..." Image content in the three

人創作與群展合輯。

其中《張照堂》（韓文版）為韓國Youl Hwa Dang出版社所發行經典攝影家書系中的一集，屬一小型平裝攝影集，惟印刷品質良好。內容自1962起至2005年止，雖大部採編年式編輯，影像則捨去描寫客觀具體現實的作品，改以斷頭的背影、男子的裸身與凝視、依傍在紗窗旁的老婦、斑駁的女孩肖像、滿置南瓜的室內空景、巨型的豬隻身影、陽明山上的女優與馬匹、地上成列的塑像、七股鹽山等，趨近主觀內在寫實的作品，加上晚近於澎湖、甘肅、東京、京都等地所攝新作。使得攝影集的整體風格，不單只是遊移在思想與情感的夾縫間，同時聚焦於劇場、文學及哲學感知的敘情式描寫，更顯張照堂在所分處的時代氛圍中，獨特的開創與追尋。

《歲月‧風景 1959-2005》則為張照堂於國立中央大學藝文中心舉行個展時，所推出的攝影集，也是他首次在國內推出較大開本的攝影集，推出之後短短數月即被搶購一空。內容除了增加1959至1961年間的作品，圖像也因開本放大後呈現不同

的視覺張力，全篇雖採編年式，作品挑選則強化內容與氛圍的對應與轉折，直式開本中刻意的橫幅作品上下並置，一方面維持橫幅作品在直式開本中的較大尺幅，同時增加觀者在翻閱攝影集過程中的觀覽節奏與形式變化，也自然反射其性格中不拘泥於傳統的高度與視野。

《凝視‧對望：福爾摩莎之眼》為張照堂針對二十八位創作者所提交大量作品，經層層篩選後，以「凝視」和「對望」為子題所形成的創作合輯。由於二十八位創作者風格內容各異，如何在殊異的視覺語言與書寫形式中，有效歸納不同的內容與圖像，在理性與感性間，尋找並實踐適切的對應與邏輯，便成為此書編輯過程中的難度與可供參考之處。《狗眼人生：葉清芳創作回顧》則是另一集結已故攝影家葉清芳攝影和繪畫作品的彙編。至於針對特定族群、地域與事件的《看見原鄉人：臺灣客家光影紀事》、《女人‧臺北》、《老‧臺北‧人》及《認真的臺北人》等攝影集，則普遍定調在時序脈絡下的場域、內容、氛圍與視覺圖像的組構。

notebooks he filled from 1977 to 1980, although still accompanied by extended writings or short essays, shifted from drawing to mostly photography, and comprised contemporary works by himself as well as Liang Chen-Chu, Juan I-Jong, Lei Hsiang, Huang Yong-Song, Guan Xiao-Rong and others.

After 1988 Chang started routinely compiling a great deal of data about Taiwanese photography, participating in or leading projects and gradually developing the work of cataloging, outlining and editorializing images. Books resulting from this work that included in-depth interviews conducted and edited by Chang were: *In Search of Past: Taiwan Realism Photography 40s – 60s*, volumes 1 and 2 (1988); books one and two of the series *Aspect & Vision: Taiwan Photographers; and Nostalgia & Memory: Deng Nan-Guang*. Photography compilations organized around the themes peoples, places and events include: *50 Years of Tamsui River Views; Image of Hakka; Women in Taipei; Taipei: Past; Working Hard in Taipei;* and *The Homeland: After the 921 Earthquake*. And other books featuring individual or groups of photographers were: *Seeing: Perspectives of Nine Taiwanese Photographers; Life in a Dog's Eyes: Ye Chienfan; To Gaze and to Look Beyond: Eyes of Formosa; Chang Chao-Tang* (Korean edition); *Moments in Time: The Photography of Chang Chao-Tang 1959-2005; and The Invisible Contact 1959-1961*.

A small paperback of very high quality, *Chang Chao-Tang* was one of a series of monographs about notable photographers published by Youl Hwa Dang Publishing House in Korea, and covers his activity from 1962 to 2005. The images are mostly arranged chronologically and not intended to document reality in an objective fashion, but rather tend toward subjective, inner realism. Works include a torso of a male nude with his back to the camera and head removed from the photo, an old woman leaning against a window screen and gazing into the distance, a sun-splashed portrait of a young girl, an interior space filled with pumpkins, a silhouette of a huge pig, an actress with a horse on Yangmingshan, statues arranged on the ground, and a famous mountain of salt in Chigu District, Taiwan, as well as more recent photographs taken in the Penghu Islands, Gansu Province, Tokyo and Kyoto. The book is comprehensive in its presentation of styles, not only wandering over the narrow space of thoughts and emotions in the work, but also focusing on references to theater and Chang's perceptual narrative style reminiscent of both literature and philosophy. These editorial choices highlight Chang's explorations and unique innovations in the different temporal milieus delineated by the book's chronology.

由於近年來，攝影集作為攝影創作者，雖小但不失細緻與全面的展演實體，不論在題材、開本、設計、材質、印刷、裝訂及行銷等思維上，皆已逐步邁入必要且成熟的階段。相較於其他藝術類型，普遍將統稱為畫冊的出版品，定位在作品圖集或藝術商品目錄的層次。而如同電影的類型理論或作者論，將靜態攝影作品以攝影集形式，進行作者研究與題材類比，不僅足供理解攝影者的藝術成長過程與發展脈絡；長期涉入具特定結構、內容或議題的專題攝影集閱讀，更能內外的、前後的、深淺的、疏密的，引發關於主題、觀點、圖像、視覺、結構、編輯、印製等等的關鍵性辯證。而類似的辯證越是緊密，越是深刻，越是頻繁，越是能提供攝影藝術家，在蒼茫的創作旅程中，邁出穩健的步履。個人甚至以為，對於有志於從事影像藝術創作，並積極開展學習者，實應盡早培養長期並大量閱讀專題攝影集的習慣(意指特定議題、形式、內容或語彙等之攝影集)。如此，不僅將有助於釐清影像產製或視覺表述過程中的矛盾疑慮，同時更可能因上項深刻閱讀的長期積累，深化視覺內容的價值與意義。

針對閱讀相關攝影集後的梳理，標準化為可資援用的工具雖然有些困難。就如同憂愁的、遊蕩的、茫然的、劇場的、放逐的、神祕的……，等等描述張照堂靜態攝影作品的形容歸納，實則若隱若現的在其所編著的攝影集裡抽象地流動，但我仍試著透過提問，將張照堂常年編輯攝影集的心得，轉化為文字，期能成為對從事攝影集編輯實務有興趣的世代，相對清楚且具體的參考方向。得到的關鍵字是：「調性」、「故事性」、「時間性」、「轉折」、「符號」、「空間地域的連貫性」、「比例」、「留白」。要如何開始？「先把好的照片挑出來，再說吧！」。至於要如何訓練自己？張照堂沉思了一下，他是這麼說的，「多看電影、多看攝影集」。

*Moments in Time: The Photography of Chang Chao-Tang 1959-2005* was published in conjunction with Chang's solo exhibition at the National Central University Art Center, and was notable for being his first large-format photography book published in Taiwan. A few short months after publication, it completely sold out. The book presents never-before published works from 1959 to 1961, and its large format allowed for a different kind of visual tension in the images. The presentation style is chronological, and image selection and their juxtaposition on pages taller than wide emphasize corresponding or contrasting subject matter and moods. To allow for the printing of images suggesting a horizontal scroll format, they were arranged one above another, which not only creates rhythm and variation, but naturally reflects Chang's innovative, non-traditional vision of photography.

*To Gaze and to Look Beyond: Eyes of Formosa* is a large compilation of photography by twenty-eight artists carefully selected and organized under the sub themes of "Gaze" and "Look Beyond" by Chang. An important feature of the book is its successful editing and arrangement of the ranging style and content of so many artists. The unique visual language of each was effectively summarized under different categories by finding correspondences and logic through reason and perception. The monograph *Life in a Dog's Eyes: Ye Chienfan* is a collection of photography and paintings of the late artist Ye Chien-Fan. Compilations presenting specific peoples, places and events, and organized chronologically, by place, content, mood and pictorial qualities include: *Image of Hakka; Women in Taipei; Taipei: Past;* and *Working Hard in Taipei.*

While presenting detailed and comprehensive "exhibitions" in the space the size of a book, the publish industry in Taiwan has matured in terms of subject matter, book dimensions, design, materials, printing technology, binding and marketing in recent years. Compared with other art forms, the publishing of picture collections is generally defined as a commercial art and put in the same category with portfolios or catalogs. Yet if we can use photographs and their organization into collections to advance research on artists and thematic comparisons as genre and auteur theories has done, this will help us to understand the artistic development of photographers and the contexts in which they have worked. And if we can continue to study photography books that contain specific structures, content and themes, then we can also initiate key dialectics of inner and outer, before and after, deep and shallow, and loose and tight in areas such as theme, viewpoint, pictorialism, vision,

composition, editing and printing. These dialectics get deeper, more intense, and more frequent as our ability to provide photographers with well-made roads on which to embark on their journeys of boundless creativity increases. I even believe those with the will to engage in creative image production, those energetic, open-minded young artists need to develop early on the habit studying many photography books for long periods of time (I am referring to photo collections covering specific issues, form, content, or vocabulary). Long-term, in-depth reading not only helps them dispel doubts about the processes of visual expression and image production, but also deepens the significance of visual content in their minds.

Organizing and standardizing what one reads in photography books for the purpose of creating worthy citations is difficult work. For example, words such as melancholy, aimless, bewildered, theatrical, exiled and mysterious that I use to describe Chang's still photography actually intermittently appear in the abstract flows of the photography books he has edited. I still try, though, to write about what I learn from the books Chang has edited over the years, and expect that what I write will be a clear and specific reference useful to those who are interested in editing photography books. Some key terms used in photography criticism are: tonality, narration, temporality, transition, symbol, spatial coherence, proportion and negative space. How does one start? Chang Chao-Tang says, "First choose a photograph, and then you'll see! As for training oneself, after thinking for a bit, he answered, "See more films and look at more photography books."

圖版
PLATES

# Images
of Youth

1959-1969

少年心影

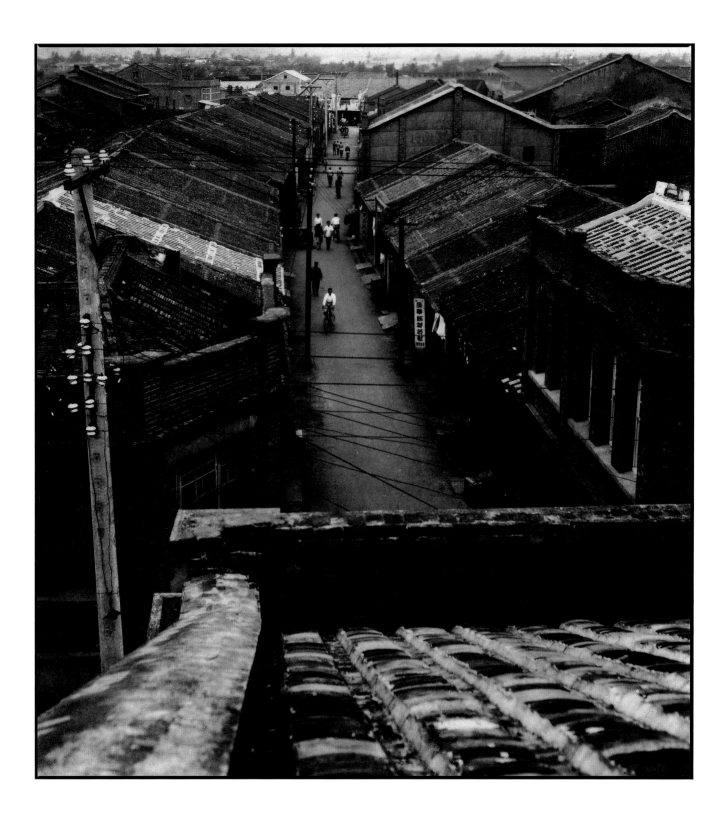

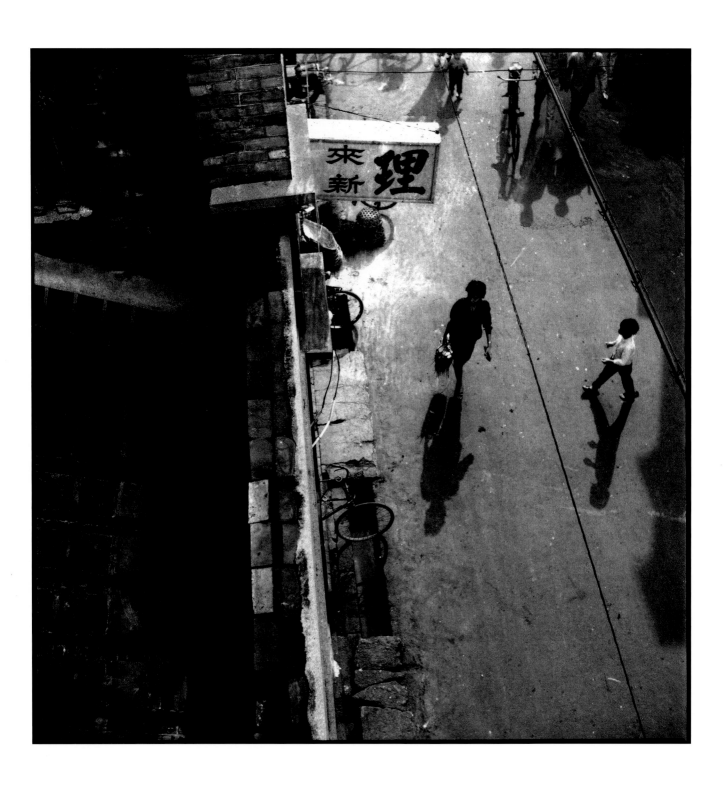

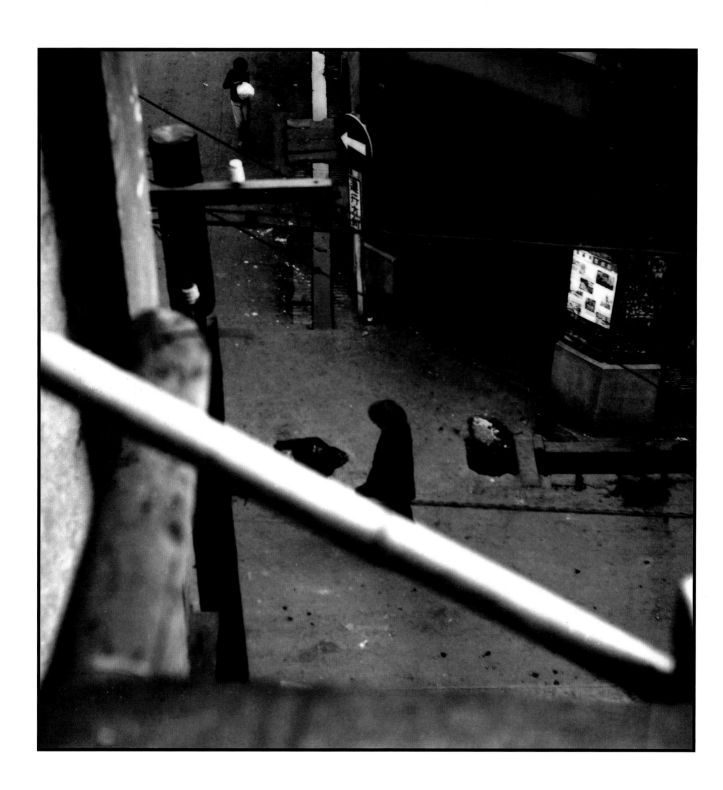

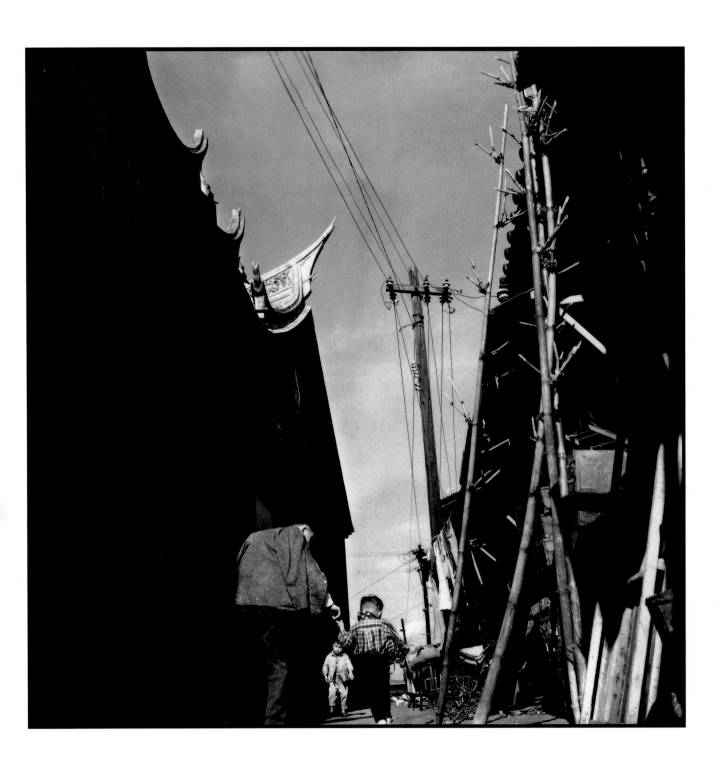

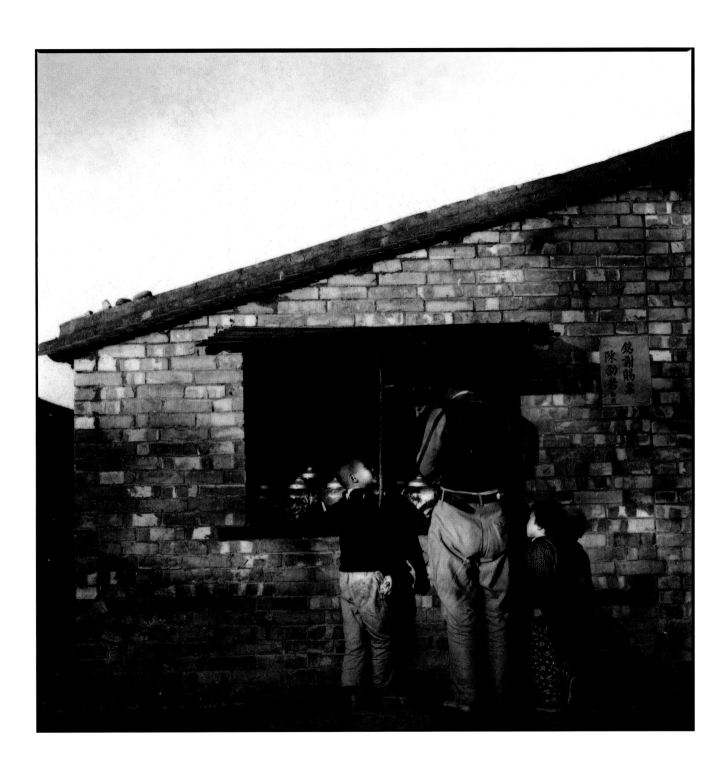

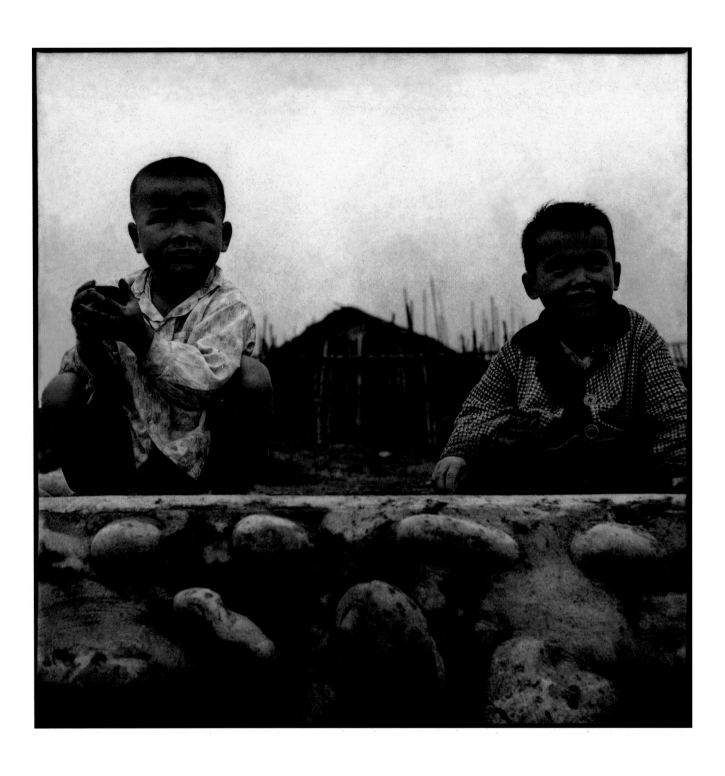

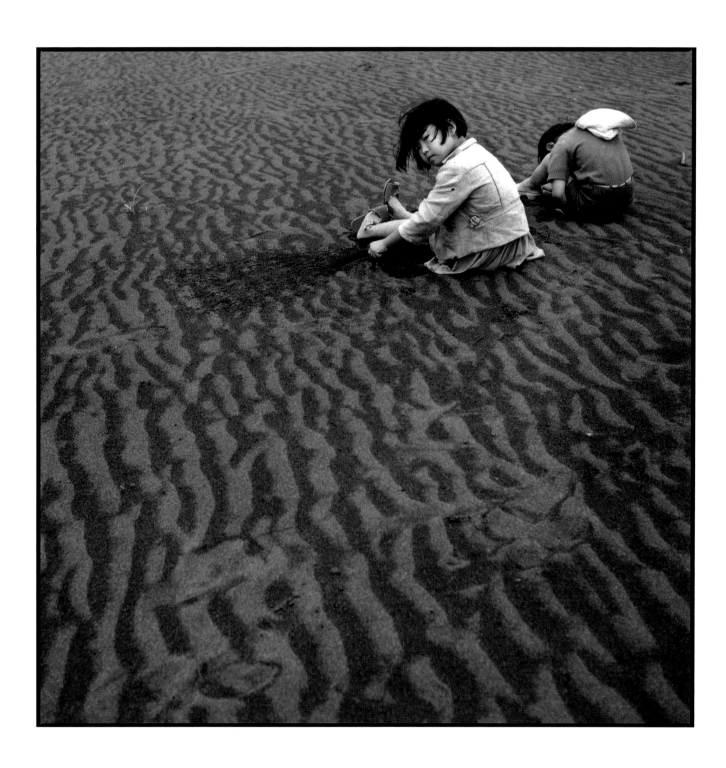

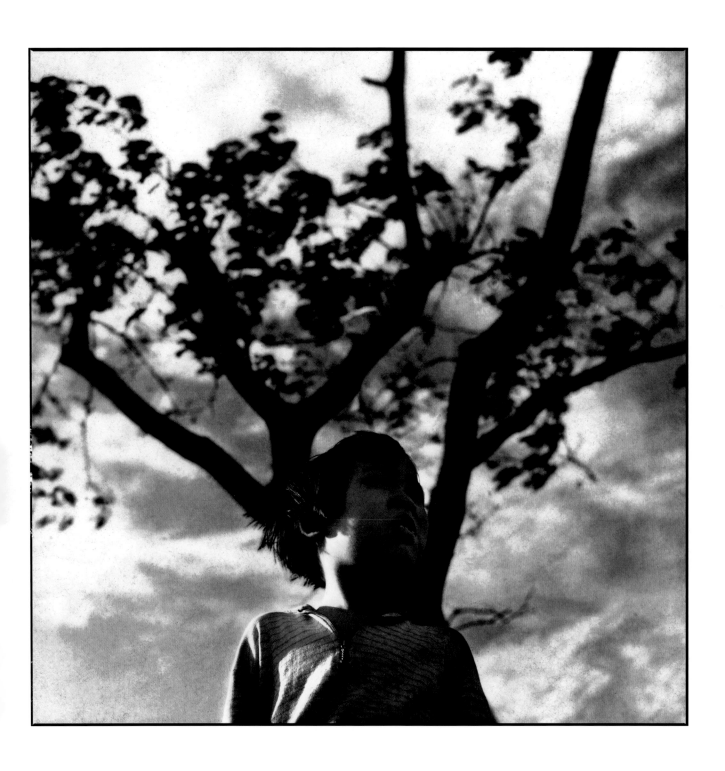

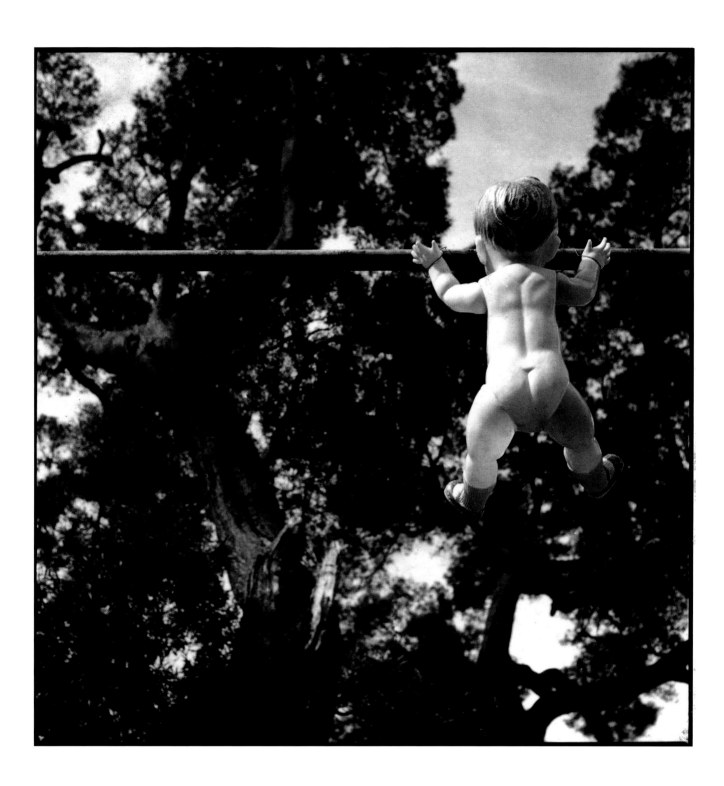

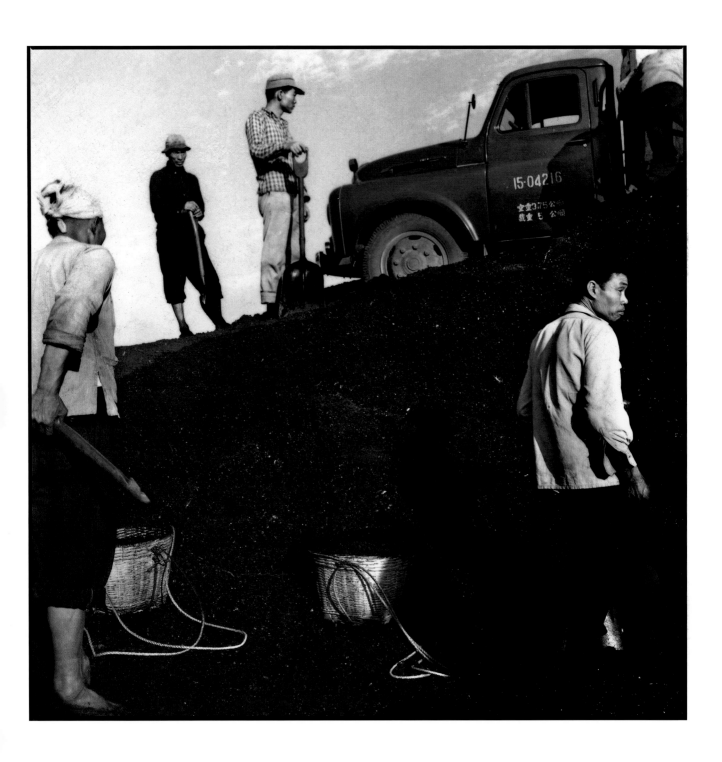

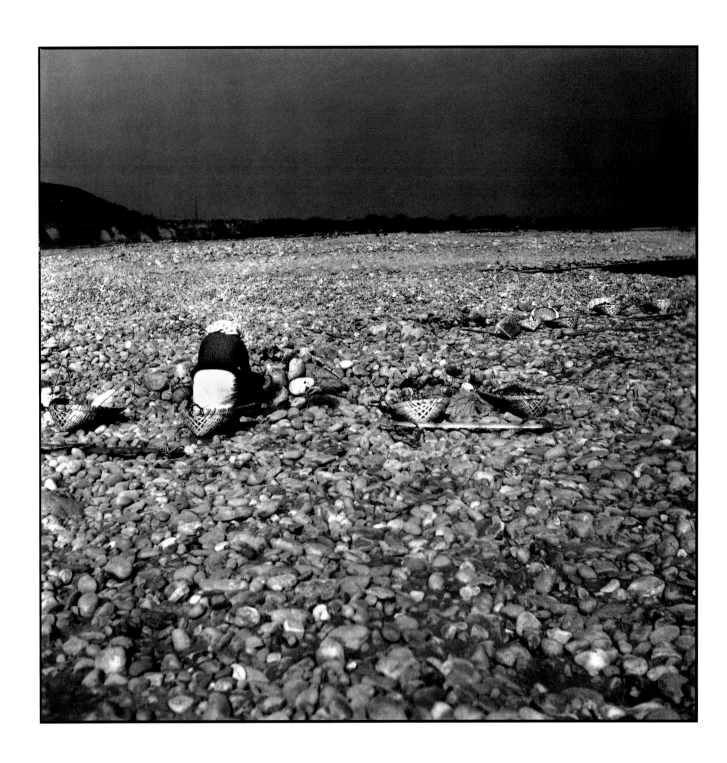

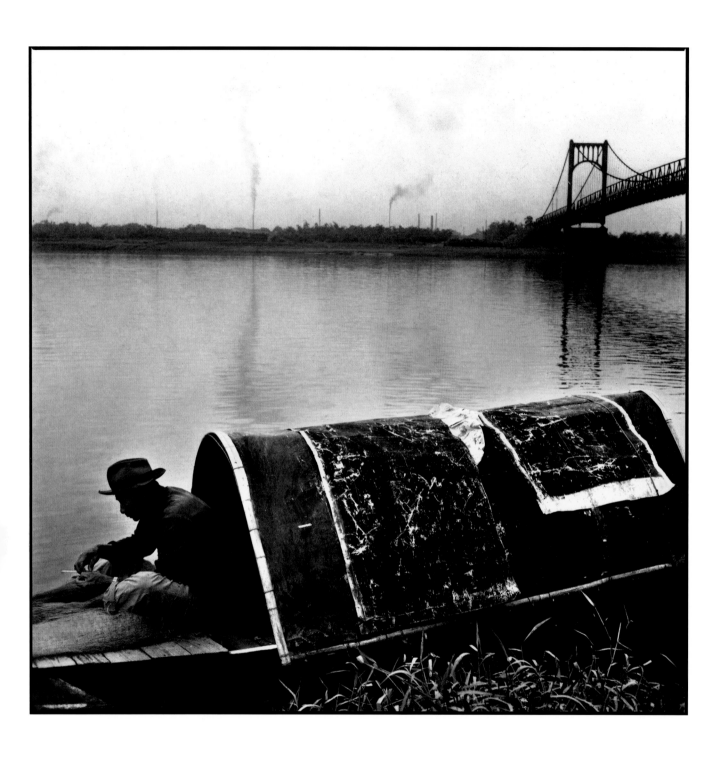

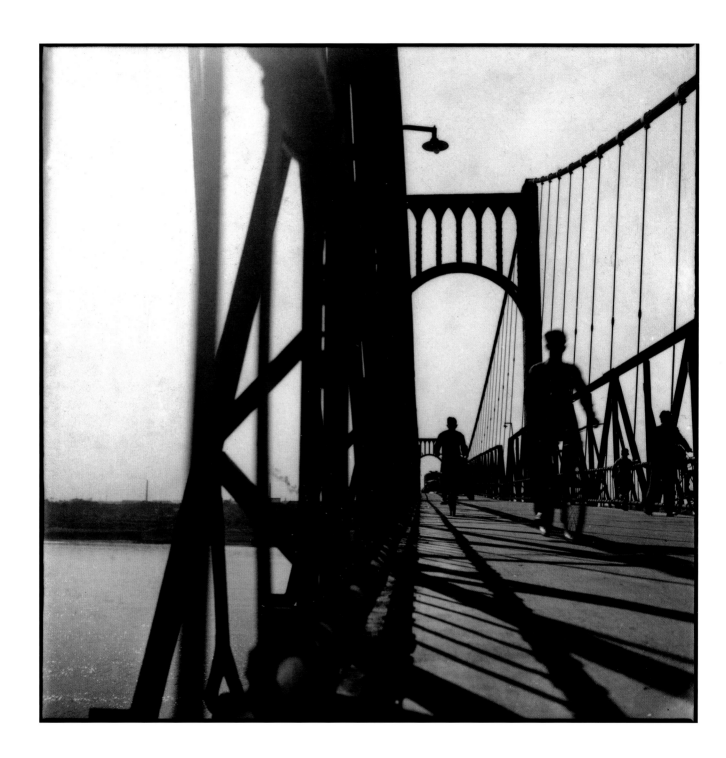

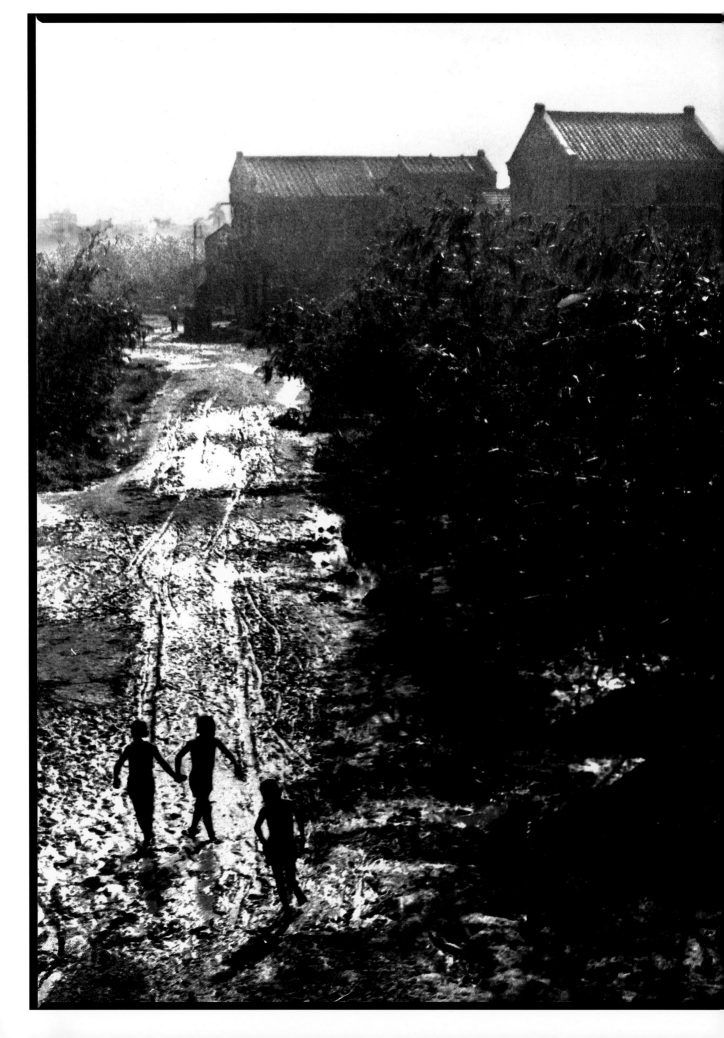

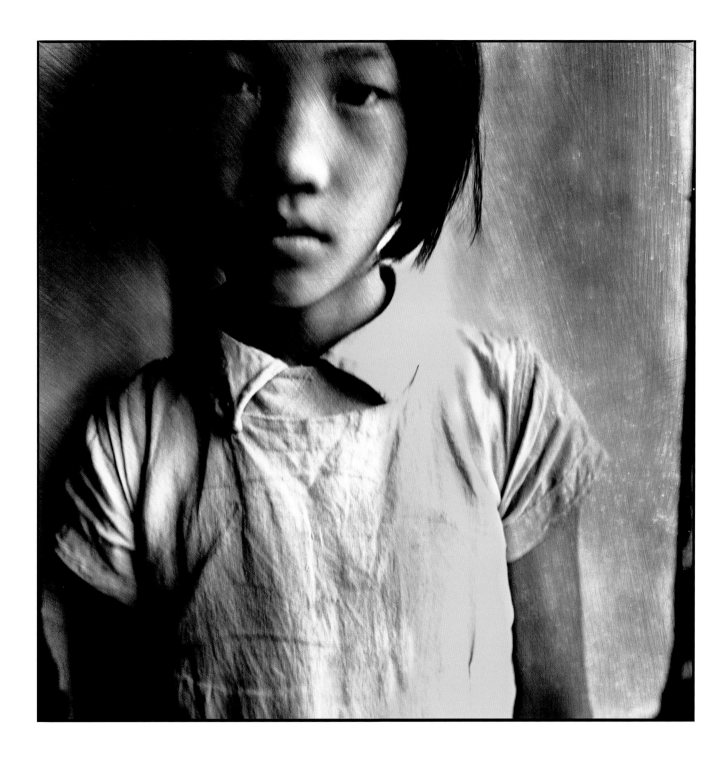

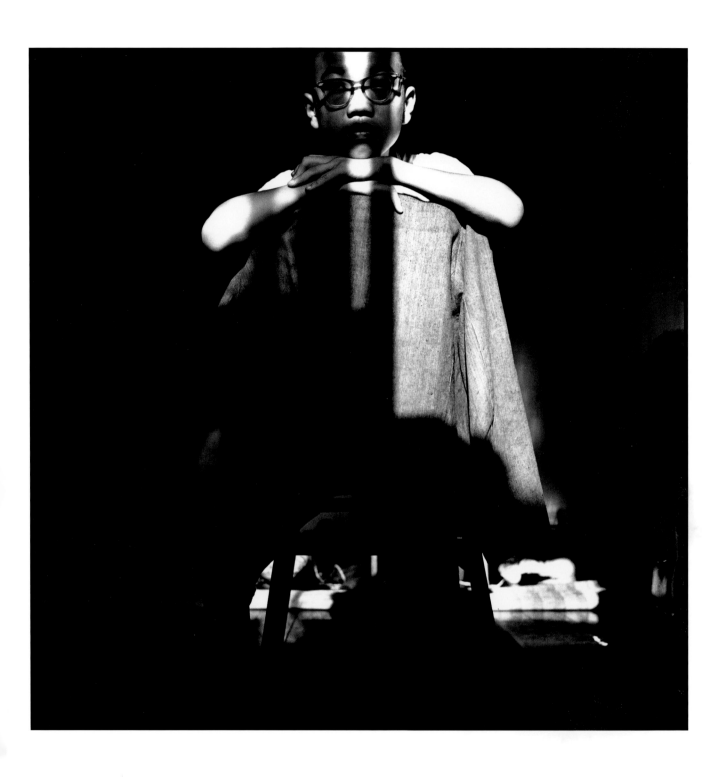

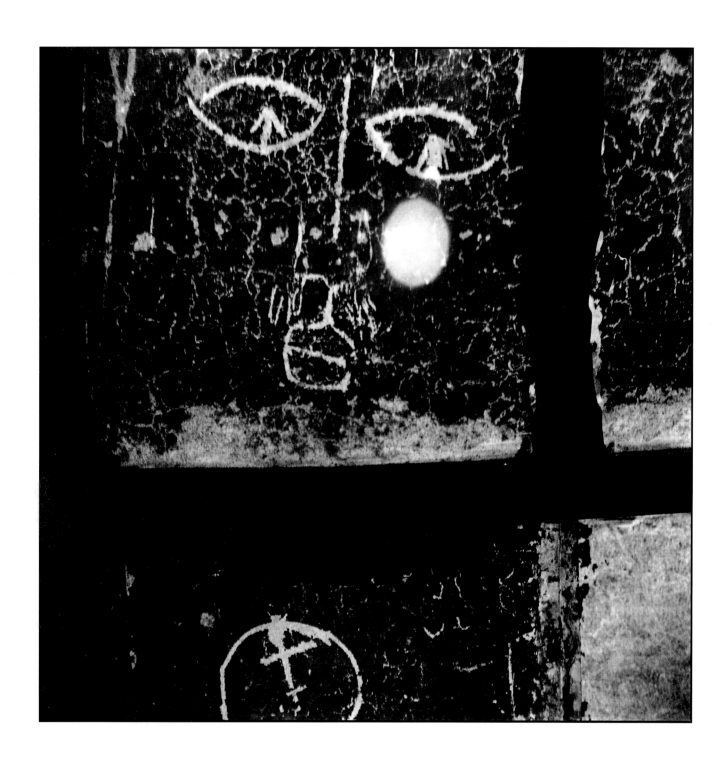

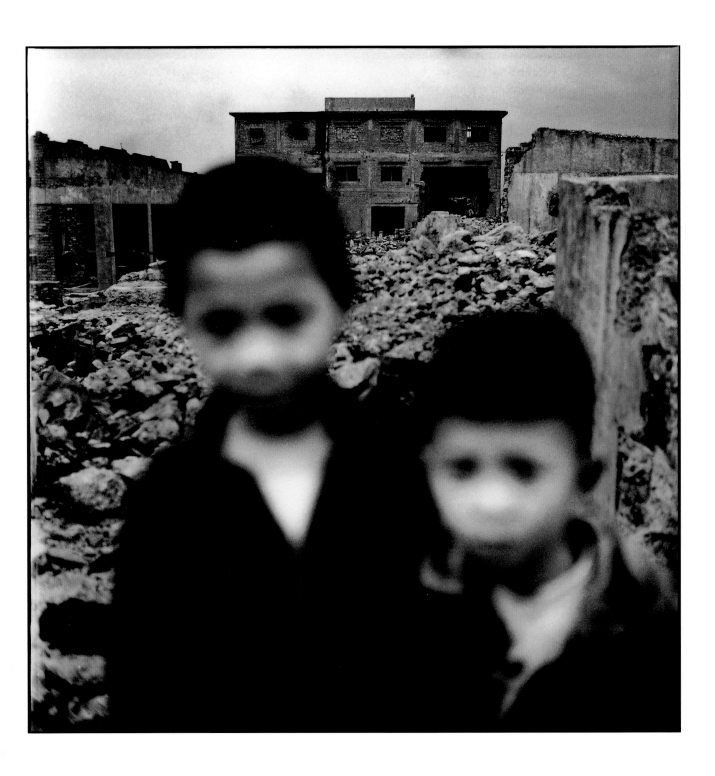

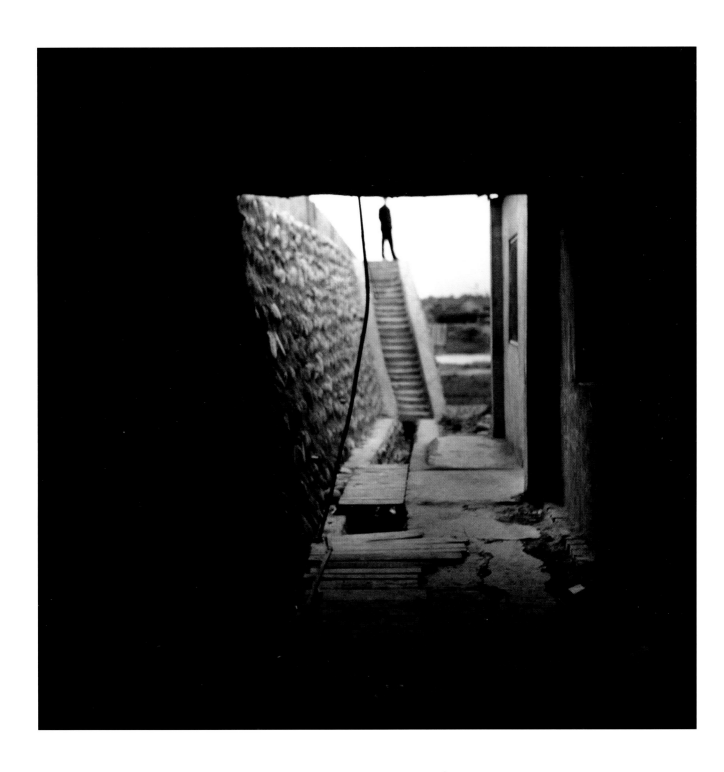

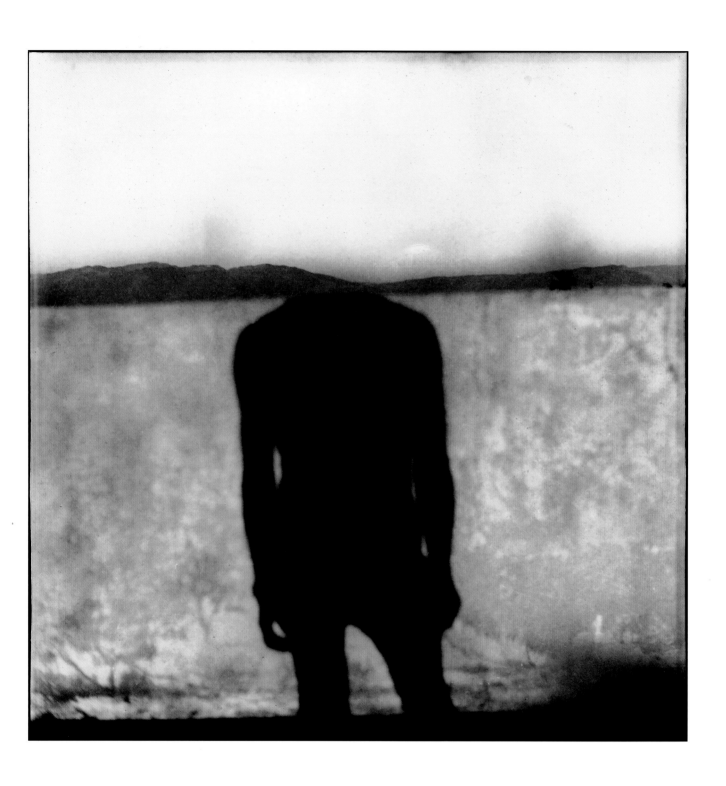

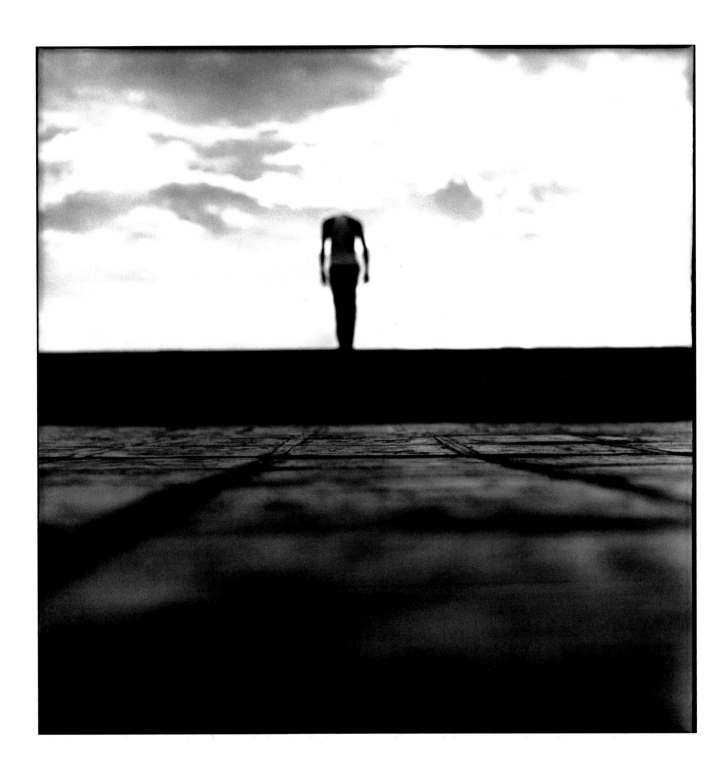

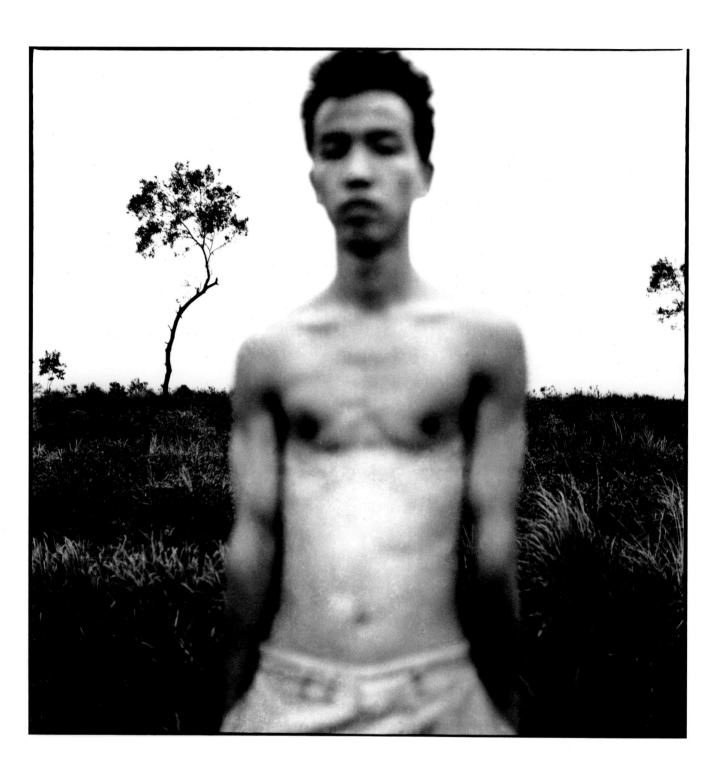

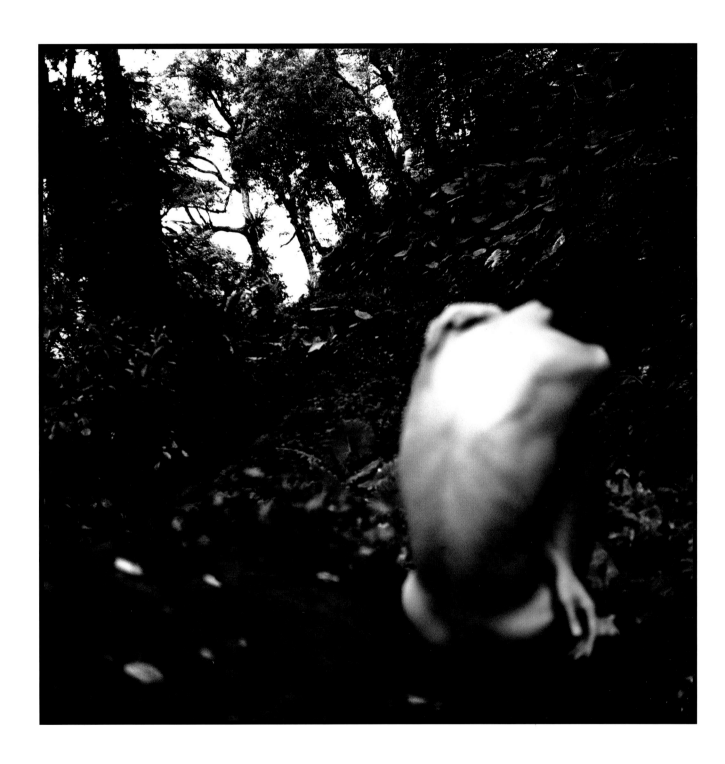

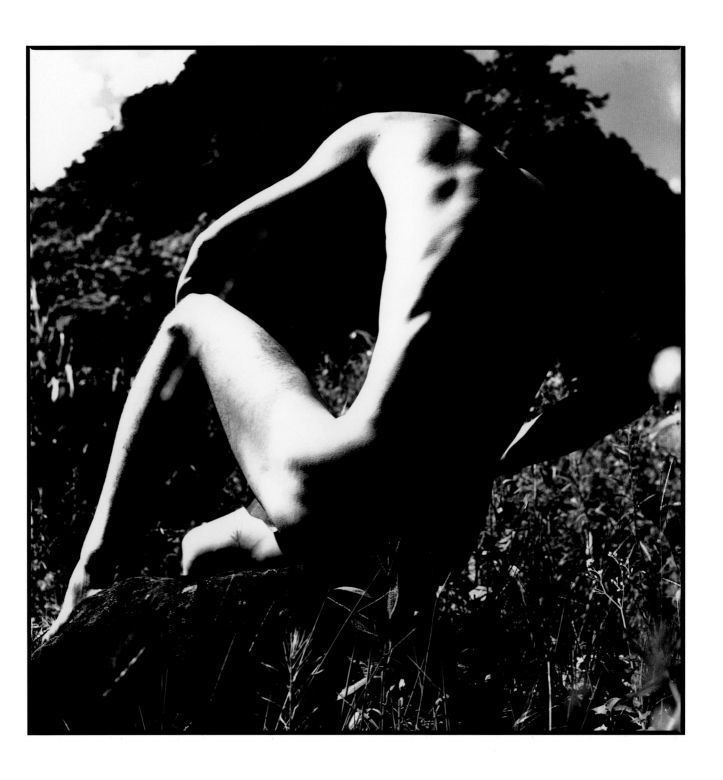

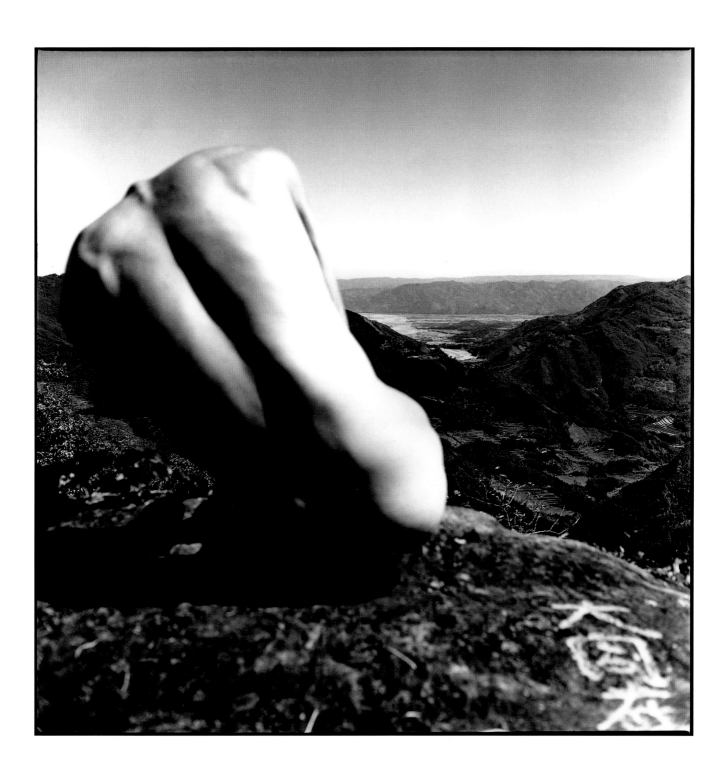

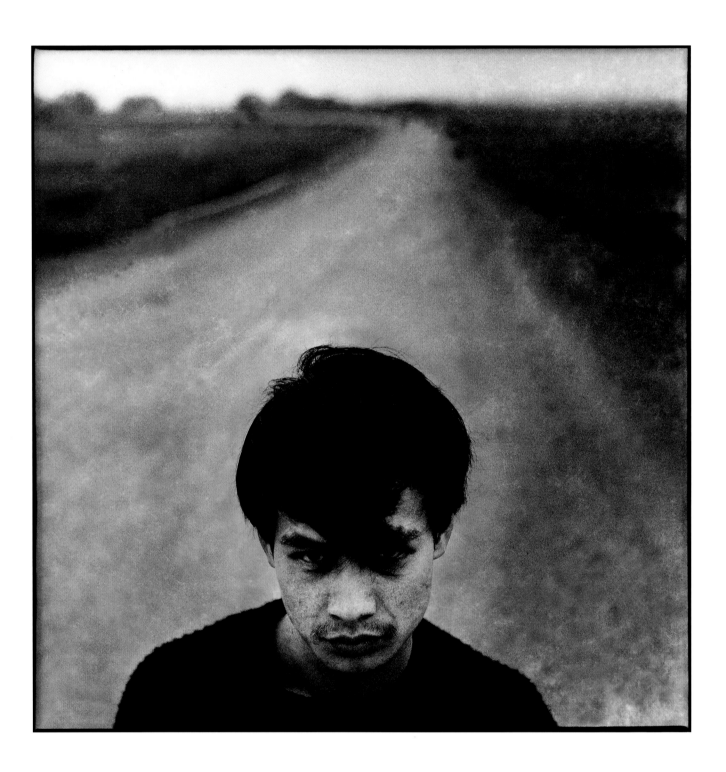

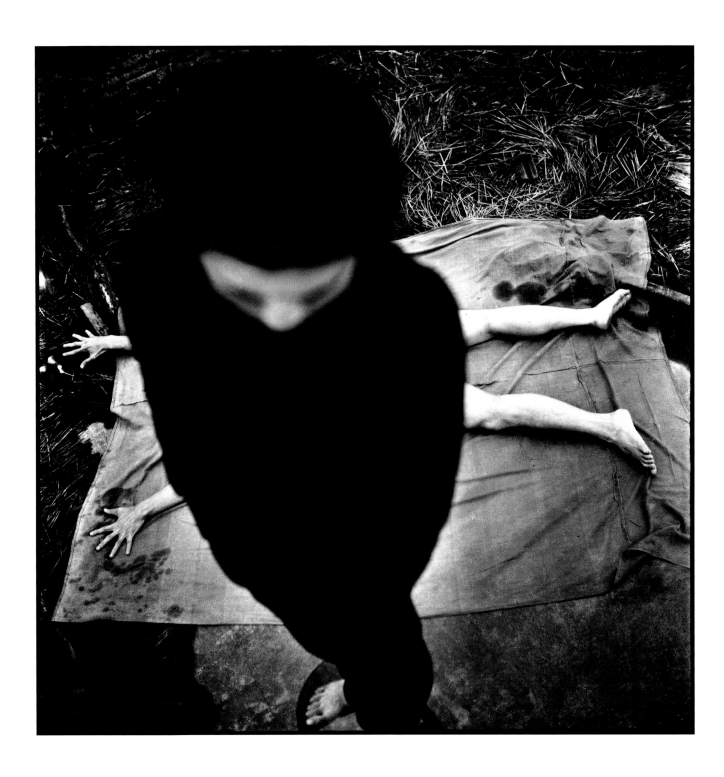

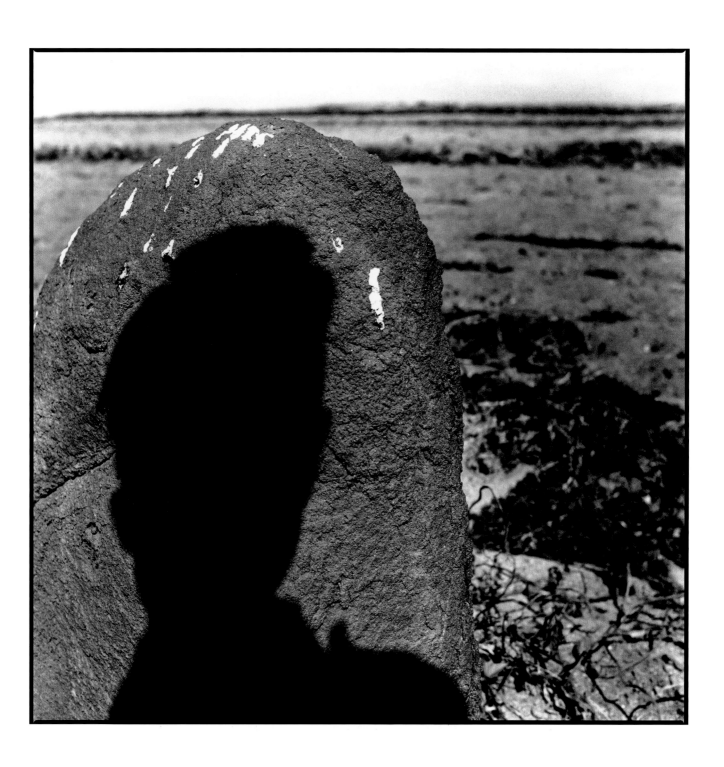

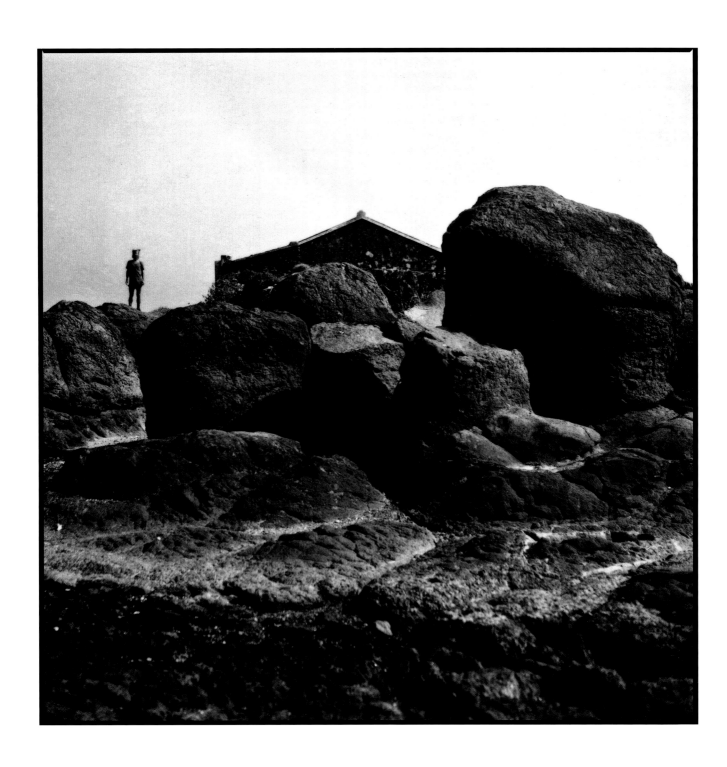

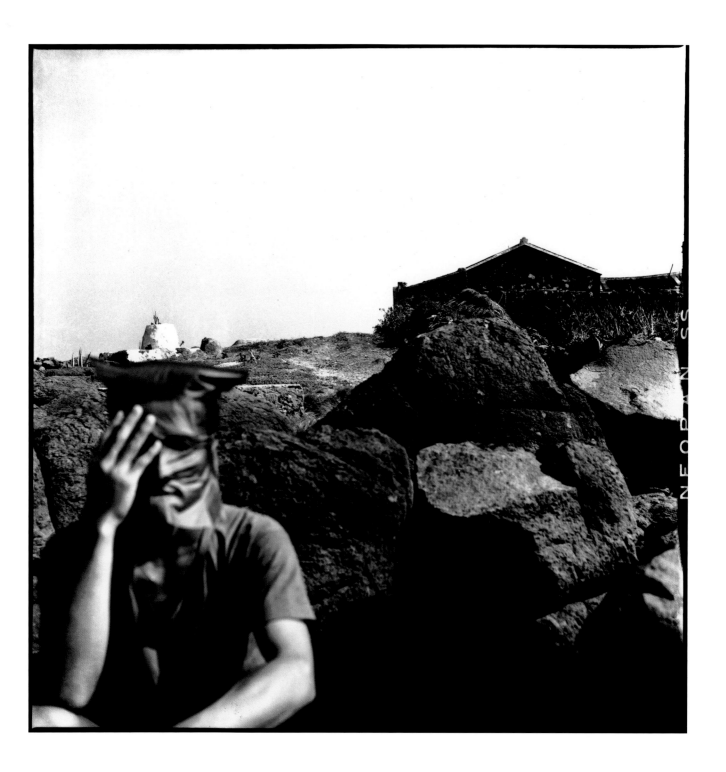

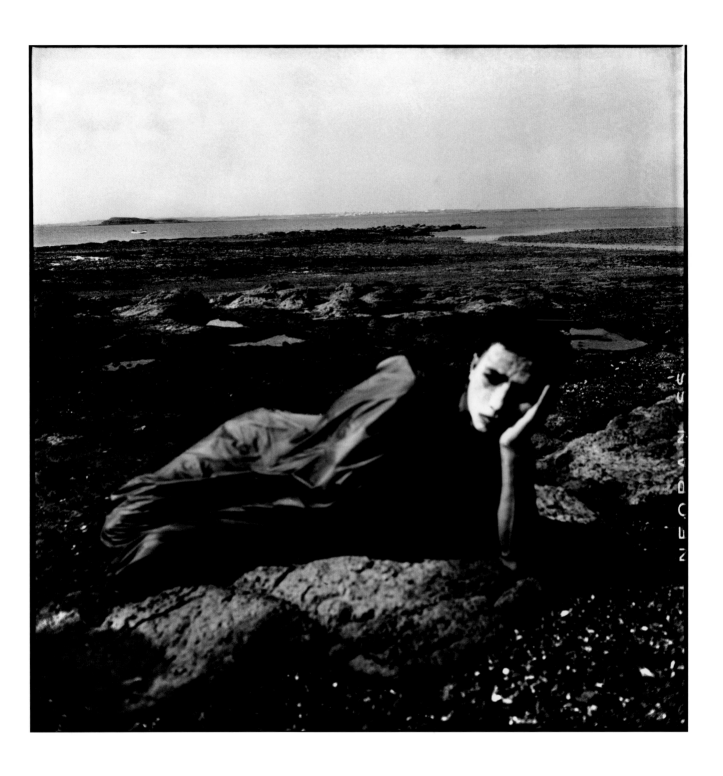

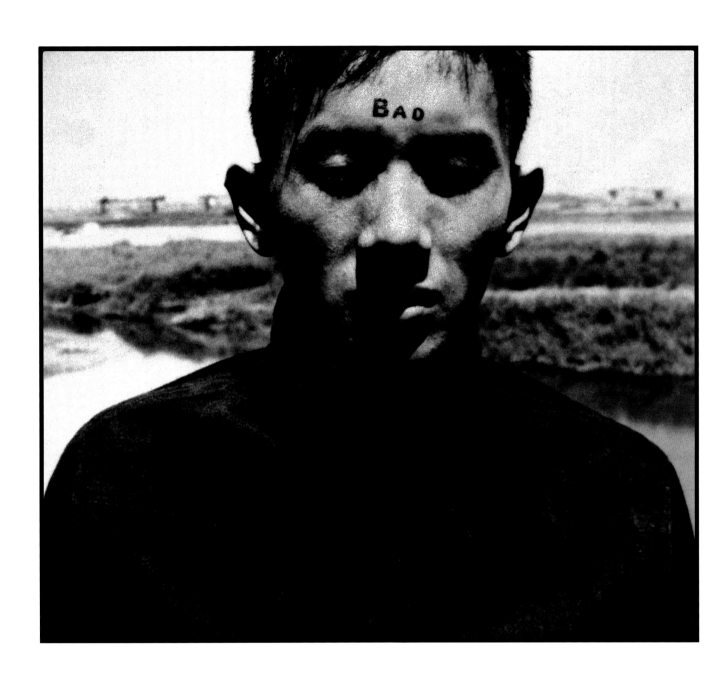

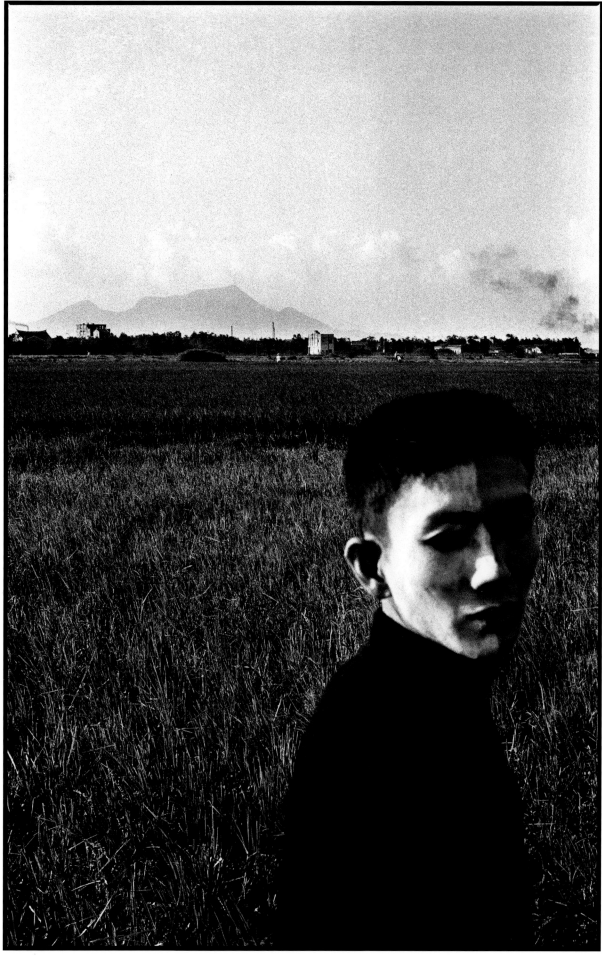

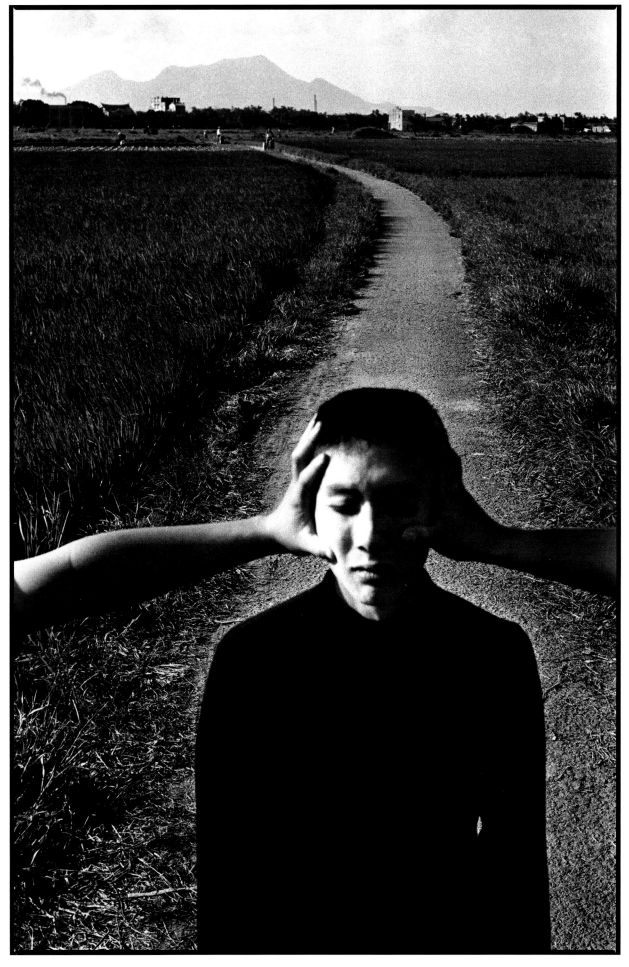

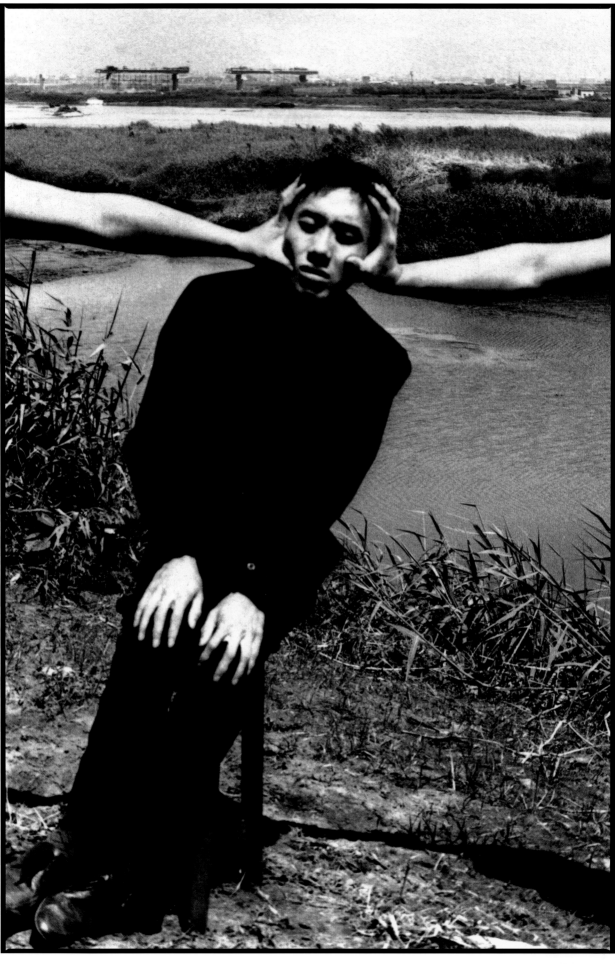

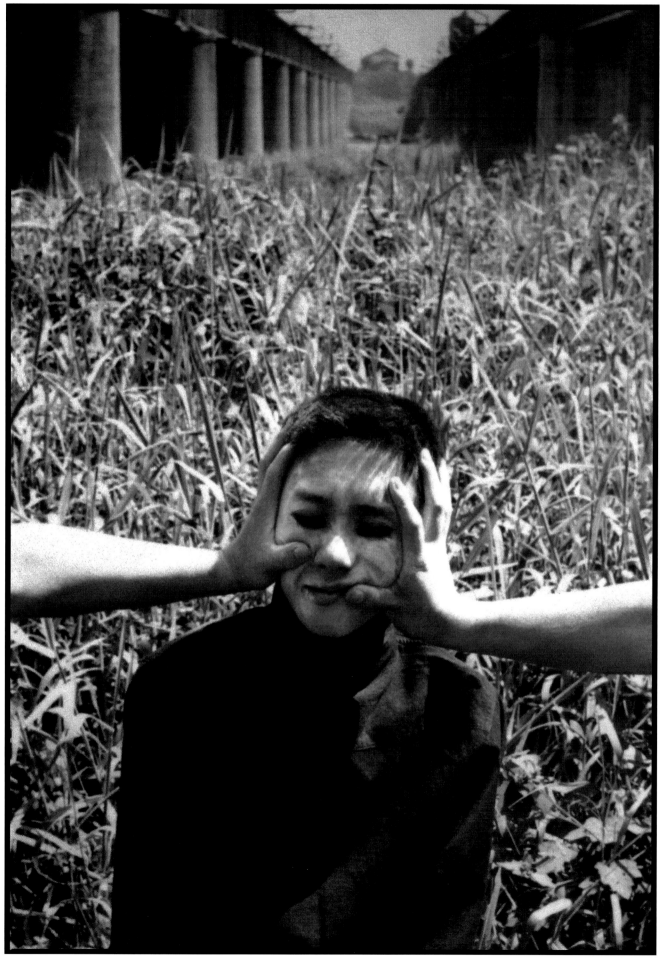

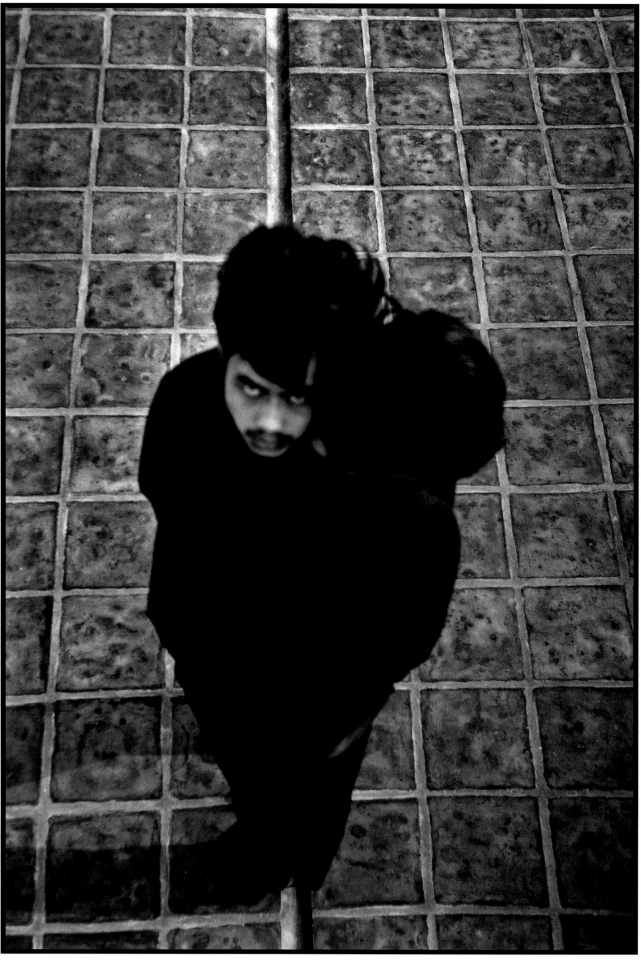

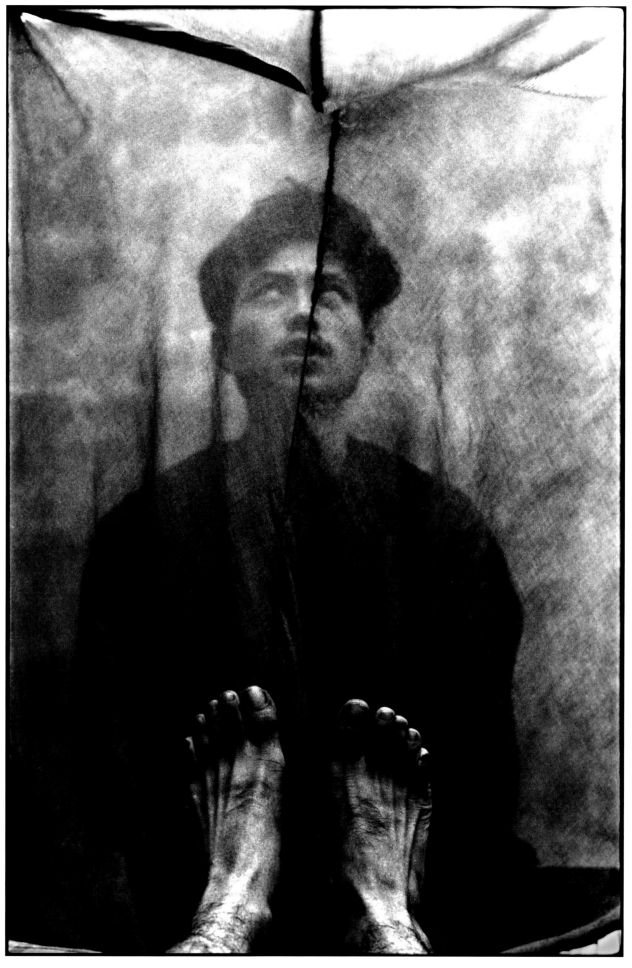

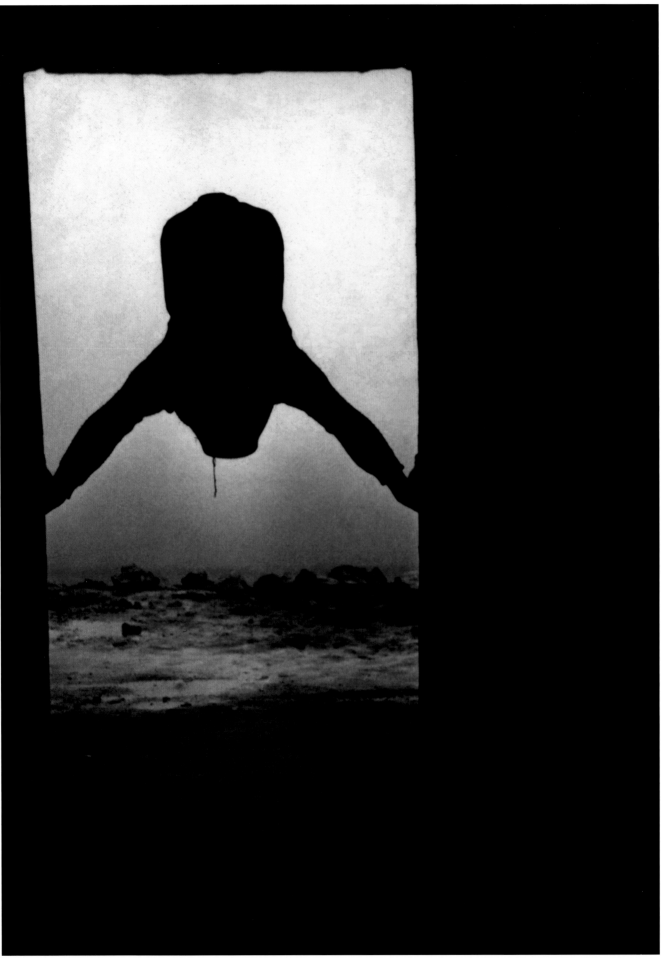

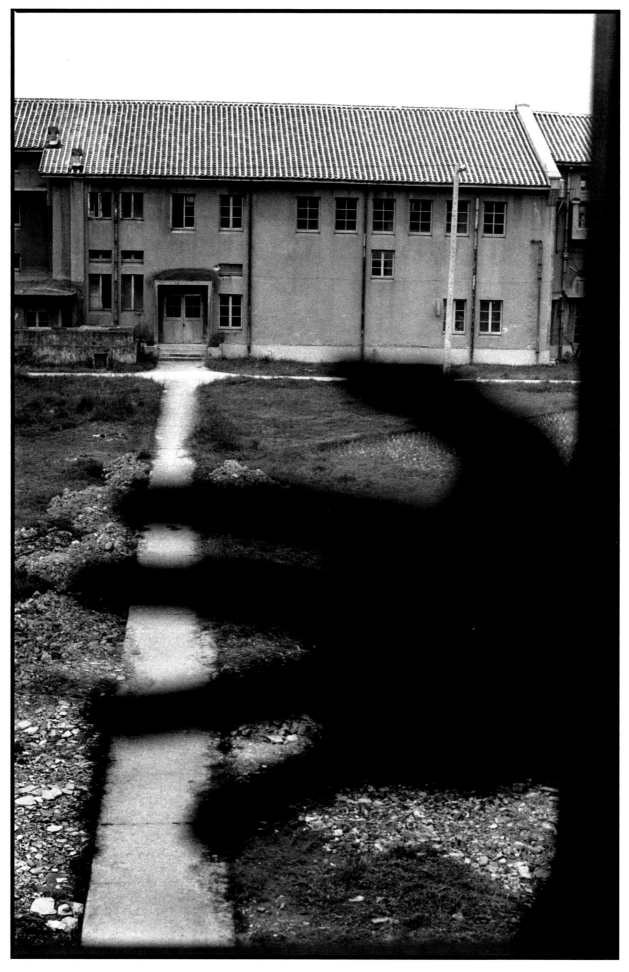

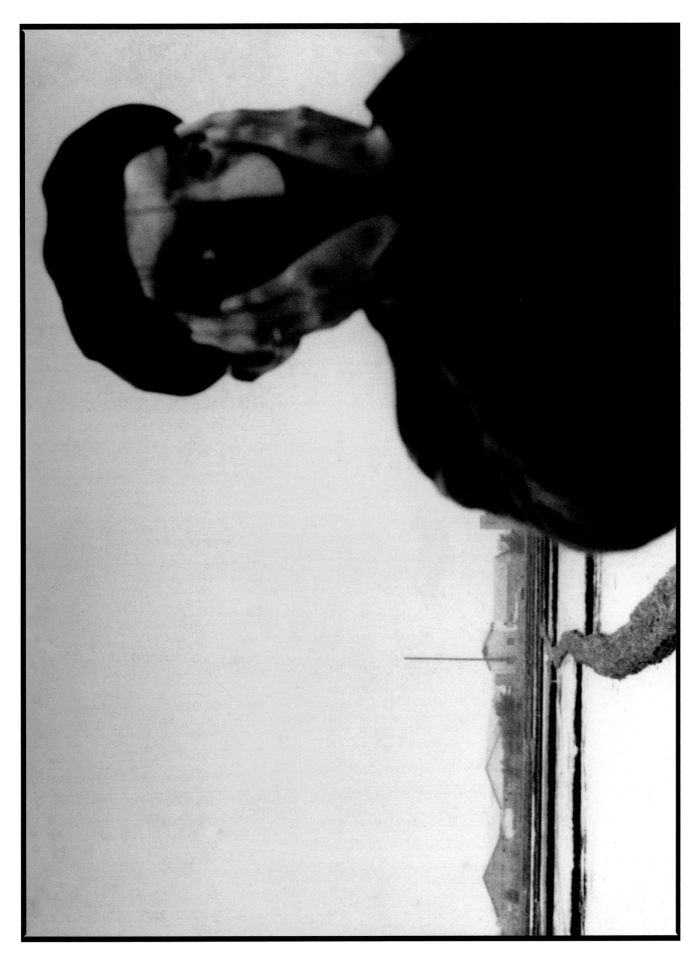

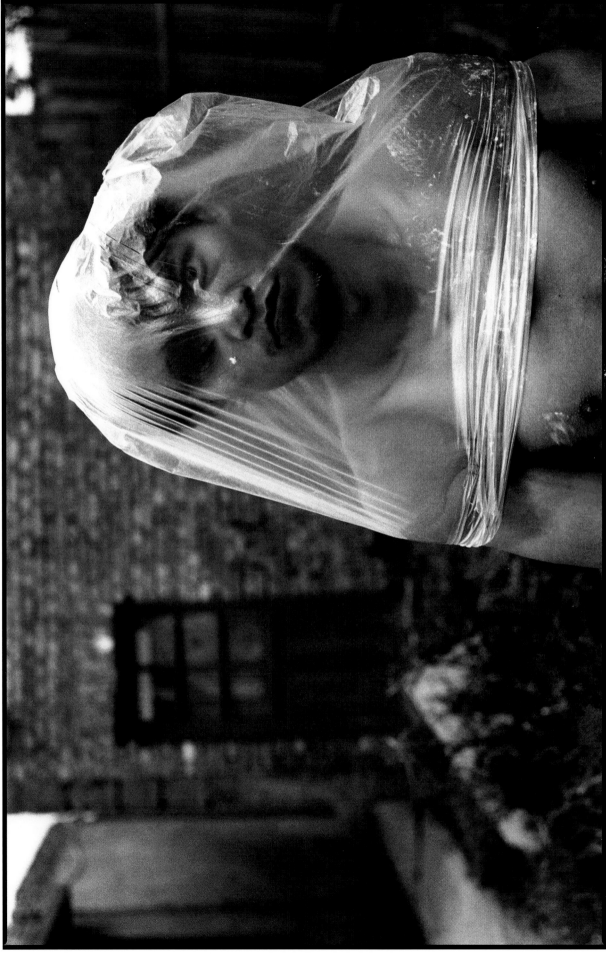

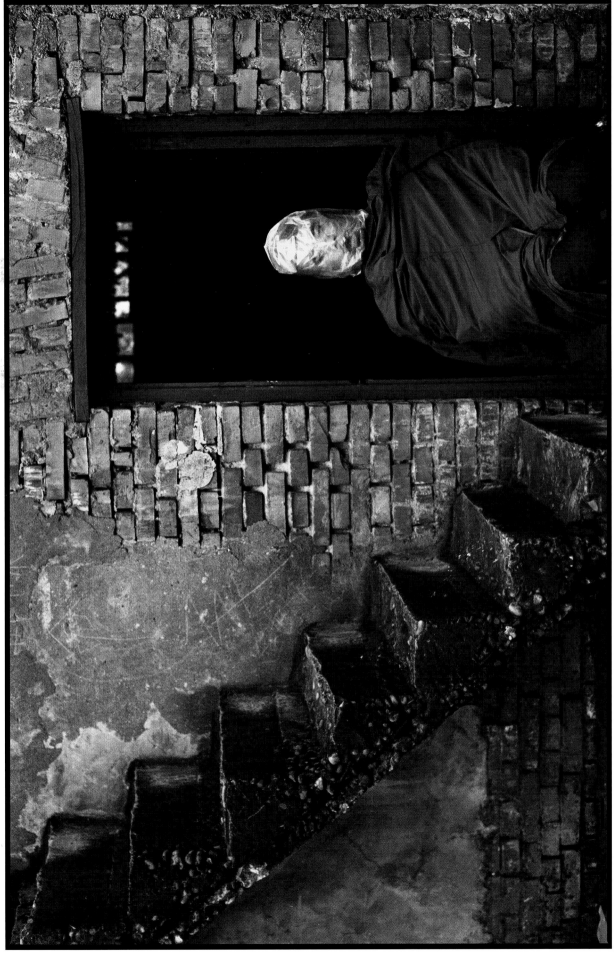

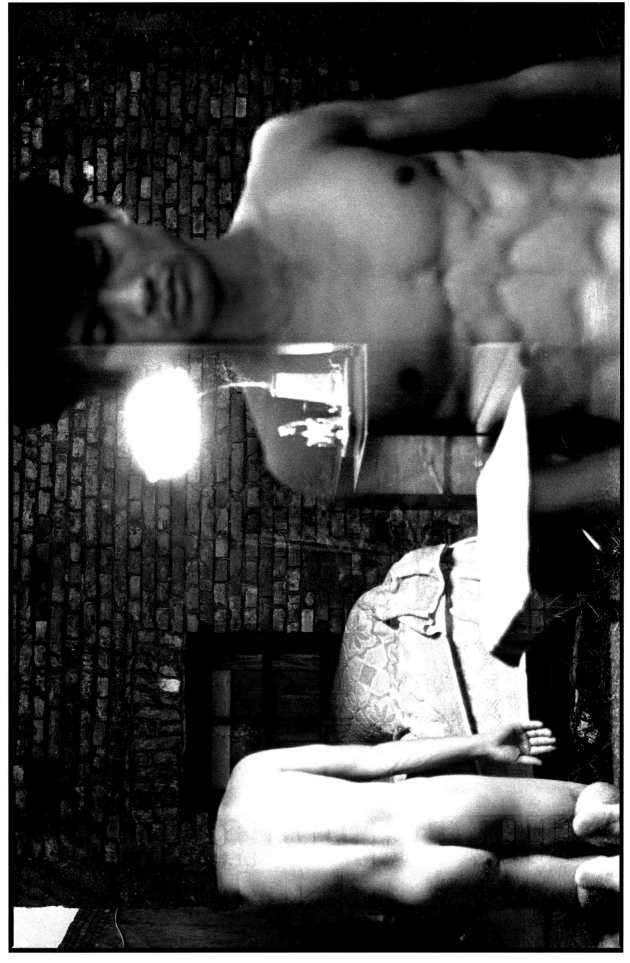

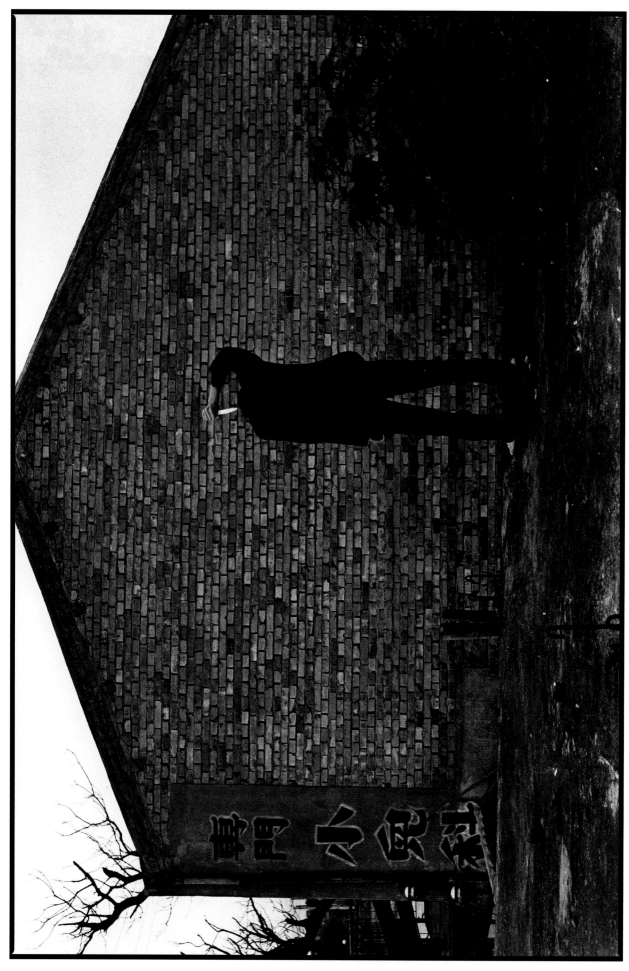

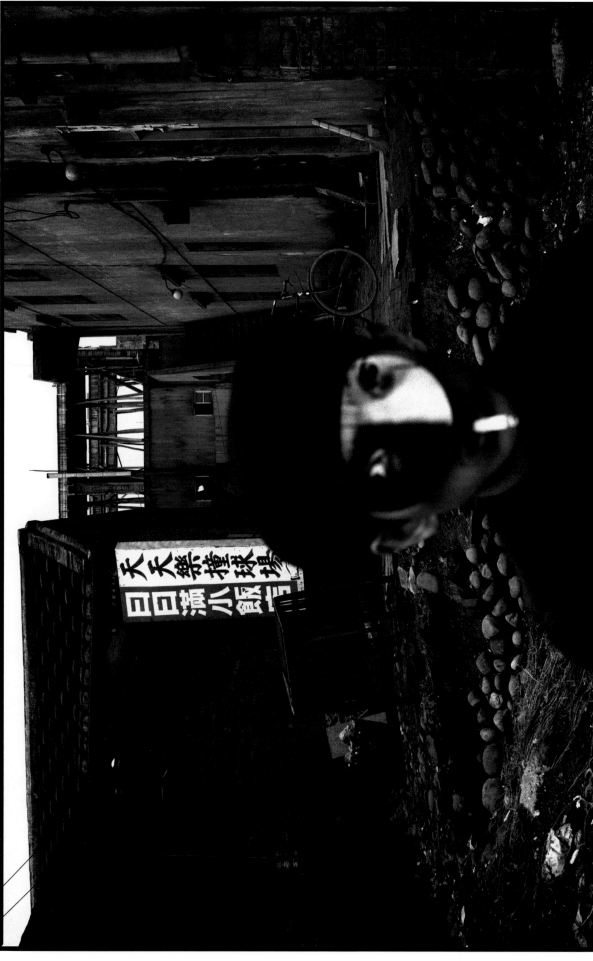

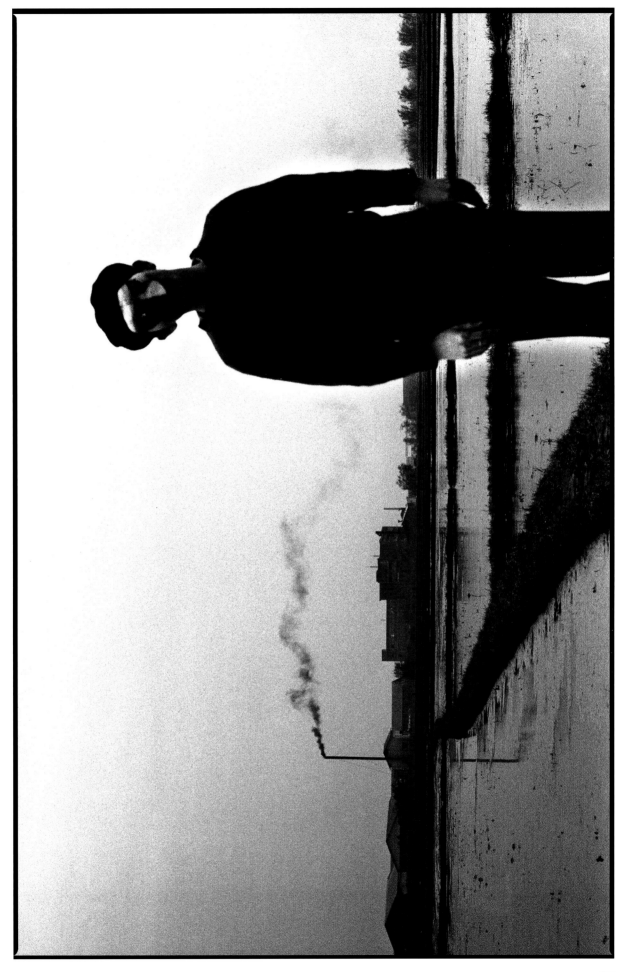

# Social
# Memory

1970-2005

社會記憶

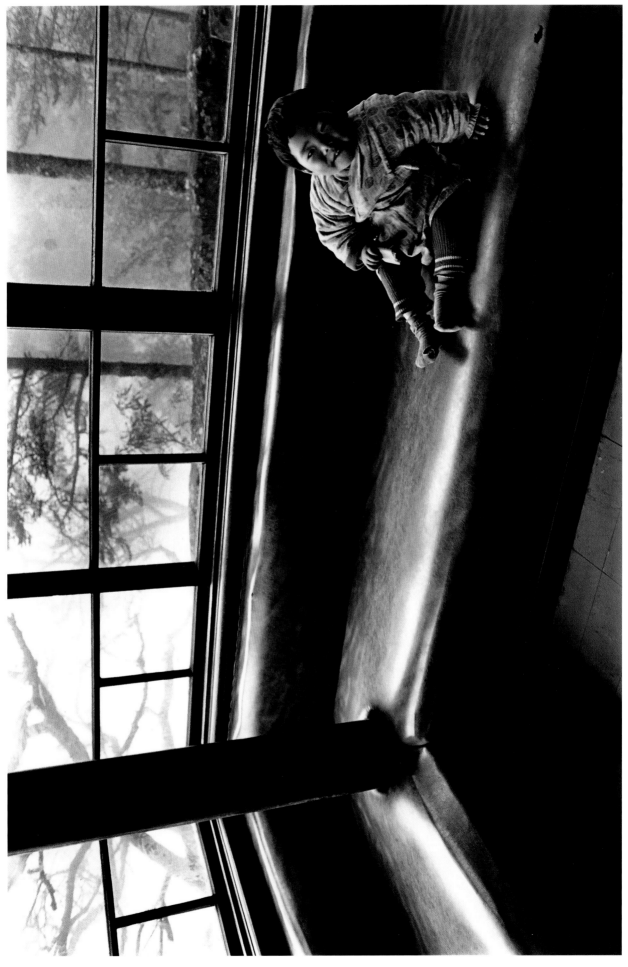

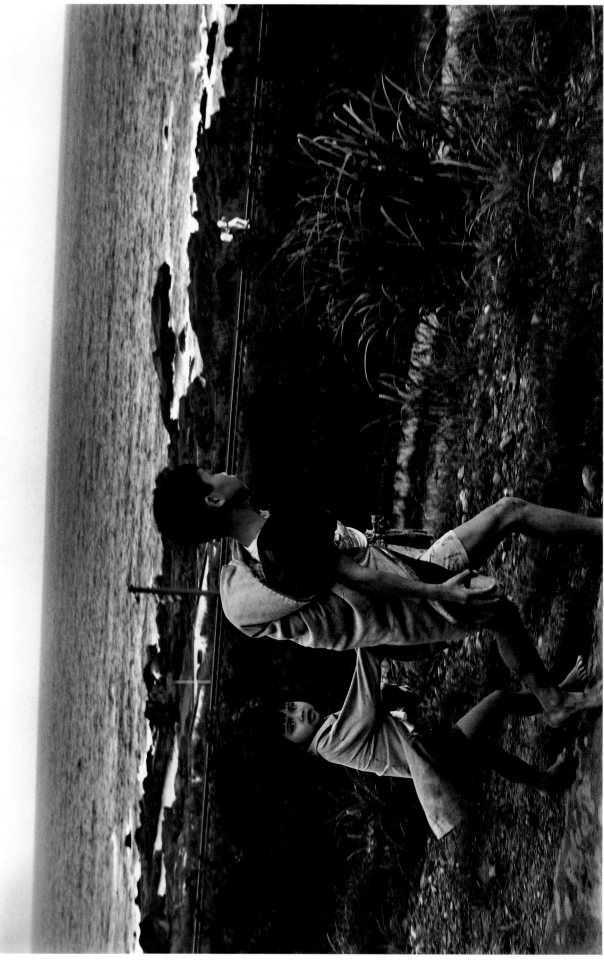

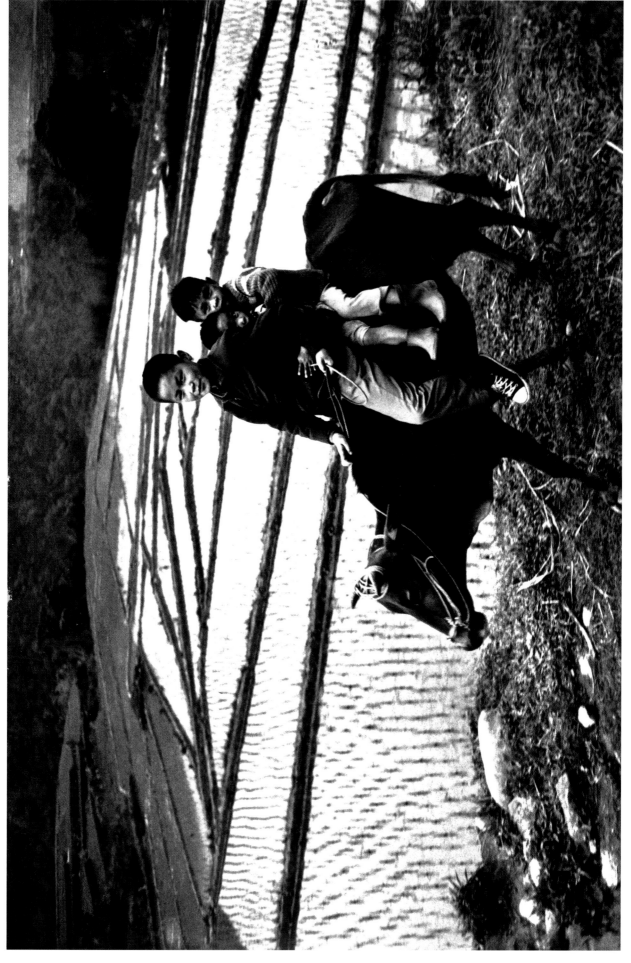

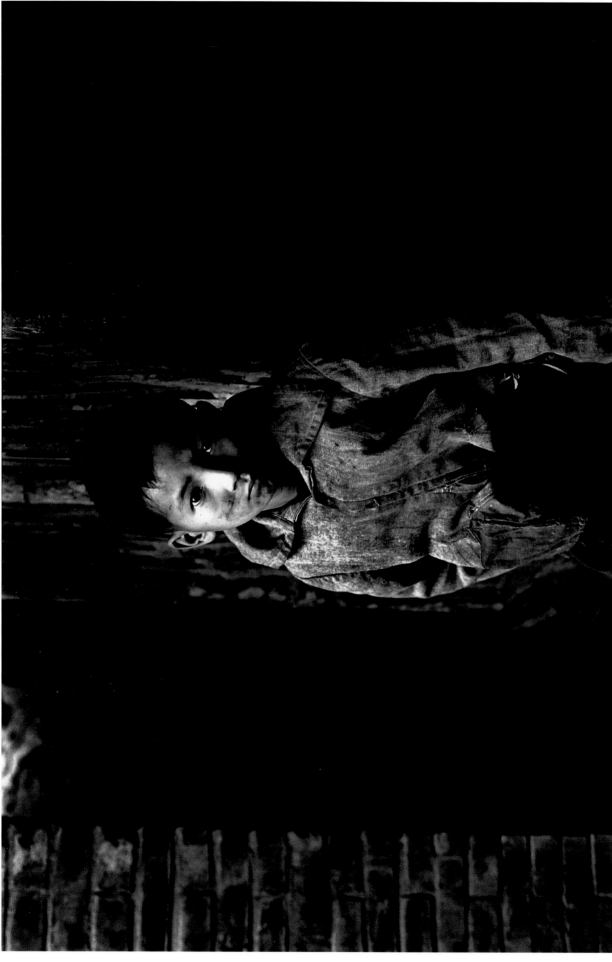

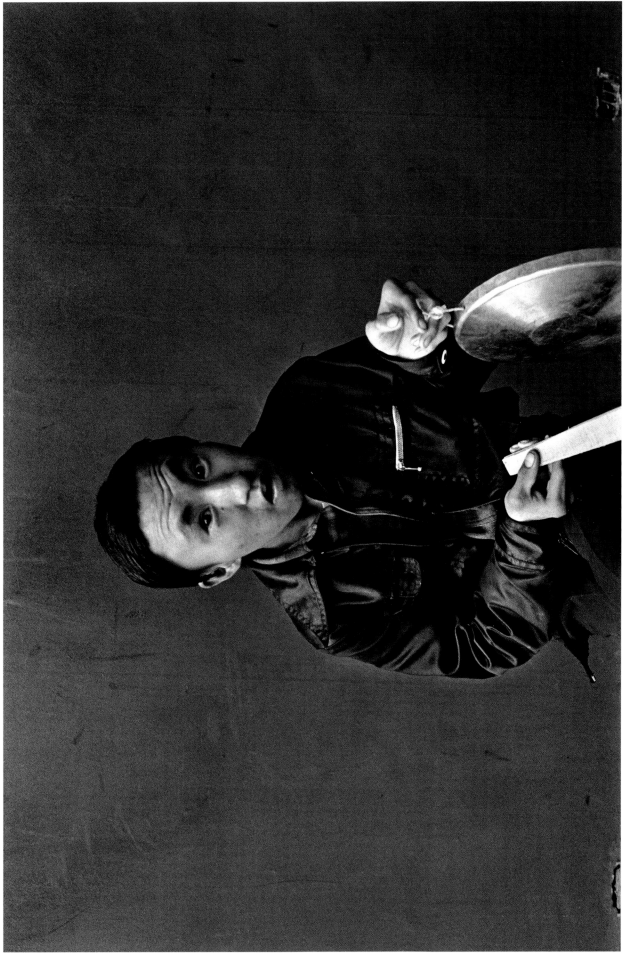

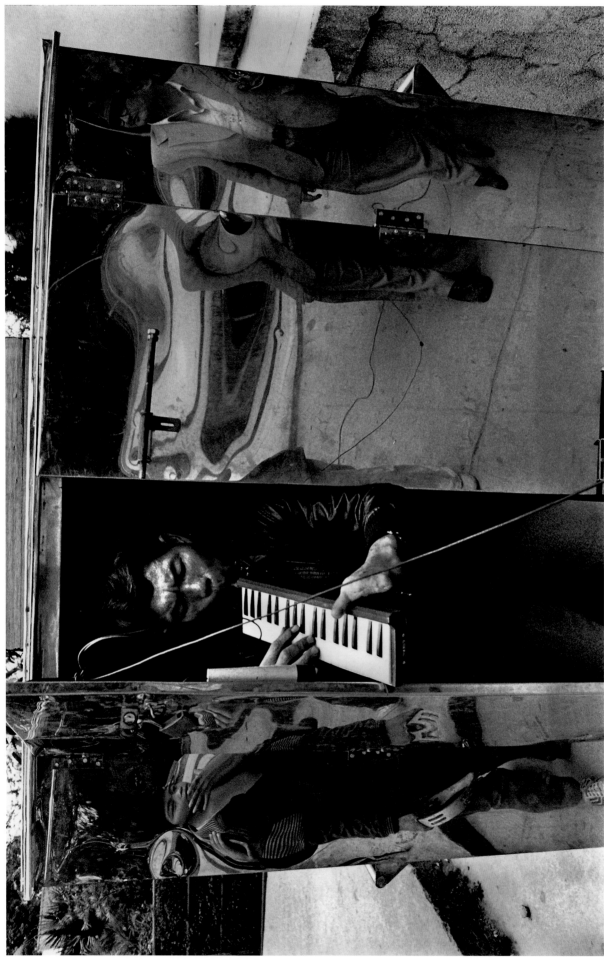

176

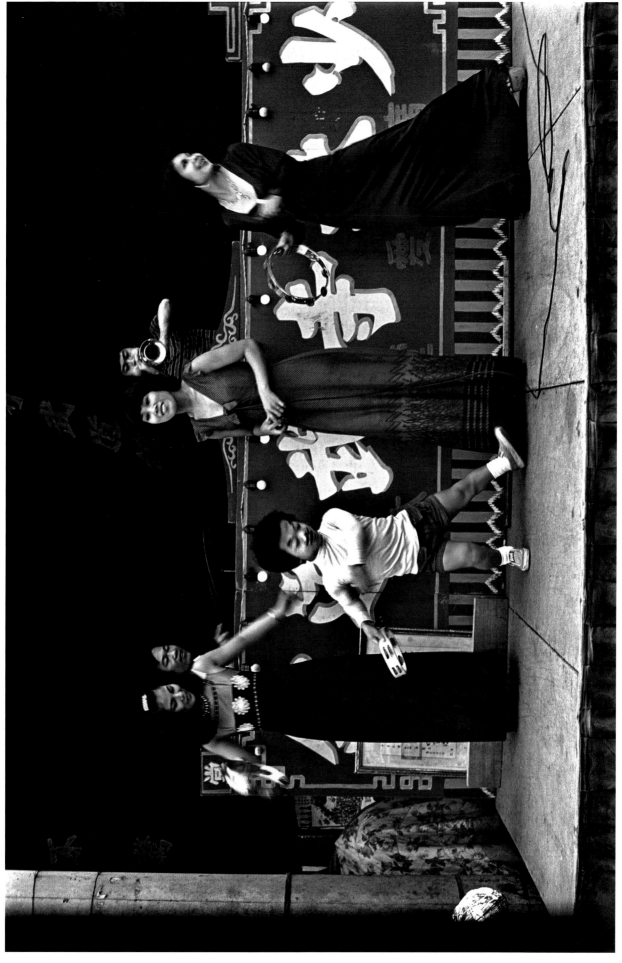

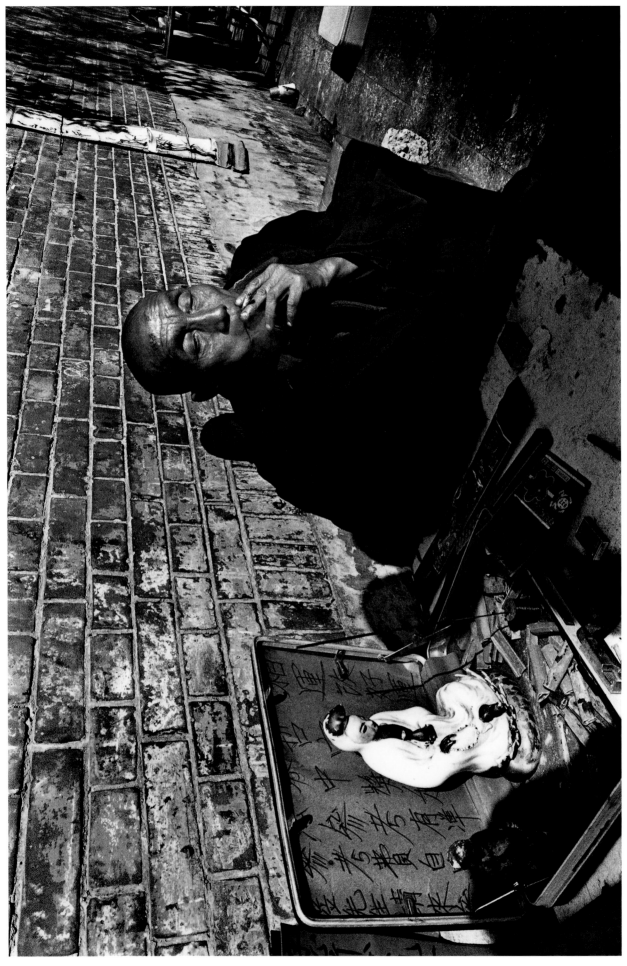

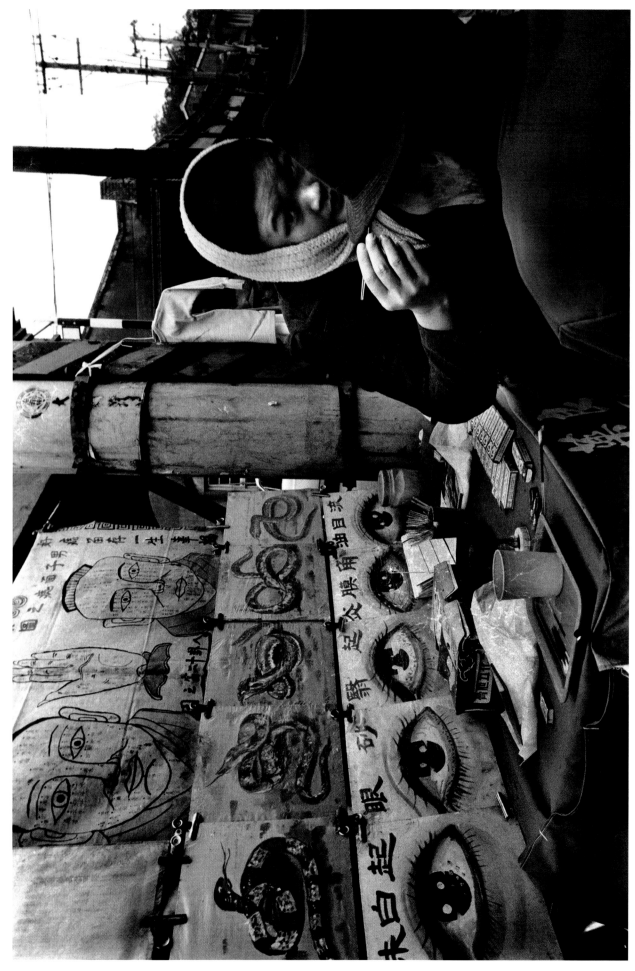

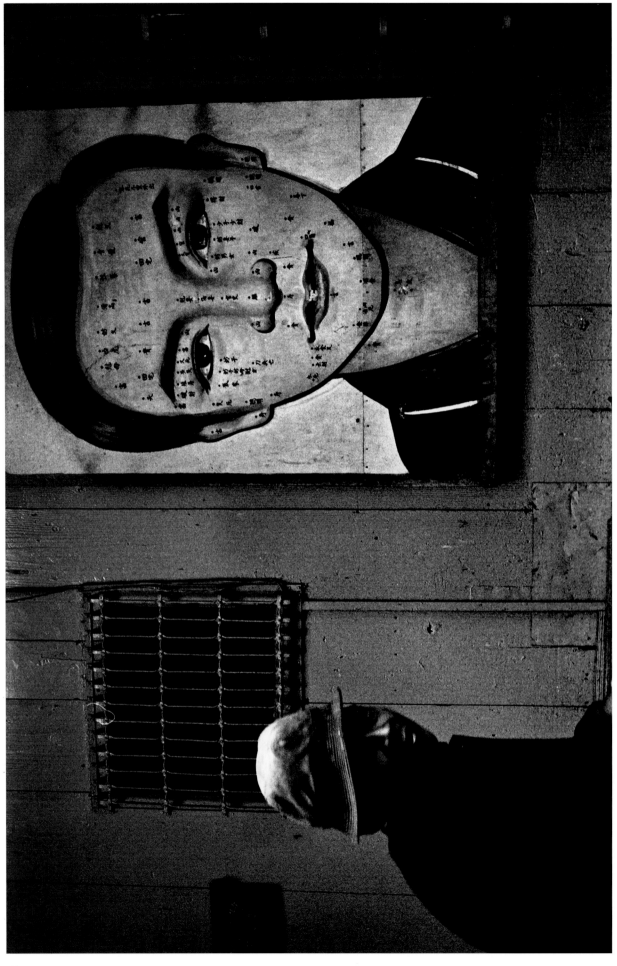

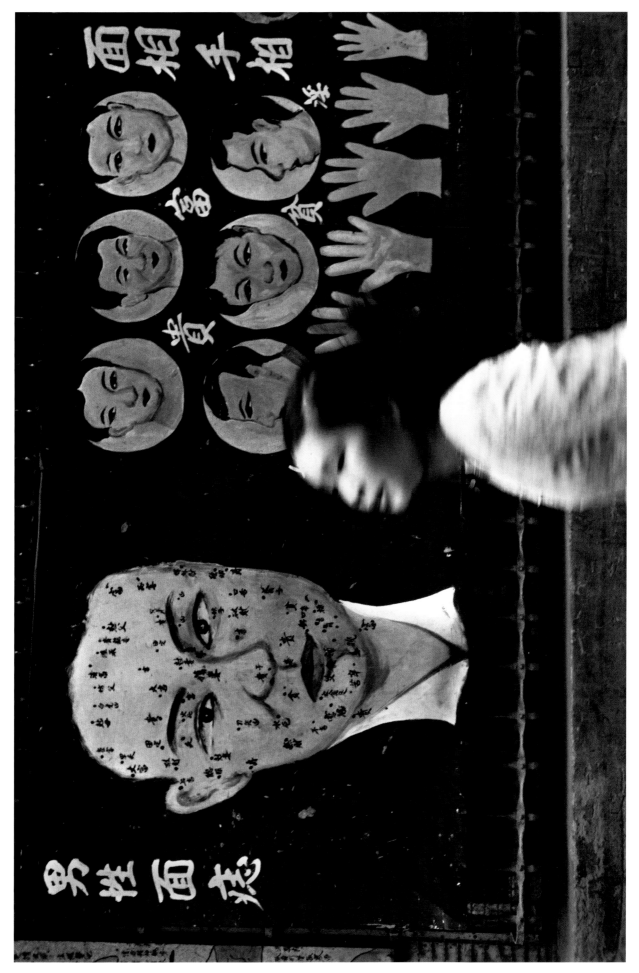

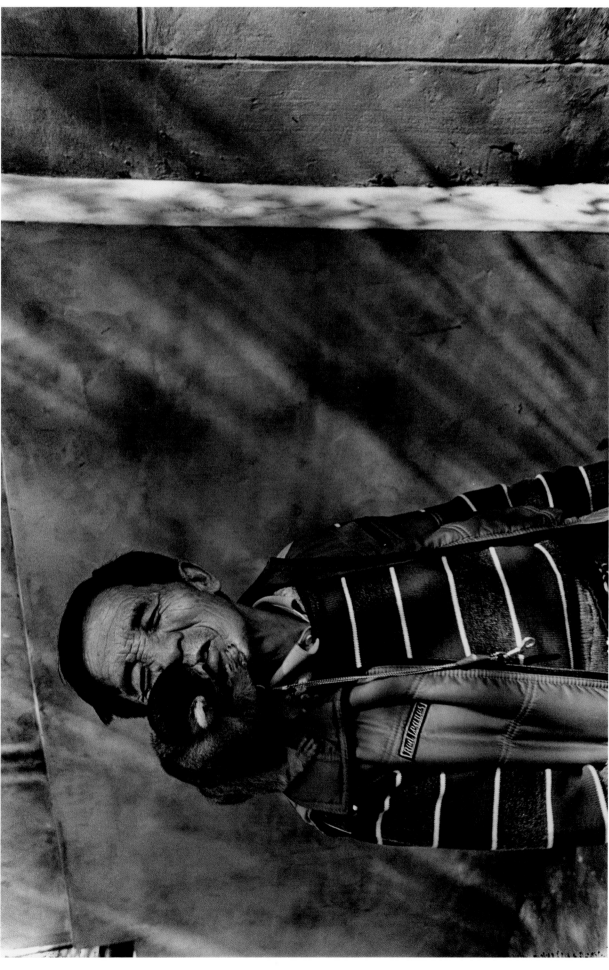

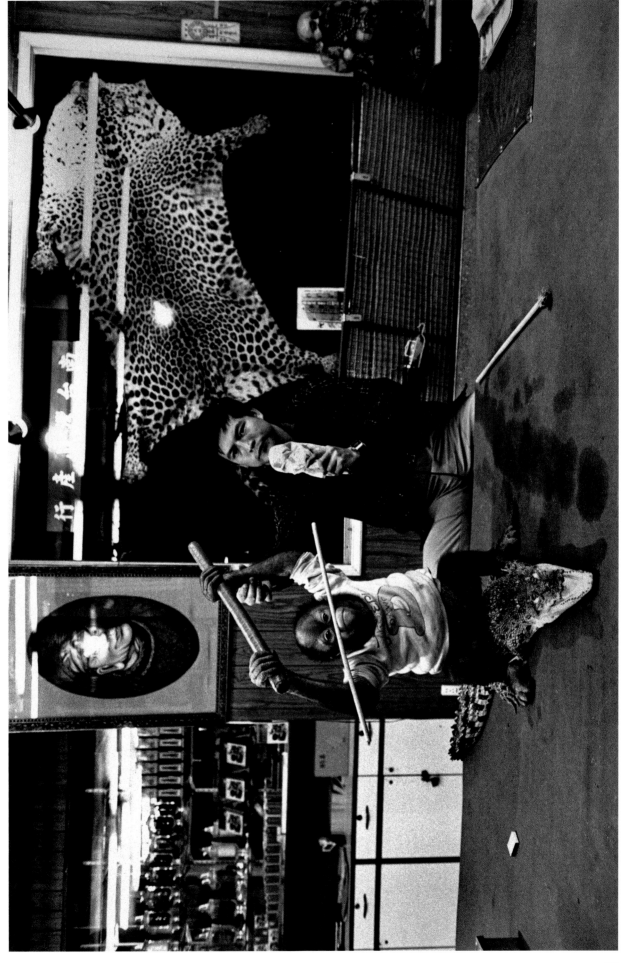

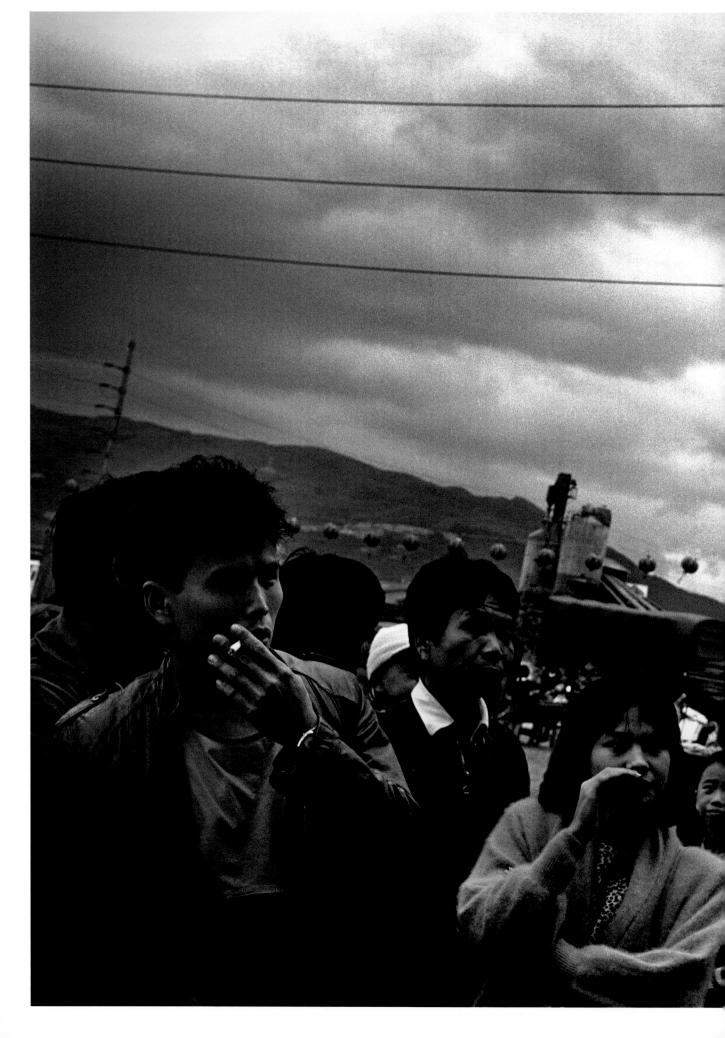

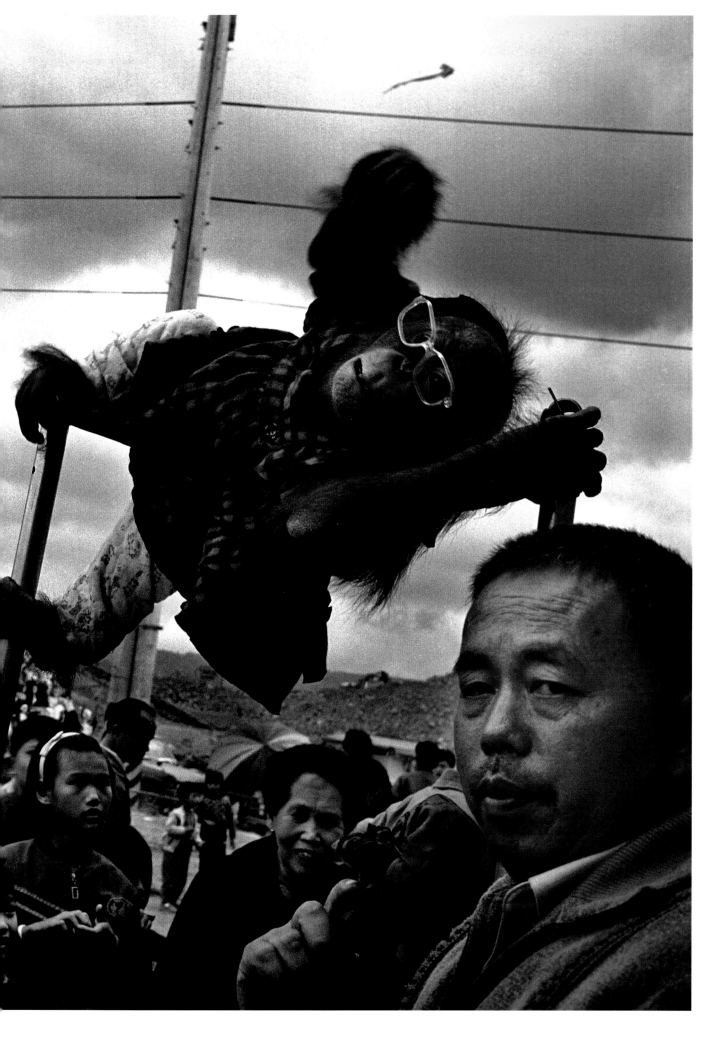

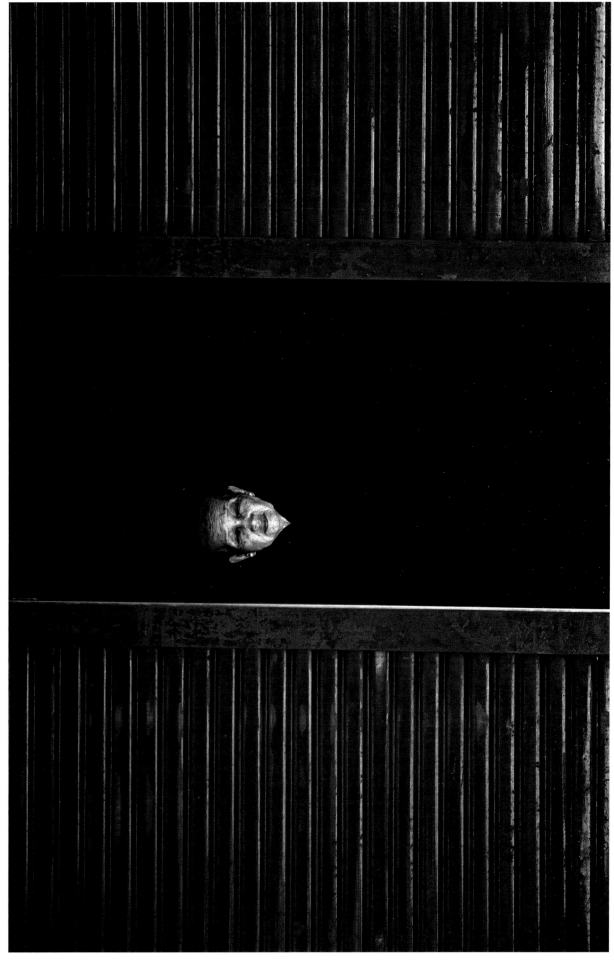

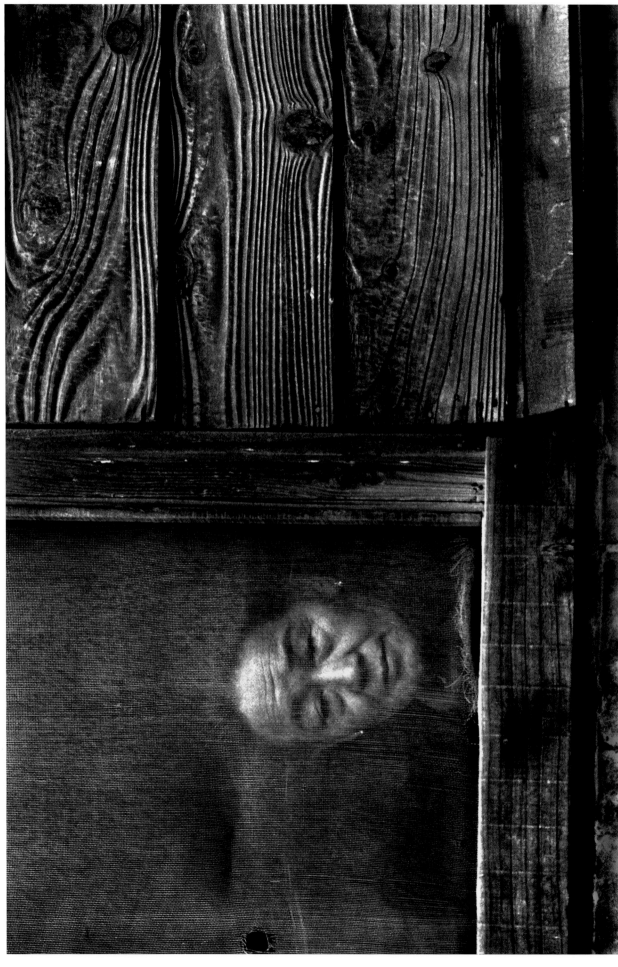

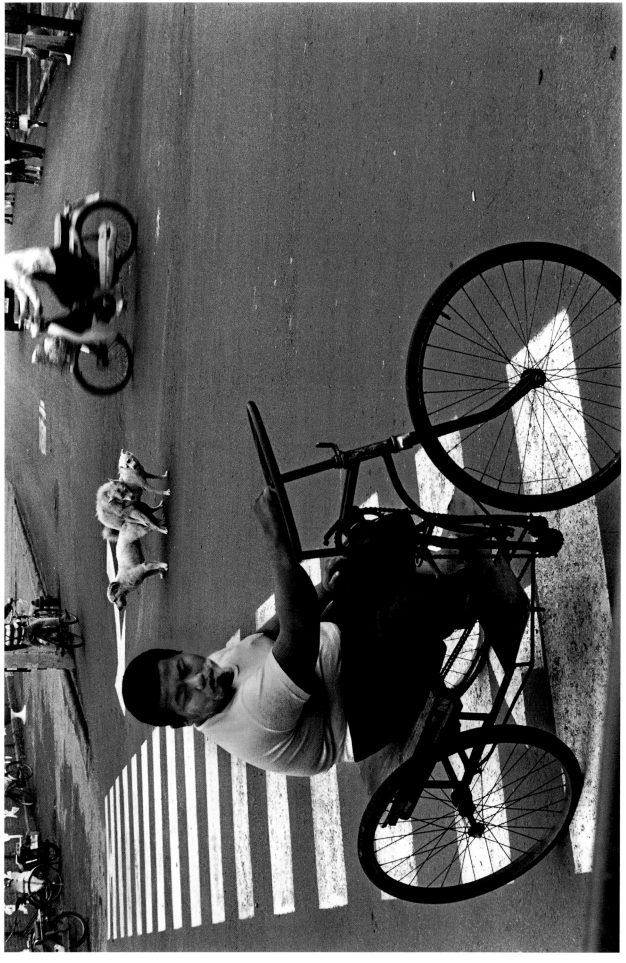

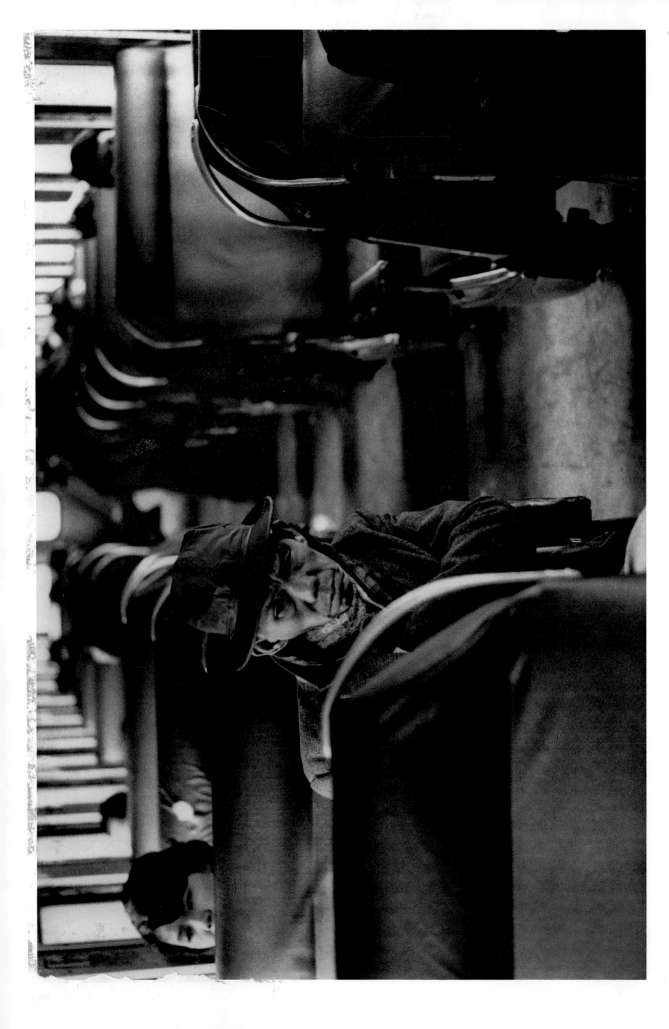

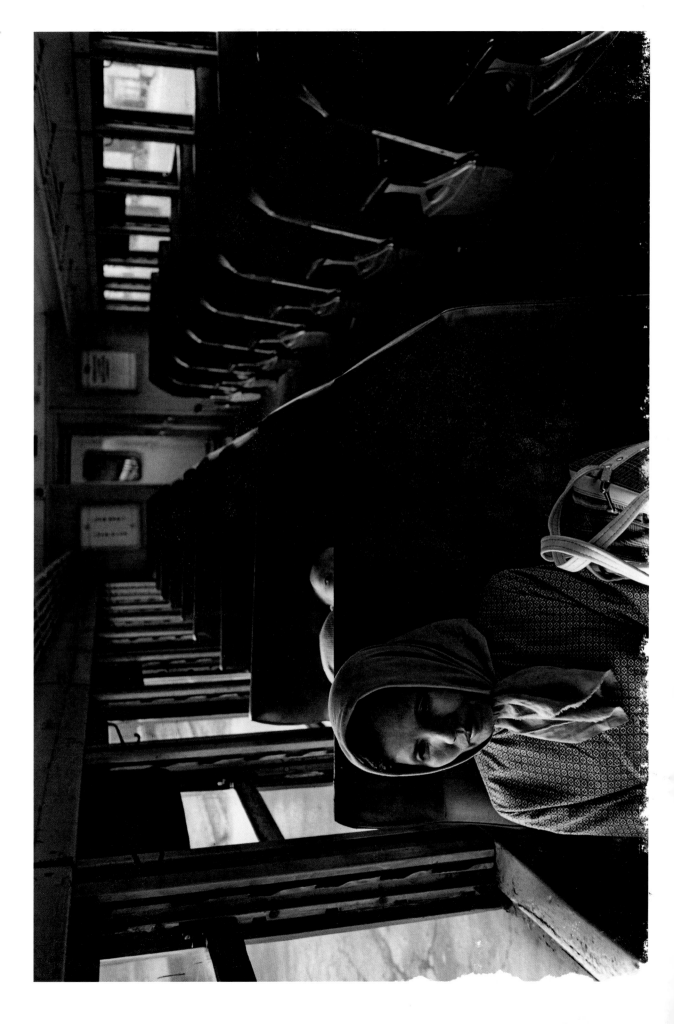

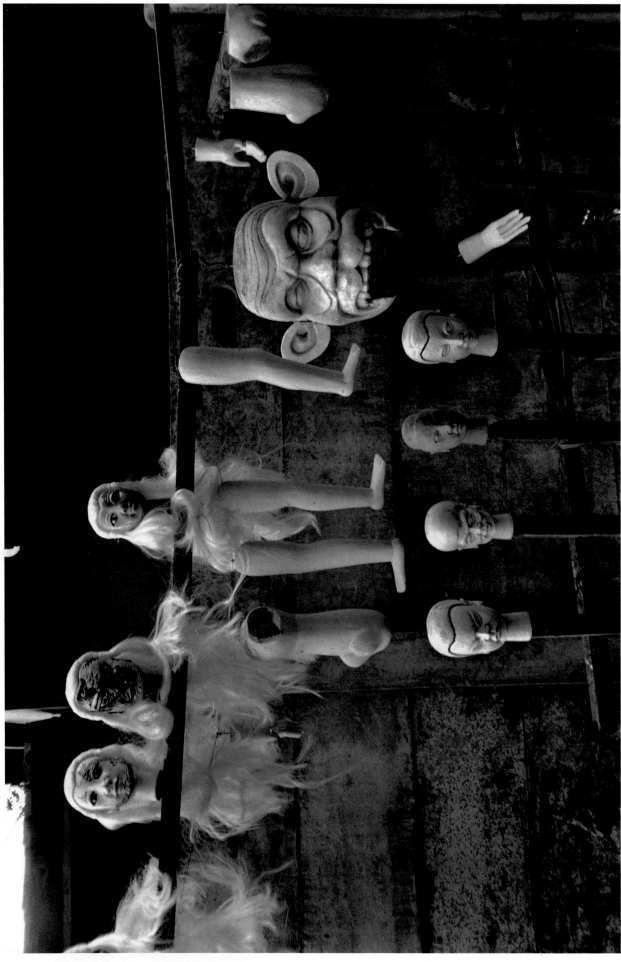

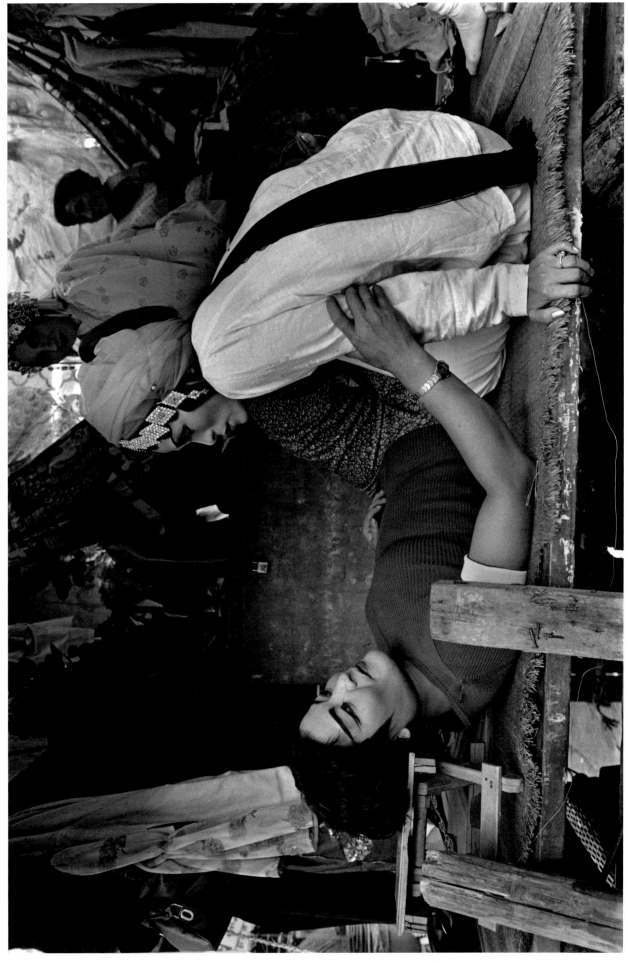

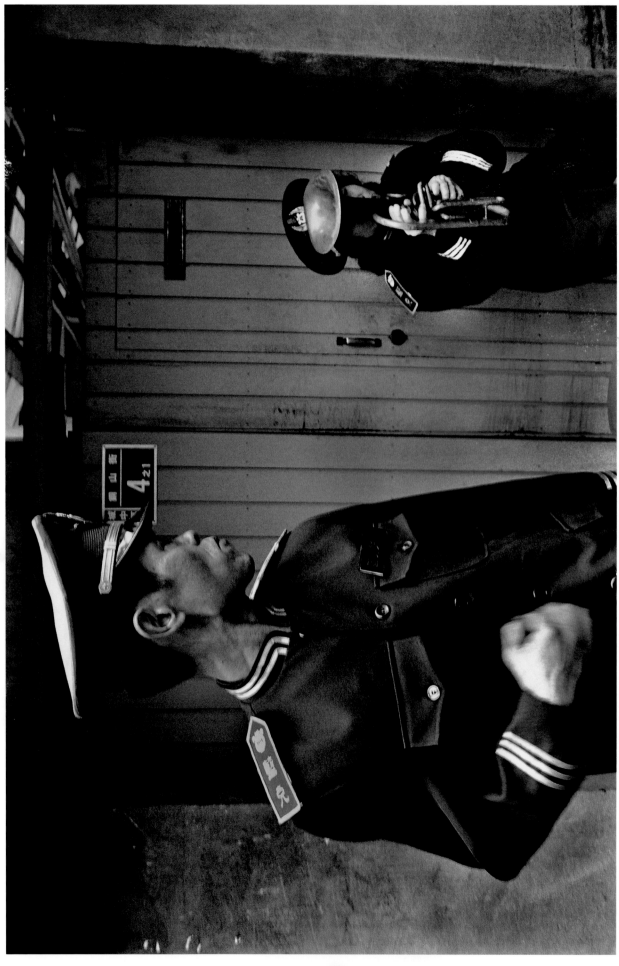

207

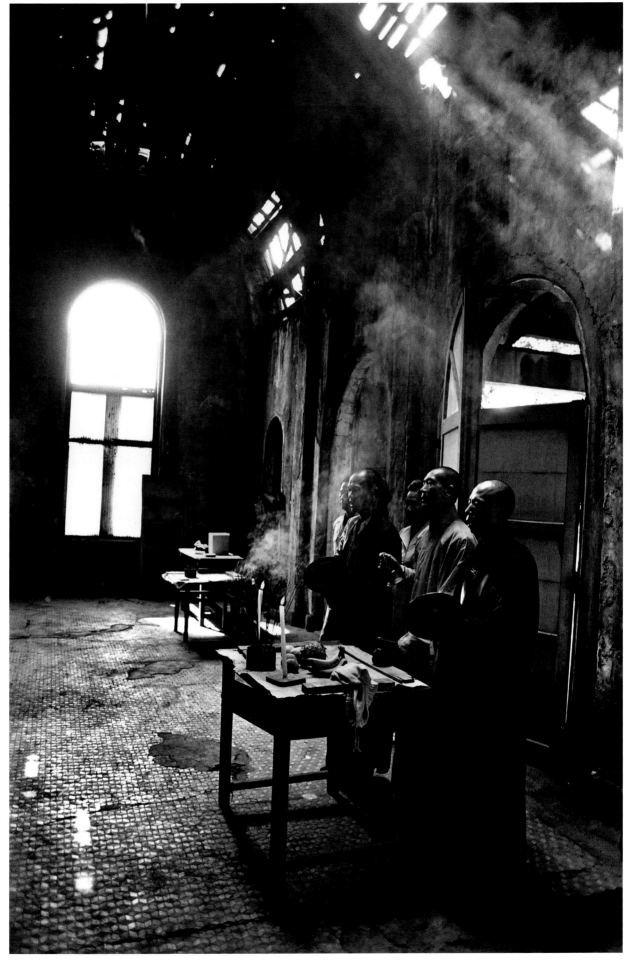

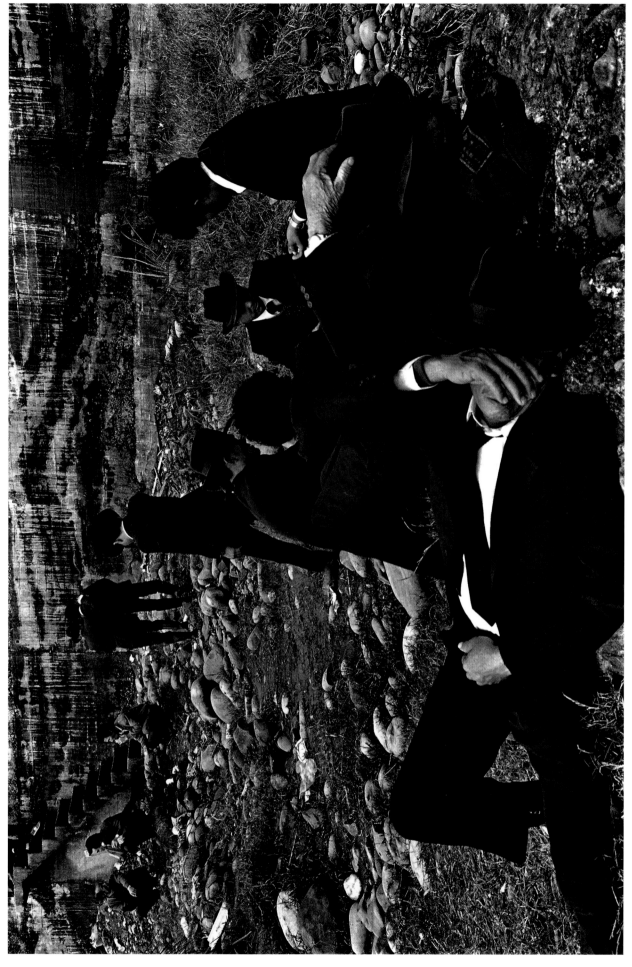

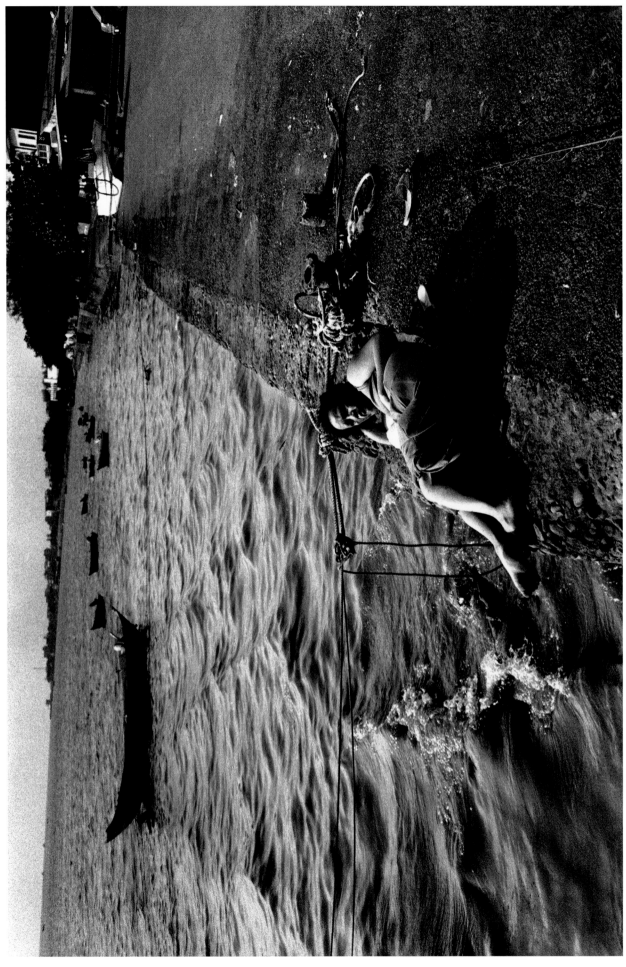

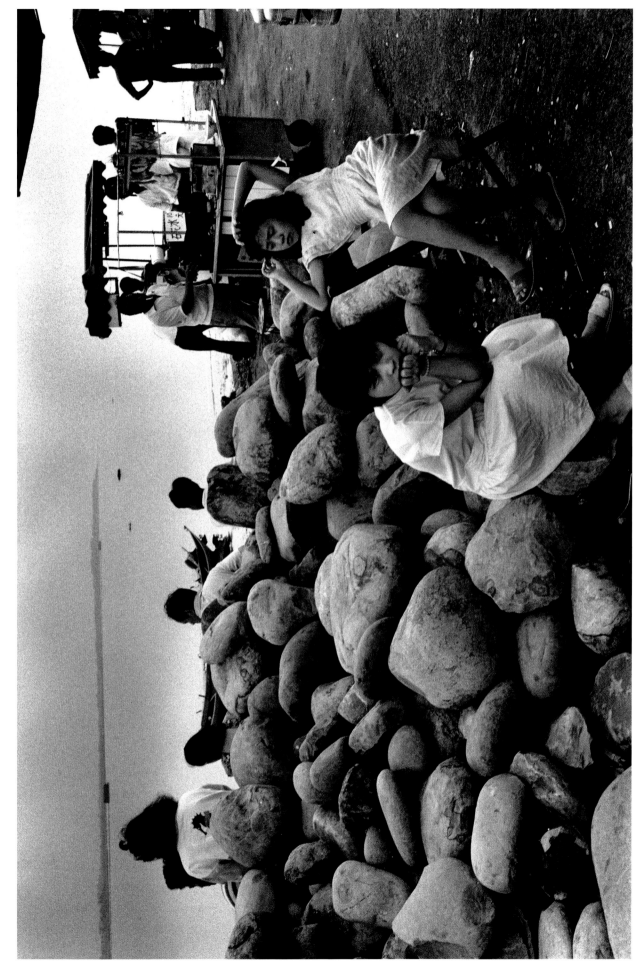

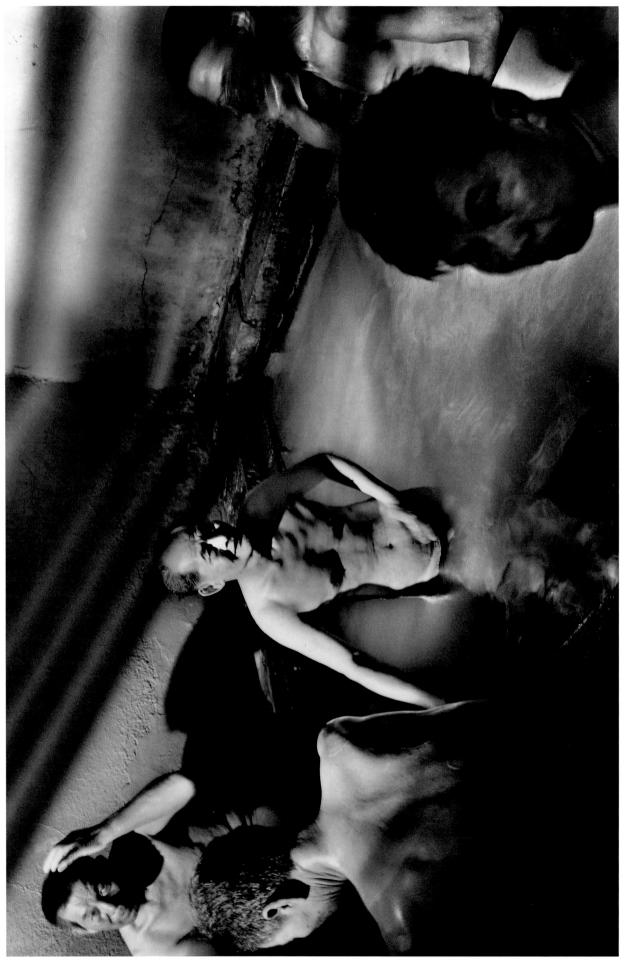

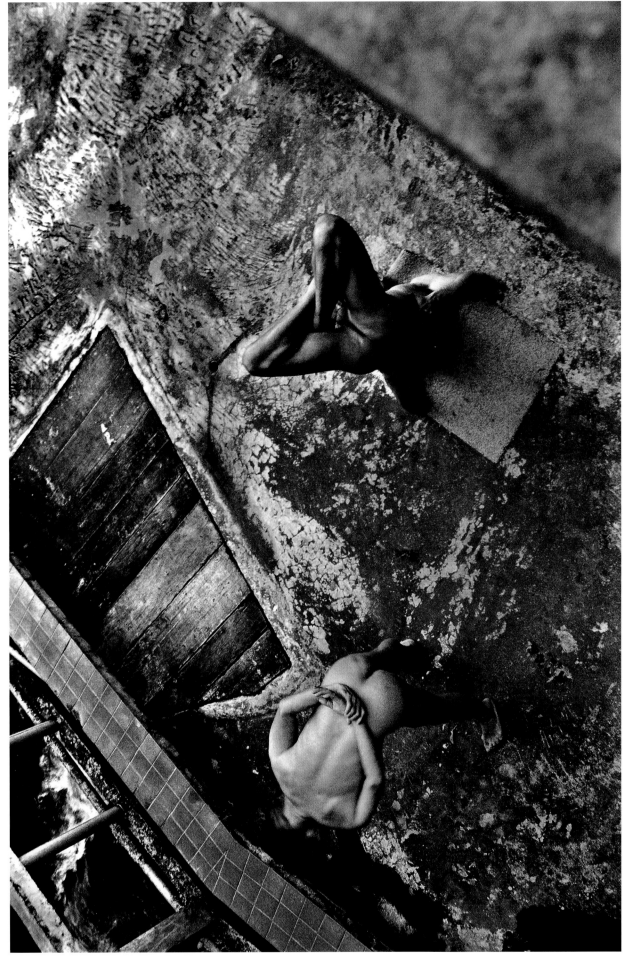

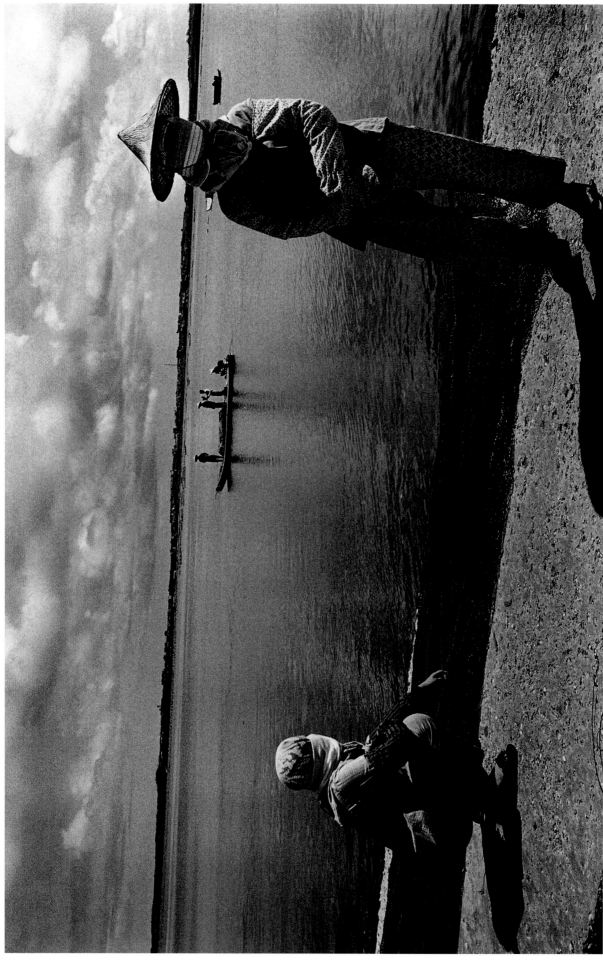

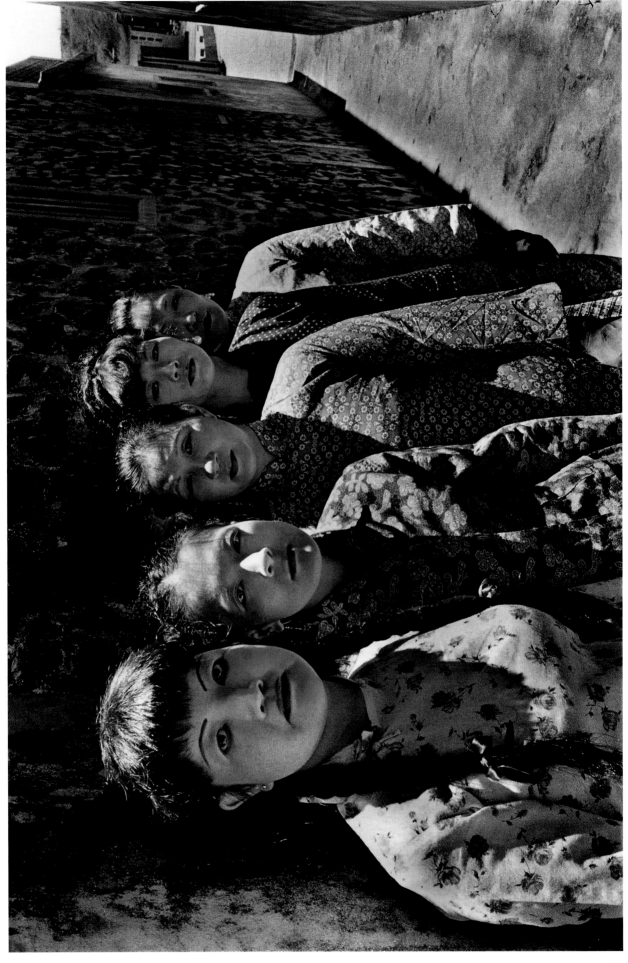

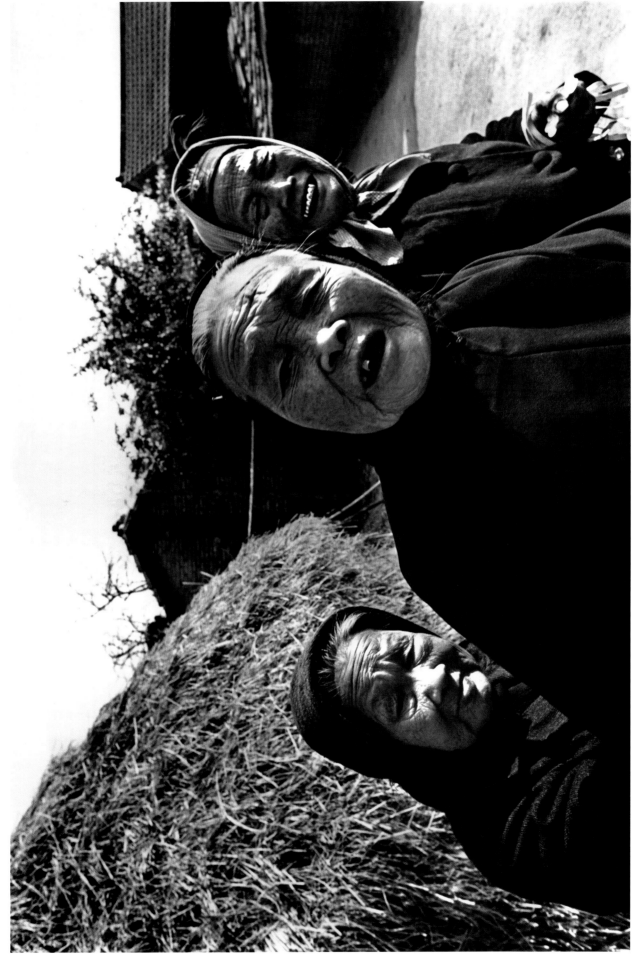

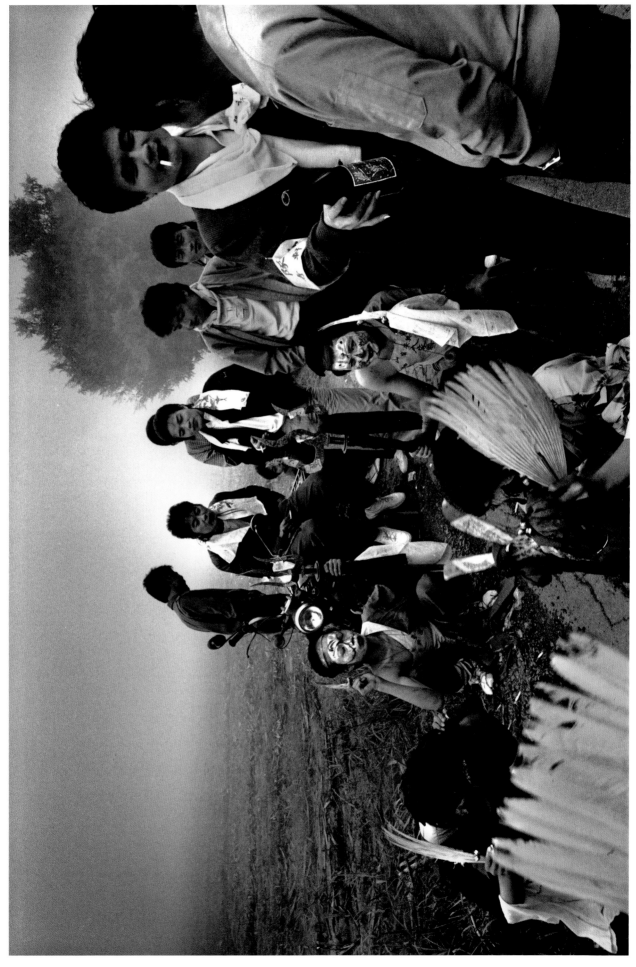

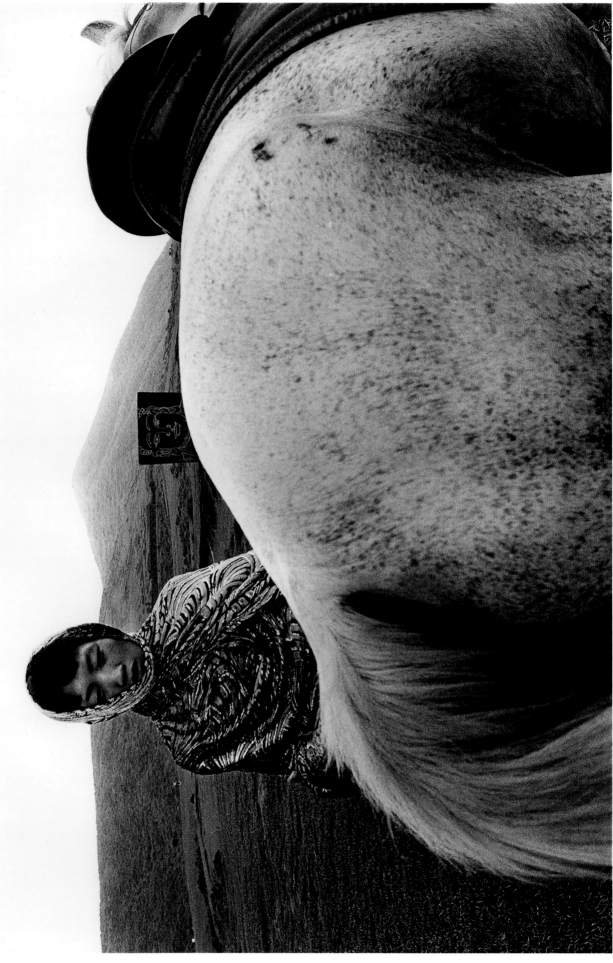

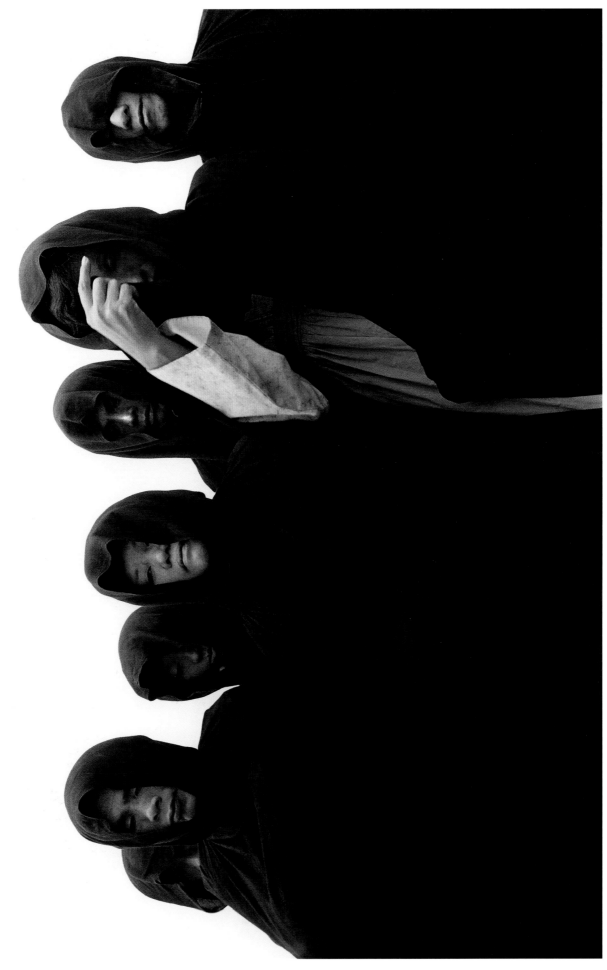

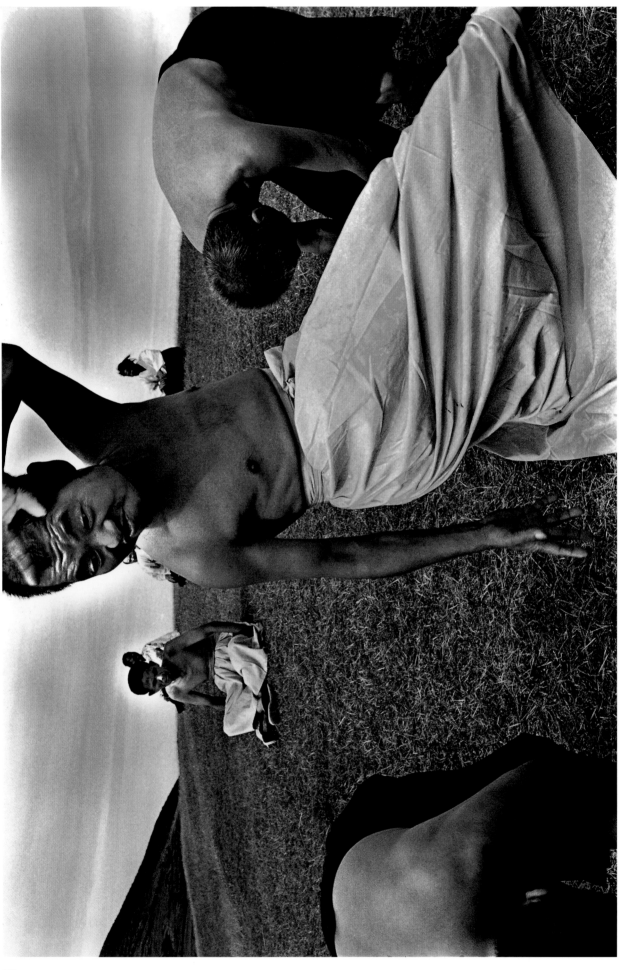

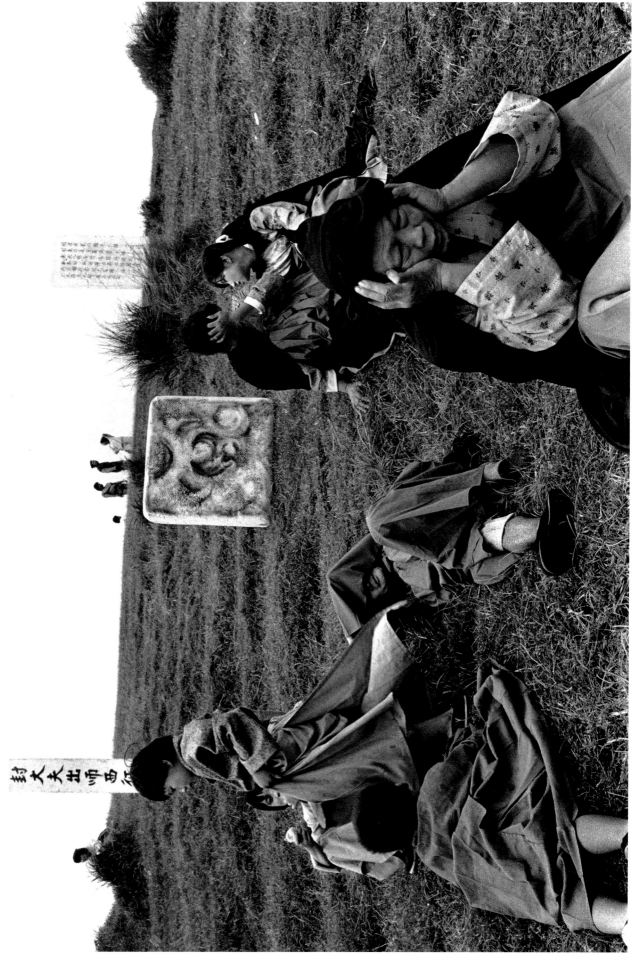

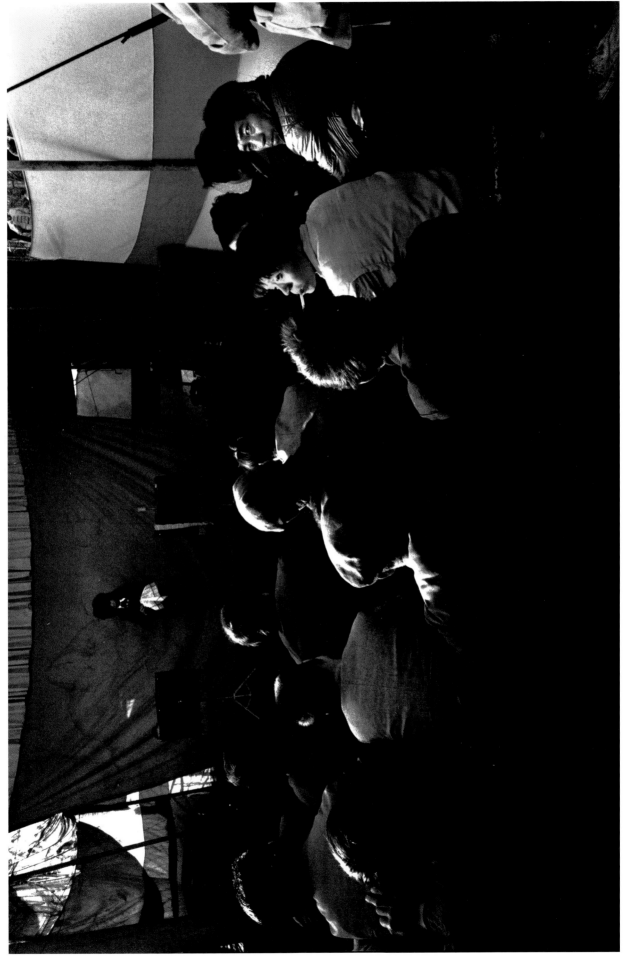

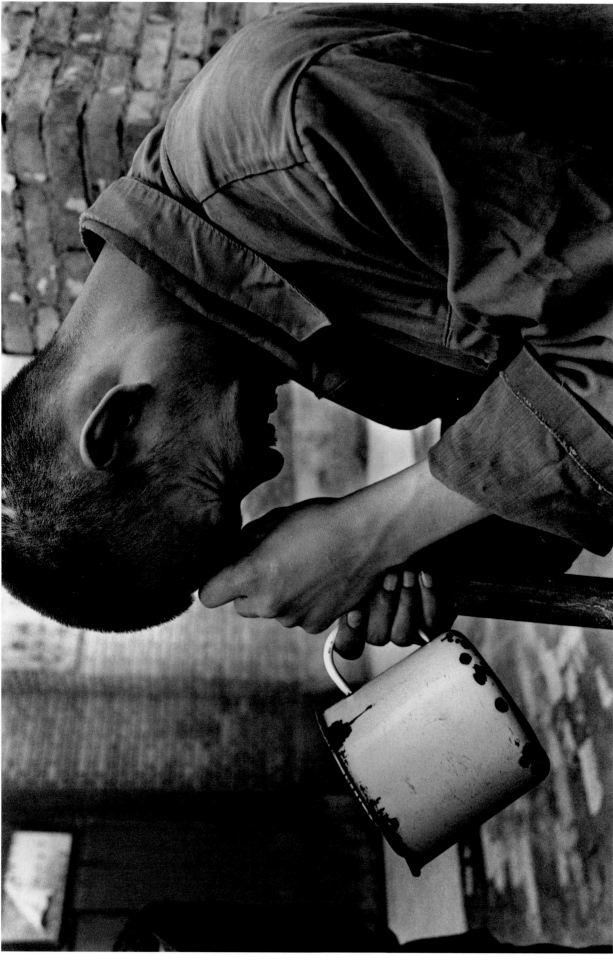

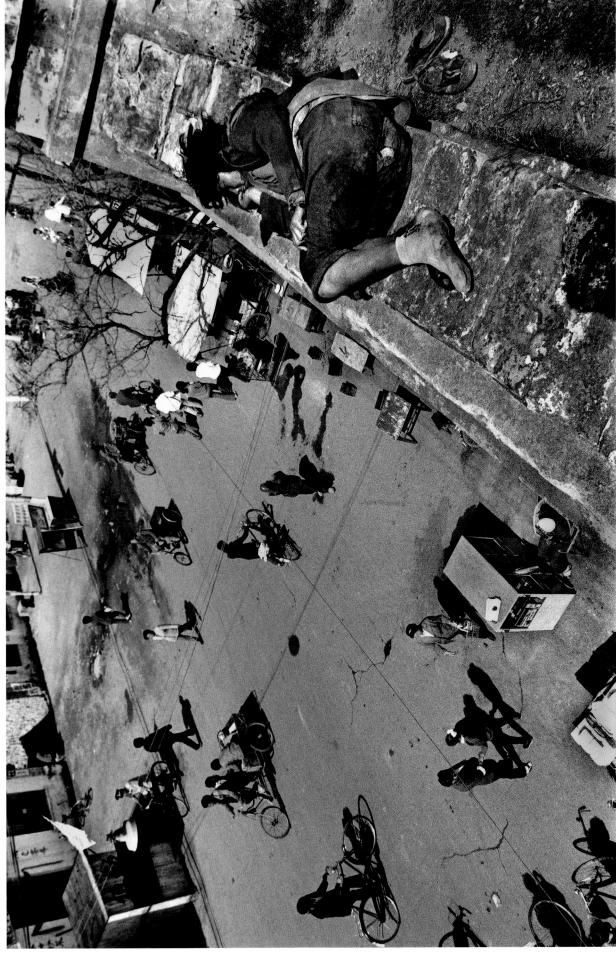

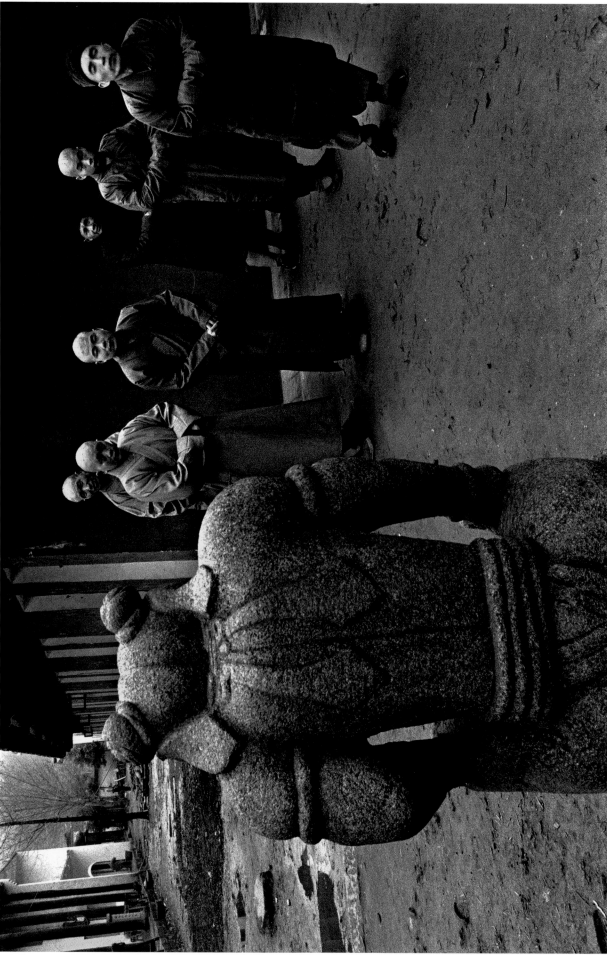

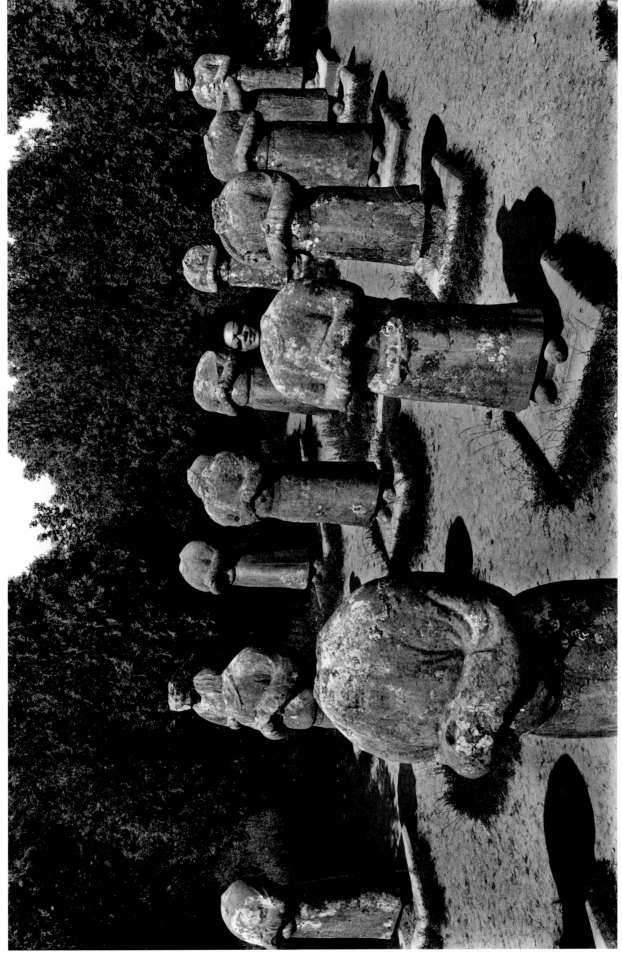

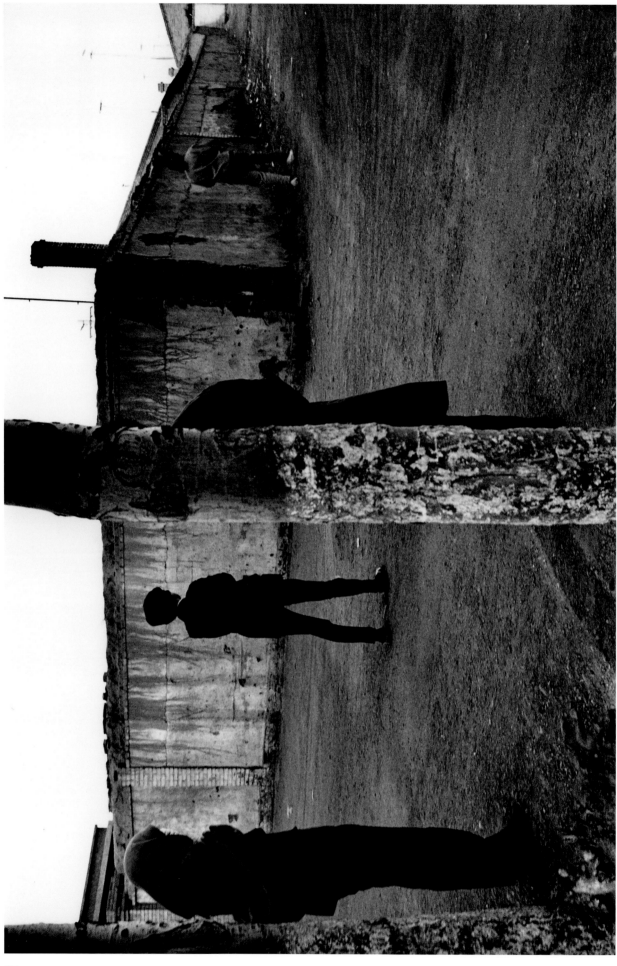

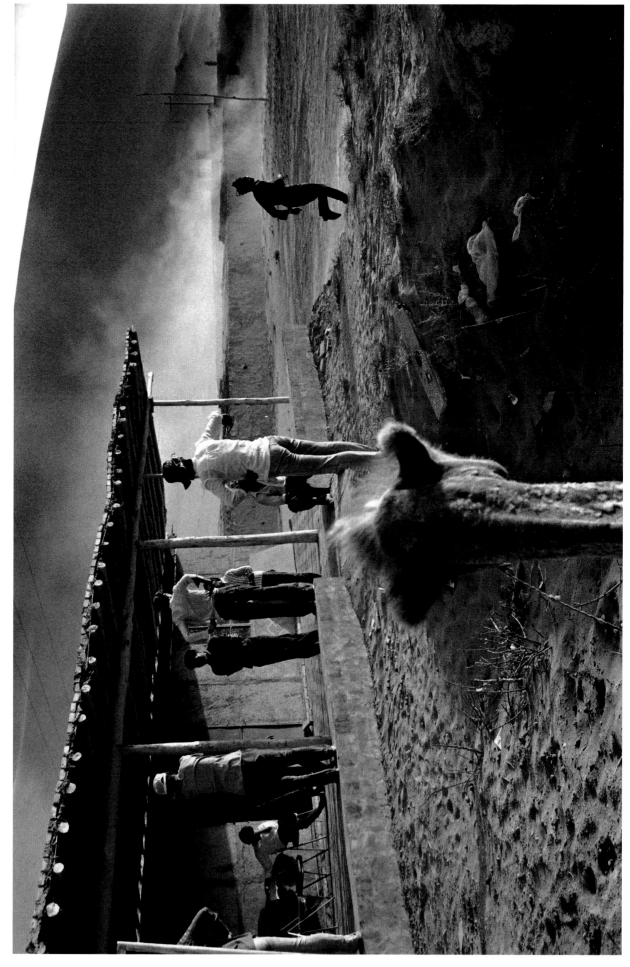

# Faces
# in Time

1962-2013

歳月
容顔

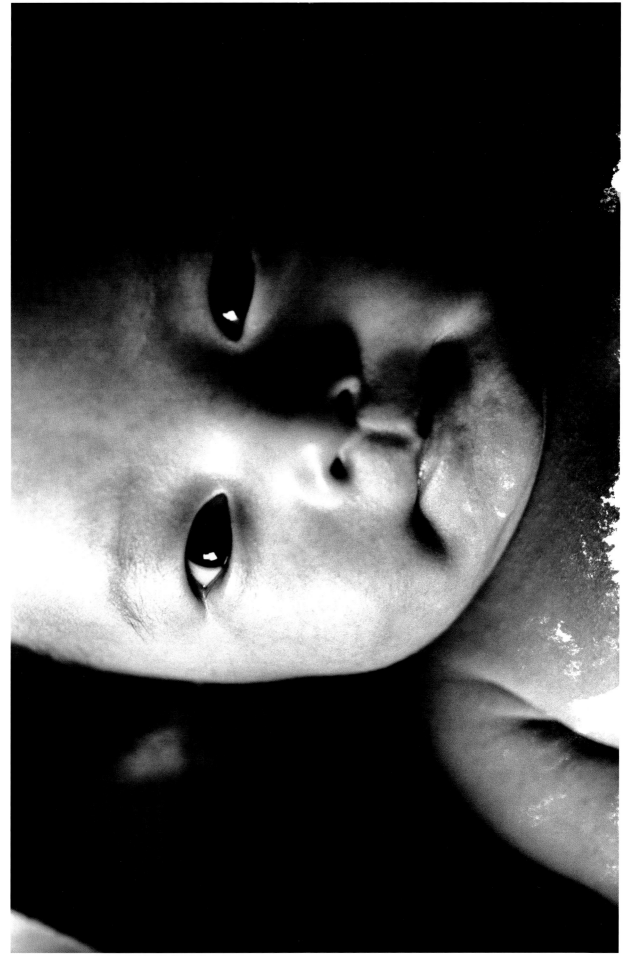

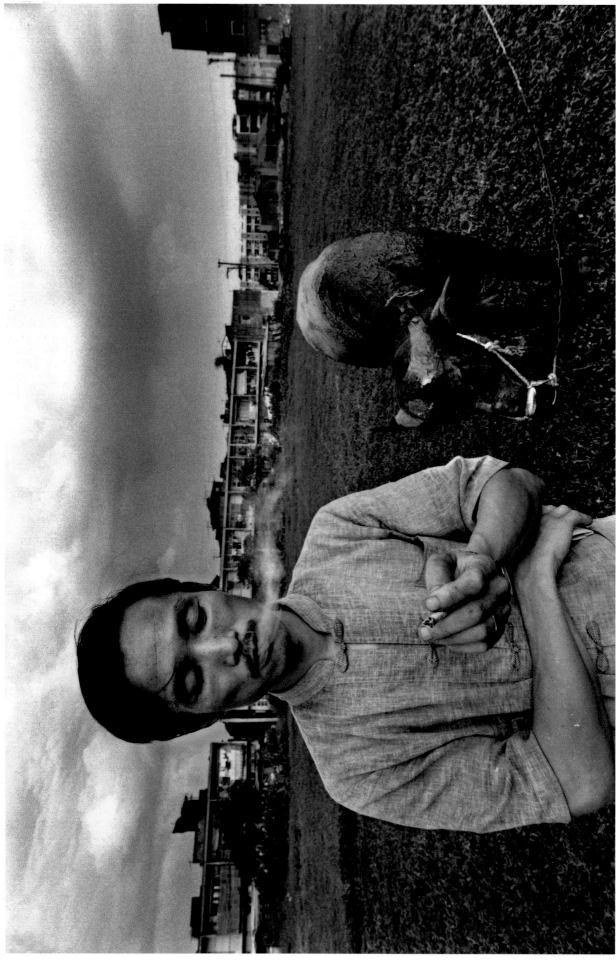

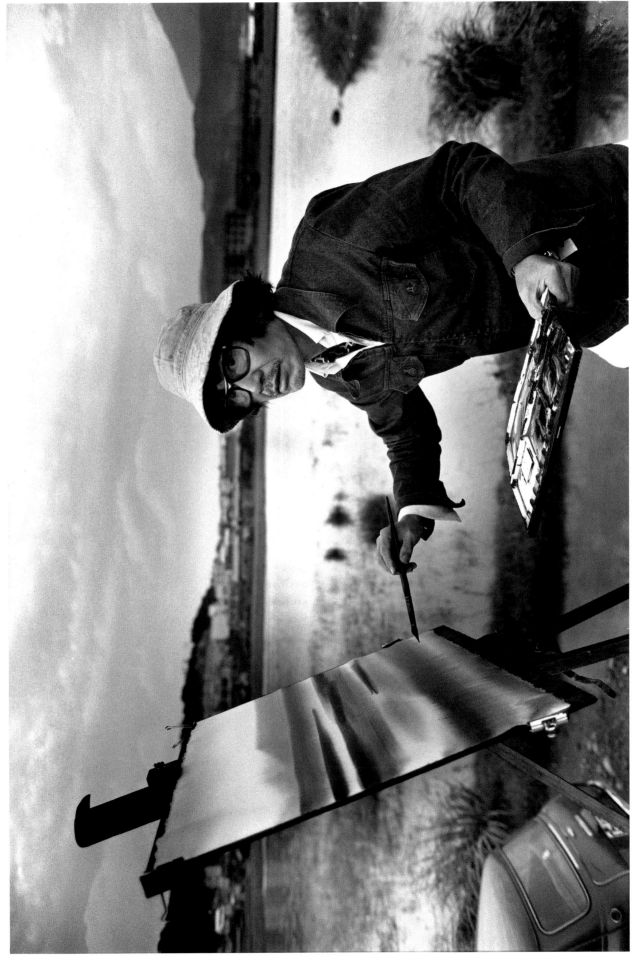

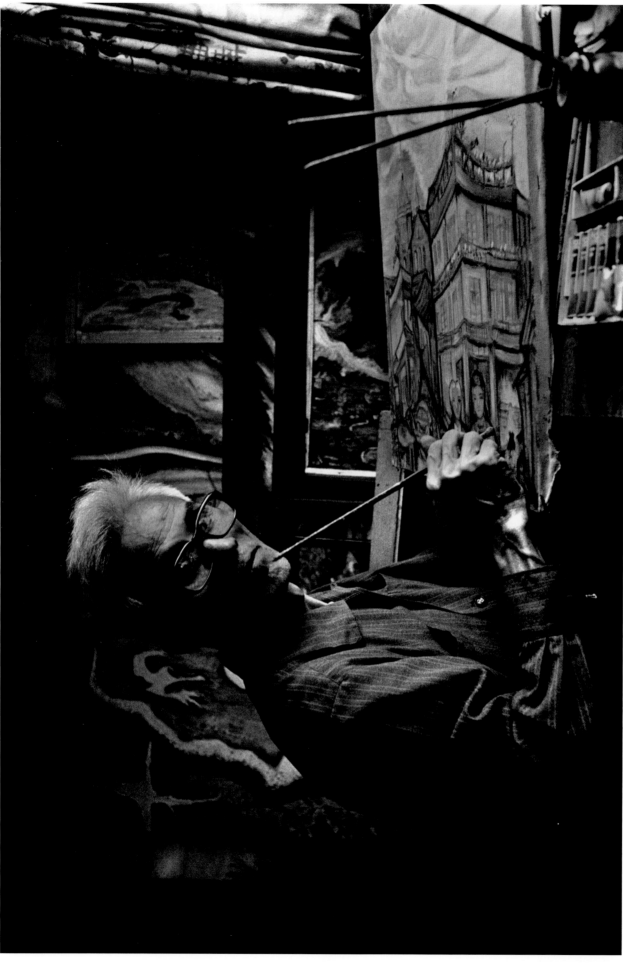

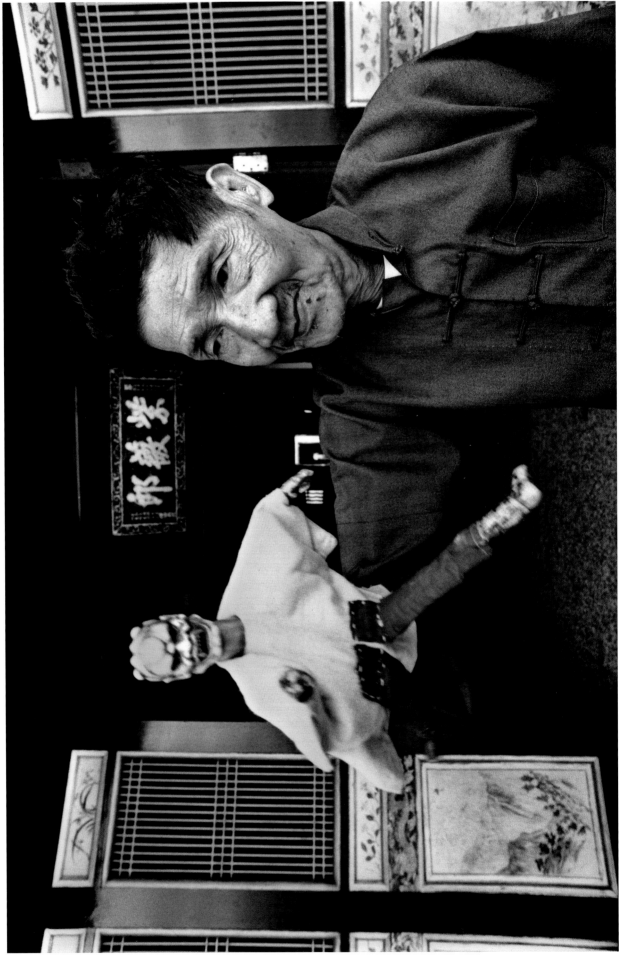

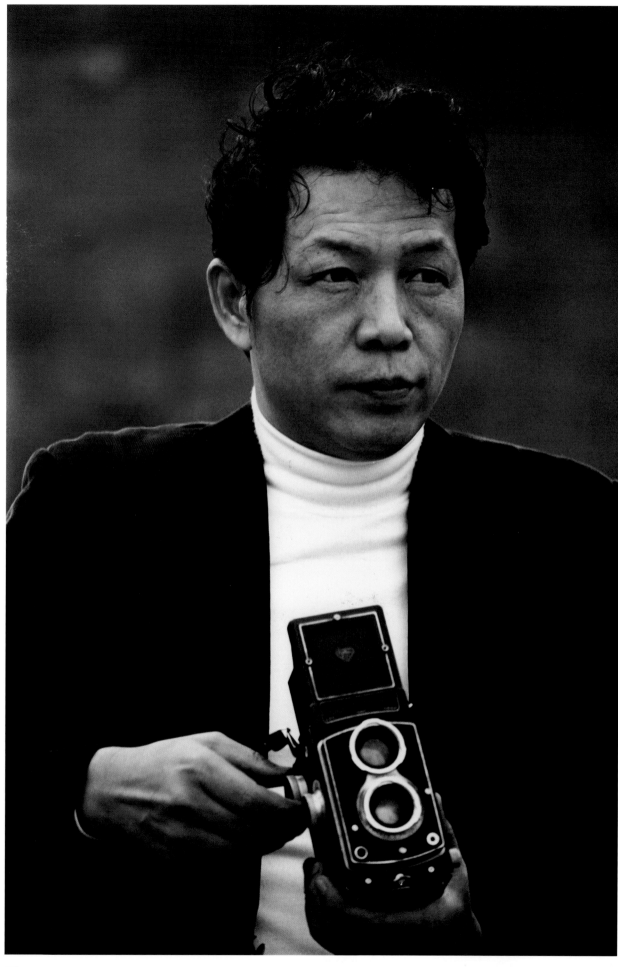

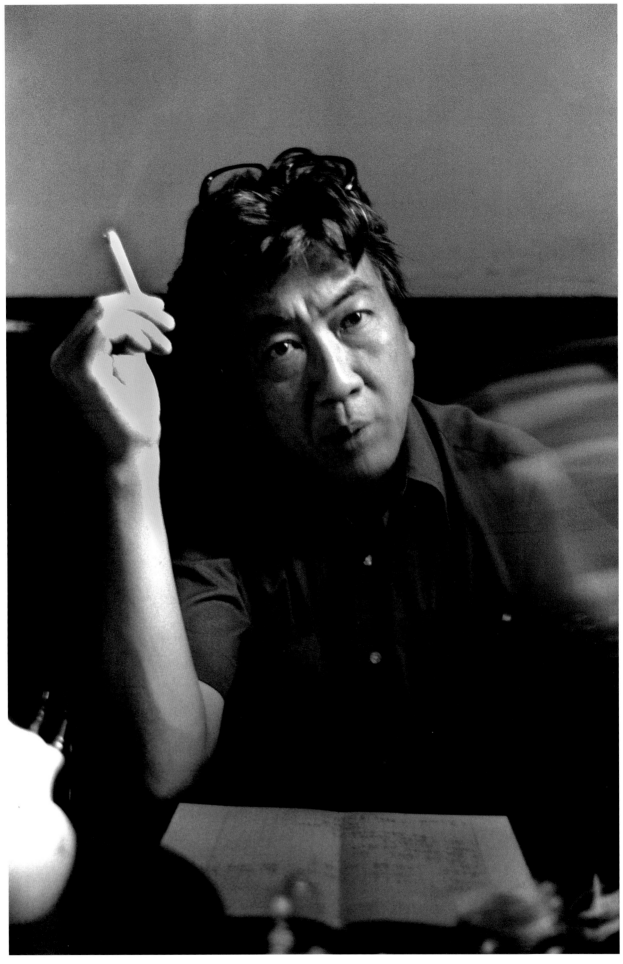

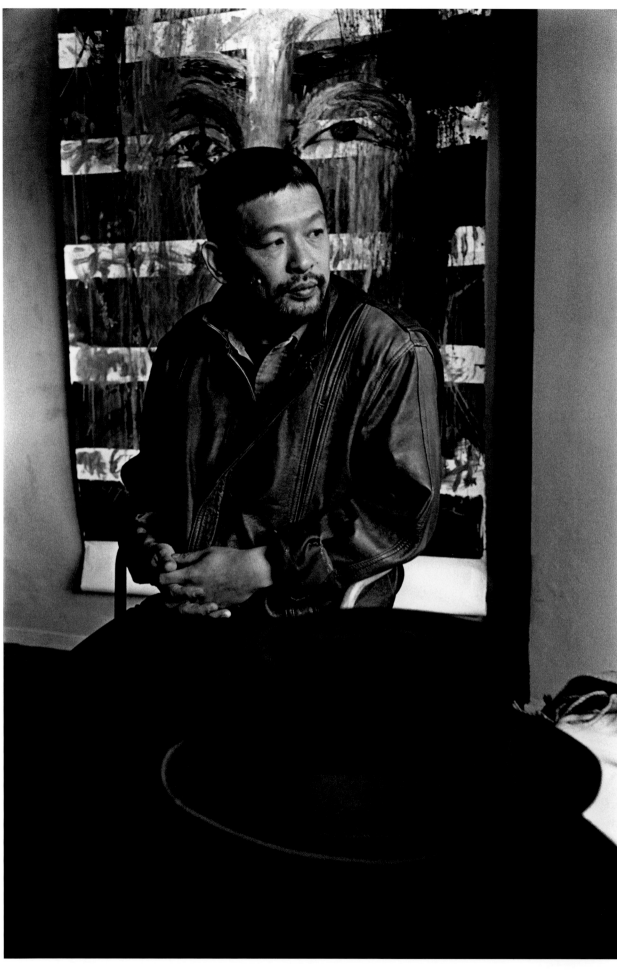

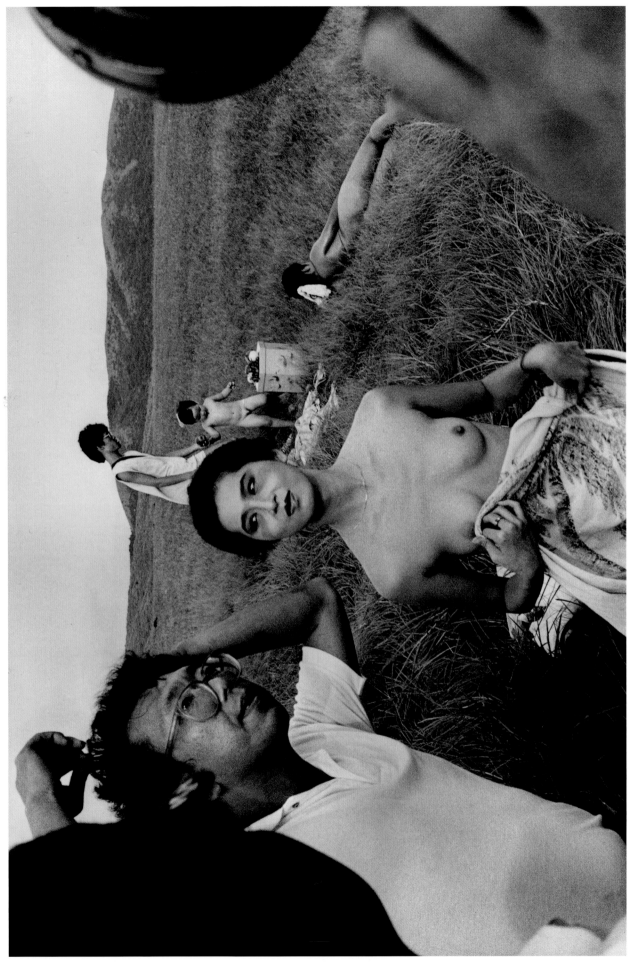

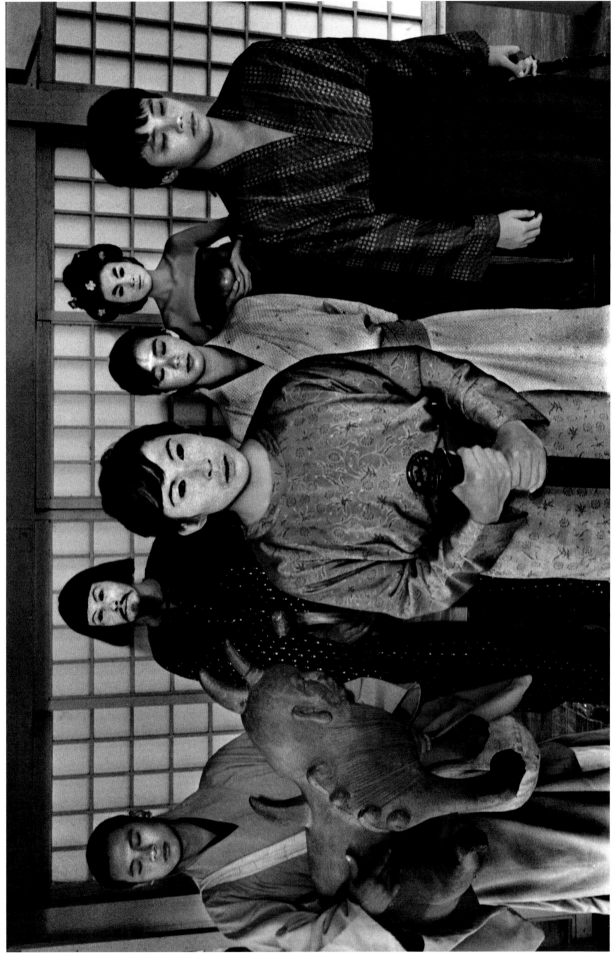

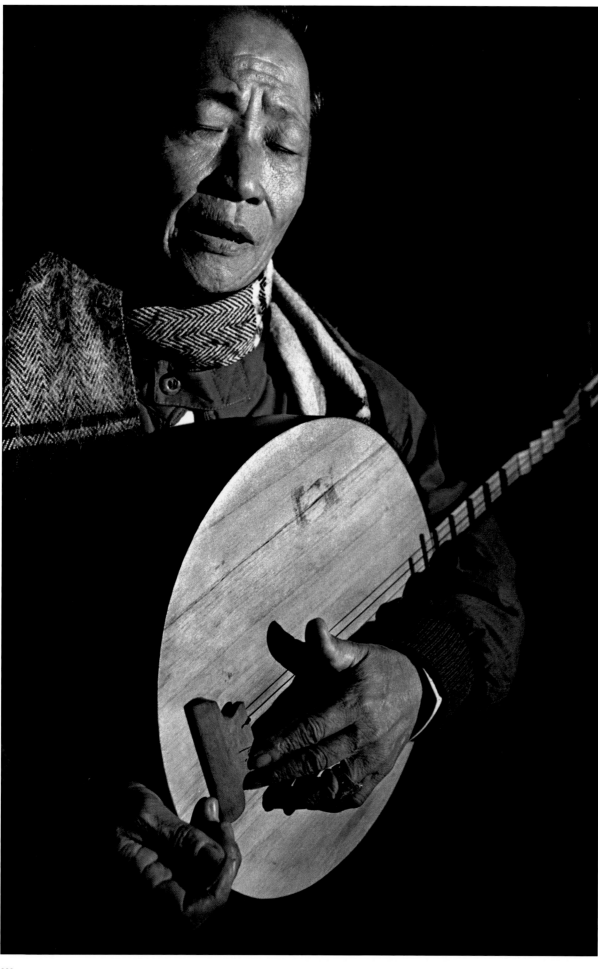

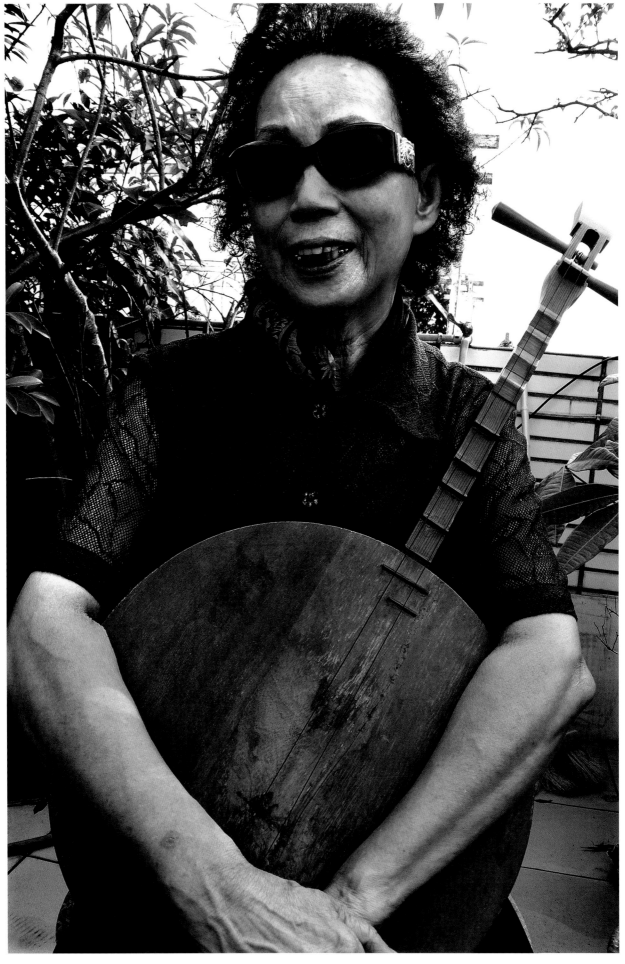

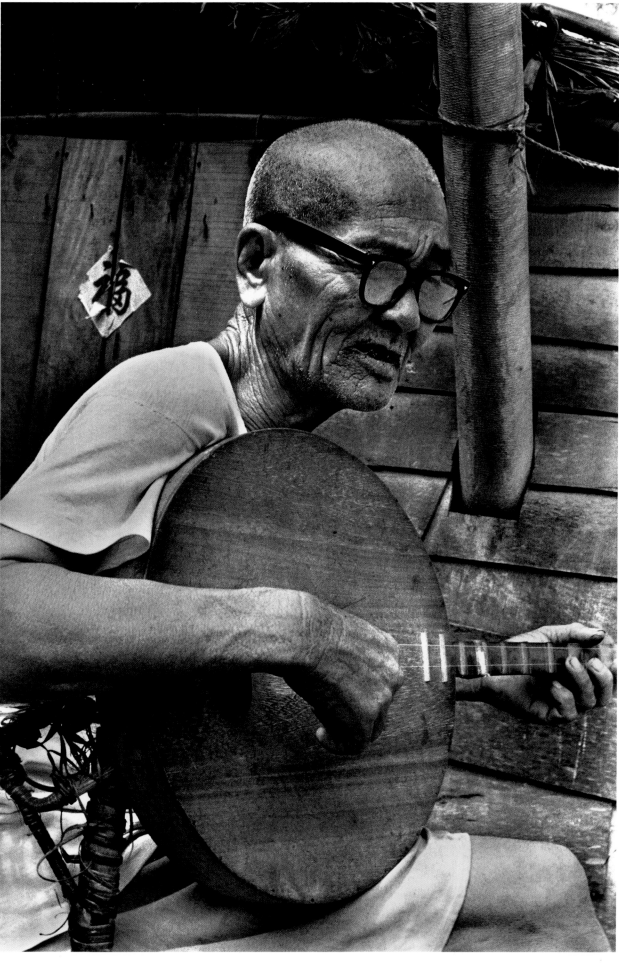

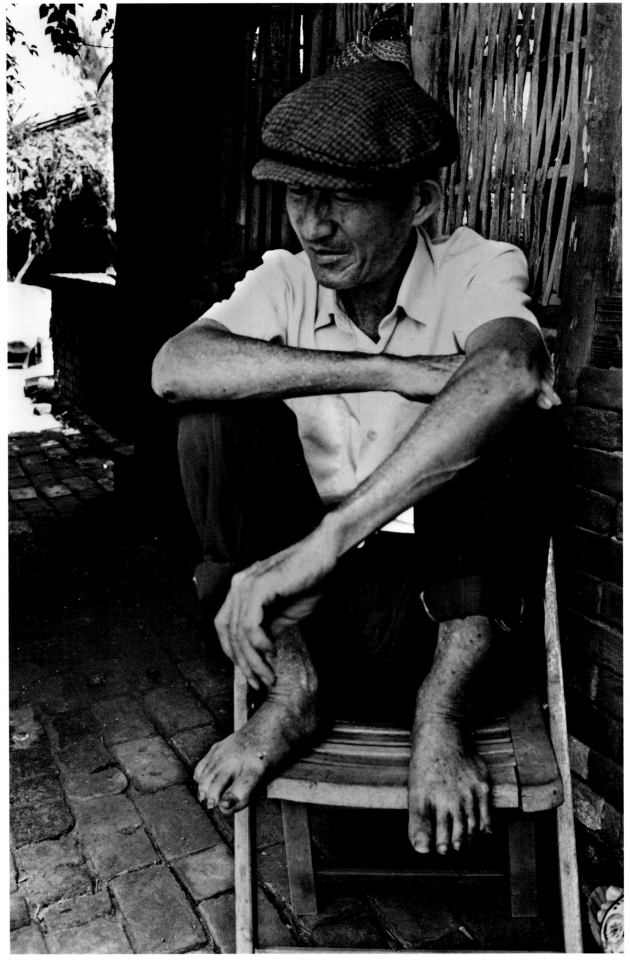

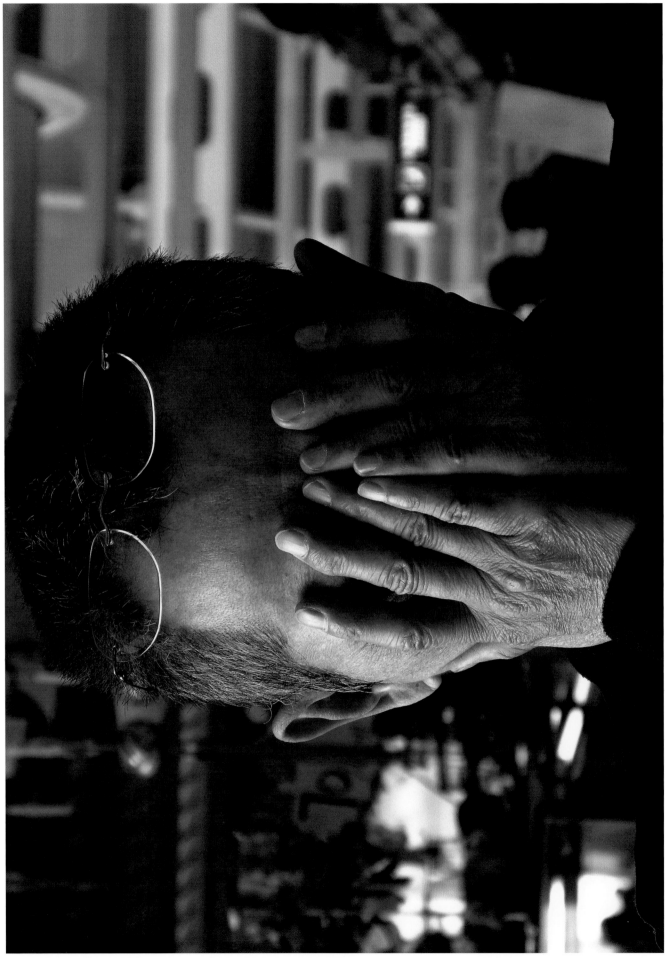

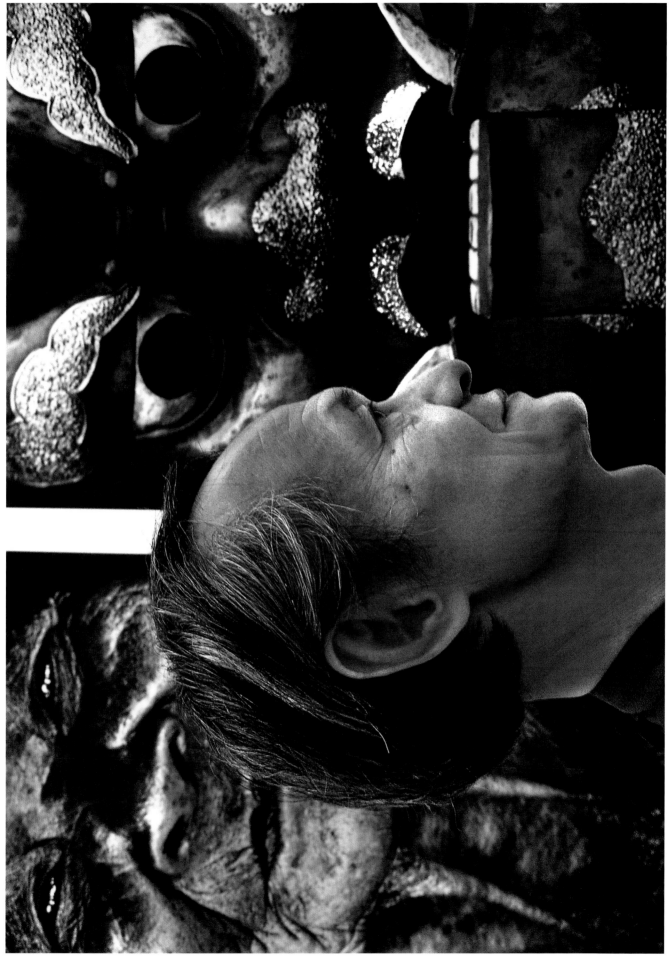

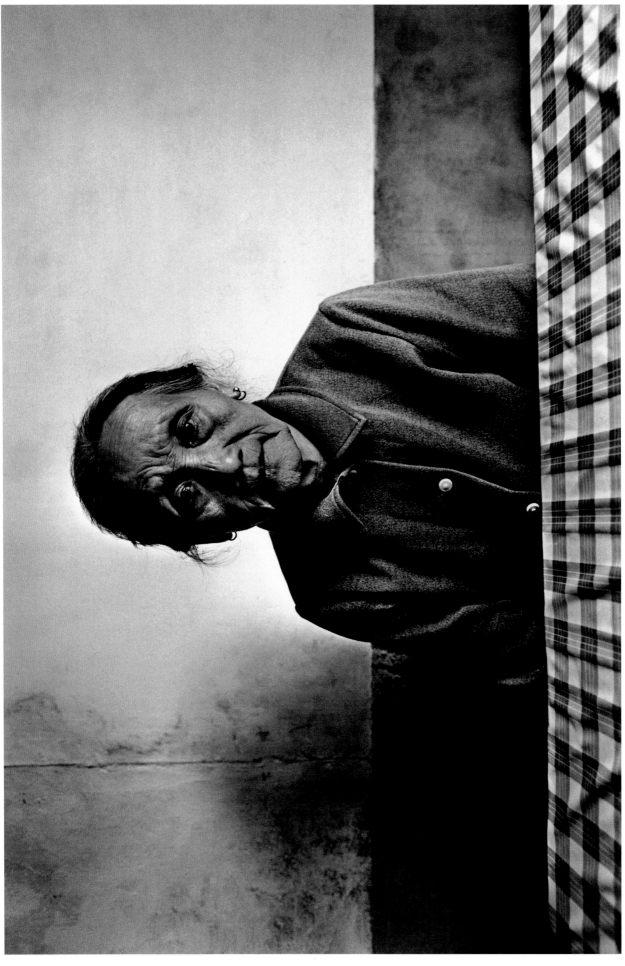

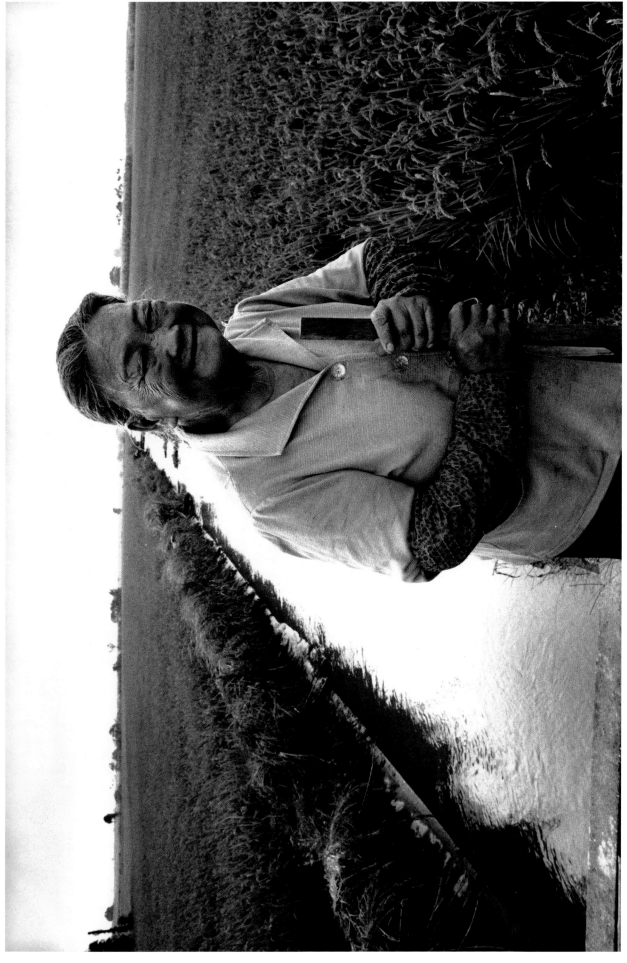

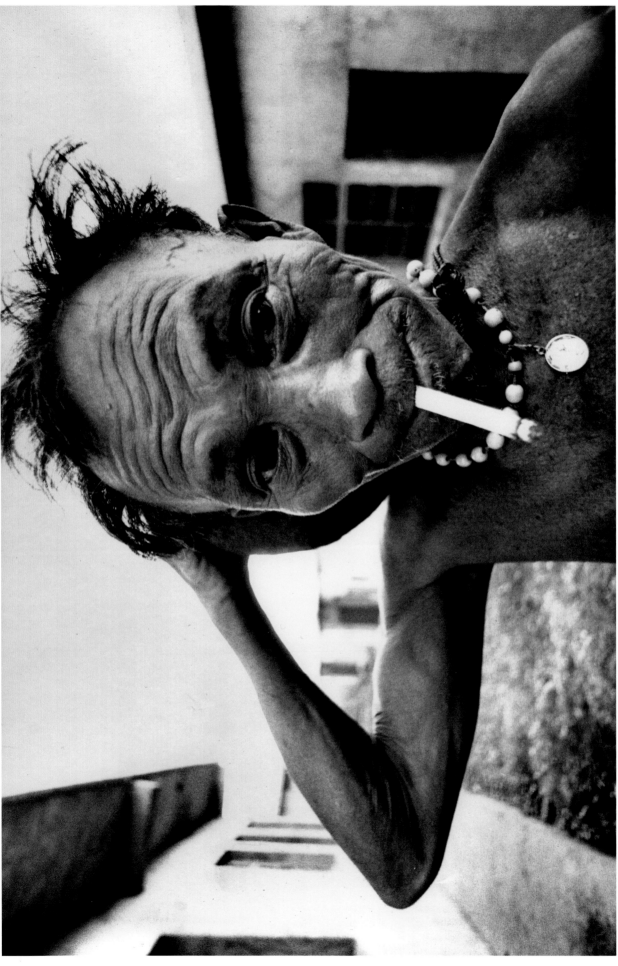

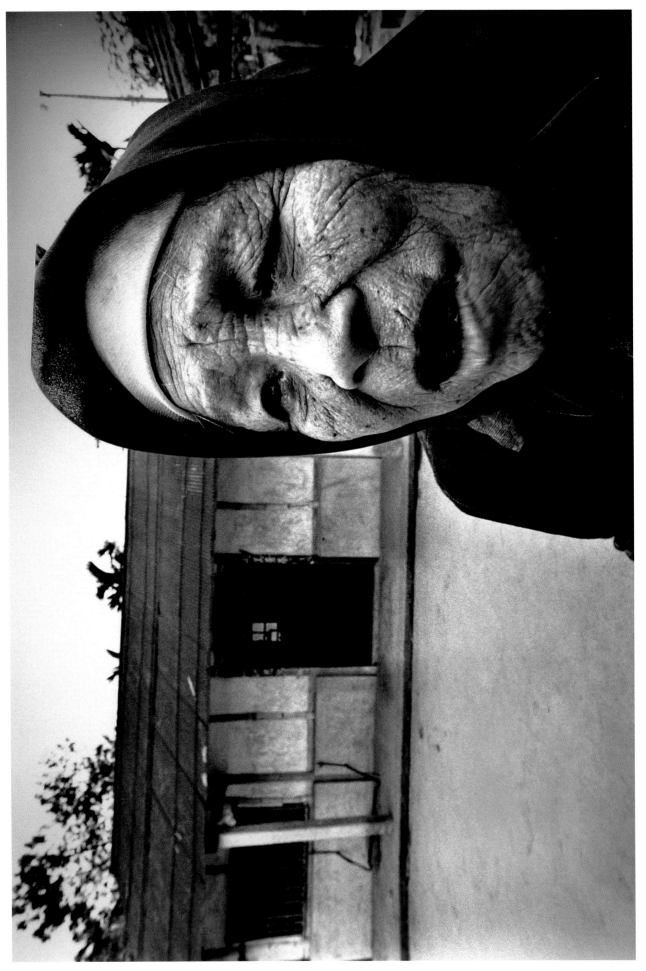

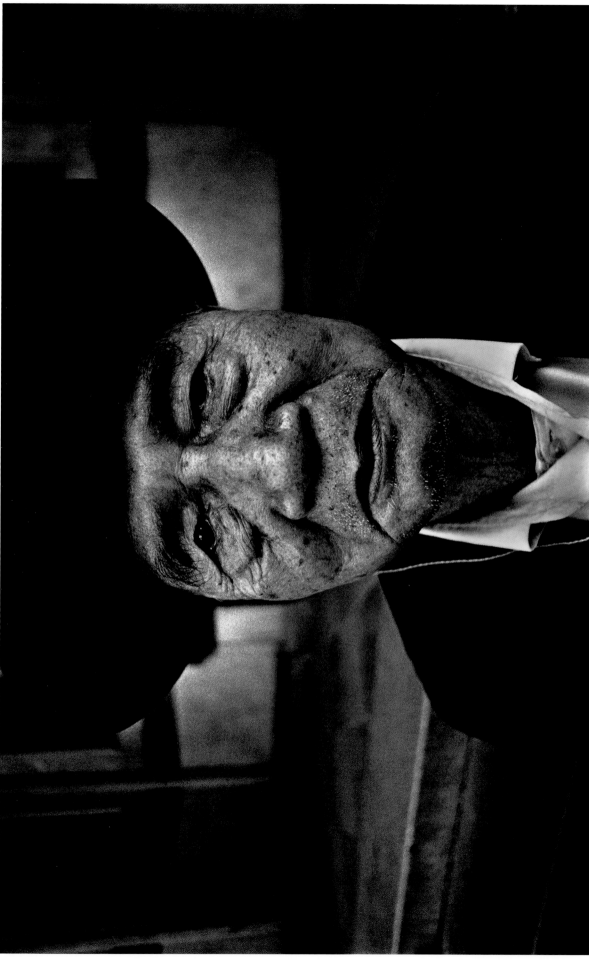

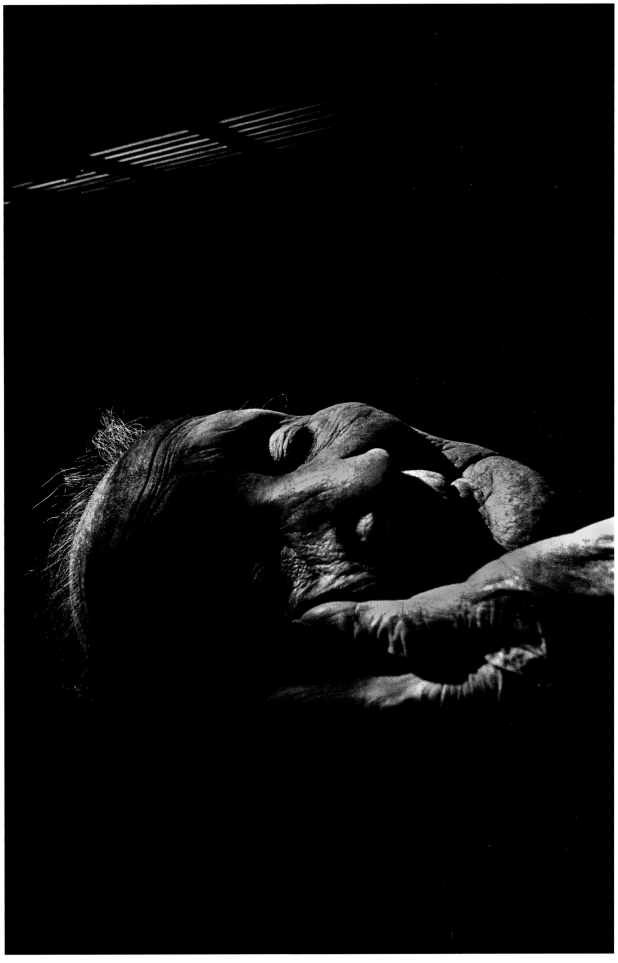

# Inner
# Landscapes

1970-2005

內心風景

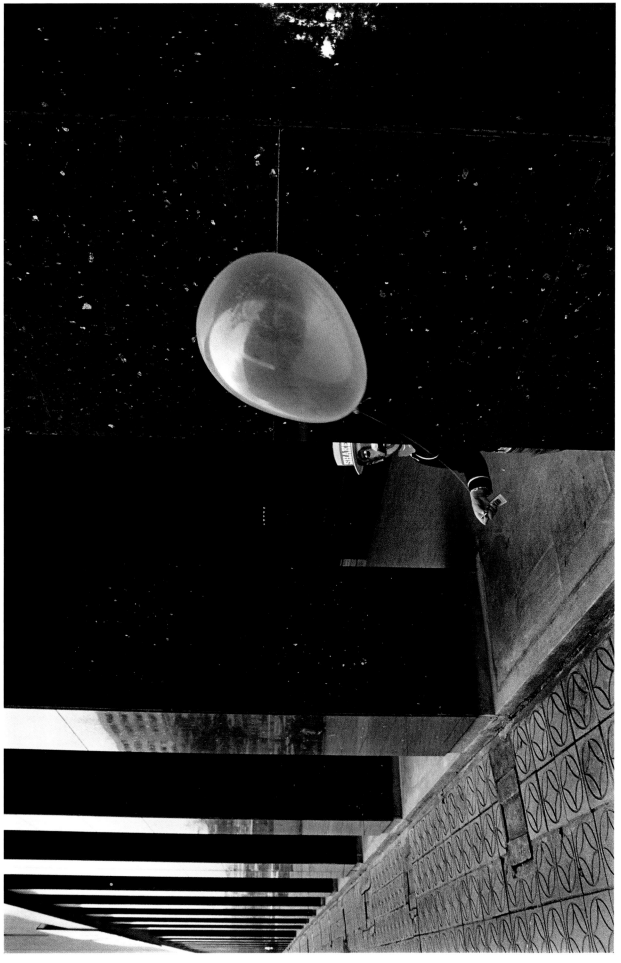

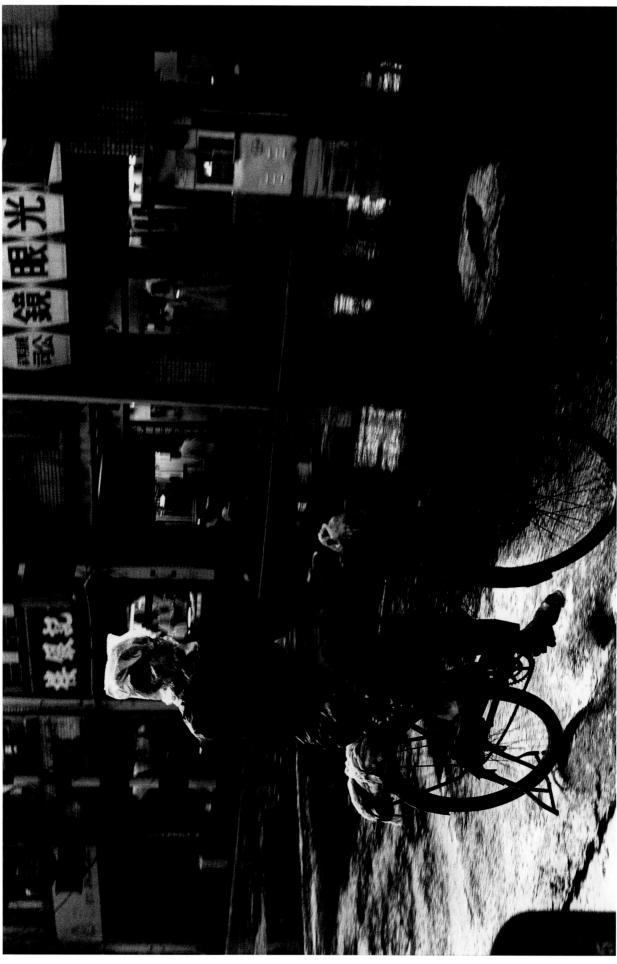

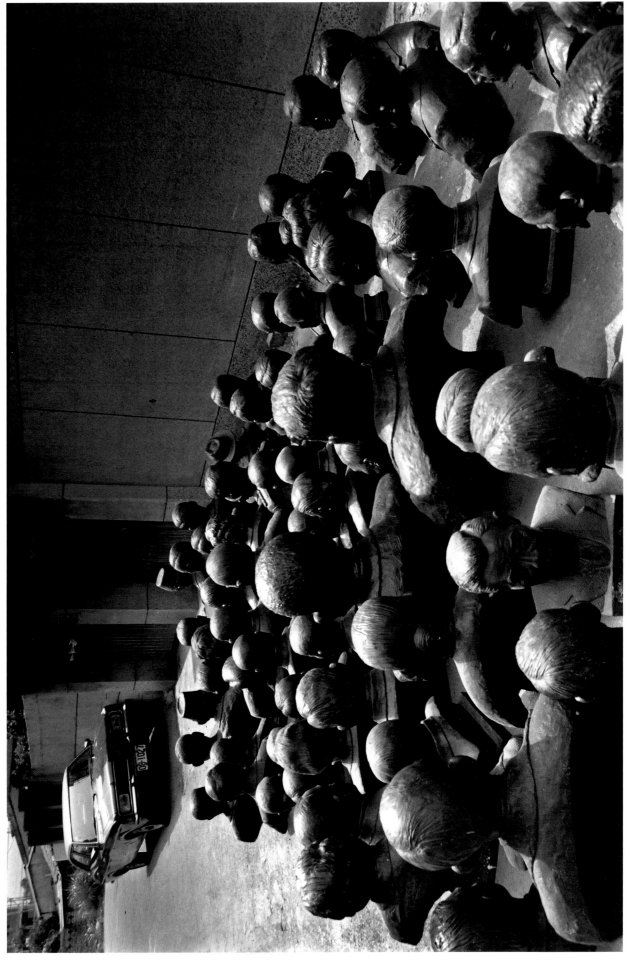

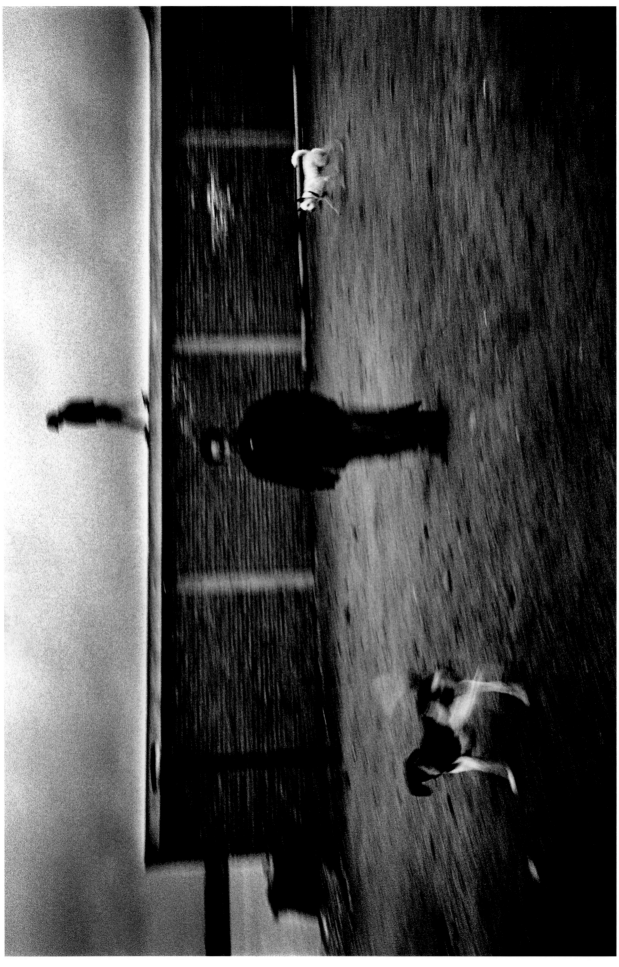

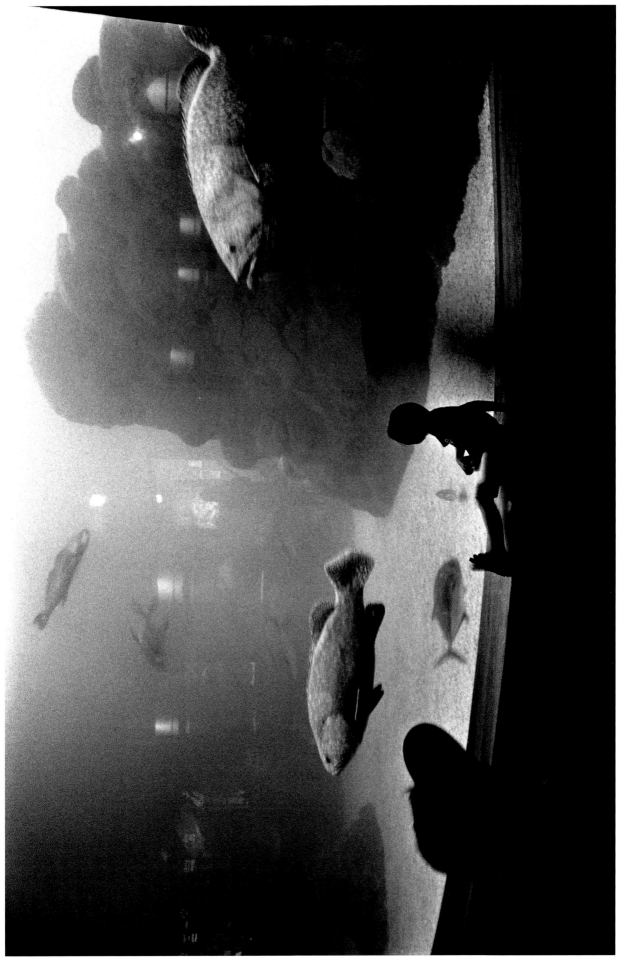

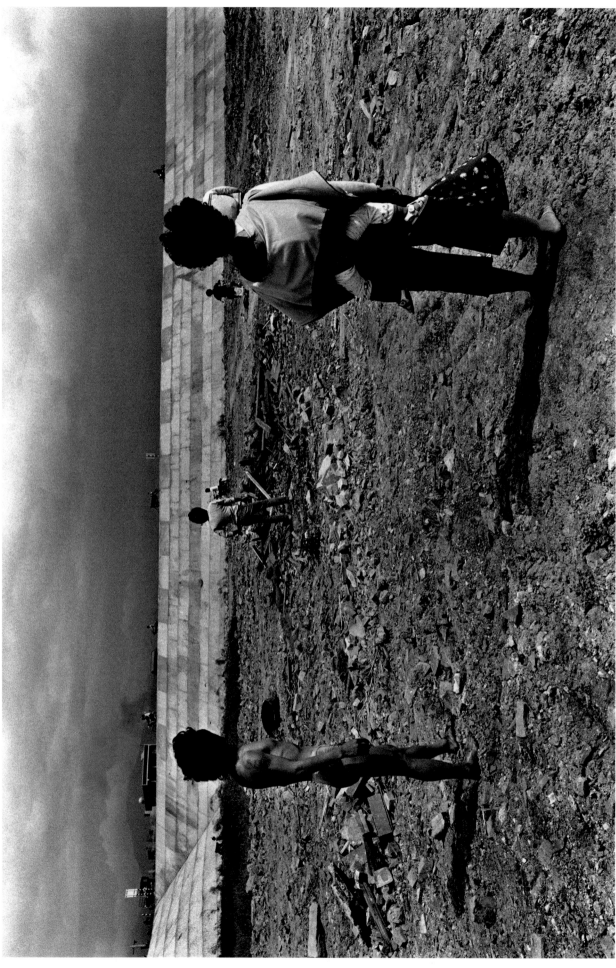

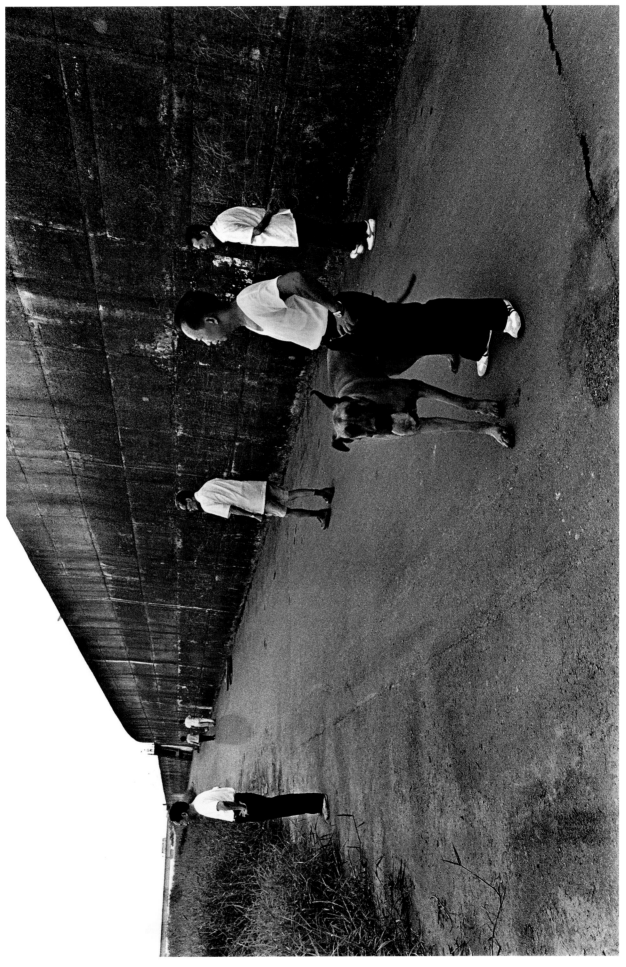

300

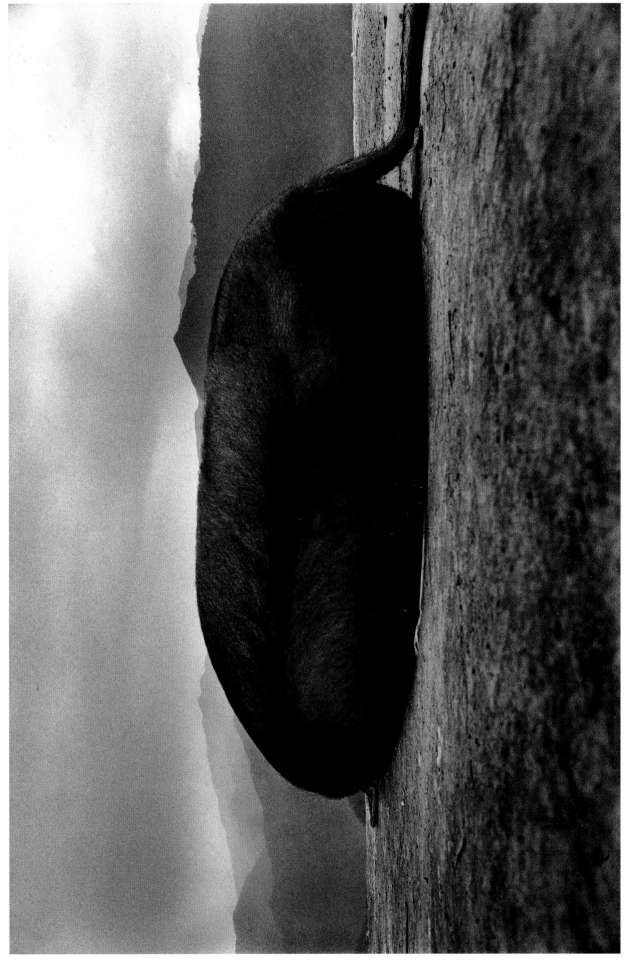

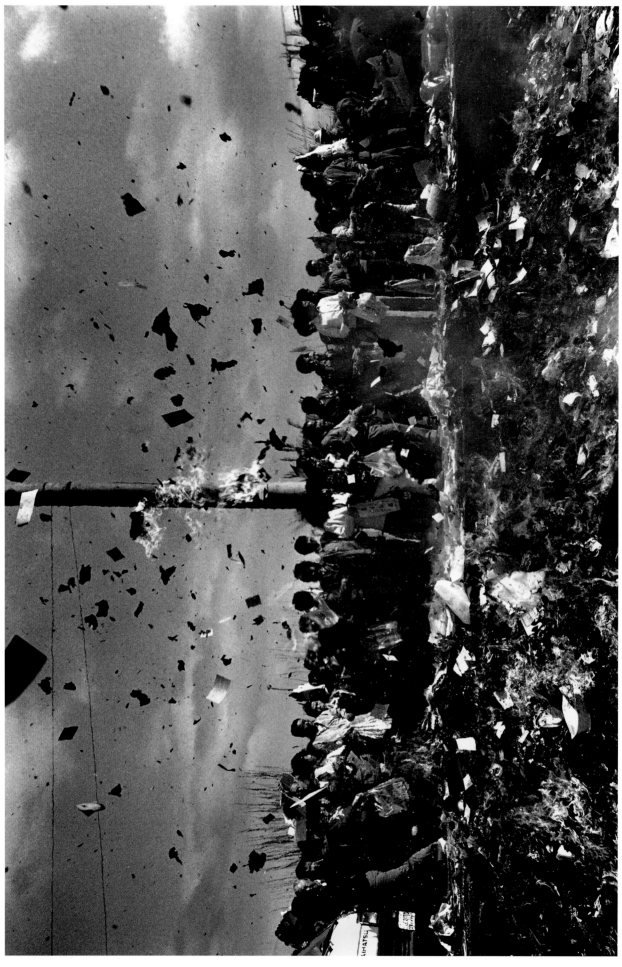

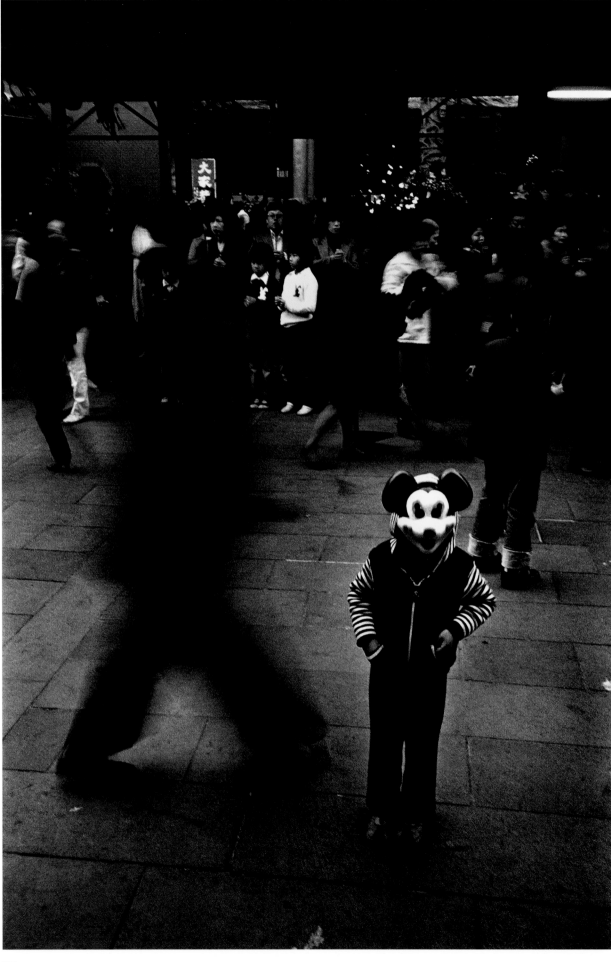

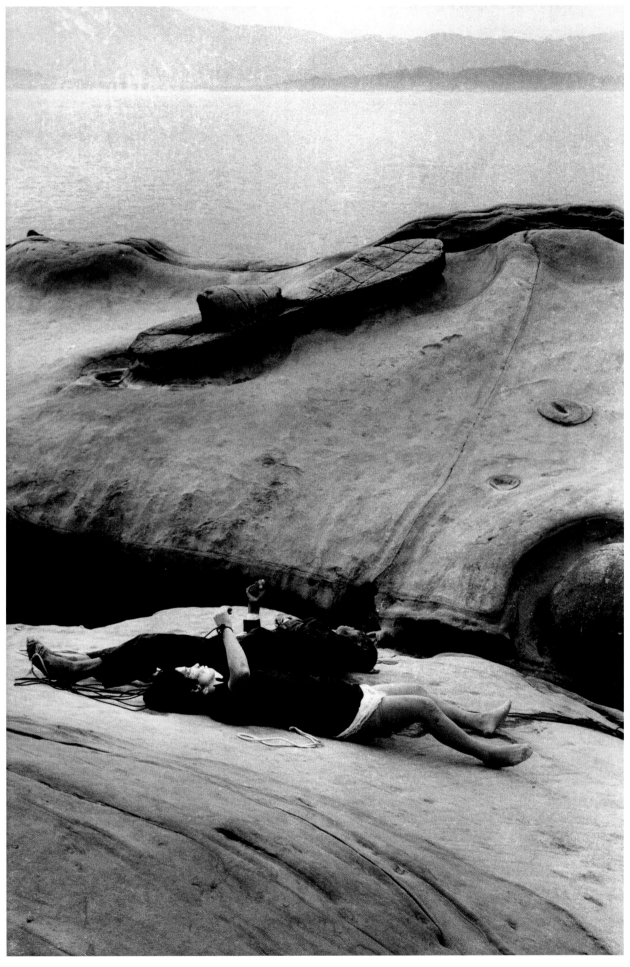

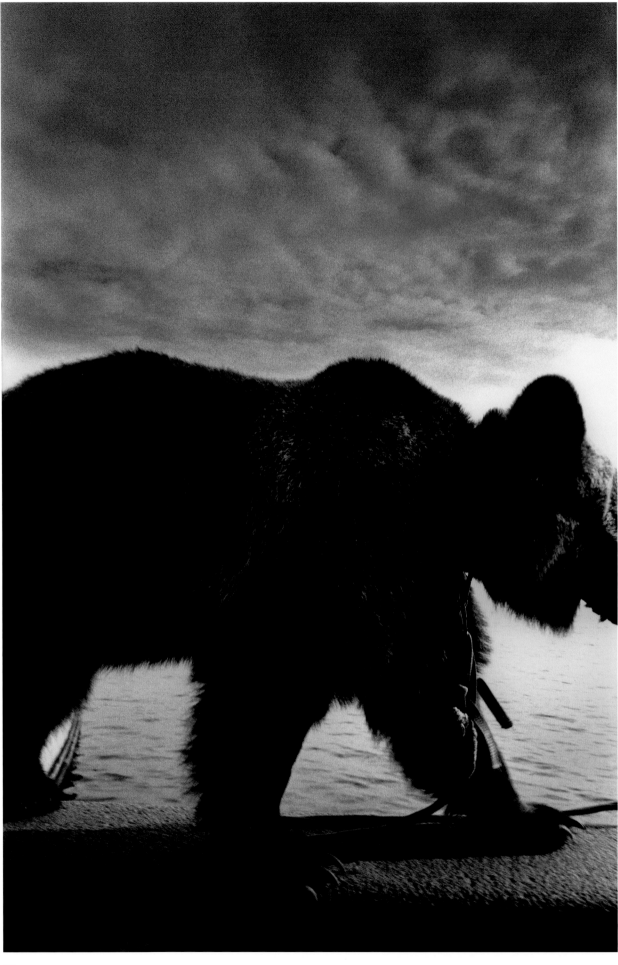

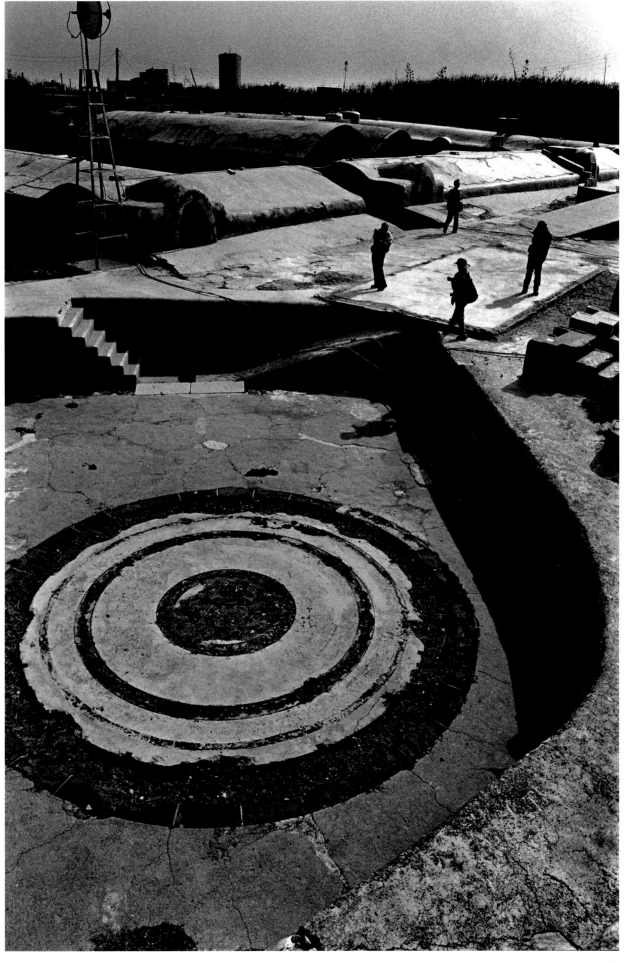

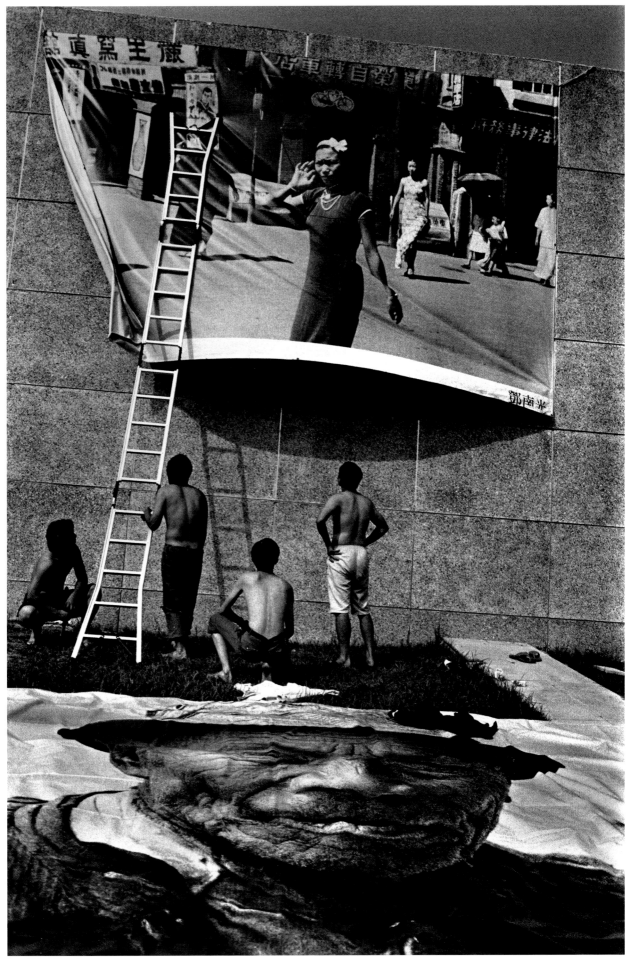

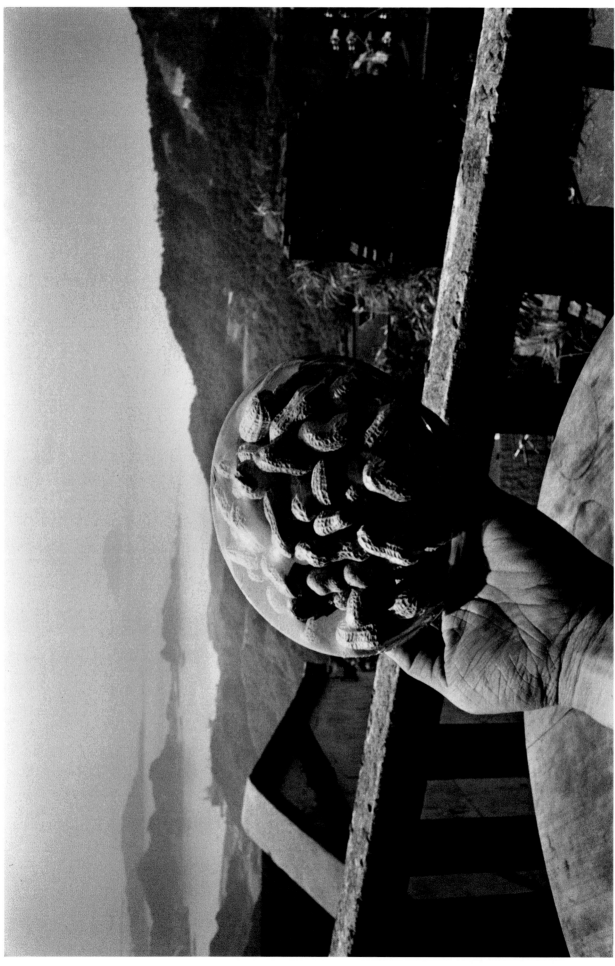

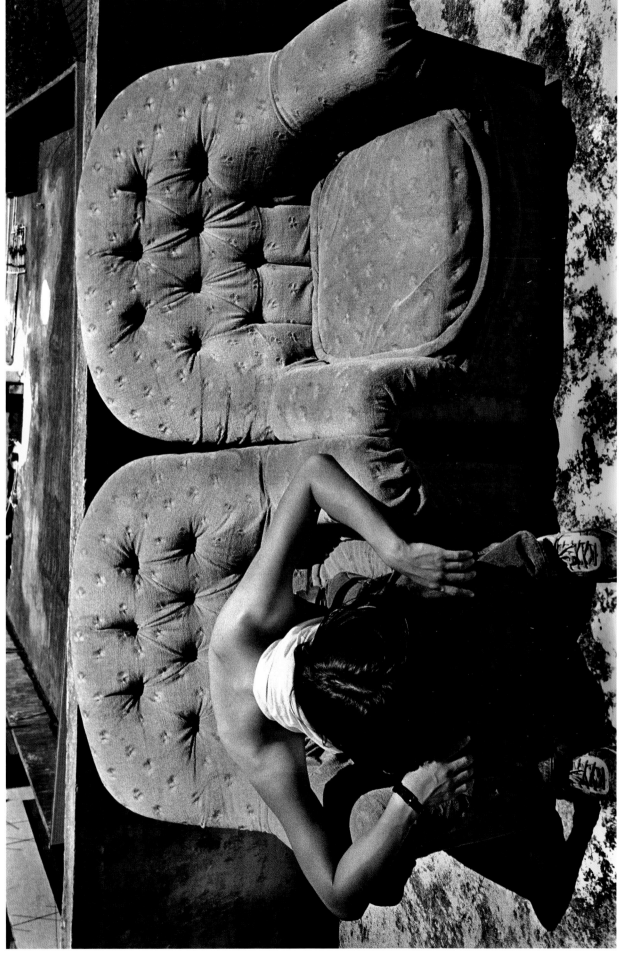

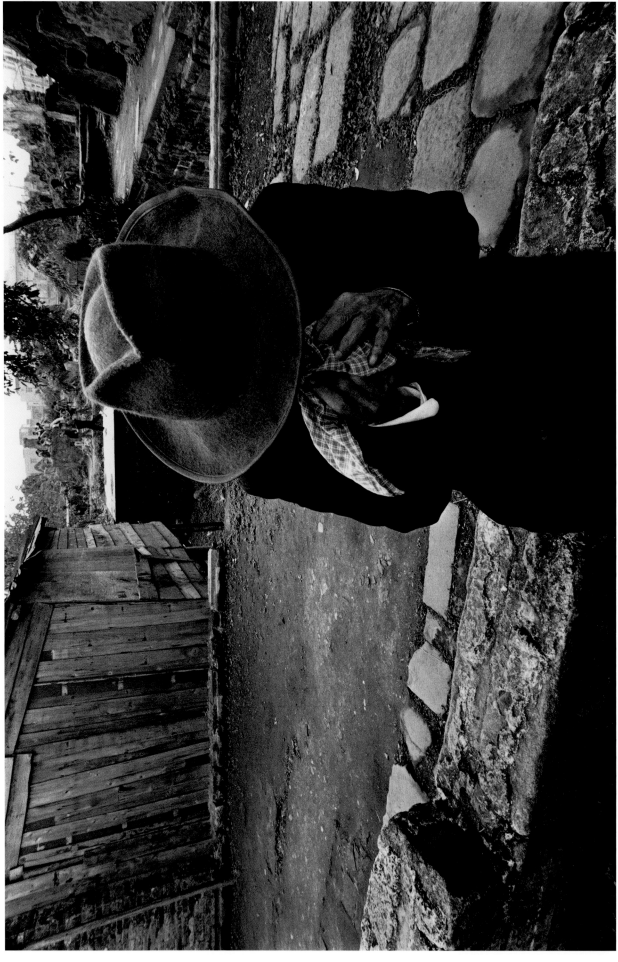

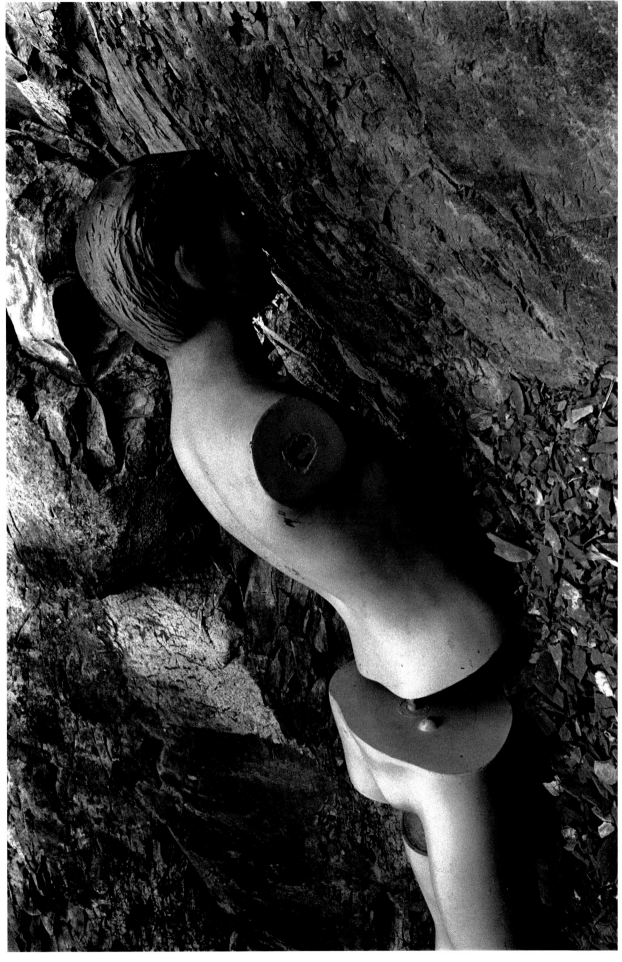

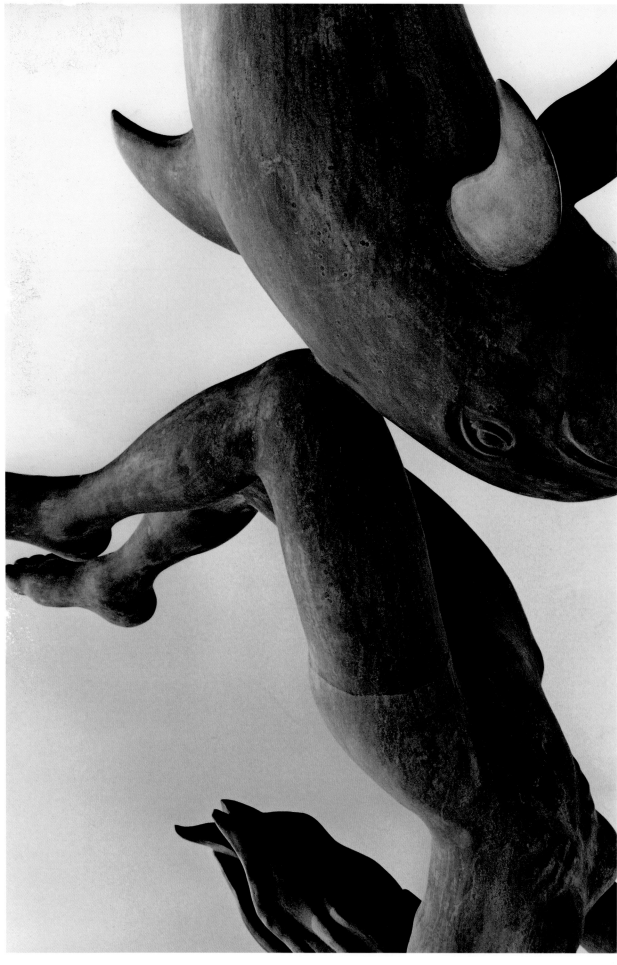

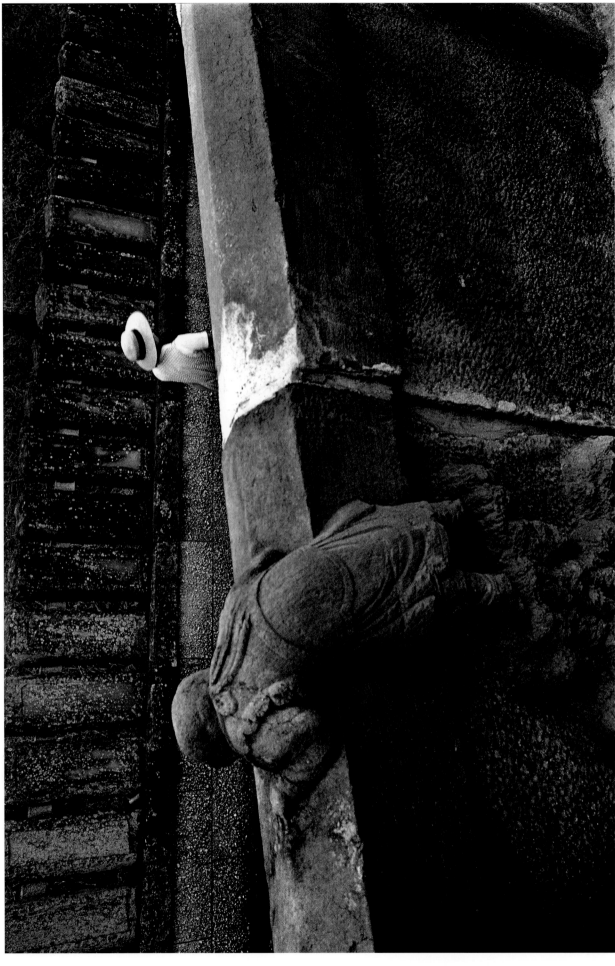

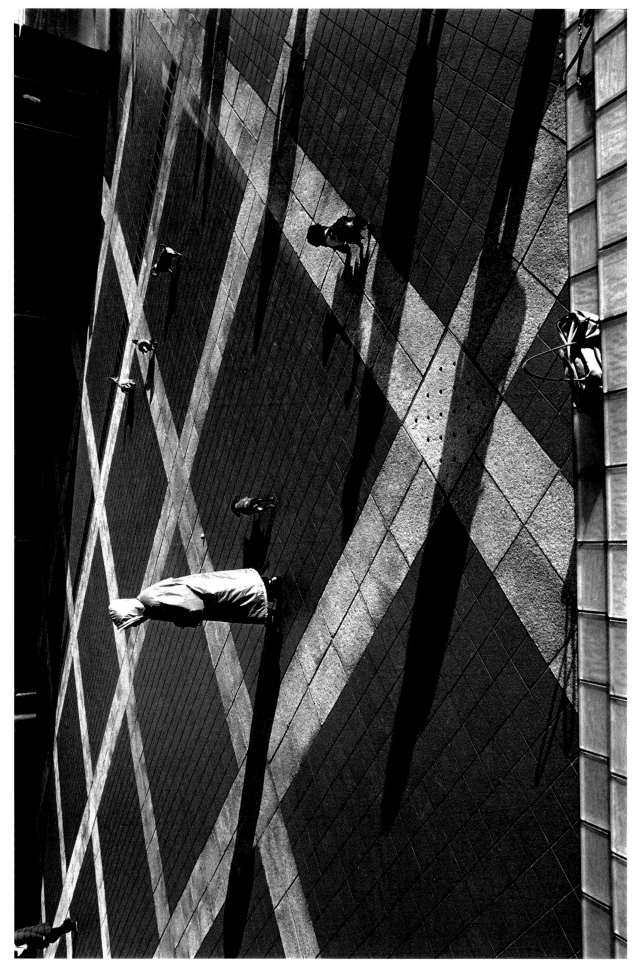

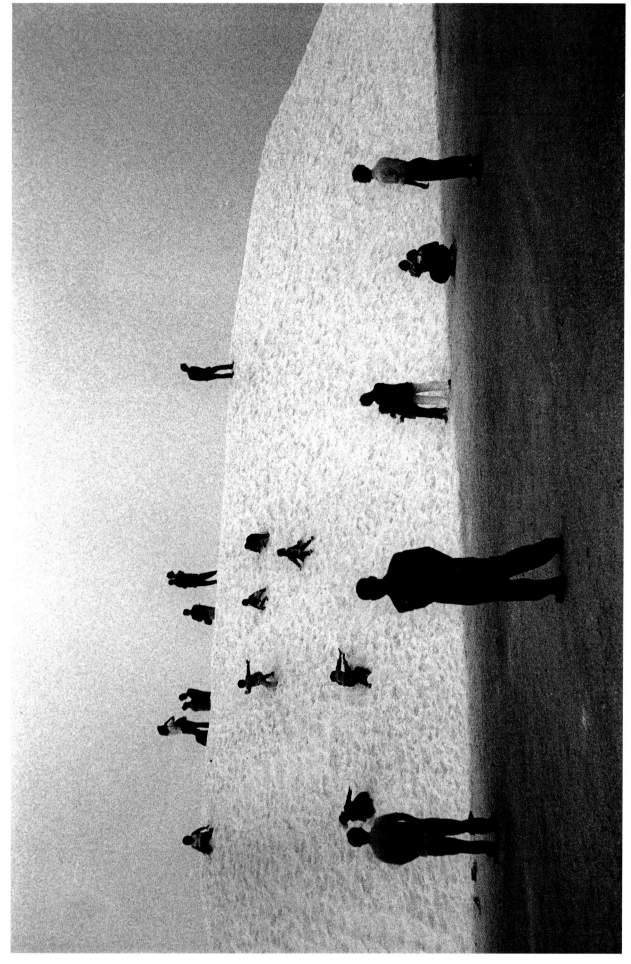

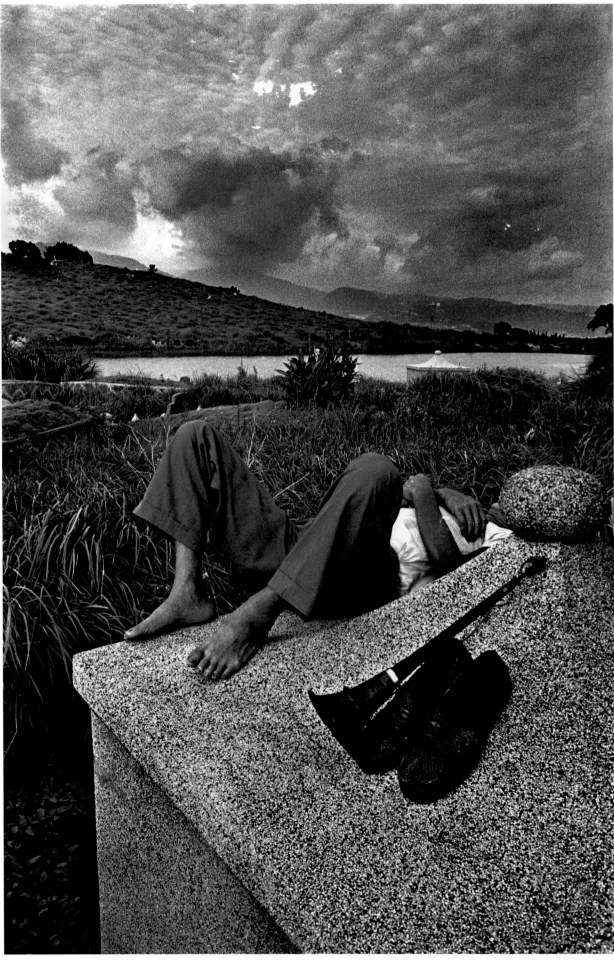

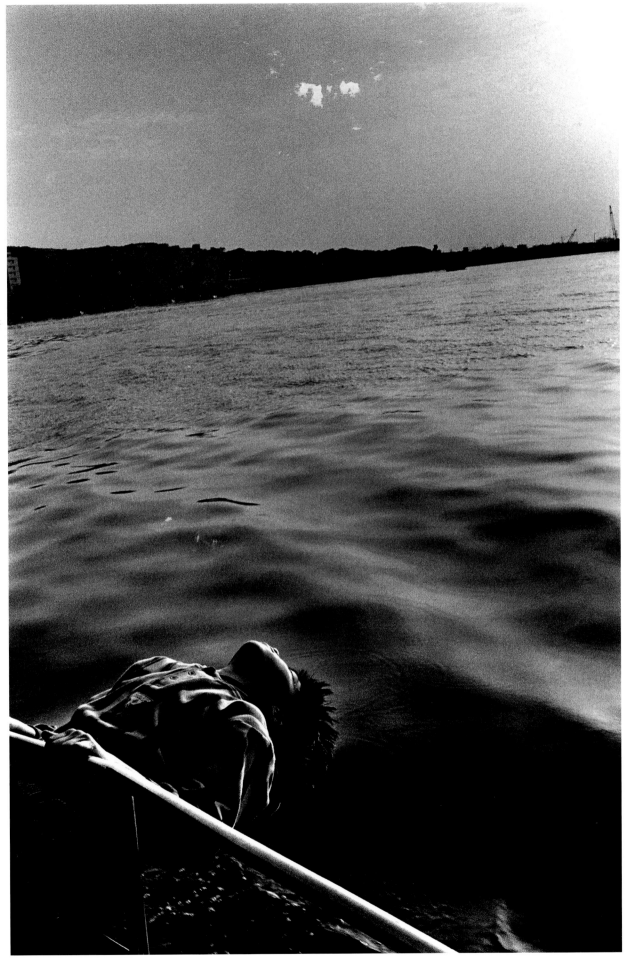

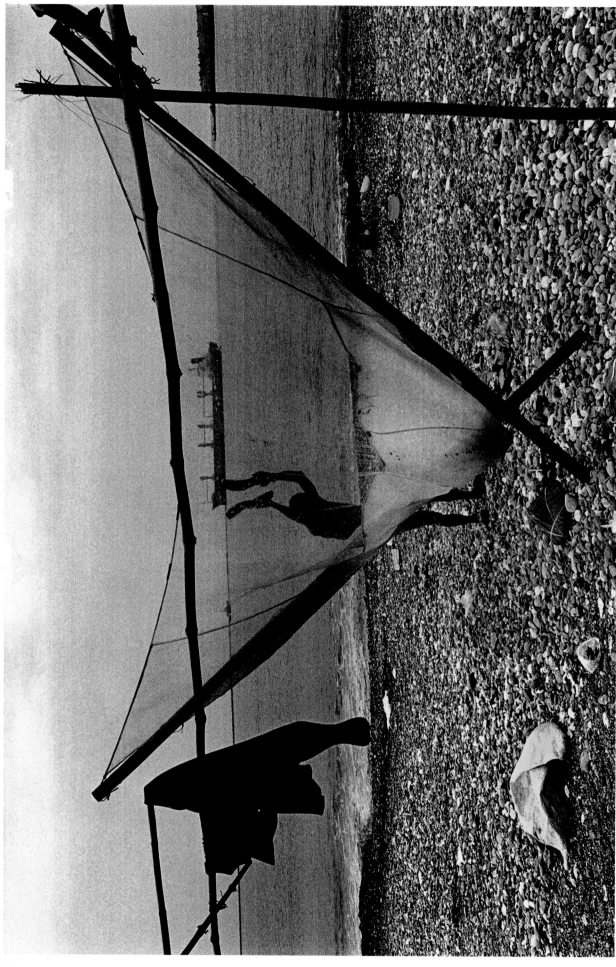

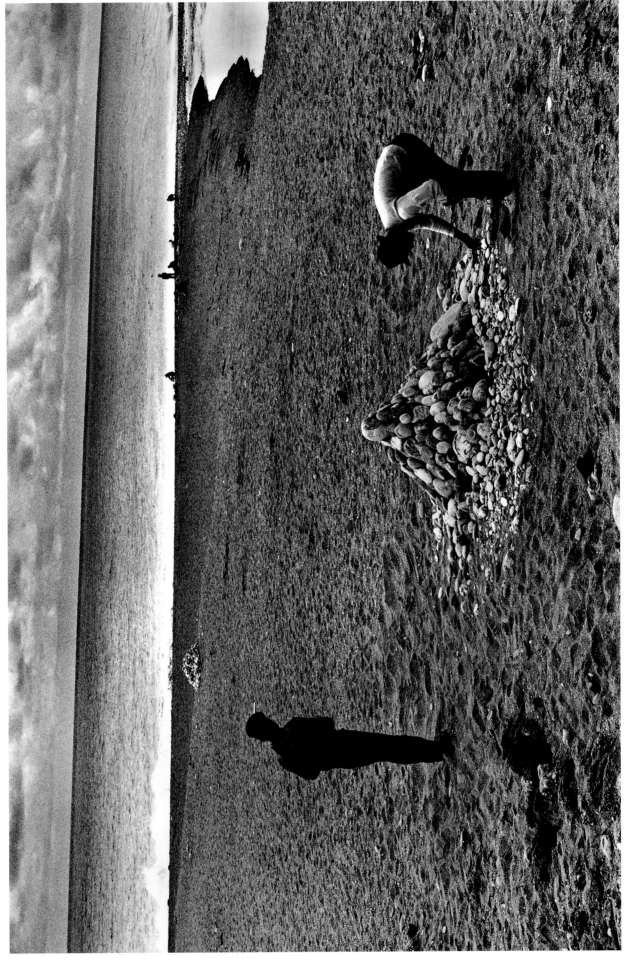

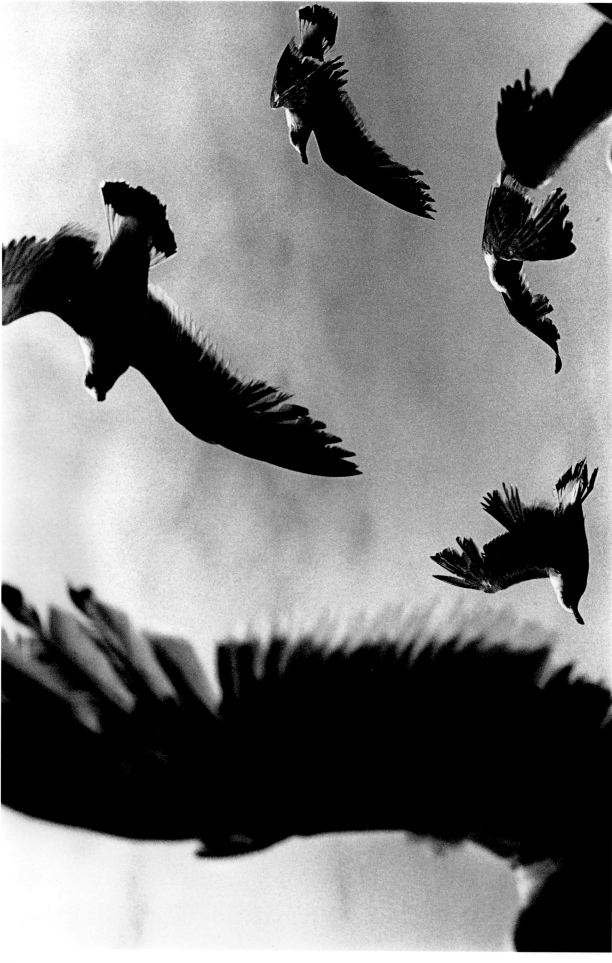

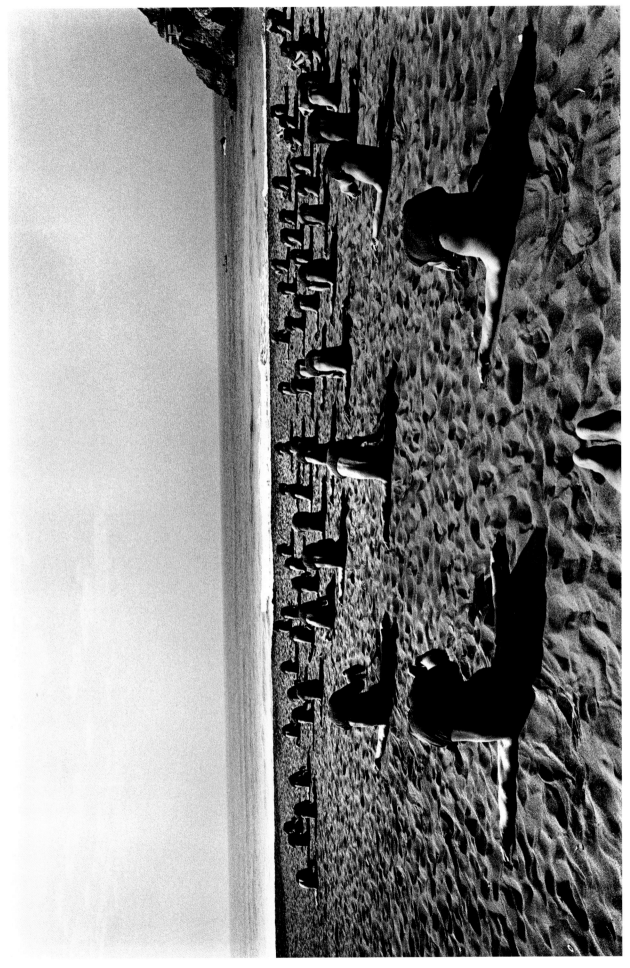

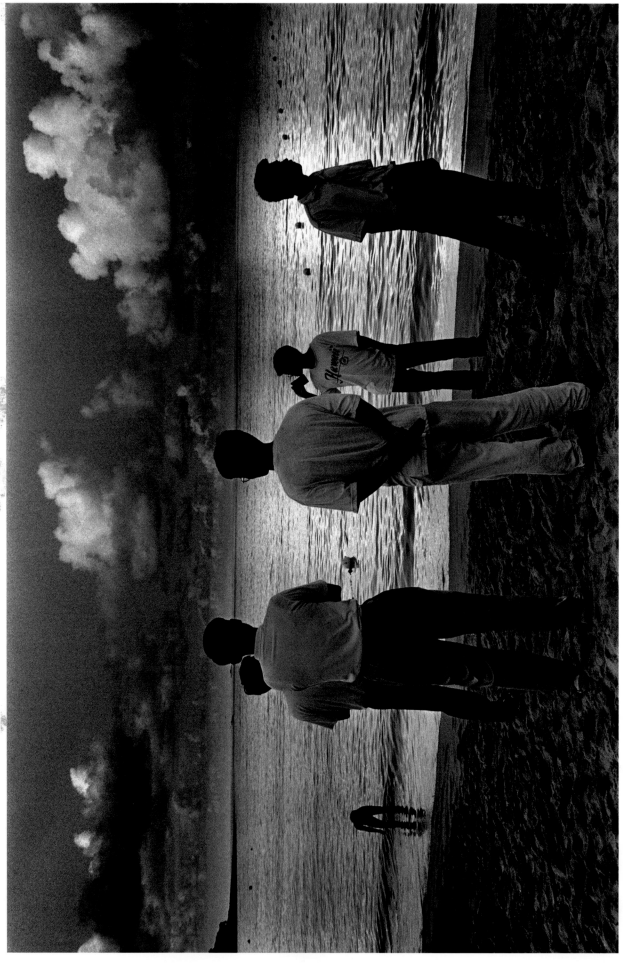

# The
# Sleepwalking
# Before ...

## 2005-2013

夢遊——
遠行之前……

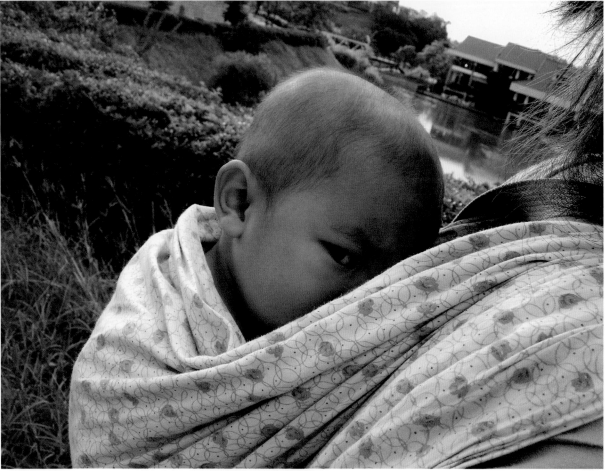

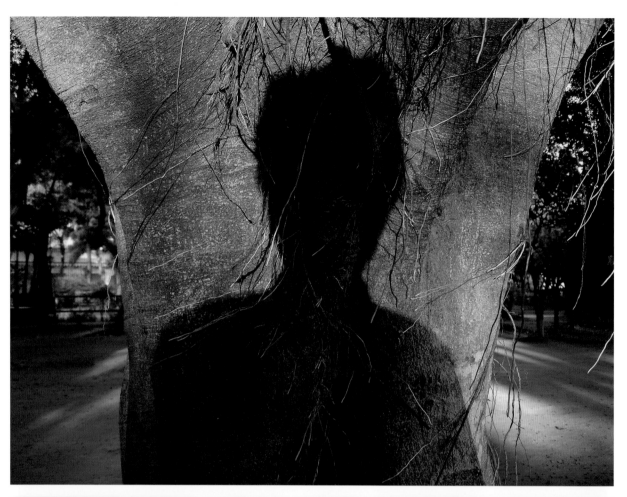

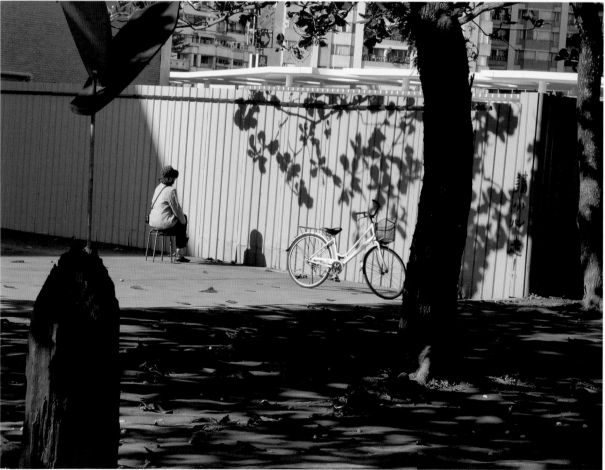

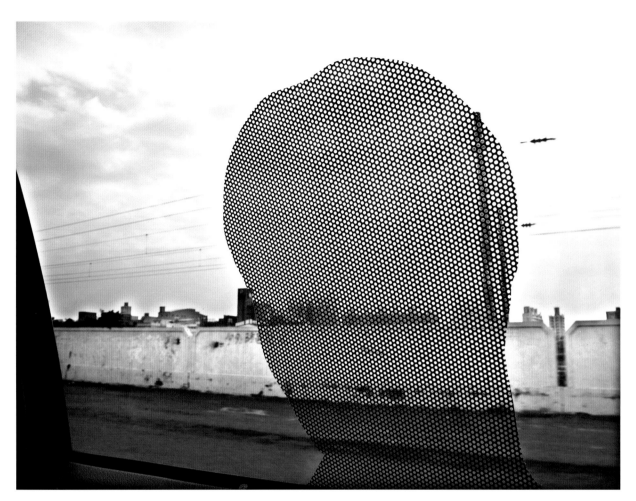

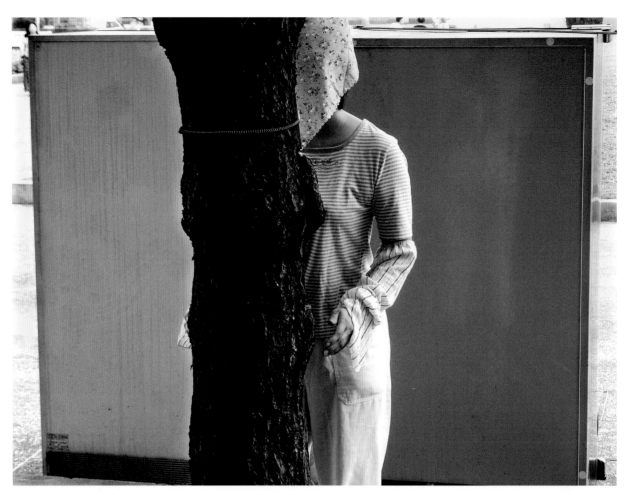

# Taiwan –
# And then
# Nuclear
# Disaster…

2005-2013

# 臺灣——
# 核災之後……

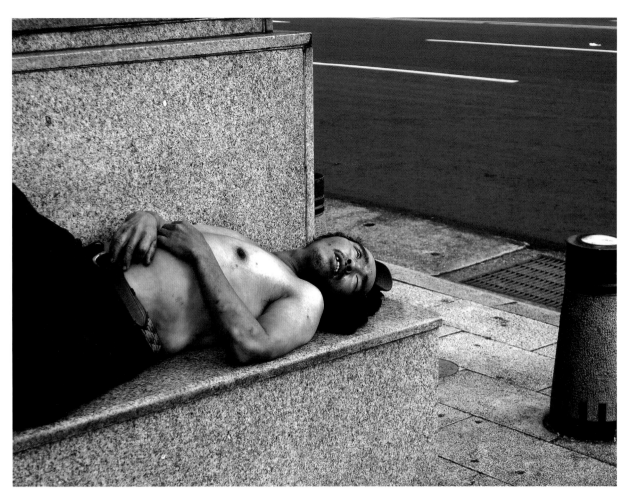

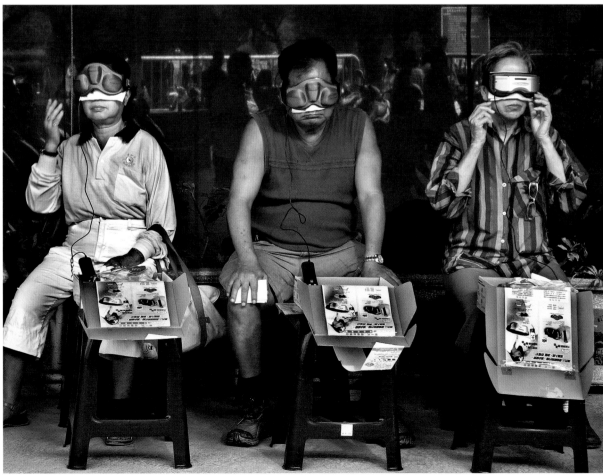

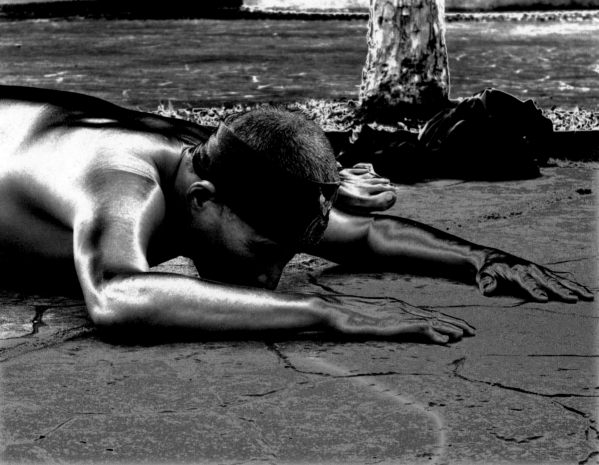

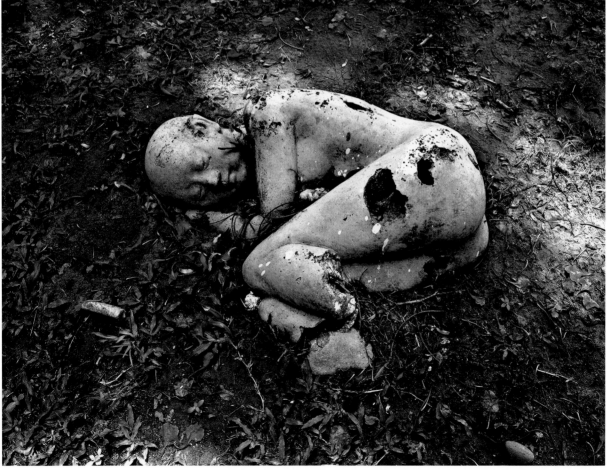

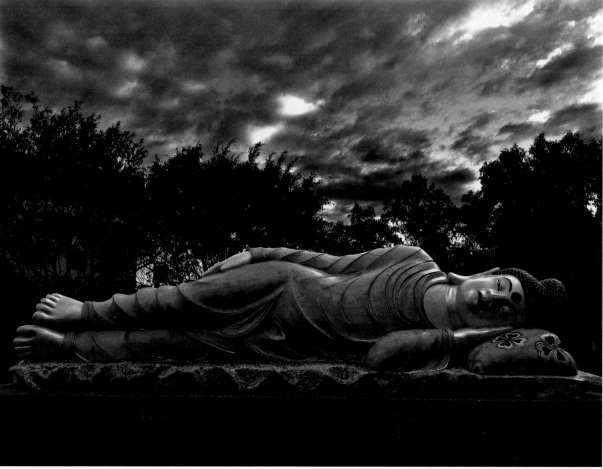

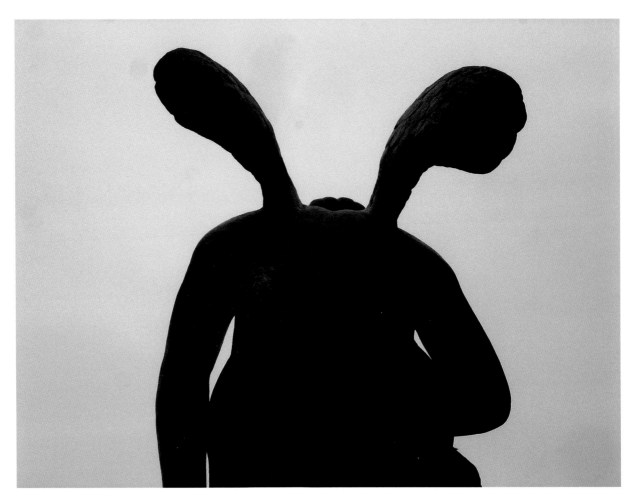

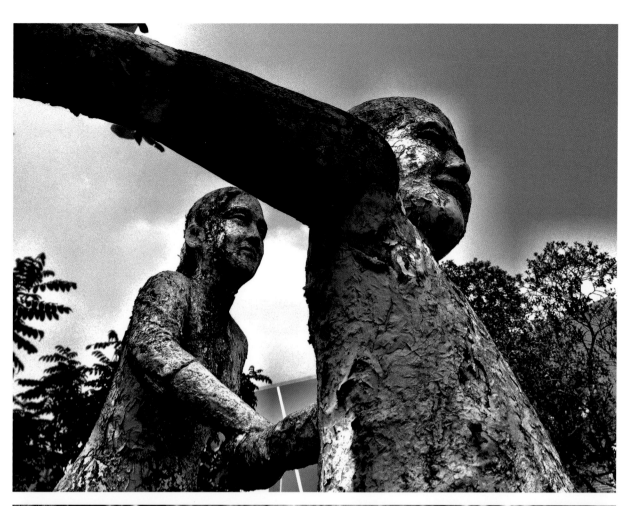

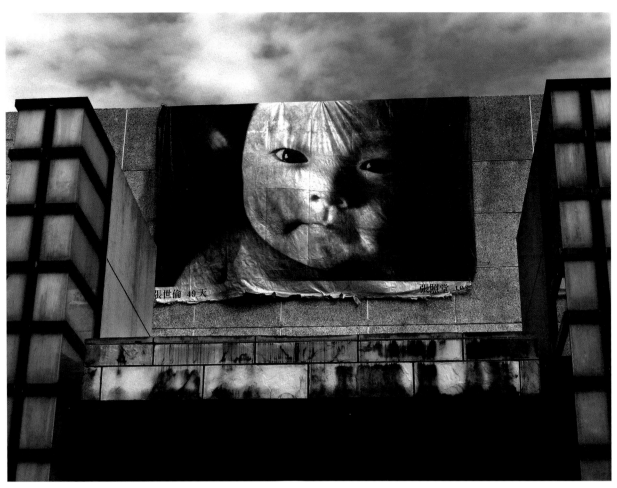

張世倫 49 天　　　　　　張照堂 196?

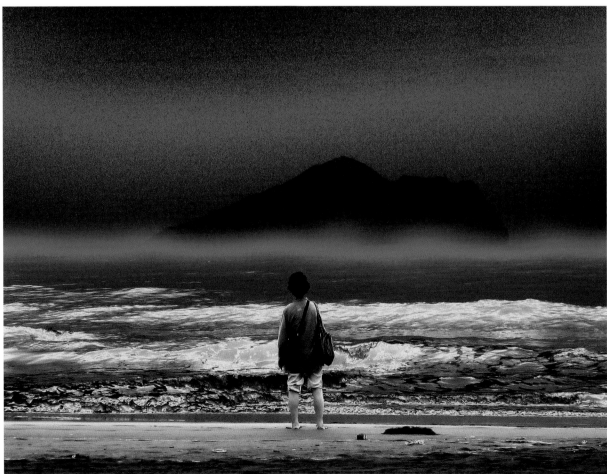

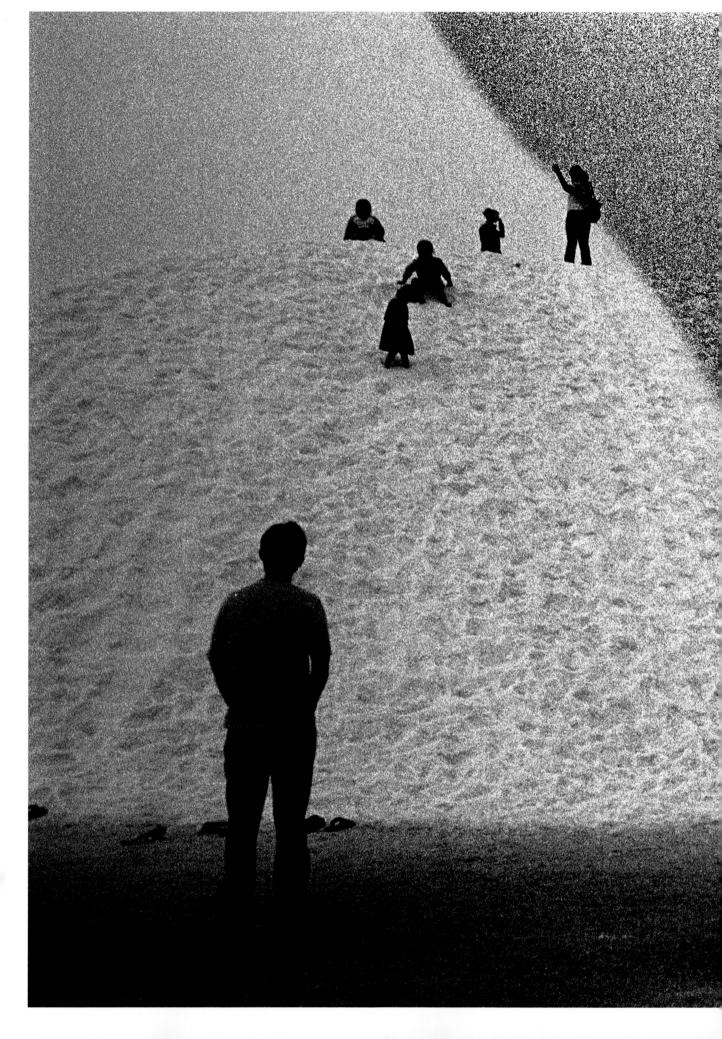

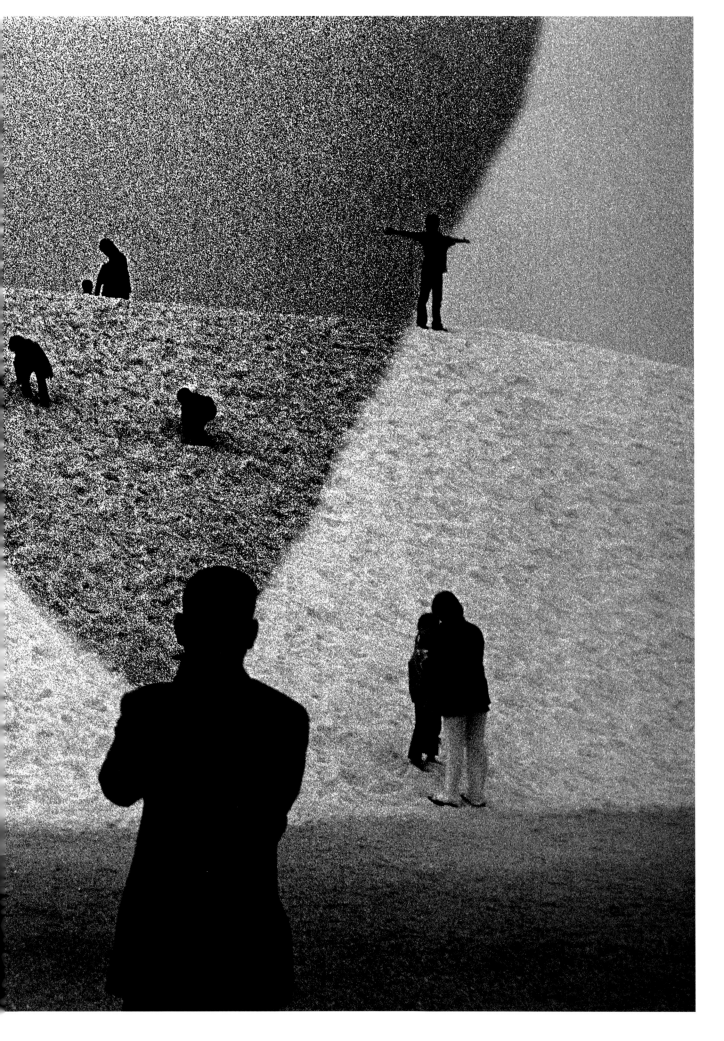

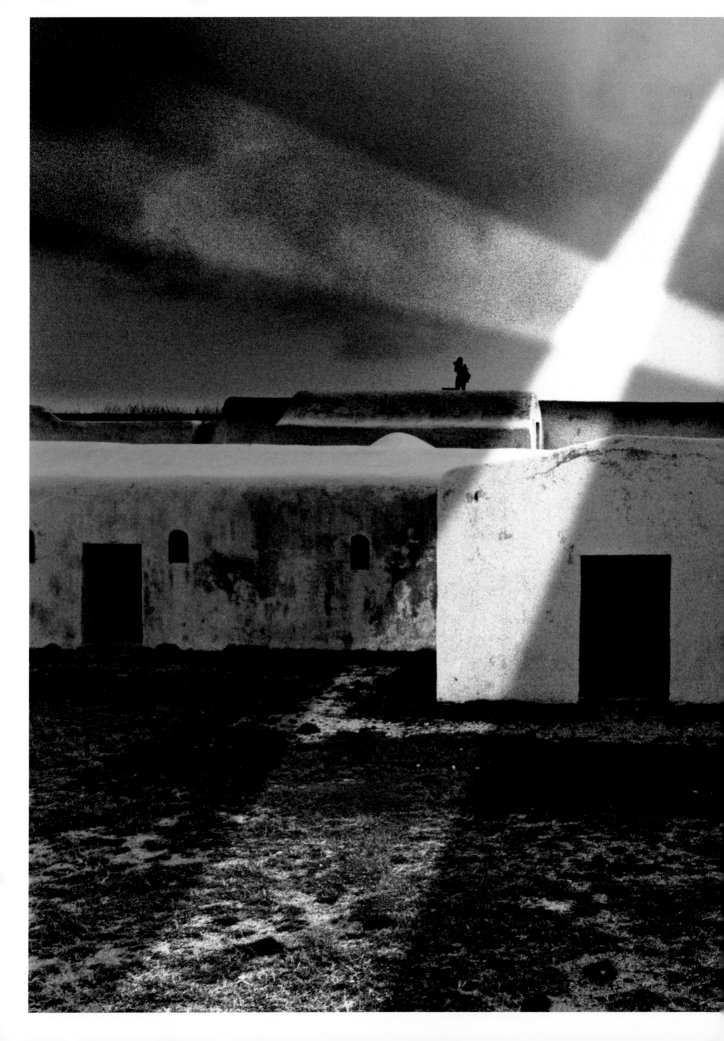

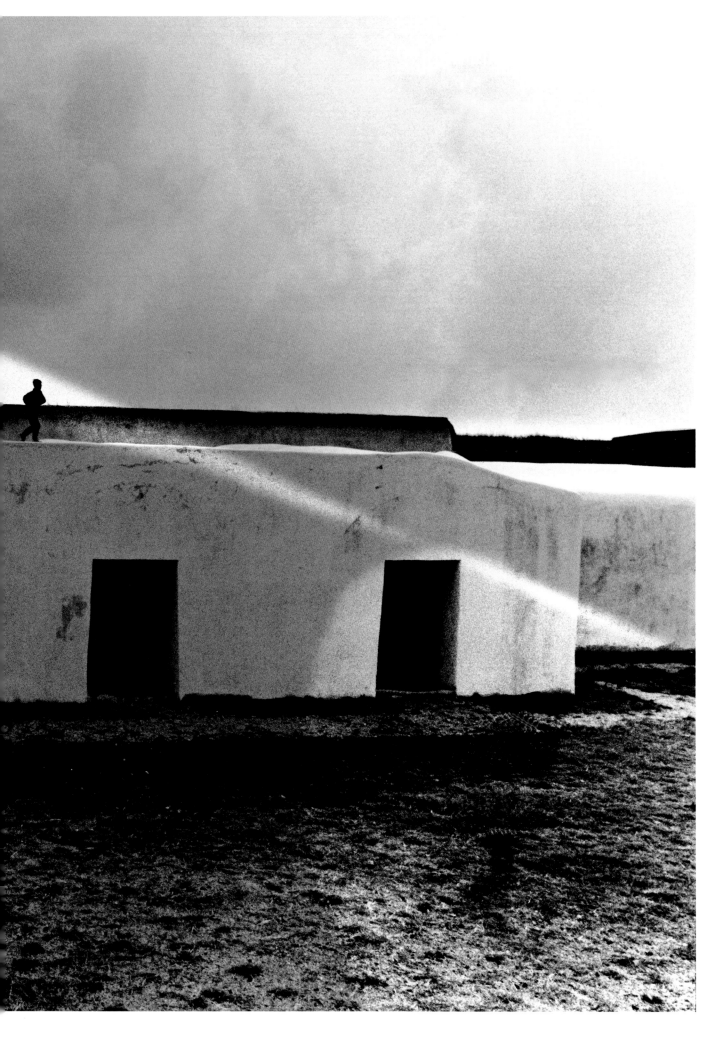

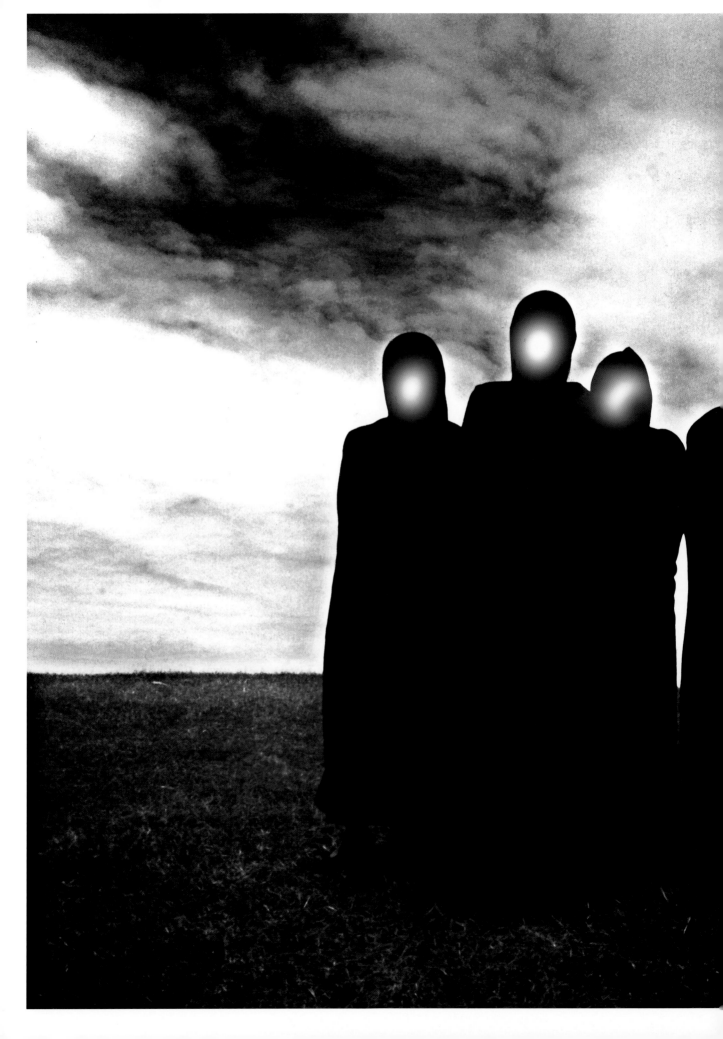

1943　臺灣省臺北縣板橋鎮出生
　　　父親業醫, 家中子女七人, 位居老五

1957　就讀成功初三時, 向大哥借 Aires Automat 120 相機把弄, 開始對攝影產生興趣

1958　成功高中時期參與學校「攝影社」, 隨同指導老師鄭桑溪學習, 四處拍照

1961　就讀臺大土木工程系時, 不務課業, 反勤於文學閱讀與藝術吸收, 著迷於超現實與現代主義的東、西方著作, 並展開概念性與現代觀的攝影創作

1965　徵招入伍, 在澎湖當兵, 平時在軍營寫文書、抄鋼板, 假日拿著相機在島上遊晃, 尋找自我意象

1965　參與鄭桑溪發表「現代攝影雙人展」, 表現型式與內容新穎、突異, 引發攝影界爭議與注目
　　　與廖淑貞結婚

1966　參與「現代詩畫展」, 以洛夫詩作〈石室之死亡〉為註, 發表攝影裝置作品
　　　長子張世和出世

1967　參與「不定形」展, 製作《生日快樂》、《未完成》等多媒材與現成物隨興裝置作品
　　　參與「劇場」第二次電影發表會, 拍攝8mm實驗影片《日記》

1968　進入中視新聞部擔任攝影記者, 在張繼高率領下, 參與製作「新聞集錦」製作, 試圖將鄉土風情、民間習俗與西方音樂結合, 營造新氣象。拍攝《北港牛墟》、《煙毒迷惘》、《四個攝影家》、《李錫奇的版畫世界》、《二龍村的龍舟競渡》等專題

1972　參與中視「新聞眼」、「人物特寫」等專欄拍攝, 與潘健行合作《王小亭的鏡頭世界》、《謝家父子藝術家》、《楊森的養身》、《張英武的高人世界》等報導

1973　擔任《再見中國》(唐書璇 執導) 電影攝影師

1974　舉辦「攝影告別展」, 與不確定的攝影走向告一了斷

1975　參與「芬芳寶島」第一季拍攝, 與黃春明完成《大甲媽祖回娘家》、《淡水暮色》、《咚咚響的龍鼓船》等16mm紀錄片
　　　次子張世倫出世

---

1943　Born November 17 in Panchiao City, Taipei County, Taiwan, the fifth of seven siblings. His father was a physician.

1957　As a ninth-grader at Cheng Kung Junior High School, he borrows an Aires Automat 120 from his older brother, and develops an interest in photography.

1958　When studying at Cheng Kung Senior High School, he joins the school photography club under the guidance of Cheng Shang-Hsi, starts photographing in a wide variety of settings.

1961　Studies in the National Taiwan University Department of Civil Engineering. Instead of attending to his studies, he devotes himself to literature and art, becomes infatuated with surrealism and modernism, both Asian and Western. Begins to engage in conceptual and modernist photography.

1965　Performs his compulsory military service on Penghu, where day to day he writes and makes stencils on his base, and travels the island with his camera on holidays, looking for images to express himself.

1965　Takes part in the joint exhibition "2-Men Contemporary Photography" with his mentor Cheng Shang-Hsi. His forms and content are innovative and original, inciting controversy and attention.
　　　Marries Liao Shu-Chen.

1966　Participates in the exhibition "Modern Poetry", with a work of photographic installation illustrating the poem "Death of a Stone Cell" by Lo Fu.
　　　Eldest son Chang Shih-Ho is born this year.

1967　Participates in the exhibition "Formless" with *Happy Birthday* and *Unfinished*, two installations made with mixed media and readymade goods.
　　　Contributes to the Theater Experimental Film Festival with the 8mm short film *Diary*.

1968　Works as a photojournalist for the China Television (CTV) news department in Taipei; joins the production team of "News Digest" led by Chang Chi-Kao, creating a new style of news feature combining local Taiwanese settings, folk customs and Western music. Films such special features as *The Cattle Market of Peikang, Swooning from the Smoke, Four Photographers, Lee Shi-Chi's World of Print* and *The Dragon Boat Races of Erlung Village*.

1972　At CTV, does camera work for the feature news programs "News Eye" and "Close-up". Works with Pan Chien-hsing on news reports including *The Photographic World of H.S. Wong; The Hsieh Family, Father and Son Artists; Health with Yang Sen;* and *Chang Ying-Chih the Giant.*

1973　Serves as cinematographer for the motion picture *China Behind* (directed by Tang Shu-Shuen)

1974　Holds the photo exhibition "The Farewell", declaring an end to incomprehensible photography.

1975　Helps film the first season of "Fragrant Formosa". In collaboration with Huang Chunming, he produces the 16mm documentaries *The Matsu of Tachia Comes Home, Tamsui Twilight*, and *The Booming Dragon Drum Boat.*
　　　Second son Chang Shih-Lun is born.

1978 參與中視「六十分鐘」電視新聞雜誌製作,拍攝《王船祭典》、《陳達的恆春民謠》、《洪通的傳奇》、《灰窯村的子弟北管戲》、《林讚成的傀儡戲團》、《廣慈雛妓募援:青草地演唱會》等專題報導

1979 參與「芬芳寶島」第二季拍攝,與余秉中完成《古厝》、《美濃的油紙傘》紀錄片

1980 《古厝》與《王船祭典》紀錄片攝製,分別獲得年度電影金馬獎最佳攝影與電視金鐘獎最佳攝影／剪輯
擔任三臺聯播節目《美不勝收》、《映像之旅》紀錄片系列編導／攝影

1984 接續三年,擔任《殺夫》(曾壯祥執導)、《唐朝綺麗男》(邱剛健執導)、《淡水最後列車》(柯一正執導)電影攝影師

1992 任職於公共電視籌委會,策劃／製作《臺灣視角》系列紀錄片

1994 進入超級電視臺工作,製作《調查報告》、《對抗生命》、《生命告白》(汪其楣、黃春明、陳映真主持)等紀錄報導系列

1996 自由影像工作者,「雲門舞集」舞作影帶編導,「後視野工作室」策劃／顧問,《世紀的容顏》、《臺灣世紀回味》紀錄片系列監製

1997 國立臺南藝術學院音像紀錄研究所任教

1998 策劃、推動第一屆「臺灣國際紀錄片雙年展」

1999 獲頒文建會第三屆國家文藝獎―「美術類」得獎人

2000 公視紀錄片系列《世紀的容顏》企畫／監製

2002 公視紀錄片系列《臺灣世紀回味》企畫／監製

2011 獲頒行政院第三十屆國家文化獎

1978 Films the magazine-format television news program "60 minutes", producing such television reports as *The Boat-Burning Festival*; *Homage to Chen-Da*; *Homage to Hung-Tung*; *The Peikuan Opera of Hueiyao Village*; *The Puppet Theater of Lin Tsan-Cheng*; and *Benefit for Child Sex Workers – Concert on the Green*.

1979 Works on second season of "Fragrant Formosa". Completes the documentaries *An Old House – Chinese Traditional Architecture* and *The Oil Paper Parasols of Meinung* in collaboration with Yu Ping-Chung.

1980 Wins Golden Bell Award for TV cinematographer and editor of the year for *The Boat-Burning Festival*; and Golden Horse Award for best documentary cinematographer for *An Old House – Chinese Traditional Architecture*. Writes and films the documentary series *The Beauty of Taiwan* and *Portrait Journey*, broadcast on all three of Taiwan's major television stations.

1984 Starts working as cameraman for the three films *Woman of Wrath* (directed by Tseng Chuang-Hsiang), *Tang Dynasty Dandy* (directed by Chiu Kang-Chien) and *Last Train to Tamsui* (directed by Ko I-Chen), which are completed over the following three years.

1992 Serves on the planning committee for Taiwan's public television station; plans and produces the documentary series *Taiwan Perspective*.

1994 Starts working for the television station Super TV; produces the three documentary series *Investigative Report*, *Challenging Fate* and *Sharing Life's Meanings* (hosted by Wang Chi-Mei, Huang Chun-Ming, and Chen Ying-Zhen, respectively).

1996 Starts freelancing as a filmmaker; writes and directs a series for Cloud Gate Dance Theatre; works as a planning consultant for Revision Broadcasting Company; and produces the documentary series *Faces of the Century* and *Scanning Taiwan*.

1997 Starts teaching at the Graduate Institute of Studies in Documentary and Film Archiving at Tainan National University of the Arts.

1998 Curates and promotes the first Taiwan International Documentary Festival.

1999 Receives the Third National Award for Arts of Taiwan in the category of fine art.

2000 Executive Planner/Executive Producer for Public Television documentary series *Faces of The Century*.

2002 Executive Planner/Executive Producer for Public Television documentary series *Scanning Taiwan*.

2011 Receives the 30th National Cultural Award, ROC.

個展

1974 「攝影告別展」, 臺北

1983 「恩寵與寬容」, 臺北、舊金山、香港、紐約

1986 「逆旅」, 臺北、東京

1994 「逆旅·意象」, 巴黎

1996 「1962·夏日」, 臺北

1997 「現象·一瞥」, 臺中

2009 「在與不在」, Epson, 臺北

　　　「歲月·一瞥」, Place Gallery, 東京、Gallery Now, 首爾

2010 「歲月·風景 1959-2005」攝影巡迴展
　　　（中央大學、靜宜大學、成功大學、高雄駁二藝術特區、
　　　花蓮松園別館、宜蘭羅東圖書館、政治大學）

　　　「歲月印樣 1959-1961」, 臺灣國際視覺藝術中心, 臺北

　　　「旅次·風景 2005-2010」, 萊卡藝廊, 臺北

2011 「光影鏡頭外」, 市長官邸, 臺北

　　　「省視 Introspectives 1960-2005」, 聖·安東尼國際中心, 美國德州

　　　「視線 Sightlines」, 墨西哥文化會館, 聖·安東尼國際中心, 美國德州

2012 「潛越：臺灣意象 1960-2005」, 臺灣書院, 美國紐約

2013 「歲月／照堂：1959-2013影像展」, 臺北市立美術館

## SOLO EXHIBITIONS

1974 "The Farewell", Taipei

1983 "Human Grace and Forgiveness", Taipei, San Francisco, Hong Kong and New York

1986 "Trip – Reverse", Taipei and Tokyo

1994 "Image of Trip – Reverse", Paris

1996 "Summer of 1962", Taipei

1997 "a glance, a phenomenon", Taichung

2009 "Within, Without", Epson Art Gallery, Taipei

　　　"Years In, Years Out", Place Gallery, Tokyo; Gallery Now, Seoul

2010 "Moments in Time 1959-2005", National Central University, Chungli City; Providence University, Taichung; Cheng Kung University, Tainan; The Pier-2 Art Center, Kaohsiung; Pine-garden Gallery, Hualian; Luo Dong Library, Yilan; National Chengchi University, Taipei

　　　"The Invisible Contact 1959-1961", Tivac Gallery, Taipei

　　　"Images - Journey beyond", Leica Gallery, Taipei

2011 "Outside the Lens", Gity Mayer Salon, Taipei

　　　"Sightlines", Instituto Cultural de Mexico, San Antonio, Texas

　　　"Introspectives: Photographs of Taiwan 1960-2005", City of San Antonio International Center, Texas.

2012 "Introspectives: Photographs of Taiwan 1960-2005 "

　　　Taiwan Academay, Taipei Cultural Center, New York

2013 "Time: The Images of Chang Chao-Tang, 1959-2113", Taipei Fine Arts Museum

群展

| | | | |
|---|---|---|---|
| 1965 | 「鄭桑溪／張照堂，現代攝影雙人展」，臺北、基隆、高雄 | 2000 | 「家園重見：走過921影像報告」，臺北 |
| 1971 | 「V-10視覺藝術群：《女》展」，臺北 | 2002 | 「又見V-10：視覺藝術群30年」，臺北 |
| 1991 | 「看見與告別：臺灣攝影家九人意象展」，臺北、舊金山 | 2006 | 「彼岸，看見：臺灣攝影20家（1928-2006）」，北京、上海 |
| 1993 | 「雲門快門 20」，臺北 | | 「風華再現：美而廉藝廊（1953-1973）回顧展」，臺北 |
| | 「看見淡水河」，臺北、巴黎 | 2007 | 「廣州國際攝影双年展」，廣東 |
| 1994 | 「中·港·臺 當代攝影展」，香港藝術中心 | 2008 | 「The Hidden 4：大邱國際攝影雙年展」，韓國 |
| 1996 | 「躍動的亞洲意象」，東京都寫真美術館，東京 | 2011 | 「快門·開演：Ten Eyes on Stage」，新北市 |
| 1997 | 「看見原鄉人：臺灣客家光影紀事」，臺北 | 2012 | 「臺灣臉書：用心生活」，臺中 |
| 1998 | 「老·臺北·人」，臺北 | | 「2012台北雙年展：想像的死而復生」，臺北 |
| 1999 | 「創意的原點：全球概念藝術展 1950s-1980s」，紐約 | | |

## GROUP EXHIBITIONS

| | | | |
|---|---|---|---|
| 1965 | "2-Men Contemporary Photography", Taipei, Keelung and Kaohsiung | 2006 | "Retrospective: Taiwan Photography", Beijing and Shanghai |
| 1971 | "V-10: Womanology", Taipei | | "A Legend of Rose Marie Gallery 1953-1973", Taipei |
| 1991 | "Seeing-Perspectives of Nine Photographers", Taipei and San Francisco | 2007 | "Guangzhou Photo Biennial", Guangdong |
| 1993 | "20 Years of Cloud Gate Dance Theatre", Taipei | 2008 | "The Hidden 4: Daegu Photo Biennale", Korea |
| | "50 Years of Tamsui River Views", Taipei and Paris | 2011 | "Ten Eyes on Stage", New Taipei City |
| 1994 | "Contemporary Photography from China, Hong Kong and Taiwan", Hong Kong | 2012 | "Taiwan Facebook: A Mindful Living", Taichung |
| 1996 | "Asian View: Asia in Transition", Tokyo | | "Taipei Biennial: Modern Monsters/ Death and Life of Fiction", Taipei |
| 1997 | "Image of Hakka", Taipei | | |
| 1998 | "Taipei: Past", Taipei | | |
| 1999 | "Global Conceptualalism : Point of Origin, 1950s-1980s", New York | | |
| 2000 | "The Homeland: After the 921 Earthquake", Taipei | | |
| 2002 | "V-10 / 30 Years After", Taipei | | |

編輯

## EDIT BOOKS

社會記憶 | Social Memory

內心風景 | Inner Landscapes

本書為「歲月/照堂：1959-2013影像展」出版《張照堂》套書之一
展覽由臺北市立美術館策劃，展覽日期為2013年9月14日至12月29日

發 行 人 ｜ 黃海鳴
編輯委員 ｜ 蔣雨芳 蕭淑文 劉建國 張麗莉 于平中 林秋鳳 蔣明宗
執行督導 ｜ 詹彩芸

攝 影 家 ｜ 張照堂
主　　編 ｜ 張照堂 余思穎
執　　編 ｜ 余思穎 張曉華
翻　　譯 ｜ 韓伯龍 張至維 陳靜文
美術設計 ｜ 思緒溝通有限公司

空間設計 ｜ 一點點創意事業有限公司
展場監製 ｜ 馮健華 鄭瑞瑜 張琬怡
展場攝影 ｜ 陳泳任 陳志和 阮臆菁
資訊小組 ｜ 林　嬿 廖健男
公　　關 ｜ 林玉明 楊舜雯
燈　　光 ｜ 蔡鳳煌 簡偉洲、王群元

印　　刷 ｜ 佳信印刷股份有限公司

著作權人 ｜ 臺北市立美術館
發 行 處 ｜ 臺北市立美術館
　　　　　中華民國臺灣臺北市104中山北路三段一八一號
　　　　　Tel: 886-2-2595-7656　Fax: 886-2-2594-4104

出版日期 ｜ 中華民國103年1月 再版

國際標準書號　978-986-03-8132-0
統一編號　1010201971
套書定價　2,000 元

展售門市：

國家書店松江門市
104臺北市松江路209號1樓　TEL：02-25180207

五南文化廣場臺中總店
400臺中市中山路6號　　TEL：04-22260330

臺北市立美術館藝術書店
104臺北市中山北路三段181號　TEL：02-25957656-734

國家圖書館出版品預行編目資料

歲月照堂 ／ 張照堂, 余思穎主編.
-- 再版. -- 臺北市：北市美術館, 民103.01
冊； 21 × 27.5 公分　中英對照

ISBN 978-986-03-8132-0(全套：精裝)

1.攝影集 2.藝術評論
958.33　　102019310

Published for the representation of "Time: The Images of Chang Chao-Tang, 1959-2013"
at the Taipei Fine Arts Museum, Taipei, Taiwan from 14 September to 29 December, 2013.

CATALOGUE
DIRECTOR ｜ Huang Hai-Ming
PUBLISHING COMMITTEES ｜ Chiang Yu-Fang, Jo Hsiao, Liu Chien-Kuo,
Lily Chang, Yu Ping-Chung, Lin Chiu-Feng, Chiang Ming-Tsung
CHIEF OF RESEARCH DEPT. ｜ Chan Tsai-Yun

PHOTOGRAPHER ｜ Chang Chao-Tang
CHIEF EDITORS ｜ Chang Chao-Tang, Sharleen Yu
EDITORS ｜ Sharleen Yu, Olga Chang
TRANSLATORS ｜ Brent Heinrich, Chang Chih-Wei, Christine Chan (Chinese to English)
GRAPHIC DESIGN ｜ THOXT Communications & Design INC.

GALLERY DESIGNER ｜ One Dot Dot Creative
DISPLAY COORDINATOR ｜ Feng Chien-Hua, Cheng Juei-Yu, Chang Wan-Yi
DISPLAY PHOTOGRAPHERS ｜ Chen Yung-Jen, Chen Chih-Ho, Juan Yich-Ing
INFORMATION TECHNOLOGY ｜ LinYen, Chiennan Liao
INTERNATIONAL RELATIONS ｜ Lin Yu-Ming, Yang Shun-Wen
LIGHTING ｜ Tsai Feng-Huang, Chien Wei-Chou, Wang Chin-Yuan

Printed at Chia Hsin Printing CO., LTD, Taipei, Taiwan

PUBLISHER ｜ Taipei Fine Arts Museum
© Taipei Fine Arts Museum
181 Zhongshan N. RD. Sec. 3 Taipei 104 Taiwan
Phone + 886 (0)2 2595 7656, Fax + 886 (0)2 2594 4104

Publishing Date: January, 2014

ISBN　978-986-03-8132-0
GPN　1010201971
Price　NTD 2,000

RETAIL OUTLETS:

GOVERNMENT  PUBLICATION BOOKSTORE, SONGJIANG STORE
1F No.209 SongJiang RD. Taipei 104 Taiwan　　Tel: 886-2-2518-0207

WU-NAN BOOK INC., TAICHUNG MAIN STORE
No.6 Zhongshan RD. Taichung 400 Taiwan　　Tel: 886-4-2226-0330

TAIPEI FINE ARTS MUSEUM, ART BOOKSTORE
181 Zhongshan N. RD. Sec.3 Taipei Taiwan　　Tel: 886-2-2595-7656 #734